GOVERNMENT PATRONAGE OF THE ARTS IN GREAT BRITAIN

GOVERNMENT PATRONAGE OF THE ARTS IN

GREAT BRITAIN

JOHN S. HARRIS

The University of Chicago Press / Chicago & London

International Standard Book Number: 0-226-31743-9
Library of Congress Catalog Card Number: 72-120007

THE UNIVERSITY OF CHICAGO PRESS, CHICAGO 60637
THE UNIVERSITY OF CHICAGO PRESS, LTD., LONDON

© 1970 by The University of Chicago. Published 1970

Made and printed in Great Britain by
William Clowes and Sons Ltd, London and Beccles

To Lois

CONTENTS

CHARTS

TABLES

PREFACE

Patronage of the arts was slow to develop in Britain. In fact, Treasury subventions to the performing arts were not authorized by Parliament until World War II, when the nation found itself in the throes of a life-and-death struggle for survival. Emergency programs, designed to entertain a war-weary population and to provide employment for musicians, actors, and artists, were organized on an extensive scale. With the return to peace, a permanent program of government assistance to the arts was mounted under the aegis of the Arts Council. Legislation was subsequently enacted authorizing local authorities to spend appreciable sums in providing assistance to the arts. This book describes and analyzes the development during the past thirty years of Britain's successful patronage programs, administered by public authorities. The essential features of a viable patronage system are carefully examined and principles of subsidy management tentatively put forward. It is hoped that readers in Britain, the United States, and elsewhere will profit from this study, gaining an understanding of an important area of government activity thus far largely neglected by scholars.

The writing of this book was made possible by the Rockefeller Foundation which extended two grants to partially defray the costs of travel and research. I also wish to acknowledge financial assistance given by the Research Council of the University of Massachusetts. I am particularly grateful to Gerald Freund, formerly Associate Director of the Foundation's Humanities and Social Sciences Division, and to Edward Moore, Chancellor of the Massachusetts Board of Higher Education, for their personal interest and encouragement.

The author is indebted to countless individuals who were generous enough to take time from busy schedules to discuss the problems encountered by the arts in postwar Britain and the role of governments in making available financial support and encouragement. Museum directors provided useful insights concerning the status of the visual arts and the need for public funds to underwrite more adequate arrangements for increased public access to the nation's art treasures. Practicing artists talked freely about how public moneys could be effectively utilized to stimulate creative effort. In opera and ballet, company managers and veteran singers and dancers shared with the author thoughts pertaining to the precarious condition of these performing arts and depicted the urgent need for adequate fiscal transfusions. In music, extended interviews highlighted serious operational difficulties encountered by the London and the provincial symphony orchestras, as well as by other musical organizations, emphasis being given to benefits stemming from subventions made available by the Exchequer and local councils. The current

status of British drama was described by theater managers, who praised the role played by the Arts Council and local authorities in preventing the demise of existing theaters and their achievements in underwriting a remarkable postwar revival. Persons engaged in fostering a variety of literary endeavors were interviewed, as were many associated with regional arts associations and selected arts centers and clubs.

Specifically, I wish to acknowledge my indebtedness to the following persons who were particularly helpful: Eric W. White, Assistant Secretary and Literature Director, M. J. McRobert, Deputy Secretary and Finance Officer, and Nigel J. Abercrombie, Chief Regional Adviser, all staff officers of the Arts Council of Great Britain; Alexander Dunbar, Director, Northern Arts Association; William A. Robson, Professor of Public Administration (emeritus), London School of Economics and Political Science; and S. K. Ruck, also formerly associated with the London School of Economics and Political Science. However, responsibility for the work remains, of course, entirely mine.

GOVERNMENT PATRONAGE OF THE ARTS IN GREAT BRITAIN

1 / THE NATURE OF ARTISTIC PATRONAGE BY GOVERNMENTS

Is not a patron, my Lord, one who looks with unconcern on a man struggling for life in the water, and when he has reached ground encumbers him with help? The notice which you have been pleased to take of my labours had it been early, had been kind; but it has been delayed till I am indifferent and cannot enjoy it; till I am solitary, and cannot impart it; till I am known, and do not want it.
—Samuel Johnson, 1775

The arts have never flourished without patronage of some kind. It is less a question, today, of whether than of whom, to what extent and how the State should help. Far more support is needed for the arts than in the past, and more will be required in future to maintain new standards of creation and performance.
—Arts and Amenities Committee, 1962
Conservative Party, House of Commons

Samuel Johnson's bitter remarks about private patrons, in a letter to Lord Chesterfield, sprang from personal disillusionment.[1] Although Dr. Johnson's financial condition was desperate during the many years that his *Dictionary* was in preparation, Chesterfield had ignored him. And yet, when the work was published, the noble lord added his voice to the chorus of enthusiastic admirers and publicly praised it. But Johnson had already registered his contempt for cavalier patrons: the *Dictionary* defines "patron" as "commonly a wretch who supports with insolence, and is paid with flattery." Again, in poetry—*The Vanity of Human Wishes*—Johnson complains, "There mark what ills the scholar's life assail / Toil, envy, want, the patron, and the jail," including the word "patron" in a catalog of hardships. Dr. Johnson's jaundiced attitude toward arts patrons did not, fortunately, totally reflect reality. In the eighteenth and nineteenth centuries patronage by wealthy private individuals and to a limited extent by the church, although it did not usher in a "golden age," did render the visual arts much-needed support and encouragement. On the continent, patronage flourished in France, Germany, and other countries; it was provided by kings, princes, and aristocrats and, later, by democratic governments, both national and local. It is a truism that patronage is essential to the well-being of the arts. And today it must come primarily from governments, since private benefactors no longer have the resources to undertake adequate financial support.[2]

During the years prior to World War II, the need for government patronage was almost never articulated in the British House of Commons or discussed in London's fashionable clubs. Few questioned the dominant philosophy that opera and ballet companies, theaters, and symphony orchestras could exist only if they sustained their operations without continuing deficits. Art galleries, maintained by the national government and by local authorities, were an exception although even here public funds were not generally available for purchase acquisition. Although the war stretched the nation's physical resources and manpower almost to the breaking point, public provision was, miraculously, undertaken on a modest scale: Exchequer funds were expended to underwrite the programs sponsored by the Council for the Encouragement of Music and the Arts. This wartime program, with its bipartisan political support, was continued after the return to peace. For a decade, opposition to state subsidy was voiced occasionally and criticisms were leveled against the Arts Council and the trustees of galleries and museums. By the mid-1950s, however, artistic patronage had become an accepted function of government.

1. James Boswell, *Life of Dr. Johnson* (1791), 1:156.
2. Foundations in Britain have provided support and encouragement to the arts. However, funds available to them are limited, since the nation's tax structure does not encourage private citizens and corporations to make contributions to underwrite this type of patronage. The Carnegie United Kingdom Trust, the Pilgrim Trust, the Calouste Gulbenkian Foundation, and the Ford Foundation are among nongovernmental organizations most active in providing cultural assistance.

The precise nature of arts subsidy is not stipulated by parliamentary enactment. Set forth in its 1967 charter, the objectives of the Arts Council, Britain's chief instrumentality for providing encouragement and support, serve as guidelines for its activities but do not constitute an exact definition of artistic patronage. Under the charter, the council is expected to "develop and improve the knowledge, understanding and practice of the arts" and to increase the accessibility of the arts to the public, both in London and in other large cities and in the rural areas. In this study, patronage will be viewed from the vantage point of the professional arts. This qualification is an important one, for the council does not utilize its resources to underwrite amateur artistic activity. Occasionally, a clear differentiation between the amateur and the professional is not possible. And in the case of the National Federation of Music Societies, whose membership of approximately 1,000 amateur music clubs and choral and orchestral societies receive small council subsidies, an effort is made to raise standards of performance by employing for each concert some professional musicians and singers.[3]

Eric Newton, formerly art critic for the *Manchester Guardian*, formulated a succinct statement about the nature of the arts which can serve here as a basic definition: "It is certainly necessary to know what art is, and if I define it briefly as a human conception made manifest by the use of a medium, and if I define good art as a noble (or arresting, or interesting, or valuable) conception made manifest by the skilful use of a medium, I can then have done with definitions."[4] Such a definition merely provides a backdrop in a study of government patronage which must itself establish the limits of its scope. Subsidy of poetry and certain other forms of literature is considered in this book, but maintenance of libraries by public authorities is excluded. Museums devoted to science, technology, natural history, transportation, and archaeology are not dealt with. Some institutions are multifunctional, like the British Museum, which houses the National Library of Books, the National Museum of Archaeology, and a collection of works of art in all media (except paintings) from primitive times to the present. In each instance, only the museum's activities relating to the visual arts are examined. Emphasis is upon the "fine" rather than the "applied" arts, although the dividing line between the two is not always clear.

In the architecture field, the national government is firmly committed to fostering high standards in new building construction and to preserving the best of the nation's heritage. Government departments concerned with domestic architecture are the Ministry of Housing and Local Government and the Scottish Development Department. They are responsible in their respective areas for approving the layout and design of local authority housing schemes and for setting standards for local authority housing. The

3. Encouragement and support accorded the arts by governments in Northern Ireland are excluded from this study.
4. Newton, *European Painting and Sculpture*, 4th ed. (London: Penguin Books, 1958), p. 12.

Ministry of Public Building and Works controls the design, construction, and maintenance of government civil buildings and also is involved in the preservation of historic buildings and ancient monuments in Britain. Special aspects of architecture are the concern of state-sponsored organizations. Thus, the Royal Fine Art Commission (appointed in 1924) advises government departments, planning authorities, and other public bodies about questions of public amenity or artistic importance. In England, Wales, and Scotland, Royal Commissions on Ancient and Historic Monuments are at work, recording in detail all ancient and historical remains, and publishing surveys which ultimately will cover the whole of Britain. Ancient Monuments Boards for England, Scotland, and Wales, constituted by authority of Parliament, consider which monuments should be officially listed and advise the Minister of Public Building and Works on questions relating to ancient monuments. Historic Buildings Councils, one each for England, Scotland, and Wales, set up under an act passed in 1953, advise the central government about the extension of grants to assist with the repair and maintenance of such buildings. Although these activities all reflect a public responsibility for the arts, they are not central to the main thrust of this inquiry and have not been included.

The contributions of British education to greater public understanding and appreciation of the arts is of the utmost importance. Youth in the elementary and secondary schools can acquire a lifelong interest in music, theater, and the visual arts, a concern which later will induce them to support artistic enterprises in their own communities. Some high schools offer professional instruction in the arts. At the university level much is done to foster an interest in the arts, and specialized professional training is made available in most of Britain's institutions of higher learning. Located throughout the United Kingdom are more than a dozen regional colleges of art, each of which offers instruction in most branches of the visual arts. In addition, schools of art are found in many of the larger provincial towns. In London, instruction is given by the Royal College of Art and the Central School of Arts and Crafts of the Greater London Council, both emphasizing industrial design, and the Slade School of Fine Arts in the University of London; other leading institutions emphasize the teaching and study of the history of art—the Courtauld Institute, the Department of Classical Art and Archaeology in University College, and the Warburg Institute, all of the University of London. Theatrical training is provided by a number of dramatic schools and institutions in London and the provinces, two of the more important being the Royal Academy of Dramatic Art and the Guildhall School of Music and Drama. Specialized education in music is given at colleges of music; the best known are the Royal Academy of Music and the Royal College of Music—both in London—the Royal Manchester College, and the Royal Scottish Academy, Glasgow. Education throughout Britain benefits from large infusions of funds from the national government and from local authorities and could be included in a study of artistic patronage. This field

has not been dealt with here, however, because of the sheer immensity of the task.

The film as an art form has likewise been excluded from consideration, a decision arrived at only with reluctance. The British Film Institute since 1933 has devoted its energies to promoting the film as an art. Its activities have been financed in part by an Exchequer allocation. In 1967–68 the institute received a grant from the Treasury totaling £359,000. It promotes the making and showing of quality films and encourages the public to appreciate them. The British Film Institute administers the National Film Theatre in London on the South Bank of the Thames, showing films of outstanding historical, artistic, or technical interest. This theater is unrestricted by commercial considerations, by age, or by country of origin. Operated by the institute is the National Film Archive containing over 18,000 films, including newsreels, besides scripts, art designs, posters, and almost a half million photographic stills, all selected to illustrate the history and the art of the film, or to comprise important social and historical records.

Mention should be made of the British Council and its activities overseas which promote throughout the world a greater knowledge of Britain's culture and artistic life.[5] As one of its numerous functions, the council organizes and dispatches art exhibitions to other countries, disseminates picture reproductions and photographs, sponsors lectures, and provides information and advice to inquirers abroad and to visitors in Britain. It also makes available financial assistance for tours abroad by British theater companies, orchestras, soloists, and opera and ballet companies; sponsors recordings of works by British composers; and maintains libraries of British music in some seventy countries. Upon occasion the council invites musicians and other artists to visit Britain in order to become acquainted with various phases of British culture. Since the council does not subsidize the arts within Britain, its activities do not come within the scope of this inquiry.

The British Broadcasting Corporation, established by royal charter in 1927, has made an invaluable contribution to the arts by encouraging millions of listeners to develop an active interest in and appreciation of music, opera, theater, literature, ballet, and art. Thus, an environment is created which is conducive to the growth and development of artistic enterprises assisted by the national government and local authorities. When sound broadcasting became technologically feasible, the government decided to grant a single broadcast license, requiring the limited company, which was specially constituted, to serve "as a means of disseminating information, education and entertainment" devoid of commercial advertising or sponsored programs. Presided over by a board of governors, the corporation is responsible to the Postmaster General but does not receive subsidy from the Treasury. Listeners are charged an annual license fee, which is collected by the Post Office, the

5. The British Council, founded in 1934, is empowered by Royal Charter to promote abroad a wider knowledge of the United Kingdom and the English language and the development of closer cultural relations between Britain and other countries.

proceeds of which are turned over to the BBC. Expenses incurred in collection are deducted and retained by the government. This arrangement was severely .criticized by the economist John Maynard Keynes, who viewed the license fee as an impediment to cultural dissemination, an odd relic of Puritanism which he thought should be abolished.[6] Radio programs are presented throughout the country on four channels, two of which feature a wide range of musical programs, plays, discussions about art and literature, as well as news and information features. BBC television has made a major contribution to the arts. The BBC enjoyed a monopoly of television broadcasting until 1954, when Parliament decided to establish the Independent Television Authority to operate an alternative service. ITA programs are provided by program companies under contract, and the system is financed by commercial advertising; emphasis given the arts is appreciably less than that accorded by the BBC.[7]

Importance of Arts Patronage

In order to flourish, the arts require substantial financial support and constant encouragement; this has been true in Western Europe since the days of the Greeks and the Romans. The performing arts of opera and ballet are tremendously expensive to sustain, and serious theater and symphonic music, although less costly, cannot pay their own way. Creative artists are commonly thought to have been well cared for in the eighteenth and nineteenth centuries by royal or aristocratic patrons, but in Vienna, Mozart, barely able to make ends meet, was forced to play three instruments, give concerts, and teach whenever he could find pupils. The great composer eked out an existence in abject poverty, his death at age thirty-five probably being hastened by destitution. Similarly, Handel was compelled to go into the entertainment business, and Bach diverted his energies to support himself as an organist.

The response to this need and the consequent position of the arts in the national culture have varied from country to country.[8] In the Middle Ages the church played a significant role in patronizing the arts, but in present-day Europe its role is limited. Private and corporate subsidy have provided assistance which should not be overlooked, but the total impact has remained modest. Principal reliance has been upon governments—national, state or provincial, and municipal. The arts flourish in Germany and are performed in cities throughout the country, partly because, until unification, each court engaged in active patronage, so that provincial centers enjoyed a tradition of princely or aristocratic support. Similarly, the capital cities of the Italian states recognized patronage as a valued function of government, and when Italy became a nation, they continued to provide needed assistance. Un-

6. Keynes, "Art and the State—I," *The Listener*, 26 August 1936, p. 372.

7. See John S. Harris, "Television as a Political Issue in Britain," *Canadian Journal of Economics and Political Science*, August 1955, pp. 328–38.

8. For a detailed account of the evolution of arts patronage in Europe, see Frederick Dorian, *Commitment to Culture* (Pittsburgh: University of Pittsburgh Press, 1964).

fortunately, in both countries the national governments have not always performed responsibly as arts patrons. Mussolini, who liked to think of himself as an artist because he played a violin, first sponsored programs and activities which were constructive. But being fully aware of the popular appeal of the arts, he soon subordinated them to the purpose of the regime and saw to it that they were used as vehicles for fascist propaganda. Hitler, on becoming Reich Chancellor, quickly demoted the arts to a level of servitude under the nazi state and mobilized their resources with new forms of patronage to further his private objectives. Provincial and municipal theaters, opera houses, and orchestras were brought under tight central domination. Rigidly enforced racial laws excluded "non-Aryans" from cultural institutions. Tight arts censorship was inaugurated; objectionable books were burned; "decadent" paintings were removed from museums. A Chamber of Culture was established to control and exploit the arts.

The French experience in creating a viable system of public support and encouragement, since it has often served as a model for other nations both in Europe and in other parts of the world, merits more detailed consideration. After the Revolution, the function of the arts required reinterpretation; old standards were subjected to critical scrutiny and new ways developed to enable the arts to speak to the masses. During the previous 146 years, three French kings had engaged in an elaborate and munificent system of royal patronage. Louis XIV's long reign, often termed the Golden Age of French art, brought unparalleled expenditures on the arts. The king's patronage was autocratic, self-glorifying, and nationalistic, but highly productive. Painting and other arts flourished at the court, and three great French institutions devoted to the performing arts were founded—the Comédie Française, the Opéra, and the Opéra Comique. The king's sponsorship of Molière and Lully, of Racine and Corneille, elevated a galaxy of genius that enriched all of Western civilization. Versailles became a lasting monument to the pomp of court life, an impressive architectural creation and the locus of much that was great in art. Wealthy aristocrats and affluent bourgeois imitated their monarch in their lavish provision of patronage. During the reigns of Louis XV and Louis XVI, royal support continued to opera, theater, music, and the visual arts, but on a lesser scale.

The period after the Revolution was one of adjustment and transition, support of institutions previously patronized for the most part being continued. New forms of cultural expression were created; attempts were made to give voice to the ideologies then prevalent. Napoleon was not only a great general and hero; he was, too, a vigorous and imaginative patron of the arts. Under his leadership the national organization for the performing arts was revamped and strengthened. The national theater's administration was reconstituted, with greatly increased sums granted to underwrite drama. Most remarkable was the signing by Napoleon of the Moscow Decree on 15 October 1812. Bogged down in the Russian snow and numbed by the cold, defeated with a loss of four-fifths of his army, Napoleon affixed his signature

to a decree covering the organization of the Comédie Française, setting a pattern of operation which guides the French theater down to the present day. The Third and Fourth Republics witnessed a continuance of government patronage, accompanied by increased monetary allocations and entrepreneurial innovations. Particularly noteworthy was the construction of the Paris Opera House, a costly and sumptuous structure. It is a major attraction in the French capital today. Important also was the Réunion des Théâtres Lyriques Nationaux in 1939, a joining of the two major lyrical theaters of France, the Opéra and the Opéra Comique, under a single administration with governmental supervision completely subsidized by the French government.

After 1945 the Fourth Republic, acutely aware of the decline of theater in the provinces, set up dramatic centers in five strategic locations in an effort to establish permanent theaters which could draw audiences from the surrounding regions. Subsidization for the new centers came primarily from the national government, but important contributions derived from municipalities and from private sources. The government also embarked upon a long-range project involving operatic decentralization, a more costly undertaking than its dramatic counterpart. The French Treasury subsidizes a number of provincial lyrical theaters to the extent of one-half their annual deficits, the other half being met by their respective municipalities. A Lyrical Center not only presents a full-length season of operas, but also engages in significant educational functions, some in association with local educational authorities. In Paris a Théâtre des Nations was founded, supported financially by the national government, the city, and the department of the Seine. It features in German, Russian, Italian, and other languages plays as well as opera and ballet; visits by companies from abroad are actively solicited. Also established was the Théâtre National Populaire, which won for the theater new audiences who came to appreciate great dramatic works which previously had been deemed beyond the grasp of the masses.

Charles de Gaulle's election to the presidency in 1958 ushered in an era of relative stability in French politics which has permitted greater continuity in government policies relating to artistic support. The Fifth Republic has strongly favored government aid and encouragement, insisting at the same time on high professional standards. Highly significant was the establishment of a Ministry of State for Cultural Affairs, headed by André Malraux, which administers the government's various types of arts subventions. Reforms have been effected in the national theaters, subject to government supervision, that are designed to insure a greater cultural impact. The government has also sought to bring about a reinvigoration of French opera, to encourage young playwrights and other creative artists, and to support symphony orchestras in the provinces. Of particular interest is the establishment of a number of cultural centers in various parts of the country in which plays, opera, ballet, symphony concerts, and chamber music will be performed, and exhibitions of painting and sculpture displayed.

Objectives of This Inquiry Artistic patronage by governments did not originate in Britain. What the British did was to forge for themselves, during World War II, a program of public encouragement and support attuned to the requirements of the moment, and when peace returned they transformed this program into a permanent system of artistic patronage. Drawing upon the experience of other nations, they devised new programs, refined and expanded government support, making their alterations conform to changing conditions. This process continues today, although the major features of Britain's subsidy system are firmly established.

This book may be viewed as a case study of the operation of the highly successful British system of artistic patronage. But it is more than that. It depicts the conditions in Britain which led Parliament to sanction the assumption of these new responsibilities by the national executive and induced local authorities to embark upon new ventures. Details relating to the evolution of support programs in the visual arts, music, theater, opera, ballet, and literature are included only if they are essential to convey to the reader a sense of the urgency which existed, of the severity of the crises encountered by artistic organizations, of the enthusiasm of advocates of new solutions, and of the dedication and wisdom displayed by the "cultural statesmen" who provided the leadership and presided over the launching of new enterprises. The present functioning of the British system is analyzed in an effort to deduce principles of subsidy management, to set forth tentatively organizational patterns and subsidy techniques which may ultimately be recognized as elements of a new "science" of government arts patronage.

Those concerned with the welfare of the arts in the United States can profit greatly from a knowledge of the British experience with artistic subsidy. Congress in 1965, for the first time in its history, sanctioned a systematic national arts support program, establishing a National Foundation on the Arts and the Humanities whose National Endowment for the Arts extends grants and other forms of assistance to artistic bodies. Funds are also made available to the states to encourage them to participate in cultural subsidization.

2 / PUBLIC SUBSIDY OF THE ARTS IN GREAT BRITAIN UP TO 1945

The exploitation and incidental destruction of the divine gift of the public entertainer by prostituting it to the purposes of financial gain is one of the worser crimes of present-day capitalism. How the State could best play its proper part it is hard to say. We must learn by trial and error. But anything would be better than the present system. The position today of artists of all sorts is disastrous.
—John Maynard Keynes, 1936

God help the government that meddles with art," Lord Melbourne, Liberal prime minister in the 1830s, once warned. His advice was taken to heart by successive governments during the nineteenth and the first half of the twentieth centuries.[1] British governments in the eighteenth century, too, had played it safe, keeping aloof from the arts, especially when funds were needed. This policy contrasted sharply to that of the ancient world, which recognized the public's need of circuses as well as bread. Wealthy aristocrats in many parts of Europe provided generous support in the seventeenth, eighteenth, and nineteenth centuries. By the middle of the nineteenth century the expanding industrial upper class also undertook to subsidize the arts. Private patronage, however, was not destined to continue on a significant scale, and started to decline in the years immediately prior to 1900.

A new view of the functions of the state and of society began to emerge in the eighteenth century, reached its climax in the nineteenth, and prevailed until the outbreak of World War II. This view was described by John Maynard Keynes, in 1936 as "the utilitarian and economic—one might almost say financial—ideal, as the sole, respectable purpose of the community as a whole; the most dreadful heresy, perhaps, which has ever gained the ear of a civilized people."[2] Government programs had to be justified almost entirely on economic grounds. Asserting that even education and public health only crept in under an economic alias because they "pay," Keynes came out strongly in favor of the use of government powers and public expenditure to preserve scenic beauty and valued national monuments from threatened exploitation and destruction. Particularly vigorous was his plea for Exchequer funds to foster and support the arts.

Beginning in 1700, the attention of successive governments and the energies and resources of the British people were concentrated, almost exclusively, upon political and economic problems—overseas exploration and colonization; numerous wars; industrialization and economic development; and the emergence of democratic political parties and governmental institutions. Scant attention was given to the need for governmental aid to the arts. When questions were asked in Parliament or in the press concerning the plight of the artist, the health of the theater, or the current condition of music in Britain, they were brushed aside as inconsequential. The prevailing basic assumption was that the arts should stand on their own feet. The government's contribution to the arts rarely went beyond the maintenance of museums and galleries. The quality of the living arts did not matter to the politicians who could take effective remedial action. The struggle for reform

1. "Artists in War—and Peace," *The Listener*, 11 January 1940, p. 60. William Lamb, Second Viscount Melbourne (1779–1848), a popular politician of modest talents, was Home Secretary 1830–34, and Prime Minister 1835–41. His favorite dictum in politics was, "Why not leave it alone?"

2. Keynes, "Art and the State," *The Listener*, 26 August 1936, pp. 371–74.

in British society which began in the 1880s was concentrated in the political and economic areas. Even radical left-wing Labour Party reformers failed to raise the cry of reform in behalf of the arts. Of the scores of pamphlets and other documents published by the Labour Party, not one mentioned the performing arts until the mid-1930s, when only very limited reforms were advocated. The Liberal and Conservative parties were even less interested, paying no attention to the arts until the beginning of World War II.

The Era of Indifference and Neglect Adam Smith's *The Wealth of Nations*, published in 1776, articulated in the economic sphere the theory of *laissez faire*, which held that the state should exercise the least possible control in trade and industrial affairs. It provided a theoretical justification for the abandonment of mercantilism and helped to set the general tone of hostility to governmental intervention in business and engendered similar attitudes about the role of government in other areas.

Proof that government support of the arts was held unwise and, if undertaken at all, was to be offered reluctantly and on a miserly scale can be easily deduced by checking the government's record of participation during the two hundred years prior to the outbreak of war in 1939. Breaking with tradition, in 1753, Parliament took the first step leading to the eventual establishment of the British Museum by grudgingly approving government expenditure of £20,000 to purchase a private collection of great diversity assembled by Sir Hans Sloane and offered to the nation upon his death. Sloane's collection, containing nearly 80,000 items, exclusive of books, consisted primarily of objects other than art, and the museum in its early days was known not so much for its paintings and drawings as for its other "treasures"—embryos, cockleshells, insects, minerals and precious stones, fossils, pottery, and so forth. By 1939 it had become a world-famous institution with a magnificent library, a semi-independent Natural History Museum, and a series of other museums all under one roof. Several of its departments contained priceless collections of art, particularly the Department of Prints and Drawings. From the beginning the government's support of the museum was parsimonious. Moneys for the initial purchase in 1753 and for certain substantial acquisitions, plus the cost of erecting a combined museum and library, derived not from the Exchequer but from a public lottery, conducted amid accusations of scandal which produced a profit of £95,000.[3] A Treasury grant of £2,000, sanctioned in 1762, covered a two-year period. Special grants to underwrite definitely named purchases were made from time to time. Thus, the Towneley marbles were acquired in 1808 at a cost of £20,000, and the Parthenon marble artistry brought from Greece by Lord Elgin was purchased in 1816, after a prolonged investigation by a committee of enquiry. Parliament appropriated for the purpose £35,000.

3. Geoffrey Grigson, *Art Treasures of the British Museum* (London: Thames and Hudson, 1957), pp. 11–43.

Regular annual Treasury grants earmarked for acquisitions were subsequently made available. By the turn of the century provision for the museum's operation and continued expansion was reasonably adequate.

The establishment of the National Gallery was essentially "accidental," growing out of an offer by George Beaumont in 1823 to present his fine collection of pictures to the nation, provided a suitable accommodation could be found for it by the government. In the same year the House of Commons agreed to provide £60,000 for "the purchase, preservation and exhibition of the Angerstein collection" to prevent its being acquired by the Prince of Orange and lost to the country forever. The nation thus acquired title to its thirty-eight pictures, and on 10 May 1824 the new gallery opened its doors at 100 Pall Mall, the home of the late owner.[4] Treasury funds for the acquisition of new works of art were forthcoming in modest amounts and usually only when a particularly desirable work became available for purchase. Thus, in 1834 the Treasury provided funds for the government to acquire two works by Correggio for the then enormous sum of £11,500. During this period and indeed down to the end of the Second World War, the bulk of the pictures acquired to make up the gallery's excellent collection were obtained by direct gift from wealthy patrons or purchased with funds donated to the gallery, and not from government appropriations, which remained painfully small.

The National Gallery moved to Trafalgar Square in 1837, but by 1865 the facilities were hopelessly overcrowded and only a portion of the collection could be shown at any one time. The efforts of the trustees to cope with the gallery's space needs were met all too often by governmental indifference; even when facilities were added, they failed to keep pace with the continuing growth of the collection. By 1884 the annual purchase grant stood at £10,000. Parliamentary allocations to finance the acquisition of paintings fluctuated from year to year, totaling only £5,000 in 1906, a sum woefully inadequate considering the current price of pictures. Modest purchase grant allocations were continued during the 1920s and 1930s, with special grants advanced by the Treasury from time to time. The extent of Exchequer support for the National Gallery at the end of this period is shown by the parliamentary allocation for 1938–39 of £18,355 to cover salaries and other operating expenses and £7,000 for the purchase of pictures and drawings, a total of £25,355. Maintenance of the building, heat, light, furniture, property taxes, and stationery costs were carried separately on the votes of the Ministry of Works and other departments. The annual purchase grant was lowered to £5,600 in 1939–40 and entirely eliminated for five years during the war, preventing the gallery from acquiring works when the art markets were generally depressed and prices were low.

The Victoria and Albert Museum, containing outstanding collections of fine and applied arts, celebrated its hundredth anniversary in 1952. Its origin

4. Anthony Blunt and Margaret Whinney, eds., *The Nation's Pictures* (London: Chatto and Windus, 1950), pp. 29–30.

goes back to the recommendations of a select committee of the House of Commons appointed in 1835 to "enquire into the best means of extending a knowledge of the arts and of the principles of design among the people (especially the manufacturing population of the country)," which induced the Treasury to release funds for the establishment of a Government School of Design. The school opened in London in 1837. Subsequently, twenty provincial schools were founded throughout the country, supported in part by government funds: Exchequer allocation in 1851 amounted to £7,500.[5] In 1852 the school became a part of a Department of Practical Art under the Board of Trade; in the following year a Department of Science and Art was added. The new department was expected to administer the existing art schools and to establish "museums by which all classes might be induced to investigate those common principles of taste which may be traced in the works of all ages." The Museum of Ornamental Art, opened in September 1852, moved within five years to the present site, where it later became part of the great collective South Kensington Museum. The Department of Science and Art was shifted from the Board of Trade in 1856, becoming a part of the Education Department. There it remained until 1899, when it was placed under the jurisdiction of the newly constituted Board of Education. The museum soon outgrew its facilities and a rather haphazard building program was undertaken, financed largely by private gifts and government appropriations. In March 1898, Parliament voted £800,000 to complete the South Kensington buildings; in 1909 the new facilities were officially opened. At this time the Victoria and Albert became exclusively an art museum, the scientific collections being shifted to the Science Museum. Annual purchase grants sanctioned by the Treasury to underwrite acquisitions in science and art varied considerably between 1865 and 1895. The largest sum was £19,200. Art acquisition expenditures stood at modest levels before World War I, and in the 1920s and 1930s purchase grants were distressingly inadequate.

The House of Commons on 6 June 1856, after brief debate, approved 98 to 28 a motion "that a sum not exceeding £2,000 be granted to Her Majesty towards carrying out measures for the formation of a Gallery of the Portraits of the Most Eminent Persons in British History." The appropriation was to cover the initial fiscal year. The National Portrait Gallery in London possessed the only collection of its kind in the world in its early years, and even now its holdings are unique in scope of coverage and artistic worth. Museum policy stipulates that in acquiring portraits the principal consideration is "to look to the celebrity of the person represented rather than to the merit of the artist." The gallery during its first forty years was forced to move several times from one building to another in a desperate effort to acquire sufficient space for exhibition, storage, and study. Its present home on Trafalgar Square, opened to the public in 1896, cost the taxpayers little, for the bulk of the money was contributed by William Henry Alexander. An

5. Henry Cole, *Fifty Years of Public Work of Sir Henry Cole* (London: George Bell and Sons, 1884), 1:281.

extension, given by Lord Duveen and opened in 1933, augmented these facilities. By 1945 approximately one-half of the collection had been acquired by gift or bequest and one-half by purchase. As in the case of the other galleries, the National Portrait's annual purchase grant was grossly inadequate.

The hundreds of thousands of visitors to the Tate Gallery, an imposing edifice on the banks of the Thames containing the nation's major collections of British painting and of modern foreign painting, would be amazed and perhaps disillusioned if they were aware of the long, frustrating, and sometimes bitter struggle that accompanied its development. While some people in the Victorian era recognized the importance of building a collection of contemporary art, both British and European, the prevailing sentiment was one of indifference and even hostility. Successive governments refused to allocate moneys to erect a suitable gallery or initiate an energetic acquisitions program. In fact, sums of money for art acquisitions and several remarkably rich and diverse collections of British and modern paintings were given to the nation with the stipulation that the government construct a building to house them adequately. Usually the bequests were accepted, but the conditions stipulated were ignored. Toward the end of the nineteenth century the position of governments was becoming increasingly untenable. In October 1889, an offer from Henry Tate, philanthropic sugar magnate, to give a collection of sixty-five English paintings to the nation, provided that they be suitably housed, touched off a series of developments which broke the impasse and led to the creation of the new gallery of modern art. *The Times*, in an 1890 editorial, chided the government for its long neglect of the British school and proposed a remedy:

> A wealthy country like ours, which possesses so fine a national school as we do—a school of landscape and a school of portraiture containing so many of the elements of greatness—ought to be able to stop the mouths of foreign critics by showing them a really representative and choice collection of our art gathered together in some great central gallery. . . . Why cannot we have in London, started partly by voluntary effort and afterwards subsidized and directed by the Government, a gallery that shall do for English art what the Luxembourg does for French?[6]

In November 1892, a new Chancellor of the Exchequer assumed office. Tate renewed his offer which had been previously rejected, and the government sanctioned the establishment of a new gallery, making available a site at Millbank. Construction of the building began at once, and the Tate Gallery was formally opened on 21 July 1897. Its affairs were put under the aegis of the Trustees of the National Gallery. Paintings were transferred to the new gallery from the National Gallery and other museums; the famous Chantrey collection was brought from the South Kensington Museum; and numerous gifts and bequests were received. The Tate Gallery and its collections underwent continuous expansion in the decades that followed, due to the generosity of private donors and of the Contemporary Art Society and the National

6. *The Times*, 13 March 1890, p. 9.

Art-Collections Fund. The scope of the gallery increased rapidly; in 1915 it was officially decided that it should house the National Collection of British Painting for all periods, and in 1917 it was designated as the National Gallery of Modern Foreign Art. In the latter year a new organizational structure was constituted with a separate board of trustees and a separate director; now the gallery could pursue a relatively independent policy. The Tate's collection grew impressively in the 1920s and 1930s into one of the world's great art museums. The bulk of its paintings, drawings, and sculpture were acquired by private gift and bequest, with the result that the expansion of its collection could not be carried out as systematically as was desired. No continuing annual purchase grants were accorded it until after World War II.

Until 1939, Treasury funds were appropriated by Parliament to maintain two art galleries in Scotland—the National Gallery of Scotland and the Scottish National Portrait Gallery. The National Gallery, established in Edinburgh in 1859, possesses an extensive collection of paintings, drawings, and engravings, a major portion of which were gifts and bequests from private individuals. The Portrait Gallery opened in 1889 and exists primarily to illustrate Scottish history by means of authentic contemporary portraits. The National Galleries of Scotland Act, 1906, joined the two institutions under a single board, which in the following year appointed the first full-time director. Financial support made available by governments during the three succeeding decades increased gradually, although at no time were adequate funds available for acquisitions.[7]

The Treasury, in an effort to encourage a more orderly growth and development of Britain's national museums and galleries, constituted in 1930 a Standing Commission on Museums and Galleries, charging it with the following responsibilities:

(1) to advise generally on questions relevant to the most effective development of the National Institutions as a whole, and on any specific questions which may be referred to them from time to time;

(2) to promote co-operation between the National Institutions themselves and between the National and Provincial Institutions; and

(3) to stimulate the generosity and direct the efforts of those who aspire to become public benefactors.[8]

In a series of reports issued through the years, the commission had reviewed the progress made by the national institutions, providing information useful to museum administrators, government policy-makers, and other interested persons. Many of its recommendations pertaining to specific galleries and museums—their buildings, staff, purchase grants—have been accepted and acted upon by successive governments.

7. Two museums maintained by the national government, the National Museum of Wales and the National Maritime Museum, both of which hold important art works, are not dealt with in this book because of space limitations.

8. Standing Commission on Museums and Galleries, *Third Report* (HMSO, 1948), p. 4.

Expenditures on the arts by the British government in 1938–39 are set forth in Table 1. It is important to note that almost all the funds were used to preserve and display existing works of art—dead men's treasures, to put it bluntly—to support museums and galleries, and to maintain historic buildings and ancient monuments. No moneys were allocated to subsidize the performing arts. At no time during the 1920s and 1930s was a serious attempt made to assess the needs of opera, ballet, music, and literature; no efforts were made to commission directly works by established artists except during a brief period toward the end of World War I when a few artists were paid to record with brush and pen the course of the war and the men who fought it. Use of Exchequer funds to encourage young composers, playwrights, painters, actors, singers, and other artists in the early stages of their careers was not seriously considered. Such radical innovations, it was thought, had to be avoided at all costs.

TABLE 1 Government Expenditures on the Arts, 1938–39

Arts museums and galleries	
(a) Direct expenditure	£483,031
(b) Allied services	333,188
Other arts bodies receiving Exchequer aid	36,070
Royal commissions, etc.	14,119
Historic buildings and their contents, and ancient monuments, by Minister of Works	54,529
Total	£920,937

Source: H.M. Treasury, *Government and the Arts in Britain* (HMSO, 1958), p. 22.

World War II and the Emergence of Government Support When Britain declared war on Germany in 1939, few observers of the contemporary scene could have predicted that the six years of bitter conflict and privation would induce the nation to undertake a new and significant activity—public patronage of the arts. The government, utilizing funds voted by Parliament, for the first time undertook support of the performing arts on a limited scale. This development, however, did not occur overnight. The initial undertakings, leading ultimately to the establishment of the Arts Council and its diverse programs of artistic subvention, were implemented only with difficulty and in a halting and haphazard fashion. Public patronage traveled the road of experimentation and gradualism; it was a product of the pragmatic evolution typical of many British institutions.

At the outbreak of war, anticipating that the enemy would begin immediate and intense aerial bombardment, the government at once closed all places of entertainment and prohibited "all large gatherings for purposes of entertainment and amusement whether outdoor or indoor." It was soon apparent, however, that a complete blackout was unenforceable. By 15 September a general reopening was authorized in London except in a section immediately adjacent to Leicester Square, the city's entertainment center. A few weeks later, theaters and other cultural activities even in this area were

allowed to operate until 10 p.m.; and by 5 December the police commissioner was empowered to sanction closing hours later than 11 p.m.[9]

After this brief period of hesitation, the government realized that entertainment and relaxation were needed to bolster efficiency in wartime. Herbert Morrison, Home Secretary, speaking to the House of Commons on 12 March, 1942, described the government's policy as it had evolved:

> The Government's wartime policy with regard to entertainments has been to permit them to continue on a restricted basis in the belief that, within reason, popular entertainments act as a lubricant rather than a brake to the war machine. . . . The Government will not impose more restrictions than war requirements render expedient, but such requirements must obviously be the first consideration and there will be no hesitation to impose such further restrictions as may be needed in the interests of the war effort. On the other hand there is no intention of imposing needless hindrances to recreation or of carrying restrictions so far that total war unnecessarily becomes total misery.[10]

Regulations imposed by the government covered not only the arts and cultural activities but also entertainments such as popular theater, moving pictures, and sport. Civil defense security, designed to minimize the dangers to large crowds resulting from air attack, induced the government to limit the size of its audiences in theaters and other buildings. A total blackout enforced nightly throughout the British Isles precluded the holding of outdoor events after dusk. Theater managers were required to remove all outside illumination, to cover windows, and to route their patrons through darkened lobbies. At first theatergoers were reluctant to venture out into unlighted streets, but as people became accustomed to the blackout, fewer stayed away on this account. Transport restrictions adversely affected the arts. While gasoline was available to citizens whose cars were essential to their business or to the performance of public duties, it could not be used for private pleasure or entertainment. Extra trains or buses were not put on to transport theater or concert enthusiasts.

Local communities were urged to provide their citizens with varied entertainment within walking distance. In the summer the government encouraged local authorities to organize "holidays at home" programs, featuring music, open-air plays, dances, and other entertainment, presented by local groups and by touring companies. These events were carefully scheduled not to conflict with work vital to the war effort. Manpower shortages were detrimental to the arts, for generally artists were not exempt from national service. Musicians could be deferred by an advisory committee responsible to the Ministry of Labour; actors appearing in commercial theater and those working for the Entertainments National Service Association (ENSA) were dealt with by other advisory bodies. Deferments were more readily accorded to actors working full-time for ENSA in entertaining the armed forces and

9. *Entertainment and the Arts in Wartime Britain* (London: British Information Services, 1944), p. 3.

10. *H.C. Debates*, vol. 378, cols. 1178–79, 12 March 1942.

war workers than to those performing in commercial theater.[11] Orchestras, theaters, and other cultural organizations were for the most part forced to rely on men and women not liable for national service, military or industrial. To obtain additional revenues to help finance the war, special admissions taxes were imposed on live entertainment—plays, ballet, concerts, and lectures as well as vaudeville and circuses. The heavy rates—3s. on a 7s. 6d. seat—interestingly enough, did not reduce attendance to any appreciable extent.[12]

Wartime patronage of the arts, financed by the Exchequer, was undertaken on a large scale and administered primarily through two bodies: the Council for the Encouragement of Music and the Arts, CEMA, and the Entertainments National Service Association, ENSA. CEMA is dealt with in a subsequent section. ENSA, formed as a voluntary society in 1938, prepared in advance for a wartime pool of theatrical talent to entertain the armed forces. Shortly after the conflict started, headquarters were set up in the Drury Lane Theatre, London; an administrative organization was constituted, and teams of entertainers were recruited. Most of ENSA's administrators and performers came from the commercial theater, with which it maintained a close relationship. By 1941 ENSA was recognized as the sole official organization (except for CEMA) responsible for entertaining the military services. The association was dependent upon a government grant administered by the Navy, Army, and Air Force Institutes, a nonprofit company established to provide amenities for British servicemen. By 1944 annual expenditures amounted to about £2,200,000.[13] Token admission fees were usually levied, 3d. for enlisted men, 6d. for noncommissioned officers, and 1s. for officers. ENSA performed in army camps and installations, navy bases, and air force stations throughout Britain and at overseas establishments in war zones where British forces operated. In 1940, after Dunkirk, the government decided that rearmament, involving extremely long hours of work, necessitated the provision of entertainment and relaxation for war workers. ENSA's mandate was expanded to include civilians: music and concert parties were featured in factories and workers' hostels. As the association activities broadened, more effective coordination became urgent, and in May 1941 a National Service Entertainments Board was constituted, composed of representatives of the Service Departments, the Ministry of Labour, and the Navy, Army, and Air Force Institutes, and entrusted with responsibility for organizing all ENSA activities.

ENSA's programs were restricted to the fields of music and drama. They featured musicians and orchestras playing dance and other light music intended for popular entertainment; response in workers' canteens and

11. Military deferment of men under thirty was not recommended. Actors who were excused from service were required to perform for at least six weeks each year under the auspices of ENSA through the Theatres War Service Council.

12. *Entertainment and the Arts in Wartime Britain*, pp. 4–5.

13. Ibid., p. 6.

hostels, as well as in army camps, was enthusiastic. ENSA was not content, however, to cater only to popular tastes. It set up an Advisory Music Council with responsibility for fostering serious musical activities among military personnel, defense workers, miners, and members of the Women's Land Army. To each military command were assigned advisers who arranged professional concerts. These advisers also organized orchestras, choirs, and chamber music groups, and staged festivals featuring orchestras, conductors, and soloists; all participants were military personnel. In October 1943, ENSA sponsored a series of 160 concerts for war workers which were presented by some of the nation's finest orchestras and soloists. In 1944 a series was presented for miners. Hundreds of gramophone circles were formed among factory workers and members of the armed services, some assembling their own record collections while others obtained music from ENSA libraries.

ENSA director Basil Dean, in a BBC broadcast in late 1939, reported on nine weeks of activities that included entertainments of wide diversity for nearly a million troops attending over 2,000 performances. The launching of a program of this magnitude in so short a time inevitably resulted in numerous minor snarls, some of them quite amusing.

There was the case in the early days when for lack of precise directions one of our very first concert parties turned up to give a show in a large marquee. They were rather disappointed because there seemed to be only about two hundred men there, and until they began to work these men weren't taking much notice of them. However, the concert was in full swing when an extremely irate colonel stormed into the tent to ask them what the so-and-so they were doing there, as over a thousand of his men had been waiting in a tent two miles away for the last three-quarters of an hour. The party promptly packed up and proceeded to their proper destination, taking with them their first audience who led them in triumph into the other camp.

Then there was the case of one of Gracie Fields' concerts in France, where a small box had been specifically reserved for the Mayor of the French town that was lending the theater. This gentleman arrived at the theater in good time, accompanied by his Chef de Pompier and other officials, only to find his box packed to suffocation with stalwart Scotties. The subsequent altercation in French and good broad Hie'land was only terminated by the strains of the Marseillaise which compelled all to stand to attention. Eventually the disappointed French officials were accommodated with boxes behind the backcloth on the stage—holes were cut in the scenery through which they could peep. As the scenery was their own property, this didn't matter.[14]

ENSA's activities in theater were largely restricted to the armed forces, entertainment of civilians being left generally to CEMA. Efforts were made to attract not only Britain's most renowned actors and comedians, but also other artists of varying skills. Salaries were limited to a basic National Service scale, famous stars frequently donating their time and talent. ENSA policy called for the provision of good entertainment on a regular basis to supplement ordinary commercial entertainment as opposed to sending out occasional star-studded shows. Its traveling troupes staged regular one-night stands for servicemen, frequently performing in difficult circumstances during tours lasting from a few days to many months.

14. Basil Dean, "Entertaining the Troops," *The Listener*, 7 December 1939, p. 1114.

ENSA's theatrical program embraced four different types of shows: large revues or plays presented in permanent buildings for camp audiences; small groups of actors who visited less permanent places, taking with them portable stage and lighting equipment; mobile cinemas; and teams, consisting of four persons, generally with their own piano, who conducted sing-songs in camps and factories and provided entertainment not requiring stage equipment. The scale of this phase of its operations was impressive. At the end of 1943, ENSA was giving an average of 3,070 dramatic performances a week to the armed forces in Britain.[15] Fully equipped garrison theaters were either constructed by the War Office or located in structures adapted to this purpose.[16] Lunch-hour entertainment was enthusiastically received by defense workers, and by December 1943, nearly 2,000 factories were visited regularly, an average of 1,375 performances per week being given. Full-scale stage productions were undertaken by ENSA at this time; several London plays were made available by producers for special three-week seasons playing in garrison theaters and naval bases. These plays, warmly received, included, among others, Robert Sherwood's *There Shall Be No Night*, starring Alfred Lunt and Lynn Fontanne.

Both voluntary and official organizations provided entertainment for air-raid shelter occupants. Thus, the West Ham Shelter Entertainments Group and the Bermondsey Shelter Council were successful in making shelter life more bearable for those forced to endure it. Toynbee Hall, the renowned settlement house in East London, took groups of entertainers, compliments of ENSA, to the shelters. Shelter occupants began to act in plays which they themselves presented. A series of drama festivals, each lasting about eight weeks was held on successive Saturday afternoons; well-known producers acted as judges. Similar amateur festivals were arranged in other parts of the country.

The visual arts suffered greatly as a result of the jolting changes brought about by the war.[17] Many artists were drafted for war service or industrial work. Severe material restrictions were imposed—canvas, paint, wood, and metals became difficult to acquire. Landscape artists were cramped by restrictions imposed under the antiespionage control of photography orders, but later they were allowed to pursue their work out-of-doors with a permit from the Central Institute of Art and Design.

An Artists' Advisory Committee, associated with the Ministry of Information, was set up in 1939 to commission artists to record significant aspects of the war and to advise concerning purchase of artistic works of merit for the national art collections. By early 1944 the committee had pur-

15. *Entertainment and the Arts in Wartime Britain*, p. 14.
16. An Advisory International Council was assigned responsibility for entertaining military personnel of allied nations stationed in Britain, in their own language, by artists of their own nationality. In December 1942, ENSA put on fifty performances per week for American soldiers in Britain. Nor were military personnel in hospitals and on prisoner-of-war camp staffs neglected.
17. Sir Kenneth Clark, "The Artist in Wartime," *The Listener*, 26 October 1939, p. 810.

2

chased more than 2,000 works, including numerous paintings of excellent quality. Acquisitions were made in several ways. A few artists were employed on a full-time salary and assigned to work with the armed services and the Ministry of War Transport. Some were attached to the Admiralty and sailed with the fleet, recording appropriate scenes with brush and palette; others worked out of the War Office, following the troops and depicting the battle in the Middle East, North Africa, and Europe.[18] Still others were commissioned for limited periods on salary to record a specific subject such as RAF bomb destruction, barrage balloons, and the Women's Land Army at work. Single works in considerable numbers were commissioned at fixed rates. The war was well documented in portraits, landscapes, battle scenes, still life, and men and women at work and in action. Works from the committee's collection were shown in war artists' exhibitions held at intervals in the National Gallery; later selections were displayed on provincial tour by CEMA.

A Committee for the Employment of Artists in Wartime, established in 1939 under the Ministry of Labor, submitted many useful recommendations to the government, one of which was the "Recording Britain" scheme. Partially financed by the Pilgrim Trust, this plan insured a permanent artistic record of Britain's "heritage of beauty." Buildings and views selected by the committee for recording were extremely varied; structures likely to be destroyed were given priority. When this program was terminated in 1944, the collection totaled more than 1,800 works covering thirty-two English and four Welsh counties and consisted of quiet landscapes of great charm done in watercolours, gouache, pen, and pencil.

The evacuation of important art gallery collections from London to prevent possible bomb destruction was imperative. The National Gallery's collection was sent to Wales and ultimately stored 300 feet below ground in the Manod Slate Quarry. But in late 1939 the gallery building was reopened for the extremely appealing lunchtime concerts organized by Dame Myra Hess and Sir Kenneth Clark; these were presented daily from Monday to Friday and continued until April 1946.[19] Beginning in 1940 special exhibitions were held in the gallery, some organized in association with CEMA

18. Among the most prominent were Edward Ardizzone, Sir Muirhead Bone, William Coldstream, Anthony Cross, Eric Kennington, Paul Nash, Eric Ravilious, Stanley Spencer, and Graham Sutherland.

19. Speaking in late November 1939, Clark gave his impressions of the initial concert: "The Gallery where the concerts are held seats about seven hundred people. Ten minutes before it began every seat was taken, and there were people sitting on the floor and standing all round the walls. . . . What sort of people were those who felt more hungry for music than for their lunches? All sorts. Young and old, smart and shabby, Tommies in uniform with their tin hats strapped on, old ladies with ear trumpets, musical students, civil servants, office boys, busy public men, all sorts had come, because they were longing for something to take them out of the muddle and uncertainty of the present into a world where even the most tragic emotions have dignity and order.

The first concert was given by Miss Hess herself. . . . I have never known people listen so earnestly, nor applaud with such a rush of pent up emotion and gratitude." Kenneth Clark, "Concerts in the National Gallery," *The Listener*, 2 November 1939, p. 884.

and the Royal Institute of British Architects. The next year marked the beginning of the popular "Picture of the Month" feature: one picture a month was brought from the national collection in Wales, exhibited, and then returned as the next one arrived. The Tate's collection was similarly evacuated, but this gallery continued to acquire new works; by 1942 the governors were anxious to display some of these to the public. Bombing destruction precluded using the gallery's own building, but facilities provided by the National Gallery permitted the exhibition of 140 Tate acquisitions. Encouraged by public response, the Tate assembled other exhibitions in these same rooms for another four years.

While the national art collections survived the war with only minor damage, the great buildings with their precious heritage in stone, marble, metal, wood, and glass did not fare so well. Bombs wrought devastation, usually in a few hours, particularly in Coventry, Canterbury, Bath, Bristol, Exeter, Southampton, and London. No sure form of protection could be devised. In many instances, woodwork, glass, and metal were taken down and safely stored; portrait busts could be removed without difficulty. "But the wealth of carved work, the marble pillars and pavements, the painted decorations and the tombs" owed their chances of survival to the protection of sandbags.[20] Ancient and exquisitely ornate glass in churches and cathedrals was particularly vulnerable, for even when a building was not hit, a heavy explosive falling many yards away often shattered in an instant a window centuries old. And there could be no question of repairing such damage.

Mention should be made of two lesser art programs. In June 1942, the British Institute of Adult Education organized a successful scheme which involved the participation of the 2,144 government-owned British Restaurants located throughout the country, where 618,000 meals were served daily. It afforded painters an opportunity to bring their work before the public and to provide suitable decoration for public buildings. By the end of the year 130 British Restaurants had participated; 1,200 lithographs were purchased for display; 220 original pictures were borrowed; and 500 war artists' pictures were exhibited. Although no real school of mural painting existed in Britain, some attention was given to this art form; murals were painted in many restaurants, canteens, and merchant navy hostels, in some cases according to designs prepared by well-known artists; others were entirely the work of local art students.

The Council for the Encouragement of Music and the Arts Late in 1939, fearing an almost complete artistic blackout for a large segment of the British people, the Pilgrim Trust appointed a Committee for the Encouragement of Music and the Arts (CEMA), to prevent cultural deprivation on the home front. Activity leading to the com-

20. Charles Peers, "Saving England's Treasures," *The Listener*, 6 May 1943, p. 543.

mittee's origin, as reported by Dr. Thomas Jones, then secretary of the Pilgrim trust, was surprisingly casual.[21]

It began on the telephone. Lord de la Warr, then President of the Board of Education, rang up the Secretary of the Pilgrim Trust to sound him about an "idea" and a possible grant; nothing very much, £5,000 perhaps. A familiar experience. The "idea" sounded promising on a first hearing, and it was arranged that the President of the Board should meet, without prejudice, the Chairman of the Trust, Lord Macmillan, then Minister of Information. They met in the latter's room at the University of London at noon, on December 14th, 1939. I was present.

Lord de la Warr was enthusiastic. He had Venetian visions of a post-war Lord Mayor's show on the Thames in which the Board of Education led the arts in triumph from Whitehall to Greenwich in magnificent barges and gorgeous gondolas; orchestras, madrigal singers, Shakespeare from the Old Vic, ballet from Sadler's Wells, shining canvases from the Royal Academy, folk dancers from village greens—in fact Merrie England. Lord Macmillan's grave judicial calm collapsed suddenly and completely. At the moment he was responsible for the national morale, and in the President's dream he saw employment for actors, singers and painters, and refreshment for the multitude of war workers for the duration. Supply and Demand kissed. Would £25,000 be any use? The Secretary blushed and fell off his stool.[22]

CEMA's first head, Lord Macmillan, in addition to being chairman of the Pilgrim Trust, held the post of Minister of Information. For many years he had participated in a wide range of civic and cultural activities. The committee first sought to help the arts to adjust to unknown wartime conditions through promoting active interest in music, drama, and the visual arts by certain voluntary organizations—the British Federation of Music Festivals, the Rural Music Schools, the National Council of Social Service, the Women's Institutes, and the British Institute of Adult Education. It gave these organizations modest grants to assist them in paying staff salaries and purchasing needed materials. Set up hastily, this enterprise was strictly an emergency measure.

The six committee members, appointed jointly by the Pilgrim trustees and the president of the Board of Education, were chosen because of a demonstrated interest in a wider distribution of the arts and because they were conveniently available in London. It was not a balanced body representative of the various arts or of existing cultural organizations. It did, however, bring to bear on policy a variety of viewpoints which influenced decisions as to programs and emphasis.[23] Lord Macmillan provided a direct channel to the Cabinet and presided effectively over committee deliberations. Sir Kenneth Clark, director of the National Gallery, possessed first-hand knowledge of arts administration and the problems likely to be encountered. Sir Walford Davis, noted pioneer of broadcast music, contributed vision and contagious enthusiasm. Thelma Cazalet (later Mrs. Keir), was a back-bench

21. The name "Committee" was changed to "Council" in April 1940.
22. *The First Ten Years; The Eleventh Annual Report of the Arts Council of Great Britain, 1955–1956*, pp. 5–6.
23. B. Ifor Evans and Mary Glasgow, *The Arts in England* (London: The Falcon Press, 1949), pp. 36–37.

member of Parliament and a collector of pictures. William Emrys Williams held the post of director of the British Institute of Adult Education and during the war served as director of the Army Bureau of Current Affairs.[24] Thomas Jones, vice-chairman, was "the driving force behind the newly founded committee and his clarity of vision, his wide experience of government routine combined with his great faith in individual initiative, above all his power of taking quick decisions on day to day problems as they arose gave from the very beginning both life and purpose to the whole movement."[25] Serving as secretary to the committee was Mary Glasgow, loaned by the Ministry of Education; at the end of the war she was appointed secretary-general of the Arts Council.

Although at first the committee was an unofficial body, it was given an office and a secretary by the Board of Education. Applications for financial assistance were immediately received, and initial subventions were sanctioned within a fortnight. The committee then explored the field more systematically. The £25,000 provided by the Pilgrim Trust was soon exhausted. In April 1940, Parliament recognized the long-neglected need for arts subsidy by authorizing appropriation of funds to underwrite committee programs. Slightly enlarged, the committee became the Council for the Encouragement of Music and the Arts. Members were appointed by the president of the Board of Education.

Grants and guarantees extended to artistic organizations were a principal mechanism by which CEMA acted to prevent the demise of numerous cultural organizations. For music, during 1942–43, grants were given to the National Council of Social Service, Scotland, of £4,409; the National Council of Music for Wales, £2,528; the English Folk Dance and Song Society, £500; and the Manchester Tuesday Midday Concerts, £200. String orchestras, symphony orchestras, music clubs, and regional concerts received guarantees amounting to £7,850. In the field of art, the British Institute of Adult Education was the principal beneficiary, receiving £6,836. Grants and guarantees for drama were made to a limited number of professional bodies: Pilgrim Players, £1,198; Bankside Players, £950; Travelling Repertory Theatre, £761; Market Theatre, £620; Perth Repertory Theatre, £400; Mercury Players, £300; Van Gyseghem Players, £250; Indian Dancers, £104. Companies organized by CEMA also received grants and guarantees—Mary

24. Educationist and pioneer, he had "a keenly original mind and a great gift for administrative improvisation."

25. "CEMA began, then, as an emergency movement. Those who conceived it and sketched its first plan of operations shared several different motives with varying degrees of emphasis. Lord Macmillan saw it primarily as a scheme which would fortify national morale in the grievous trials of war, especially among those communities which, evacuated from the cities, would find themselves without occupation for their enforced leisure. Dr. Thomas Jones, the vigilant opportunist, discerned in it fresh opportunities for spreading the arts. Other aspects of the scheme which were appraised during the early meetings of the Committee included the likelihood that it would do something to provide employment for artists whose usual outlets and opportunities were being diminished by the effects of war." *The First Ten Years*, p. 8.

Newcomb Players, £778; Stanford Holme Company, £608; and Ballet Rambert, £114—as also did a small number of amateur bodies.[26]

CEMA also inaugurated a number of experimental programs. For example, concerts were begun in factory canteens, a practice that developed into one of its main activities. Musicians were recruited to travel singly through the countryside, playing and singing wherever audiences could be assembled and organizing local choirs and amateur orchestras. These "musical troubadours" met with so favorable a response that additional performers had to be engaged; thus a comprehensive system of concert-giving, primarily by soloists or by groups of two or three, evolved. Many thousands of concerts by these artists were presented in small communities, generally isolated from the mainstream of wartime life; frequently, public interest generated in this way led to the formation of permanent concert organizations.

The national orchestras were encouraged by CEMA to visit small towns unaccustomed to good music. Later, grants were made to help symphony orchestras improve performance standards by limiting the number of concerts and increasing rehearsal periods. It became obvious, however, that the council possessed insufficient funds to meet their needs. CEMA's aid enabled orchestras such as the Hallé and the Liverpool Philharmonic to operate on a continuous and full-time basis for the first time in their history.

The functions of CEMA were never defined precisely. The council proclaimed its intention "to maintain the highest possible standard of the arts in war-time and to distribute them as widely as possible to those who, on account of war-time conditions, were cut off from them." It frequently described its policy as "the Best for the Most." The council was criticized by some who insisted that its objectives appeared contradictory. Was the achievement of the highest possible standards of performance its paramount concern, or was it the entertainment of the people? The council followed an empirical approach, responding quickly to immediate needs, learning through experimentation and profiting from constructive criticism.[27]

The public's enthusiastic acceptance of CEMA was due in part to the relief it afforded during the devastating air attacks on London. When it became clear that the Germans would fly frequent bombing missions over the city, the council began to plan informal concerts, somewhat similar to those it had successfully presented in war factories, to be given now in air-raid shelters. At first this activity was scoffingly characterized by critics as frivolous. But with the coming of massive attacks, the number of musicians engaged in this work rose sharply; by October 1940, sixty parties per week, each giving two or three concerts a night, toured the areas where the suffering was greatest. Urgent requests for music poured in from rest centers for the homeless. Air-raid wardens reported excellent audience response. Many of the nation's

26. *The Arts in War Time, A Report on the Work of C.E.M.A. 1942 and 1943* (CEMA, 1943), pp. 44–46.

27. Evans and Glasgow, *The Arts in England*, p. 40.

finest musicians took part in the scheme, even though at times it meant playing on imperfect schoolroom instruments and in crude surroundings. These "blitz concerts" brought happiness and relaxation to tens of thousands of war-strained people and helped many to discover a new and worthwhile interest. An expanded audience for music was thus created, a development that had important implications for the future.

Enemy bombing in the late summer of 1940 destroyed a number of London theaters. The Old Vic on Waterloo Road, badly damaged, was unfit for use; Sadler's Wells, commandeered by the authorities, was converted into a rest center and food store. Outside of London a theater company headed by Sybil Thorndike and Lewis Casson and an opera group led by Joan Cross went on special tours, largely to places that had no dramatic or operatic facilities.[28] Concentrating their efforts primarily in South Wales, Lancashire, and County Durham, they traveled in buses and vans and stayed as guests in private homes. This type of educational work—bringing *Macbeth*, *The Merchant of Venice*, *Candida*, and *Figaro* to audiences in schools and community halls—had far-reaching effects. The erection of large numbers of hostels for munition workers by the Ministry of Supply presented CEMA with an additional opportunity, for these structures were well equipped with stages and lighting. Since they were often built in remote places near the factories where secret and dangerous work was carried on, the eager audiences were almost entirely unsophisticated.

It is a startling fact that, at the beginning, only about two percent of these hostel audiences had ever seen a stage play before. In the early days many of them did not know how to behave before live players. They hardly seemed to realize that the peopled stage before them was not an inanimate cinematographic screen. Gradually they acquired a theater etiquette and ceased to talk, walk about and drink tea during the performances. They came to know the actors who stayed in their hostels and they came in this way to have an opportunity of learning what few citizens in ordinary times ever know, that the people in the theater are expert craftsmen in their trade, trained and disciplined to difficult tasks. . . .[29]

Some actors and actresses felt that this informality and intimacy led to a highly desirable mutual understanding between spectators and performers and an increased enthusiasm for the theater; others reacted negatively, asserting that under these conditions the illusion of the stage was lost.

CEMA was also active in the visual arts, at first financing exhibitions circulated by the British Institute of Adult Education. The results were encouraging, but the council concluded that traveling collections would have a greater impact if items from the national collections were included. In 1942 CEMA also began to send out exhibitions of its own. Thus in 1944 the Tate Gallery made available to it three exhibitions—British narrative painting, British drawings, and a collection of wartime acquisitions—and the Victoria and Albert lent its commemorative exhibition of Holbein. During the year

28. Ibid., p. 43.
29. Ibid., p. 44.

forty-four different exhibitions were organized by CEMA and sent on tour, twenty consisting of original paintings and drawings; in the same period the British Institute, under its CEMA contract, dispatched twenty-one exhibitions. The council itself acquired a small collection of paintings and drawings in order to demonstrate to the public various types of pleasing and competent contemporary work which might be purchased by ordinary people for their homes. Another scheme involved the publication of lithographs in color by contemporary artists for sale in factories, armed forces centers, youth clubs, and the premises of other wartime groups; 35,000 reproductions were sold by the end of 1944.[30] A project designed to influence developments after the war was the circulation of a set of three models for the construction of arts centers to serve a population of about 20,000 people. On a single site plans called for an all-purpose building containing theater, a concert hall, an exhibition room, study and practice rooms, and a restaurant.

Independent arts clubs played a significant role in keeping the arts alive among laymen. Such a club's emphasis depends upon the interests of the members and available artistic resources. Music, painting, and drama can be its chief concern, or members may, in addition, pursue an interest in films, literature, ballet, or sculpture. Many clubs were of ancient origin, but others sprang up as a direct result of the council's provision of concerts, plays, and exhibitions. Mary Glasgow, the council's secretary-general, believed that CEMA could not have functioned without them.

From 1941 on, the work of the Council was largely taken up in meeting the impatient demands and the critical complaints of these self-appointed clients. Although it was a delicate task, it proved more invigorating than the straight-forward provision of entertainment to passive audiences assembled as it were to order.[31]

The council cooperated with the Ministry of Labour's "holidays at home" campaign, presenting events in industrial areas during the summer, whenever possible in the open air. Some programs were more successful than others; particularly outstanding were Robert Atkins' Shakespearean Company, which had performed for years in Regent's Park, London, and Basil Langton's Travelling Repertory Theatre.[32] Whenever possible, the council elicited local authority support; it soon found that such assistance, to be effective, must be based on more than amateur enthusiasm. To obtain the best results, the efforts of town councils' Parks Committees needed to be supplemented by the services of experienced and professional entertainments officers.

Housing for the arts—housing of any kind—was one of the most acute problems faced by CEMA. Scarcity was not due solely to the war, since theaters, concert halls, and other buildings suitable for the arts had been in

30. *The Fifth Year, the End of the Beginning: Report on the Work of C.E.M.A. for 1944* (CEMA, 1945), p. 17.
31. Evans and Glasgow, *The Arts in England*, p. 49.
32. *The Arts in War Time*, p. 9.

extremely short supply during the 1920s and 1930s in country towns and villages as well as in major cities. Ingenuity was often required to locate structures in which artistic events could be presented, and the spectrum ranged from cathedrals to village inns and from public libraries to air-raid shelters. Even where theaters or halls did exist, they were often ill designed, as if created by a Puritan ogre whose chief concern had been to make appreciation of the arts as uncomfortable and inconvenient as possible. Housing deficiencies in the provinces tended to dampen local zeal for initiating new enterprises, while organizations fortunate enough to have an adequate London base were reluctant to undertake extensive tours.

An important CEMA achievement was the saving of the Theatre Royal in Bristol. This theater, built in 1766 and the oldest of its kind in the country, was sold upon the death of its owner and plans were made to erect a warehouse on the site. A public appeal to Bristol citizens for funds to save it was only partially successful. In late 1942, CEMA offered to restore the structure and assume control of its operation. A board of trustees was constituted in Bristol which acquired the theater on a mortgage and, in the capacity of landlord, leased it to CEMA. Renovation was prompt, and the theater opened in the council's name on 11 May 1943. Directly managed by the council, Theatre Royal presented a varied and, on the whole, successful series of plays and other entertainment: thirty-five different plays, including works by Shakespeare, George Bernard Shaw, T. S. Eliot, and Thomas Dekker, were mounted in 1944–45.[33] Financially, the theater was a success, its operations actually showing a profit.

By the end of 1941 the Pilgrim Trust concluded that CEMA was sufficiently well established to get along on its own, financial responsibility being vested in the Treasury. The council was reorganized on 1 April 1942; John Maynard Keynes became its new chairman, while the Pilgrim Trust representatives, Lord Macmillan and Thomas Jones, withdrew. The council remained small— a body of nine or ten persons appointed by the president of the Board of Education.

CEMA initially received advice from arts specialists who served in an honorary capacity, but this arrangement became increasingly unsatisfactory. In 1942 the directorships for music, drama, and art were converted into full-time salaried positions. Occupants of these posts as of early 1944 were Reginald Jacques, previously honorary music advisor; Lewis Casson, formerly an honorary director of drama; and Philip James, on loan to the council from the Victoria and Albert Museum.

During the same year Keynes and R. A. Butler, president of the Board of Education, acted to secure a broader range of specialist advice to help guide the planned expansion. Panels of experts in the fields of music, drama, and art were constituted; these new bodies enhanced the council's prestige and insured a program of future growth acceptable to professional opinion. Whenever possible, each panel met under the chairmanship of Lord Keynes;

33. *The Fifth Year*, pp. 14, 33.

2*

however, vice-chairmen and also council members were named to guide these meetings, which were held more frequently and with less formality than those of the council. The initial roster of panel members included many famous persons, outstanding authorities in their respective fields.

Meanwhile, the council found it increasingly difficult to maintain close ·contact with its officers outside London and to keep itself adequately informed about the organizations which it supported or directly administered. To meet these difficulties, regional offices were established, each responsible for local organization and particularly for advising administrative personnel in London about local needs and potentialities. By December 1942, eleven regional offices were in operation; a twelfth, located in Wales, was set up about a year later.[34] Regional officers, assisted by one or more specialists in art, music, or drama, were placed in charge of each office. CEMA's regional pattern of decentralization conformed largely to the model used for Civil Defense, central control and direction from London being relatively limited.

CEMA's financial resources were at no time large enough to permit it to underwrite administrative expenses and at the same time sanction subventions to a large proportion of the cultural bodies which had applied for assistance. The council in 1942–43 possessed an income of £100,000 in the form of an Exchequer grant-in-aid, contained in the parliamentary vote of the Board of Education. In addition, a terminal gift of £12,500 from the Pilgrim trustees brought the foundation's total contributions to £50,000. For 1943–44 the Treasury allocation rose to £115,000; the additional funds were used to meet increased expenses of administration, particularly in the provinces, and to underwrite factory canteen concerts. The final Treasury allocation to CEMA, 1944–45, amounted to £175,000.

CEMA utilized several different administrative devices to provide assistance to theater companies, orchestras, and other organizations. The specific method always depended upon the needs of a given body and the nature of its fiscal operations. In some instances a block grant was allocated, thus giving the recipient maximum freedom of decision on how the money should be spent. In others, loans were made by the council, to be repaid in their entirety or in part from subsequent operating profits. A practice frequently used and highly conducive to husbanding the council's resources was the guarantee against possible loss. The council itself, as an artistic entrepreneur, expended substantial sums—to directly provide musical concerts, to under-

34. Regions as of 1944, each with a headquarters in a central city, were: Region 1, Northumberland, Yorkshire (North Riding), Durham—headquarters in Newcastle-upon-Tyne; Region 2, Yorkshire (East and West Ridings)—Leeds; Region 3, Nottinghamshire, Lincolnshire, Derbyshire, Leicestershire, Rutland, Northamptonshire—Nottingham; Region 4, Cambridgeshire, Essex, Norfolk, Suffolk, Bedfordshire, Huntingdonshire, Hertfordshire—Cambridge; Region 5, London and Middlesex—London; Region 6, Oxfordshire, Berkshire, Buckinghamshire, Hampshire, Dorset, Isle of Wight—London; Region 7, Gloucestershire, Somerset, Cornwall, Devon, Wiltshire—Bristol; Region 8, Wales—Cardiff; Region 9, Herefordshire, Worcestershire, Warwickshire, Staffordshire, Shropshire—Birmingham; Region 10, Cheshire, Cumberland, Lancashire, Westmoreland—Manchester; Region 11, Scotland—Edinburgh; Region 12, Kent, Surrey, Sussex—London. *The Fifth Year*, p. 41.

write losses sustained by theater companies specially engaged by it, and to defray costs incurred in connection with art exhibits sent on tour. As the threat of air attacks and invasion lessened, the council began to expend more in places which seemed likely to develop into permanent, self-supporting centers, rather than in trying to respond to all requests. For the fiscal year ending 31 March 1944, its total income amounted to £121,510—a Treasury grant of £115,000, £5,016 in general concert profits, £1,437 in exhibition fees, and £57 in donations. Expenditures for the same period totaled £135,674, resulting in a deficit of £14,164.[35] Chart 1 shows the breakdown of these expenditures by object.

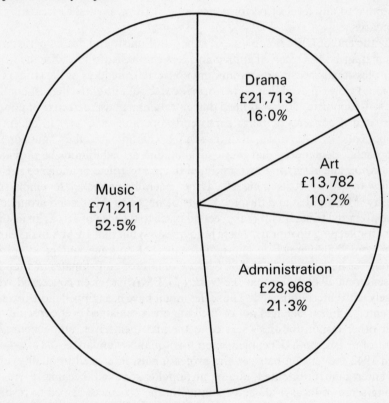

CHART 1 CEMA Expenditures, 1943–44

Once CEMA's programs were well under way, certain policy problems arose. There was a real danger that CEMA might be reduced to performing the simple role of "cultural spoonfeeding"; wartime audiences were generally not difficult to please. For many, council-aided programs afforded their initial cultural experience, and they eagerly attended as many concerts, dramatic performances, and art exhibits as they could. Once the council had

35. Ibid., pp. 22–25.

set in motion its administrative machinery, it encountered little difficulty in achieving one of its two major objectives—to bring the arts and relaxation to an overworked and warweary population. If adequate moneys were placed at its disposal, concerts could be supplied without difficulty and in large quantities, theater companies could be constituted and sent to the remote parts of Britain, and art exhibitions could be assembled and dispatched on tour in large numbers. Cultural debasement became a distinct possibility, a threat which disturbed those who were striving for artistic as well as social objectives. In times of crisis, the immediate needs of the people commanded high priority. Passive and sometimes captive audiences, indiscriminately receptive to any level of performance offered them, invited a slackening in standards.

By the end of CEMA's first year, support of music and drama performed by amateur bodies received appreciably less emphasis; to subsidize the work of professionals became its paramount concern. Defenders of the strict professional view believed that all performances should be of the highest quality and self-supporting; they assumed that entertainment was defective or poorly presented if concerts or plays persistently operated at a loss. In contrast, proponents of the mass culture school championed the "missionary approach," demanding that music, drama, and art exhibitions be provided on a wholesale basis for all who wanted them, regardless of audience size or ability to defray costs incurred. They generally neglected to emphasize quality. Many gifted and devoted artists belonged to this second group and were prepared to see quality take second place to the idea of arts as an instrument for keeping up morale. There is no question but that CEMA in the early days contributed much to the maintenance of courage and good spirits among the audiences it served. A Select Committee on Estimates in a report presented in 1949 found that the work of CEMA had been concerned very largely with entertainment.[36] The scales might have been tipped more toward the entertainment side had not council members remained ever conscious of their other responsibilities—service to the arts themselves, and encouragement of artists, both dependent upon high-quality standards.

In 1942 the tension between the professionals, interested in quality, and the entertainment-oriented, aiming at popular goodwill, became severe. A strong sense of local pride and initiative in the provinces helped to resolve the dilemma. Mere entertainment could have spawned local inertia as people enjoyed the arts brought cheaply to their communities without effort on their part. Instead, there developed a spirit of cooperation as these communities worked with CEMA; in different parts of the country, local residents selected their own artists and made the necessary production or exhibition arrangements. The council encouraged such initiative and offered local organizations limited financial guarantees against loss for a variety of musical and dramatic programs, permitting them, however, to retain profits to enrich

36. *Nineteenth Report from the Select Committee on Estimates, Session 1948–49, The Arts Council of Great Britain*, no. 315 (HMSO, 1949), p. viii.

and further extend their work. Organizers were confronted with a dual obligation—to meet council standards and simultaneously appeal to their own audiences. They also were expected to operate in the black or at least to show modest losses. This arrangement was salutary, for it mitigated the dangers of stagnation and encouraged the growth of a vigorous and responsible artistic life.[37]

How successful was CEMA in realizing its objectives? The council's achievements as patron of the arts in this difficult period in Britain's history are inevitably subject to differences of interpretation. Effective administrative organization was crucial to the attainment of the council's basic purposes. And considering the speed with which the council was constituted and the adverse conditions under which it was forced to operate, its record of accomplishment is remarkably good. A criterion for evaluation, emphasized by Lord Keynes, was economy in expenditure. Two related aspects had to be taken into account—the way public funds were expended by the council itself and the extent to which other cultural bodies, aided by it, achieved maximum artistic return with the moneys given them. CEMA spent moneys for two purposes: (1) the maintenance of the central headquarters in London and the operation of its twelve field offices; and (2) direct provision of concerts, art exhibits, and art tours. In 1943–44, CEMA's administrative costs totaled £28,968 or 21.3 percent of its operating budget, a proportion excessively high and considerably larger than that expended by the Arts Council after its establishment. This was unavoidable, since difficulties of wartime communication and travel required the maintenance of regional offices.[38] Artistic organizations supported by CEMA appear to have made good use of the Treasury funds allocated to them, although some failures inevitably occurred.

The council from the very beginning attempted to analyze the diversity of Britain's artistic needs and devised its programs pragmatically month by month. It learned by experience and experimentation, and it sought to discharge its responsibilities as constructively as possible. When adverse criticisms were lodged, the council made a concerted effort to respond positively. When it believed in the correctness of its position, it defended itself vigorously. Thus, early in 1943 a member of Parliament questioned the Chancellor of the Exchequer whether "in view of the poor quality and debasing effect of the pictorial art evinced at the exhibitions provided by CEMA, he will reduce the yearly grant to this institution from His Majesty's Treasury." A spirited exchange of letters followed in *The Times*, some supporting the attack and others defending the council and its selection of modern art. One letter of condemnation, answered directly by Lord Keynes, was signed by several persons, including the president-elect of the Royal Academy. The council felt that it had vindicated its position, and the art

37. Evans and Glasgow, *The Arts in England*, p. 48.
38. In 1943–44, £17,612 were expended by the council to maintain its regional offices.

panel asserted that it was pleased to patronize contemporary art, even if particular works sometimes happened to be controversial.[39]

Another dispute, less acrimonious, centered on the authenticity of certain paintings contained in a council exhibition. James Bomford had generously loaned to CEMA a collection of French paintings, which were then sent on tour, "in the hope, above all, that it will help the general public to understand modern art." Professor Thomas Bodkin of the Barber Institute, Birmingham, assailed the owner's contention that two of the pictures were by Manet, again sparking a peppery correspondence in *The Times*. When the dust settled, the council admitted its continuing doubts about the infallibility of art experts and promised that future catalogs would indicate the origin of the attributions that were included.[40]

CEMA's most serious difficulty was lack of adequate Treasury financial support. Once CEMA was established, the demand for directly provided concerts and art exhibits, and requests for grants and guarantees, steadily increased, and many applications had to be reluctantly rejected.

Ten years later the Arts Council analyzed CEMA's wartime struggles and achievements and discovered three important facts that might prove useful to those attempting to establish an effective, permanent program of governmental patronage.[41] First, "the size and ardour of the audience which its activities attracted far exceeded all expectations." While admittedly the peculiar conditions of war and the paucity of competing attractions resulted in audience response far larger than could be expected when peace returned, CEMA conclusively demonstrated that a vast, unsatisfied cultural demand existed and that its activities had whetted the appetites of millions of people for more art, music, and drama. Second, CEMA had demonstrated "the necessity to distinguish between the professional and the amateur practice of the arts." The council had withdrawn almost entirely from the amateur field and had concentrated its efforts on the professional side, for this was judged to be the most effective way of achieving and preserving high standards. This action was not designed to denigrate the amateur practice of the arts; participation in music, theater, or painting, it believed, brought to its practitioners numerous benefits. Third, CEMA's pilot run revealed "the relative paucity in the country of buildings worthy of and suitable for the reputable professional performance of music and drama."

One matter is clear. CEMA played a vital role in keeping the arts alive in Britain during World War II. Had not the coalition government implemented the Pilgrim Trust's initial effort, cultural life in Britain today would be less rich and diverse. Not to be overlooked are the benefits CEMA conferred upon individual artists, for it provided employment directly and indirectly to a substantial number of musicians, actors, singers, dancers, and artists, under conditions of relative freedom for individual expression and enterprise, devoid of bureaucratic regimentation or censorship.

39. *The Fifth Year*, pp. 15–16.
40. Ibid., p. 16.
41. *The First Ten Years*, pp. 12–14.

3 / THE ARTS COUNCIL: DECISION-MAKERS AND PATRONS

The purpose of the Arts Council . . . is to create an environment to breed a spirit, to cultivate an opinion, to offer a stimulus to such purpose that the artist and the public can each sustain and live on the other in that union which has occasionally existed in the past at the great ages of a communal civilized life.
—John Maynard Keynes, 1945

hile viewing a CEMA collection of pictures on display in the National Gallery in 1942, Richard Austen Butler, Minister of Education, enthusiastically predicted that the council would survive the war and become the government's permanent instrumentality for artistic patronage. He was not alone in forecasting a continuance of public support for the arts. Other political leaders as well as cultural "statesmen" in various artistic fields expressed approval of the work of CEMA and urged that it be retained. On 12 June 1945, Sir John Anderson, Chancellor of the Exchequer, in speaking to his colleagues in the Commons commended CEMA for the work it had done. He explained how it had demonstrated that a body to encourage the understanding and practice of the arts would be needed with the return of peace. Further, he announced the decision of the coalition government to continue the existence of CEMA, with a redefined mandate from Parliament, as the Arts Council of Great Britain.

An attempt to create a body such as the Arts Council prior to 1939 would have required arduous and protracted negotiations. Agreement among sponsors of such a novel project in Britain would have been difficult to achieve. And they would have been hard put to gain the active political support of scores of bodies concerned with the arts, "many of them vigorous adherents of conflicting policies and practices, and some of them hardly on speaking terms with each other."[1] CEMA's obvious success during its five war years, however, made such negotiations unnecessary. The government's decision in 1945 was arrived at apparently without difficulty and in the absence of vigorous opposition, partisan or otherwise.

Shortly after the general election in July 1945, John Maynard Keynes, speaking on the BBC to the British people, analyzed the importance of the coalition government's predissolution decision to establish the Arts Council as CEMA's successor.

I do not believe it is yet realized what an important thing has happened. State patronage of the arts has crept in. It has happened in a very English, informal, unostentatious way—half baked if you like. A semi-independent body is provided with modest funds to stimulate, comfort and support any societies or bodies brought together on private or local initiative which are striving with serious purpose and a reasonable prospect of success to present for public enjoyment the arts of drama, music and painting.[2]

Keynes explained that the council would be a permanent body, independent in constitution, free from red tape, financed by the Treasury and ultimately responsible to Parliament. He praised the Commons for recognizing that the public Exchequer has a duty to support and encourage the civilizing arts. He then hastened to reassure his listeners that the council did

1. *The First Ten Years, The Eleventh Annual Report of the Arts Council of Great Britain, 1955–1956*, p. 12.
2. *The Listener*, 12 July 1945, p. 31.

not intend to socialize this phase of British life. Recalling the partisan strife of the election campaign just concluded, with its bitter attacks on the Labour Party's plans to nationalize certain industries, Keynes said he thought everyone knew that the work of the artist is by its very nature individual and free, undisciplined, unregimented, uncontrolled. The artist walks where his spirit or inspiration leads him.

He cannot be told his direction; he does not know it himself. But he leads the rest of us into fresh pastures and teaches us to love and to enjoy what we often begin by rejecting, enlarging our sensibility and purifying our instincts. The task of an official body is not to teach or to censor, but to give courage, confidence and opportunity. Artists depend on the world they live in and spirit of the age. There is no reason to suppose that less native genius is born into the world in the ages empty of achievement than in those brief periods when nearly all we most value has been brought to birth. New work will spring up more abundantly in unexpected quarters and in unforeseen shapes when there is a universal opportunity for contact with traditional and contemporary arts in their noblest forms.[3]

The Arts Council was not to be thought of as a schoolmaster. The people's enjoyment would be its first concern. Admitting that the council had little money to spend, Keynes asserted that the public by their individual patronage would determine what plays and concerts were to be presented. The unsatisfied demand and the enormous public interest in serious entertainment, discovered during the war, he attributed largely to the BBC with its influential and challenging programs initiated during the 1930s. Nor did he believe this upsurge of interest was merely a wartime phenomenon. The Arts Council wished to decentralize the dramatic, musical, and artistic life of the country, to help local authorities and private groups build up provincial centers, and to cater to local tastes and traditions. This did not mean, however, that the council intended to neglect London. Painfully aware of London's devastated condition, it planned to mobilize available managerial talent and financial resources to build a great artistic metropolis.

Establishment of the Arts Council The period following the chancellor's announcement that CEMA would be transformed into a permanent organization—the Arts Council of Great Britain— was one of intense activity. Programs currently being presented were carried forward under still changing conditions. Wartime hardships and financial stringencies abated but slightly. Knowledge that provision would be made for the future was heartening for everyone involved—council members, administrative staff, and, most important, persons responsible for planning and operating the numerous cultural enterprises being assisted. Long-range policies could now be formulated with some assurance that they would be implemented as resources became available.

The royal charter, issued on 9 August 1946, set forth the objectives of the council: to develop "a greater knowledge, understanding and practice of

3. Ibid., p. 32.

the fine arts exclusively, and in particular to increase the accessibility of the fine arts to the public . . . to improve the standard of execution of the fine arts and to advise and cooperate with Our Government Departments, local authorities and other bodies on any matters concerned directly or indirectly with those objects. . . ."[4] The Arts Council thus acquired a permanent status without being hamstrung by enforced adherence to a detailed schedule of programs and activities in which it could engage. It could develop on a more secure and long-term basis certain phases of the work already undertaken which merited continued subsidy. To these could be added new elements, making more comprehensive the council's program of encouragement and support.

The Arts Council was placed directly under the Treasury, which permitted it to administer its funds with greater freedom and flexibility than if it had been made a government department. The Chancellor of the Exchequer was to answer all questions which might be raised in the House of Commons concerning the council's work. This arrangement, a distinct departure from the one made for CEMA, which had functioned directly under the Ministry of Education, greatly enhanced the new council's effectiveness as a patronage instrumentality.

The council under the charter was made an incorporated institution, with perpetual succession and a common seal, and with full authority to administer programs of artistic encouragement and support. It was accorded specific powers: to sue and be sued; to enter into contracts or agreements to further its objectives; to accept, hold, and dispose of money or other personal property, including sums voted by Parliament; to purchase, take on lease, or otherwise acquire land and buildings; to accept funds in trust; and to invest moneys belonging to it. Income and property of the council, from whatever source derived, had to be expended solely in carrying out the functions entrusted to it by Parliament and set forth in the charter.[5]

The original charter remained in effect until 1964, when it was amended by an order issued by the Secretary of State for Education and Science shifting parliamentary responsibility for the Arts Council from the Treasury to the Department of Education and Science. In 1967 additional changes were desired, and a new charter was drawn up, approved by the queen on 7 February. Council objectives, reflecting more than twenty years of successful operation, are today defined as follows:

(a) to develop and improve the knowledge, understanding and practice of the arts;
(b) to increase the accessibility of the arts to the public throughout Great Britain; and

4. *The Charter of Incorporation Granted by His Majesty The King to The Arts Council of Great Britain Ninth Day of August 1946*, p. 3.

5. The council is not permitted to pay members a salary or other remuneration for their services, but may reimburse them for actual expenses incurred in the performance of their duties.

(c) to advise and cooperate with Departments of Our Government, local authorities and other bodies on any matters concerned whether directly or indirectly with the foregoing objects.[6]

Appointment of Council Members The Arts Council initially consisted of eleven persons; the first charter limited the maximum size to sixteen. New members were to be appointed by the Chancellor of the Exchequer after consultation with the Minister of Education and the Secretary of State for Scotland. The present charter provides that the council consist of a chairman, vice-chairman, and not more than eighteen other members, all appointed by the Secretary of State for Education and Science after consultation with the Secretaries of State for Scotland and Wales. The council designates one of its members to serve as vice-chairman. A practice customarily adhered to, although not required by law, is the appointing of two council members from Wales and three from Scotland, thus providing useful liaison with the Scottish and Welsh councils on which the appointees also serve. Final decision concerning selection of new members was, until 1965, made in the Treasury by the chancellor. Names of possible appointees were put forward by council members, and by civil servants in the Treasury, Ministry of Education, Scottish and Welsh Offices or private citizens not directly connected with government. The secretary-general was usually brought into the discussion at an advanced stage. The council chairman unofficially recommended candidates to the Chancellor of the Exchequer. Although political and personal considerations have not been entirely absent, the primary focus has been upon getting persons to serve on the council who have an intense interest in the arts and, hopefully, extensive knowledge in one or more areas. The professional pursuits of council members have been extremely varied; these are analyzed later in this chapter. New members do not have to be professionally involved in the arts. Today the Minister of State in the Department of Education and Science, who serves as government spokesman for the arts, plays a major role in the appointing process. Suggestions for council membership are submitted to him, and he in turn recommends names to the Secretary of State for Education and Science. Earlier phases of the appointment process remain essentially as they were under the Treasury.

Under the charter, council members hold office for periods not to exceed five years. Those who were on the executive committee (abolished in 1967) could be immediately reappointed, if the Chancellor or, later, the Minister of Education so desired. Other members had to wait a year before accepting a new appointment. Today, the chairman and vice-chairman of the council, of the Scottish Arts Council, and of the Welsh Arts Council, and chairmen of panels can be immediately reappointed. Most members who served a

6. *Charter of Incorporation Granted by Her Majesty the Queen to the Arts Council of Great Britain Seventh Day of February 1967*, section 3.

second term did so without an intervening gap, since they were on the executive committee. The Treasury and the Ministry of Education have upheld the principle that council membership should not be unduly prolonged, although no exact pattern of rotation has been followed. Table 2 sets forth data on the length of service of council members. It is interesting to note that nine persons held office for ten or more years and one attended meetings for fifteen consecutive years.

TABLE 2 Length of Service of Arts Council Members, 1945–67

Years Served	Number of Members	Percent	Years Served	Number of Members	Percent
1	5	7.3	9
2	11	16.2	10	1	1.5
3	14	20.6	11	2	2.9
4	8	11.7	12	1	1.5
5	11	16.2	13	3	4.4
6	4	5.9	14	1	1.5
7	1	1.5	15	1	1.5
8	5	7.3	16

The Chairman and the Executive Committee The council's chairman, appointed originally by the Chancellor of the Exchequer but now by the Secretary of State for Education and Science, holds office for an initial term of five years, subject to reappointment. He occupies a key post, and by playing his cards adroitly he can influence the government of the day, effectively present the council's financial needs when the annual estimates are projected, propose new schemes for assisting theater, opera, or music, and, to some extent, mobilize public and specialist opinion in support of more generous cultural subsidization. The chairman and vice-chairman are the council's representatives in contacts with Commonwealth countries and other nations throughout the world. Overseas visits are sometimes arranged. In September 1947, the vice-chairman, at the request of the Dominions Office, toured Canada and spoke to dozens of groups concerning the council's diverse activities. His visit undoubtedly helped to prepare the way for the creation of the Canada Council in 1957.[7]

Under the charter, a vice-chairman is appointed by the council from its membership, subject to approval by the Secretary of State for Education and Science, for a period not to exceed five years. Procedurally, the council has designated its vice-chairmen on a year-to-year basis, thus retaining maximum flexibility. But in fact, only three men have served thus far: B. Ifor Evans, 1946–51; Wyn Griffith, 1952–61; and William Coldstream, 1962 to date. Until 1967 the council was required to meet at least four times each year, but in practice it usually convened six times, normally every second month. Although frequency of meetings is not specified in the new charter, the council's increased volume of business requires it to

7. *The Arts Council of Great Britain, Third Annual Report 1947–1948*, p. 3.

meet once a month. The council has authority to regulate its procedure.[8]

The council conducted much of its business during its first twenty-two years through an executive committee consisting of the chairman, vice-chairman, and such other members of the council as it and the Lords Commissioners of the Treasury agreed upon, meetings usually being held every other month. No limits were placed upon the length of time committee members could serve.[9] Committee size slowly increased over the years: in 1946, six of the fourteen council members served on it; by 1960, eight of the now sixteen council members served; and in 1966, nine served.

The executive committee was empowered to exercise all authority possessed by the Arts Council except those powers that the council specifically reserved for itself.[10] But the council decided that there should be little difference between it and the executive committee, and that the items of business each was empowered to transact were largely indistinguishable. Most decisions made by the executive committee were not submitted to the full council but went into effect at once. And the committee on its own could vote sums of money which did not require sanction by the council. In 1967 the council decided to abolish the executive committee, preferring to discharge all of its business directly.

The presence of assessors at Arts Council meetings is an important feature of the organization's policy-making apparatus. The original charter specified that the Chancellor of the Exchequer, the Secretary of State for Scotland, and the Minister of Education, each appoint an officer from his department to serve as an assessor to the council, with the right to attend the meetings of the council, the executive committee, panels, and other committees.[11] The assessors' precise duties were not spelled out, but over a period of years they have been agreed upon by the organizations involved. Most important was the Treasury's assessor, one of the Department's Third Secretaries on the Finance and Economic Side, who was charged with responsibility for oversight of governmental arts and science activities.[12] Since the new charter

8. The quorum specified for the conduct of business consists of seven members or such greater number as the council may determine. Under the original charter, questions arising at any council meeting were decided by a majority vote of those present, and in the case of a tie vote the chairman as presiding officer was permitted a second or casting vote. In practice, formal votes are rarely taken at Arts Council meetings—informal agreement is usually reached.

9. The executive committee automatically included the council vice-chairman and panel committee chairmen, but it was not until 1953 that the chairman of the Welsh committee was added. The chairman of the Scottish committee was made a permanent member in 1955.

10. The charter empowered the person presiding at committee meetings, usually the council chairman, to refer an item of business to the full council to obtain further instructions if, in his opinion, it (1) was of exceptional novelty, or of extreme importance, or likely to lead to considerable expense; (2) gave rise to a serious difference of opinion in the committee or among its advisers and he thought the council should be informed about it; or (3) was likely to result in serious criticism or opposition from a responsible segment of the public. *The Charter*. 1946, section 11.

11. Ibid., section 15.

12. Lord Bridges, *The Treasury* (London: George Allen and Unwin, Ltd., 1964), pp. 147–50. The three assessors did not always attend executive committee meetings; as for panel sessions, the pressure of official duties did not permit them to sit in.

was placed into effect in 1967, officers representing the Secretary of State for Education and Science, the Secretary of State for Scotland, and the Secretary of State for Wales, serve as assessors to the Arts Council and its committees and panels. Each assessor, before council and other meetings, is sent copies of all papers pertaining to the items of business to be considered. Assessors do not normally take part in the discussions but may be invited to do so. They do not vote. Assessors function as watchdogs for their own departments. Under the first charter the council's position in relation to the' Treasury sometimes proved awkward. Thus, the Treasury assessor not infrequently was asked to comment upon his department's probable attitude toward a proposed increase in expenditure in a given category or upon a shift in emphasis in a particular program of artistic support.

Profiles of Arts Council Chairmen
Certain insights concerning the development of the Arts Council, the formation of its policies, the determination of its organization, and the attainment of its objectives can be acquired by looking at the backgrounds and careers of its chairmen. This key post has been held by four distinguished persons. A fifth, John Maynard Keynes, who as chairman of CEMA from 1942 to 1945 had presided over the creation of the nation's wartime patronage programs and played a leading role in setting up the Arts Council on a permanent basis, is also included. The government had appointed Keynes as the council's first chairman, but before he could take office he suddenly died, on Easter Sunday, 1946. Ernest Pooley became the council's chairman, holding office until April 1953. The chairmanship then fell to Sir Kenneth Clark, who presided over the council until April 1960. Lord Cottesloe was the only chairman whose service was limited to five years, the duration of an initial appointment. The present chairman, Lord Goodman, took office on 1 May 1965.

John Maynard Keynes was gifted in a diversity of fields. He pursued numerous careers—teacher, civil servant, writer, economist, editor, administrator, financier, party worker, theater manager, farmer, and art and book collector. But he was best known as an economist. Seymour E. Harris of Harvard observed that Keynes exercised "a greater influence on economics and public policy than any other economist in a century."

Keynes's mission in life was to save capitalism, not destroy it. In their assaults on Keynes the communists implicitly recognized his services to the system they detest. The road to salvation, as he saw it, was the maintenance of adequate demand; and without government support through appropriate tax and spending policies, demand must necessarily falter. Yet capitalism had to move the goods it produced, or it would not survive. Unemployment was the disease which, if untreated, would kill capitalism. The Keynesian Revolution in economics was largely a shift of interest from production, the best allocation of labor, capital, etc., to demand—to a concentration on the arithmetic of buying, with its relevance for employment.[13]

13. Seymour E. Harris, *John Maynard Keynes* (New York: Charles Scribner's Sons, 1955), p. ix.

Keynes's major works dealt with economic theory and policy, but he also found time to write numerous biographical essays and articles on non-economic subjects.[14] As an editor he was extremely active, his major accomplishments including the volumes on monetary reconstruction after the First World War for the *Manchester Guardian*, the Cambridge Economic Handbooks, and service as publisher of the *Nation*; particularly important were his contributions as editor of the *Economic Journal* (British). Keynes was a member of the editorial board of the *Political Quarterly*, serving from 1930, the year of its establishment, until his death. Keynes held civil servants in low esteem, and politicians were frequently the object of his attack, yet he devoted thirteen years, or almost one-third of his working life to government. Upon the outbreak of war in 1914, Keynes moved to the Treasury and quickly became immersed in the task of mobilizing the nation's financial resources to meet the day-to-day costs of the conflict. When peace came, he attended the Paris Peace Conference as the principal Treasury representative.[15] As a Liberal he unsuccessfully tried to get his party to join with Labour in a working alliance—the Liberals would accept a degree of government intervention if Labour would abandon its proposals for nationalization and equality. In practice, he campaigned against whatever government held power in Whitehall, inducing changes of policy on specific issues. His political interests were remarkably diverse. From 1940 to 1946, he was heavily involved at the Treasury, helping to mobilize and conserve dollar resources, advising on fiscal policies, and providing leadership in new programs of international cooperation. Keynes attended the Bretton Woods monetary conference in 1944 and in the following year was a negotiator for a U.S. loan.

More than most of his contemporaries, Keynes realized the supreme importance of creating a society which would make adequate provision for the leisure of its people. A passage from one of his writings reads: "The day is not far off when the Economic Problem will take the back seat where it belongs, and the arena of the heart and head will be occupied, or reoccupied, by our real problems—the problems of life and of human relations, of creation and behaviour and religion."[16] This, in one sense, appropriately summarizes Keynes's credo—a credo that the Arts Council in its final tribute to him pledged itself to uphold.

Keynes's interest in the arts and his desire to make them readily available for the people in Britain crystallized early in his life. Upon completing his studies at Cambridge, he became deeply involved with the Bloomsbury literary circle and was greatly influenced by close friends such as Lytton

14. Books published by Keynes include: *A Treatise on Probability* (1921), *A Revision of the Treaty* (1922), *A Tract on Monetary Reform* (1923), *The Economic Consequences of Mr. Churchill* (1925), *A Short View of Russia* (1925), *The End of Laissez-Faire* (1925), *A Treatise on Money* (1930), *The Means of Prosperity* (1933), *The General Theory of Employment, Interest, and Money* (1936), and *How Shall We Pay for the War* (1940).

15. Roy Harrod. "John Maynard Keynes and the Power of Reason," *The Listener*, 5 February 1941, pp. 206–7.

16. *Arts Council of Great Britain, First Annual Report 1945–6*, p. 2.

Strachey, Duncan Grant, Miss Stephens (afterward Virginia Woolf), Vanessa and Clive Bell, and Roger Fry. His Victorian heritage conditioned him to view the arts as education, but he quickly placed himself in the vanguard of those who believed that the arts should be explored and understood purely for their entertainment value. His wife, Lydia Lopokova, a dancer with the Diaghileff Russian Ballet, stimulated his artistic interests and brought him closer to the world of drama and to the related arts of stage music and design. Throughout his life he was interested in literature.[17]

In 1930 the Camargo Ballet Society was organized. At its first performance at the Cambridge Theatre, London, Keynes's wife, in a short talk, proclaimed the birth of British ballet. Keynes served as treasurer, presiding over the Camargo's financial affairs with characteristic efficiency until 1934 when the society was forced to close.

During 1935–36 Keynes initiated and supervised the erection of the Arts Theatre in Cambridge. He had formed a trust for its management by 1938, guided by a small board of which he was a member until his death. He contributed a substantial proportion of the initial capital and helped shape the theater's program by overseeing the financial side.

Beginning in 1917, when Keynes visited Paris and attended the sale of the Degas collection as a buyer for the National Gallery, he acquired a creditable collection of paintings and drawings, mostly French. He also helped organize and raise funds for the London Artists Association, an organization that provided a regular annual income for painters of ability who had not sufficient renown to be free from financial worries. As World War II neared its end he participated in negotiations for the reopening of the Royal Opera House at Covent Garden, where a new trust was set up with the cooperation of the Arts Council. Keynes became its first chairman.

Keynes became convinced that in the twentieth century the arts required a new kind of subsidy to replace the patronage by the affluent classes of earlier times. He wanted the mass of the British people to enjoy the pleasures of the aesthetic arts, which, in the past, had been the privilege of only a select few. When invited to become chairman of CEMA in February 1942, he accepted with alacrity and immediately assumed his new responsibilities while retaining a full-time commitment at the Treasury. He was uniquely qualified, possessing an unusual combination of administrative skills and understanding of the arts. He was acutely aware of the difficulties in forging an effective system of encouragement and support during the war. Most important, he commanded wide respect among Conservatives and Labourites, intellectuals and the working classes, and was able to give the new council status and prestige. Keynes vigorously insisted upon high standards and was not interested in the council's underwriting light entertainment or amateur art. He was sympathetic to experimentation and managerial adventuring, but he believed that in the long run quality arts should be self-supporting. Harrod, in his biography, reports that "his ideal for CEMA

17. Harris, *John Maynard Keynes*, p. 22.

was that at the final stage, no doubt not to be reached for a long time, it should have no disbursements except the cost of administration."[18] He constantly involved the artists themselves in the operation of the council and had no qualms about trusting the experts. Council staff were continually kept informed of his thinking and the actions he took. He could be severely critical. He wrote from America:

I was, therefore, considerably shocked by the lightheartedly enthusiastic way in which the Council gave the Executive Committee authority without, so far as I can see, any of the necessary information before them . . . no doubt you will be able to assure me that it is not quite so irresponsible as it looks from the Minutes which have reached me. There is rather too much of an air of "warm endorsement" of half-baked ideas in these Minutes to leave me quite happy.[19]

When the coalition government decided in 1945 to convert CEMA into a permanent Arts Council, Keynes arranged that responsibility for its government grant be shifted from the Ministry of Education to the Treasury. Thus, the new body now stood in the same relationship to the Commons as the University Grants Committee. This move was devised to keep future government interference to a minimum.[20]

When Hugh Dalton, Labour Chancellor of the Exchequer, designated Ernest Pooley as Council Chairman in 1946, he chose a seventy-year-old man who possessed neither Keynes's catholicity of interest nor his depth of artistic knowledge. Although distinguished in his profession, he did not command comparable public respect. Pooley attended Cambridge and was called to the bar in 1901. He served the Drapers' Company for forty years, first as Assistant Clerk, then as Clerk, and finally as Master. He had been vice-chairman of the Old Vic and a member of the governing body of Sadler's Wells, and he brought to the council an active interest in the arts, particularly their managerial and financial aspects, as well as long experience in the affairs of the City Guilds and in administration.

When Pooley retired in 1953, after presiding for seven years, the council paid tribute to his service:

The early years of this experiment in public patronage were as full of hazards as of opportunities, and Ernest Pooley had uncommon abilities in recognizing both. The Council's Charter was, very wisely, loosely drawn: and it therefore afforded opportunities of error as well as of experiment. The members of the Council, moreover, were mostly people of emphatic personality, divergent enthusiasms and considerable authority. The government of such an assembly demanded courage, experience and diplomacy, and Ernest Pooley revealed these qualities abundantly. There were frequent occasions, however, especially in the early years, when none of these three virtues could resolve an impasse in some discussion of policy. When the warmth of debate had reached a certain degree Ernest Pooley was always able, by some thermostatic impulse, to reduce the tension by a sally of irresistible humour. He could,

18. R. F. Harrod, *The Life of John Maynard Keynes* (New York: Harcourt, Brace and Co., 1951), p. 401.

19. Ibid., p. 520.

20. Ibid.

indeed, be as bold in his quips as in his judgements, but he never failed to impress even the victim of his jest with an implicit assurance of his good will and benevolence.[21]

During Pooley's term of office, the council completed the first and crucial phase of its development. By 1946 the organizational transition from war to peace was achieved, and the council was able to profit from the experience and experimentation of the war years. But now the needs of drama, music, art, opera, and ballet required precise analysis, and plans had to be evolved to meet the most urgent requirements. Existing mechanisms for patronage had to be reexamined in the light of peacetime conditions, and additional administrative techniques for artistic subsidy devised and tested. The austerity under which the nation lived, right into the 1950s severely limited what the council could accomplish. The council did, however, "overcome, except among the die-hards, the ill-disposed and the outright philistines, the reasonable doubt whether the State could or should assume the responsibilities of patronage."[22]

Kenneth Clark, who headed the council from 1953 to 1960, has been the only chairman who himself was a leading figure in the artistic world. Born in London in 1903, the only child of a wealthy thread manufacturer of Scottish background, he was afforded unusual opportunities for education and travel, leisure, and cultural enrichment. These advantages, coupled with a brilliant intellect and unusual energy, gained him early preeminence as an Italian Renaissance scholar. Later, at Oxford, he began his book on the revival of Gothic architecture. After receiving his degree in 1926, he joined Bernard Berenson, for a two-year sojourn in Florence. There they worked together on the revision of Berenson's *Drawings of the Florentine Painters*.

In 1931, Clark accepted the post of Keeper of the Department of Fine Arts at Oxford's Ashmolean Museum, the first of a series of administrative appointments, most of them public, extending over the next thirty years. In 1934 at the age of 31 he was named director of the National Gallery, the youngest man ever to be appointed to this position. Of particular interest was his tenure as Surveyor of the King's Pictures, 1934–44. In this capacity he was responsible for one of the world's largest private collections, housed at Hampton Court, Buckingham Palace, Windsor Castle, and elsewhere. In 1945 he left the National Gallery to join in the following year the faculty at Oxford as Slade Professor of Fine Art, an appointment he held until 1950.

Clark derives great pleasure from engaging in "cultural advocacy." "With quite exceptional gifts of speaking and writing, wide cultural erudition, a combination of traditional social tastes and advanced aesthetic ones, an easy manner and the entree to all the right people, he is unrivaled as a propagandist for British contemporary art."[23] He has been patron and

21. *The Public and the Arts, The Eighth Annual Report of the Arts Council of Great Britain, 1952–1953*, pp. 15–16.

22. Ibid., p. 16.

23. London *Observer*, 30 March 1958, p. 10.

successful promoter of a number of artists, including Henry Moore and Graham Sutherland.

In 1939 Clark had viewed with apprehension the dislocation of Britain's artistic life. He helped to found CEMA, devoting much time to planning and carrying into effect its programs in art. From the beginning his voice was influential, for he was one of three vice-chairmen and headed the art panel. When the Arts Council took over in 1946, Clark continued as art panel chairman for several years, remaining on the council until May 1960.[24]

As chairman, Clark exercised council leadership during perhaps its most difficult period. Titles of two of the council's annual reports, *Art in the Red* and *The Struggle for Survival*,[25] were indicative of the uphill battle it was forced to wage. The year 1956–57 might be regarded as typical. On the positive side, much was accomplished artistically by the 125 bodies accorded assistance, and box office support increased. Covent Garden performances won wide acclaim; Sadler's Wells gave memorable new productions; and Carl Rosa mounted successful provincial tours in addition to staging a fortnight in London. Encouraging was the quality achieved by the London and provincial orchestras, the Welsh National Opera, the Old Vic, and many of the repertory theaters and arts festivals. The continuing crisis was caused by mounting operating costs, lack of working capital, and inadequate subsidy from both the Arts Council and local authorities. Not only did two symphony orchestras narrowly escape dissolution; two national opera houses were also burdened with heavy overdrafts. Carl Rosa was compelled to shorten its tours and to exist on a hand-to-mouth basis. The Royal Ballet and the Old Vic had to make prolonged dollar-earning tours in America, and provincial theaters found it difficult to engage in adventurous new programs. Funds were lacking to refurnish shabby theaters and other buildings or to undertake badly needed new construction.

During 1956–57 the council focused upon a number of unique programs, some newly created and others undergoing expansion—encouragement of orchestral managements to provide greater opportunities for young conductors, extension of loans to young sculptors to assist them in the production of their initial works, sponsorship of poetry readings at the council's London headquarters and a poetry tour to a number of English cities, and provision of limited guarantees against loss to theater managements presenting new plays.

Lord Cottesloe and the present chairman, Lord Goodman, have avoided newspaper and television publicity, preferring to remain in the background and to discharge quietly the responsibilities of their office. By the time Lord Cottesloe (John Walgrave Halford Fremantle) was selected to head the

24. Information concerning Kenneth Clark, his life, and career was obtained in part from *Current Biography*, 1963, and *Who's Who*, 1964.

25. *Art in the Red, The Twelfth Annual Report of the Arts Council of Great Britain, 1956–1957*, and *The Struggle for Survival, The Fourteenth Annual Report of the Arts Council of Great Britain, 1958–1959*.

council at age sixty, he had achieved success as a businessman and had rendered distinguished public service. Cottesloe's management skills were utilized by government when he was named vice-chairman of the Port of London Authority. In politics, he was elected to the London County Council in 1945, remaining in office for ten years and obtaining deep insights into problems facing local governments. This knowledge proved to be of great value to the Arts Council when it wanted to strengthen cooperative patronage with the local authorities. Among major positions he held in the arts were the chairmanships of the Tate Gallery, of the Advisory Council and Reviewing Committee on Export of Works of Art, and of the South Bank Theatre and Opera House Board.

Lord Cottesloe's initial association with the Arts Council was as a member of the art panel, 1956–59. On 1 May 1960 he was appointed chairman of the Arts Council, serving a full five-year term. During Lord Cottesloe's years as chairman, the council continued to grapple with numerous problems carried over from the preceding period; and while some progress was achieved, sufficient funds were not allocated to permit a spectacular breakthrough in realizing long-range goals. Of the utmost importance was the publication in 1965 of the new Labour government's white paper, *A Policy for the Arts*, which indicated a keen awareness of the need for more generous financial support and contained specific proposals for organizational and program changes.[26] The white paper's recommendations are analyzed in some detail in subsequent chapters.

Arnold Abraham Goodman is the first council chairman to be named by the Secretary of State for Education and Science, rather than by the Chancellor of the Exchequer, as was the practice until 1964. Until his appointment, he had not served on the council. Educated at the universities of London and Cambridge, he became a successful solicitor. During his career he has concentrated in the main upon the legal and organizational problems encountered by cultural bodies engaged in artistic production and presentation. The Arts Council, after consultation with the London County Council, appointed a thirteen-man committee with Goodman as chairman to examine the organization and financing of the four major London symphony orchestras. In April 1965 this body submitted a detailed report containing recommendations. Earlier in the year Goodman had been named Arts Council chairman by the Labour government. He was made a life peer at this time, entering the House of Lords, where he could act as a spokesman for the arts.

In an informal conversation with Lord Goodman, William Emrys Williams, former secretary-general of the Arts Council, asked him if he had received any particular mandate. He replied:

None whatever. I do not see myself in a policy-making role. I shall be a chairman and not a generalissimo. I think the Arts Council is a well-managed body doing a difficult task effectively, and my appointment in no sense implies any revolutionary

26. Cmnd. 2601, *A Policy for the Arts*, 1965.

changes in the offing. It has an excellent executive staff and they can be assured that like any sensible ship's captain, I shall keep out of the engine-room.[27]

Arnold Wesker's suggestion that art and entertainment be made free, box offices abolished, and the National Theater opened without admission charges elicited a forthright reply:

> No, I wouldn't go along with that for a moment. I think the public should pay its whack for the arts. At Covent Garden the public pays just over half the bill and the Arts Council the rest. That's about right.[28]

Lord Goodman became chairman at an exciting point in the council's history. The full impact of Labour's white paper is beginning to be felt, and the increases of £1,790,000 in the allocation of moneys to the council for 1966–67 and £1,500,000 for 1967–68, and larger contributions by local authorities, have made possible the partial realization of many of the council's goals. These included more generous financial provision for opera and ballet, larger grants to theaters in London and the provinces, substantial progress in construction of the arts center on London's South Bank, allocation of additional funds for theater and other building construction in the provinces, and the reorganization and more adequate financing of the London symphony orchestras. On the negative side, bodies aided by the council continued to be faced with rising production costs due in part to inflation but also to the persistent drive to raise artistic standards.

Background of Council Members The Arts Council from its inception has been "watchdog and guide for government expenditure on the arts as well as patron, prop and even rescuer of the enterprises it supports."[29] The creation of a viable policy of artistic subsidy and encouragement and its effective implementation are difficult tasks at best. Until recently the council was severely handicapped by lack of funds. The council's success is due in large part to the talents and judgment of its individual members, their dedication, persistence, and inspiration. What kinds of people have served on the council; what have been their socioeconomic backgrounds and their occupational and cultural interests?

Between 1945–46 and 1966–67, sixty-eight persons served on the Arts Council.[30] Although family data are incomplete, they indicate a preponderance of middle- and upper-class families, almost none from the working class.

Comparing the educational background of members appointed by Labour

27. *The Sunday Telegraph*, 4 April 1965, p. 15.

28. Ibid.

29. Political and Economic Planning, *Public Patronage of the Arts*, vol. 31, no. 492 (November 1965): 315.

30. A more detailed analysis of the backgrounds and interests of the persons who have served on the Arts Council is contained in: John S. Harris, "Decision-Makers in Government Programs of Arts Patronage: The Arts Council of Great Britain," *The Western Political Quarterly*, vol. 22, no. 2 (June 1969): 253–64.

Governments with that of members named by Conservatives, one finds strikingly few differences. Of those appointed by Labour, 8.1 percent attended no secondary school and 18.9 percent studied in schools maintained by local authorities; corresponding percentages for Conservative-designated council members were 9.4 and 15.6. Nor was there a marked difference in the proportion who attended nonlocal-authority schools (other than the schools dealt with in the next category)—24.3 percent and 21.9 percent. The only important divergence at the secondary level is the larger percentage of the Labour appointees who received their education in the twenty best-known prestige "public schools"—37.9, as contrasted with 28.1 for the Conservatives. This pattern does not conform to the generally accepted stereotype. As for higher education, the proportion in the two groups who attended Oxford was almost identical, with 26.3 percent for Labour and 26.5 for Conservative appointees. However, more Conservative-designated members received their university training at Cambridge—20.6 percent as opposed to 10.6 percent. The role played by the University of London and the provincial universities was insignificant, and, surprisingly, contributions by professional schools of art, music, and drama were modest. Incomplete data reveal that academic specialization was largely in the humanities, while a considerable number were trained in professional fields—law, medicine, and engineering.

Of the sixty-eight council members, thirteen have been women. Their backgrounds have been diverse. Well known in political circles as Mrs. Hugh Dalton, wife of the Chancellor of the Exchequer in the Attlee postwar government and a participant in London politics. Dame Jean Roberts, a teacher, was also active in politics. She served over a period of years as leader of the Labour Party Group in Glasgow, city treasurer, and lord provost. Lady Keynes, wife of John Maynard Keynes, served on the council from 1946 to 1948. Born in Saint Petersburg, she was trained at the Imperial Ballet School and danced in the Imperial Russian Ballet. She migrated to London after the revolution, appearing in Diaghileff's Russian Ballet. In subsequent decades, she danced and acted on the London stage, performing with the Vic Wells Ballet and the Old Vic Company. Other women council members have included two distinguished actresses, Constance Cummings and Dame Peggy Ashcroft.

During the twenty-two years of the council's existence, only two members have been appointed who were less than 40 years old. The youngest was the Earl of Snowdon, husband of Princess Margaret, who was appointed at 34. However, a degree of "youth representation" has recently been introduced, junior members being appointed to the council's advisory panels. Three were named to the council at 70 or older—Ralph Vaughan Williams, Lewis Casson, and Ernest Pooley. The greatest concentration was between 55 and 59—sixteen or 23.5 percent, were appointed at ages within this bracket. The average age at appointment for all members thus far has been 56.4 years. The age configuration of appointees to the Arts Council appears satisfactory,

although a good case can be made for having at all times at least one member under 40 years of age.[31]

Only one-fourth of the sixty-eight members who have served on the council have earned their livelihoods in artistic fields underwritten by its subsidy programs. Painters, ballet dancers, and sculptors have played an extremely modest role in determining Arts Council policy. The only sculptor was Henry Moore. Similarly, ballet contributed only one member, Lady Keynes. William Coldstream, Slade Professor of Fine Art at the University of London, council vice-chairman, is a distinguished painter. Two council members earned their living exclusively as musicians and composers. Of major stature in the world of music was Ralph Vaughan Williams. Several members pursued highly successful careers as actors and actresses or producers. Special mention should be made of Lewis Casson, who did so much to develop CEMA's wartime program as its drama director and who served on the council in its early years. Beginning his stage career in 1900, he played some hundreds of parts both in London and overseas, some in association with his wife, actress Sybil Thorndike. A half-dozen dramatists, literary writers, and poets have held membership on the council. Internationally famous is Cecil Day Lewis, poet and critic, publisher, and lecturer at Oxford and Harvard. Most prolific of all council members was Eric Linklater, author of more than forty novels and plays.

Of the thirteen council members who were university professors or administrators, all but two specialized in fields in which the council functions as patron—four in music, three in English literature, two in poetry, and two in fine arts. Three taught at Oxford, one at Cambridge, and two at the University of London. Others were on the faculties of provincial universities. Serving as a council member for thirteen years and chairman of its music panel, Anthony Lewis, Barber Professor of Music at the University of Birmingham, was active as a composer and as author of numerous books and articles on musical subjects. Another well-known author is Angus Wilson, Professor of English Literature at the University of East Anglia since 1966, who for some years worked as an administrator at the British Museum. Representing a non-arts field was Alan Bullock, of the University of Oxford, a leading historian.

Council membership has included four men who specialized in the business side of the arts—managing orchestras, or directing art museums or theaters. Bronson Albery, for example, was the managing director of Wyndham Theatres; director of the Old Vic Trust; administrator of the Sadler's Wells Ballet and the Old Vic; and president of the Society of West End Theatre Managers.

Businessmen with careers in banking, insurance, shipping, publishing,

31. Michael Croft, director of the National Youth Theater, urged that a junior Arts Council be set up under the Department of Education and Science, instead of having young people appointed to the Arts Council to represent youth. This was the only way, he asserted, that "our own ideas and interests are going to be looked after." *Manchester Guardian*, 15 July 1966, p. 22.

engineering, and other enterprises have served on the council. Journalists included Ivor Brown, drama critic, and editor of the *Observer*; Richard Capell, music critic, and proprietor and editor of *Music and Letters*; T. E. Bean, once general manager of the Royal Festival Hall. One doctor has held membership on the council, two lawyers, and two army officers.

A half dozen council members worked for varying lengths of time for the government. Three deserve mention here: Wynn P. Wheldon, Permanent Secretary, Welsh Department, Board of Education, 1933–45; and William Emrys Williams and Hugh Willatt, who after service on the council both served as full-time paid employees of the council in the capacity of secretary-general. Two members were professional educators—John Newsom, county education officer for Hertfordshire from 1940 to 1957, and Joseph Compton, inspector of schools in Manchester and later director of education in Manchester, Barking, and Ealing.

Eight members served in the House of Commons, but only two while they were on the Arts Council.[32] The Chancellor of the Exchequer and the Secretary of State for Education and Science generally have avoided appointing to the council persons currently active in politics, thus helping to insure political neutrality.

A large proportion of those on the Arts Council have participated on a part-time voluntary basis in the affairs of other artistic organizations—as trustees of art galleries, directors of arts societies, officials in festival organizations, members of theatrical and orchestral bodies, and appointees to government committees and commissions.[33]

The Scottish and Welsh Arts Councils

During World War II support of the arts in Scotland and Wales by CEMA was administered mainly from London, with a regional office in Edinburgh and one in Cardiff. When the government's decision to continue arts subsidy in peacetime was announced in June 1945, Scottish and Welsh representatives in Parliament and other spokesmen demanded that under the new program varying degrees of autonomy be granted. Subsequently the government, despite greater ease of communications and travel, and forgetting the chief lesson of the war—that isolation even of a cultural nature is no longer possible or desirable—agreed to set up separate committees for Scotland and Wales. This action, though considered essential

32. Hugh Jenkins, Labour M.P. for Putney, was appointed to the council late in 1967; he is not included in this statistical analysis, which covers the period 1 April 1946 to 1 April 1967.

33. Two council members may serve by way of illustration. The Earl of Harewood, who joined the council in 1966, has occupied the following positions: editor of the magazine *Opera*; a director of the Royal Opera House, Covent Garden; chairman of the British Council's music advisory committee; president of the English Opera Group; president, Rural Schools Association; president, Royal Manchester College of Music; a director, English Stage Company; artistic director, Edinburgh International Festival; and artistic director, Leeds Festival. Sir Jasper Ridley, a banker, served as trustee of the National Gallery, of the Tate Gallery (chairman), and of the British Museum.

3

for the maintenance of cultural diversity and the survival of Scottish and Welsh art forms, was potentially dangerous.[34]

The Arts Council's charter, as placed into effect in 1946, provided that the council shall, with the consent of the Secretary of State for Scotland, appoint a committee for Scotland whose duty it is to "advise and assist the Council in the promotion of the objects of the Council in Scotland." The naming of a committee for Wales to perform the same functions in its area was also sanctioned, subject to the consent of the Minister of Education. The charter further specified that the council could determine the size of both committees, naming to them members of the Arts Council or other persons, but only after consultation with the Secretary of State for Scotland and the Minister of Education. The council was empowered to designate from its own membership the chairman of each committee and given authority to revoke appointments to either committee as well as to determine procedures governing the conduct of business. The new charter, which went into effect in 1967, altered the committee's names, specifying that "the Council shall, with the approval respectively of Our Secretary of State for Scotland and Our Secretary of State for Wales, appoint committees, to be called the Scottish Arts Council and the Welsh Arts Council, to exercise, or advise them on the exercise of, their functions in Scotland and Wales."[35] Other provisions relating to the two committees remained unchanged.

The size of the Scottish and Welsh committees is not specified in the charter, nor are guidelines provided to indicate the extent of delegation of authority. The Scottish committee first had a membership of 6. Its roster increased to 12 in 1947; it remained at that level until 1951, when it rose to 15, a size which was maintained with minor fluctuations through 1963. Today the Scottish council consists of 17 persons. The Welsh committee underwent a comparable expansion, growing from 7 in 1945 to 16 in 1968. The progressive enlargement of the two committees stemmed from the council's desire both to avail itself of the professional experience and judgment of a relatively large number of persons and to broaden the bases of its support in Wales and Scotland.

During the twenty-two-year period, 1945–46 through 1966–67, 66 persons (9 of them women) held membership on the Welsh committee. The Welsh committee has had three chairmen, each of whom served simultaneously on the Arts Council, thus keeping close liaison between the two bodies. Although appointments are made to the committee for three-year periods, 13 members have served for eight or more years, reflecting a considerable amount of continuity. The average length of service for all members during the twenty-two-year period was 4.9 years.

34. The Arts Council itself has not consistently countered the feelings of cultural and artistic separatism held by segments of the populations in Scotland and Wales. In fact, as late as 1965, the council declared that "Wales is a nation with its own traditions and language and . . . it has never lost the belief that it has an individual contribution to make to the Arts." *Policy into Practice, Twentieth Annual Report 1964/65, The Arts Council of Great Britain*, p. 55.

35. *The Charter of Incorporation, February 1967*, section 8.

Members of the Scottish committee during the same period totaled 62, average length of service being 4.8 years. Of these, nine were women. Members of the Scottish committee held appointments on the Arts Council in greater numbers than did those of the Welsh committee, reflecting in part Scotland's larger population. In fifteen of the twenty-two years, three Arts Council members sat on the Scottish committee, and in two additional years, four held dual appointments; at no time have more than two Council members served on the Welsh committee.

Five men have served as chairmen of the Scottish committee. Thirteen members have remained on the committee for eight or more years. But it was discovered that prolonged service did not generate the new ideas, insights, and enthusiasm that are essential to a successful program.

The internal organization and management of the two councils differ somewhat. In Scotland and Wales it is important to remember that professional advice and operational contacts must be obtained primarily from council members, for there are no specialist advisory panels as in England. The panels, which meet in London, do not have general jurisdiction in Wales and Scotland. The result is that the resources available to the two councils are more limited than in the case of the Arts Council itself.

Space permits a look at the Scottish council only. Its members have consistently possessed a diversity of background and professional experience. The 1967 membership roster included only four persons whose careers were not in some way related to the arts, although only a few derived their principal livelihood as creative artists. Two senior officials representing the Secretary of State for Scotland attend meetings and participate in discussions, but they cannot vote.

Meetings of the Scottish council are held every two months in the council's offices in Edinburgh. While the Arts Council is legally responsible to the Secretary of State for Education and Science and, through him, to Parliament also for all of its functions in Wales and Scotland as well as in England, it delegates wide authority to the Scottish and Welsh councils, which possess complete freedom to vote money out of the block grants which have been designated for Scotland and Wales, respectively. However, there are limits to their freedom to make changes, since the financing of most activities is done on a project justification basis. Further, the finance officer and accountant in London are responsible for the overall management of the entire Arts Council, as is the secretary-general.

Scottish council business usually is first considered by one of five committees constituted from the council's membership—music, drama, literature, visual arts, and finance and general purposes. Persons named to the first four are chosen partly because of their interest in the particular art form being dealt with and also to secure balanced geographical representation. The finance and general purposes committee focuses on finance generally; sanctions staff appointments, salaries, and conditions of work; approves Scottish office organization and major administrative procedures;

initiates proposals for financial estimates; and receives financial reports—all in accordance with general policies established by the Arts Council. The committees meet more frequently than the council. Sessions are convened by the director whenever there is sufficient business. The director's office prepares an agenda for each meeting, circulated to the members in advance. The bulk of the council's business is performed by the committees, the parent body devoting most of its time to consideration of their recommendations.

Advisory Panels The Arts Council is advised by panels, one each for drama, music (including opera and ballet), literature, art, and young people's theater, a successful organizational device initiated by CEMA and described in the previous chapter. A panel for poetry was created early in 1950; when the council decided to support literature, organizational arrangements were modified slightly. In 1965 the new functions were assigned to a reconstituted panel dealing with literature and poetry.

The council is authorized by charter to appoint "panels to advise and assist them in the exercise of such of their functions as may be determined by the Council."[36] The council is further empowered to revoke the appointment of panel members at any time.[37] Each departmental director, in consultation with the chairman of the appropriate panel, convenes meetings and acts as panel secretary. Advice is rendered on matters of general policy and also on specific projects.

The role of advisory bodies in government, both in Britain and in the United States, has been an ill-defined one with the result that the success of their work has not infrequently been illusory. Too often, when difficult or controversial decisions are called for, governments have utilized advisory committees to soften public opinion prior to taking unpopular action or to escape the onus of procrastination or neglect. Distinguished men and women often give their names to particular committees, but the terms of reference are inadequate or the committees' advice too general, with the result that the impact of the committees' work upon the organization's policies and programs is minimal. This has not been the case with the Arts Council. Mary Glasgow, secretary-general of CEMA and subsequently of the Arts Council, reported in 1949 that "fortunately the Arts Council was determined from the first that adequate relations with the professional arts could only be maintained by advisory committees which were in practice strong and active."[38] This philosophy seems to have remained dominant since then, for few panel members have resigned prior to the end of their terms, nor have criticisms been voiced that experts were being treated as ciphers. The bulk of the members have been actively involved in the arts as

36. Ibid., section 9.
37. Panel members are specifically prohibited from receiving payment for their services to the council, but may be reimbursed for expenses actually incurred in carrying out their duties.
38. Ifor Evans and Mary Glasgow, *The Arts in England* (London: The Falcon Press, 1949), p. 58.

producers, actors, theater and orchestra managers, directors of art museums, poets, artists, and playwrights. Of course, individuals professionally interested in the programs for which their advice is solicited may be tempted to forget their advisory role and project themselves into the executive sphere, but the council is free to accept or reject this advice. Rotation of panel membership to avoid development of an undue individual proprietary interest engendered by long periods of service is desirable.

The Arts Council, during the twenty-two years ending in 1966–67, has gradually increased the size of its panels in an effort to tap more varied artistic opinion and experience. Music panel membership increased from 15 to 24 and the drama panel from 14 to 28, while art panel size more than trebled, from 8 to 26, and poetry (now literature) grew from 7 to 20. Panel members are appointed for three-year terms and at the discretion of the council can be reappointed for additional periods of the same length. Panel chairmen have always been members of the council itself and are designated for periods of one year; beginning in 1966–67 the council also named from its membership a deputy chairman for each panel. This arrangement insures that the panels and the council are in constant communication. Drama panel chairmen, six in number, have served for the shortest length of time, their tenure averaging 3.7 years; chairmen of music averaged 4.4 years; of art, 5.5 years. The two in literature worked 9 years each. Professor Anthony Lewis, music, and Joseph Compton, poetry, held office for 12 years each.[39]

The precise organization and procedures of the panels vary according to the subject matter under consideration. Panel meetings are held four or five times a year. Several panels have constituted from their membership one or more subcommittees with authority to give initial consideration to specific subjects. Thus, the drama panel operates through four subcommittees, of which the most important—the policy subcommittee—acts as the panel's executive arm, doing much of the detailed work. The chairman of the panel heads this subcommittee of five other members. The drama department customarily requests its advice concerning major policy changes or problems. The subcommittee also evaluates applications for funds from theaters and other organizations which do not currently receive assistance.

The New Drama Sub-Committee, advises the department on three programs. Two of these relate to the presentation of plays, one guaranteeing theaters against loss for initial or second productions of new plays, and the other providing guarantees against loss for revival of neglected plays. A theater submits plans to participate in the programs, together with a proposed budget. It encloses copies of the play for reading by subcommittee members.

39. Among distinguished panel members have been, for music: Paul Beard, violinist and professor of violin, Geraint Evans, opera singer, Gerald Moore, pianoforte accompanist, and Ninette de Valois, director of the Royal Ballet; for art: Leigh Ashton and Trenchard Cox, who have both served as directors of the Victoria and Albert Museum, and Henry Moore, the sculptor; for drama: Peggy Ashcroft, actress, and Michael Barry, head of drama on BBC Television (who both served for more than eight years); and for literature: Joseph Compton, educationalist, and Cecil Day Lewis, poet (who also both served for more than eight years).

The third program encourages the writing of new plays through bursaries to selected authors, which free them from other responsibilities for limited periods of time. Each application is examined by the subcommittee, and recommendations are made to the panel and the drama department.

The New Designers' Sub-Committee assists the council in administering a special program for training young designers. Each year a small number of design students from art schools are placed with repertory theaters for on-the-job training, the council subsidizing their weekly compensation. Applicants are required to prepare designs and models, which are examined by the subcommittee before it recommends awards. The Theater Administration Scheme Sub-Committee differs from the others in that its membership is not drawn exclusively from the panel—two members represent the Council of Repertory Theaters and two are panel members. Four or five persons are trained in theater administration each year, members of the subcommittee screening applicants and recommending candidates to the drama department. The director and assistant director of the drama department attend panel and subcommittee meetings.

The music panel operates on a somewhat more informal basis. For the first nineteen years of the council's existence, it had no subcommittees. In 1965 it was decided that the council's operations in the opera and ballet fields had become sufficiently diverse to warrant the setting up of an opera and ballet subcommittee. The Arts Council takes fewer specific and detailed matters of policy and administration to the music panel for its advice than to the drama panel. The music panel acts as a professional sounding board, a body of experts in the fields of music, opera, and ballet. Panel advice is solicited concerning a limited number of applications for assistance, usually involving small sums of money, which are controversial in nature. Requests from the larger organizations, continuing from year to year, are not usually presented to the panel. For a general assessment of the musical standards and professional achievements of an orchestra or of opera and ballet companies, the panel is particularly useful. As a group it does not regularly inspect orchestras and opera or ballet companies, although the director sometimes asks members to investigate a particular problem. Every three years the panel invites key officials of the Royal Opera House, Covent Garden, and representatives from other grant-receiving bodies to discuss their current needs.

In the art field the Arts Council is active as an entrepreneur. It maintains its own collection of pictures and sculpture, organizes art exhibitions in London and elsewhere in Britain, and mounts tours, both of art and art films. In 1964, an exhibition subcommittee was set up to handle long-range plans for art exhibitions. In early 1965 this subcommittee considered the kinds of art exhibits the Arts Council should present in the new exhibition hall to be constructed by the Greater London Council on the South Bank. The subcommittee has advised the Arts Council on ways to avoid duplication of exhibitions or conflict of effort or emphasis with the Tate Gallery. Applica-

tions of artistic bodies for grant assistance are referred to the panel for advice as a matter of routine.

The poetry panel from the beginning was smaller than the other panels. The proportion of the council's funds allocated to poetry amounted only to £5,148 for the year ended 31 March 1965. In that same year, however, the council altered the existing poetry arrangements, changing the name of the panel from poetry to literature and increasing the number of its members from fourteen to twenty-one. Over the years suggestions had been made that the council encourage creative effort in literature and foster the dissemination of good literature. No action had been taken, in part because of the limited budgets accorded it by successive governments. The Labour government's 1965 white paper, *A Policy for the Arts* called attention to the difficulties encountered by creative writers and set forth certain positive steps which could be taken to assist them. The Arts Council's monetary allocations for the subsidy of literature were increased, amounting to £70,000 for 1967–68, but they are not yet sufficient.

By 1966 it was clear that, unless a lifesaving operation were undertaken, some of the children's theater companies in Britain would be forced to close down. Limited emergency assistance was subsequently given to five of these specialized theaters in response to recommendations contained in an interim report submitted to the Arts Council by a specially constituted committee of inquiry. In fiscal 1967–68, policy in this area crystallized further, and a young people's theater panel was set up to advise the council, with £90,000 allocated to finance programs. Four members of the new panel are also on the drama panel. Schemes to aid this segment of the theater are administered by the council's drama department. The new panel, with a membership of twenty, includes people both from education and from the theater and will give part of its attention to drama in the schools in association with the government Department of Education and Science. Adult companies are expected to expand their programs, catering to the interests of young people and receiving special council grants to help defray the added costs.

The increased articulation by youth of its views and demands in Britain prompted the council, in 1966, to appoint two junior members to each of its panels. College students and graduates, between eighteen and twenty-five are selected. They speak for a constituency not heretofore represented on the panels.

A Parliamentary Spokesman for the Arts Following the Labour Party's victory in October 1964, the national leader most prominently identified with government encouragement of the arts in Britain has been Miss Jennie Lee, Minister of State in the Department of Education and Science. Until 1965, when Labour entrusted the Department of Education and Science with general oversight of the Arts Council and the national museums, no particular minister had been given responsibility for the arts. While the Chancellor of the Exchequer and other

Treasury ministers had answered questions which related to the arts and had exercised general oversight, their major responsibilities were fiscal. They were not in a position to press vigorously for larger monetary allocations or to whip up greater public support by means of speeches and personal television appearances. When Miss Lee was appointed by Harold Wilson as Joint Parliamentary Under-Secretary of State in the department, her primary responsibilities related to the arts. The Arts Council under the new arrangement has prospered. It has received significantly larger budgetary allocations, established new programs, and expanded existing ones. To understand the developments that have taken place, one needs to know something about the person who has helped to bring them about.

Born into a coal-mining family in Cowdenbeath, Scotland, Jennie Lee was early in life exposed to the tenets of left-wing socialism through her interest in the Independent Labour Party. She attended the University of Edinburgh and after graduation embarked upon a teaching career. Her political activity at the constituency level quickly won the respect of party leaders. In 1929, at the age of twenty-four, running in a by-election, she was elected to the Commons from North Lanark, a poor working-class constituency. The 1931 general election returned the MacDonald-Baldwin "National Government," but a large number of socialist members, including Miss Lee, suffered defeat.

In 1934 Miss Lee married Aneurin Bevan, Labour M.P. from Ebbw Vale in Wales, a vigorous and colorful figure and strong advocate of left-wing policies, who later became a national leader in the postwar Attlee Government. In 1945 Bevan was appointed Minister of Health, and in 1951 Minister of Labour and National Service. Because of the Korean War, the government early in 1951 decided to augment the nation's defenses. Bevan, Harold Wilson of the Board of Trade, and John Freeman of the Ministry of Supply, strongly objected to rearmament on the grounds that it could not be accomplished without grave damage to the civil economy. Bevan, who had fostered the National Health Service, was particularly incensed and, with Wilson and Freeman, he resigned from the government. Subsequently, the Bevanites with future Prime Minister Harold Wilson as an active participant constituted a significant center of opposition to party leadership.

Jennie Lee, reelected to Parliament in 1945, participated actively in the affairs of the party and in the work of the Parliament. In 1965, she was designated Minister with special responsibility for the arts. In the following year she spearheaded a successful drive for additional Arts Council funds—allocations were increased by £1,790,000—accomplished when economic austerity necessitated stringent restrictions upon spending generally. Explanations for this more generous treatment of the Arts Council vary. Cynics allege that it is simply political window-dressing, an inexpensive way of wooing the voters. Others ascribe her success to support from the lesser Cabinet ministers instead of only from the top leaders. Perhaps the real answer lies in her close association with Prime Minister Wilson, whom she can approach directly.

Why did Harold Wilson pick Jennie Lee as the first Minister for the arts? Before entering Parliament she did not evince great personal concern for the arts by attending theater, visiting art galleries, or in other ways savoring them at first hand. Her autobiography neglects to mention interests of this kind.[40] One possible explanation is the long-standing personal friendship between the Prime Minister and Miss Lee, and the loyalty that Harold Wilson had for Aneurin Bevan.

The designation of an amateur as "Minister for the Arts" is in sharp contrast with the professional orientation of André Malraux, French Minister of Cultural Affairs. Those who might be tempted to demand that the political spokesman for the arts in Britain be a specialist would confront practical difficulties. Would a famous painter, skilled conductor, or modern Shakespeare, possess the requisite political skills to win adequate support for the arts? Also, there is the danger that a specialist might more easily succumb to the temptation to interfere with the Arts Council and museum trustees, substituting his professional judgment for theirs. Jennie Lee does not, apparently, try to interfere.

The organization of the Ministry of Education and Science must remain flexible. Its ministerial head is a Secretary of State who is a senior member of the Cabinet. Assisting him are three Ministers of State and one Under-Secretary of State. The ministry's civil service is headed by a Permanent Under-Secretary of State; each of its three major administrative units operates under a Deputy Secretary and contains several subsidiary branches. The Arts, Intelligence and External Relations Branch is grouped with three others—Schools, Special Services, and Architects and Buildings. Two Assistant Secretaries, each with a small staff, head sections concerned with the arts.

When the transfer of ministerial functions from the Treasury to the Ministry of Education and Science was being discussed in the Commons on 26 April 1965, the question was raised whether the transfer would expand ministerial powers. Government spokesmen reported that no change would occur in the relative responsibilities of the Arts Council and of the ministers in the House. Neither the Minister of State nor departmental associates would seek to further the interests of special projects, for it was clearly laid down that their "job is to improve the priority for the arts, to get more interest in the House and in the country and to get more money for the arts."[41]

The Minister of State's most obvious role is that of spokesman for the arts in the House of Commons. In 1965 Miss Lee interpreted and defended the government's transfer of artistic responsibility to the Ministry of Education and Science and took the lead in presenting the white paper on the arts. Since then she has addressed her colleagues a number of times about the government's evolving plans for making available greater assistance to the

40. Jennie Lee, *This Great Journey* (New York: Farrar and Rinehart, Inc., 1942), pp. 38–39.
41. H. C. Debates, vol. 711, col. 178, 26 April 1965.

3*

arts. Miss Lee answers the bulk of the oral questions raised in the Commons relating to the Arts Council, the national museums, and other grant-aided bodies. Answers to written questions are prepared in the department and sent to her; she may alter them to conform to her interpretation of government policy. They are inserted into the printed Hansard Parliamentary Debates at the end of each bound volume.[42]

The present government and its predecessors have refused to answer questions in Parliament which deal with the artistic policy of the organizations receiving financial subsidy. When requests are made that the government instruct the Arts Council to discontinue grants to a particular theater, on the grounds that the plays it presents are vulgar or excessively critical of revered aspects of British life, no reply is forthcoming. In 1966, Sir Knox Cunningham, M.P., demanded that the department require the Royal Shakespeare Company to stop producing non-Shakespeare plays in London or to forfeit its grant. The Minister of State refused, saying that it would be improper for the government to attempt to direct the work of the Royal Shakespeare Company. This back bench critic objected to the company's making money in Stratford and operating at a loss in London and contended that it was violating its charter.[43]

Most important, the Minister of State for the arts helps determine overall government policy relating to the arts. Arts Council members, formerly designated by the Chancellor of the Exchequer, are now appointed by the Secretary of State for Education and Science, with the Minister of State having a voice in their selection. The minister confers with the chairman of the Arts Council and other council members, discussing existing activities and possible new programs and experiments. The extent to which the minister influences general Arts Council policy is difficult to determine, but available evidence suggests the role played is a significant one. The minister's function as mentor and champion in the budgetary process is easily understood. Ministerial oversight of the council's management and the degree of influence exercised in specific areas have been subject to some criticism, for they appear to be somewhat greater than was the case when the council operated under the Treasury.

Oversight of the national art galleries and museums is to some extent exercised by the parliamentary spokesmen of the Department of Education and Science. The Victoria and Albert is actually administered by the department.

The Minister of State responsible for the arts serves as a clearinghouse of information pertaining to the arts. Petitions from private citizens and

42. To illustrate, in 1966, subjects dealt with included Arts Council grants to schools of acting, admission practices of the British Museum, financial assistance to authors, the London Orchestra grant, the current practices adhered to by the National Theatre relating to block ticket sales, the National Youth Orchestra, opening hours of museums and galleries in London, the Royal College of Music training orchestra, the possibility of establishing a school for artistic administrators, and conditions of employment adhered to by museums and galleries.

43. H.C. Debates, vol. 725, col. 1458, 3 March 1966.

organizations received by the Government are customarily referred to Miss Lee. Numerous requests come to her for funds or for other types of assistance put forward by organizations active in various artistic fields. Conferences and informal contacts aid the ministry in pressing for funds to underwrite expanded or new Arts Council programs, often enabling the department to avoid tactical errors and possible mistakes in government policy.

Perhaps the minister's most important task is to provide leadership in developing a favorable climate of public opinion relating to the arts. This is accomplished in a number of ways. Much has been done to foster international cultural exchanges with other nations.

A Ministry of Fine Arts?

Now that public subsidy and encouragement of the arts have become well established in Britain, should further changes in governmental organization be effected and a separate Ministry of Fine Arts constituted? Some observers of the British scene believe that the designation of a Minister of State as parliamentary spokesman for the arts is a step in this direction and that some future government will create a special Department whose sole responsibility will be to exercise oversight over the Exchequer moneys allocated to the Arts Council, the national museums, and other bodies active in the various artistic fields. A Minister of Fine Arts, if he were a person of distinction with a significant political following, would be able to foster a healthy respect for the arts, defend the government programs from critical attack, and insure that more liberal financial provision were made.

This question has been raised on a number of occasions. Lord Bridges, Permanent Secretary to the Treasury and Head of the Civil Service, 1945–56, in a lecture delivered at Oxford, 3 June 1958, observed: "It is perhaps specially surprising that in these latter days, when so many feel that the arts have been stingily treated, there has been no clamour for the appointment of a Minister with special responsibility for state patronage of the arts."[44] Governments chose instead to develop over the years a system of secondary or delegated responsibility. Bridges said he preferred the existing system— an arrangement under which nearly all art organizations looked to the Chancellor of the Exchequer—because it permitted free and unfettered administration by an independent body. Recognizing that the Treasury was frequently under pressure to exact economy within its own jurisdiction, to the detriment of the arts, he called for the setting up of a body similar to the University Grants Committee in higher education, to "cover purchase grants and other crucial items of expenditure of the national museums and galleries."[45]

Some years later Lord Bridges reported that "those responsible for the

44. Lord Bridges, *The State and the Arts*, The Romanes Lecture (Oxford: The Clarendon Press, 1958), p. 5.
45. Ibid., p. 18.

administration of artistic enterprises in this country are not in the least anxious to see a Minister of the Fine Arts appointed."[46] Their reluctance, he believed, stemmed from a deep-seated fear that such a minister, or Parliament, might intervene to reduce the discretion enjoyed by the boards of trustees of the galleries and museums and by the Arts Council in allocating the funds placed at their disposal. If a member of Parliament asked why the Arts Council was aiding one particular theater or orchestra rather than another or why the paintings of certain artists were being sent on tour to Scotland, the Chancellor would refuse to answer, pointing out that these matters remained strictly within the discretion of the Arts Council. Were a Minister of Fine Arts to be appointed, Bridges believed, it is "most unlikely that such matters would continue to be left to the judgment of the Council."

This viewpoint was reaffirmed by John Boyd-Carpenter, Chief Secretary to the Treasury, in the foreword to a 1964 booklet dealing with support and encouragement given to the arts. While asserting that the state needed to do much more than it had done, he observed that government support has its dangers.

Few things other than utter neglect could be worse, and more contrary to our tradition, than official artistic patterns laid down by the Governmental machine. In this country we have sought, I think successfully, to avoid these dangers by interposing between the Government, as a supplier of funds, and the Arts themselves bodies of instructed and discriminating people, completely independent of the Government.[47]

The success of the government's programs, he hastened to add, has been due to the taste, advice, and work of the many private citizens who have served on these councils, committees, and boards. Renewing the government's pledge to maintain artistic independence and freedom of action, he reported that the government had concluded that it would be unwise to effect any change in the ministerial responsibility for the arts.

Criticism of the government's programs focused primarily upon the inadequacy of the sums made available rather than upon existing organizational arrangements. There did exist, however, an undercurrent of suspicion that the Exchequer allocations to the arts might have been more generous if the receiving bodies could have dealt with a department other than the Treasury. Some observers suggested "that the Chancellor is not the right Minister to hold the direct responsibility for helping the arts, since inevitably his staff must have a bias toward economies."[48]

Britain's economic difficulties are of such magnitude that no government is likely to create a separate department for the fine arts in the immediate future. In the longer run, however, such a ministry will probably be established. Such a move can be justified even though it runs counter to the desire to keep the number of ministries as small as possible, and in spite of the fact

46. Lord Bridges, *The Treasury* (London: George Allen and Unwin, Ltd., 1964), pp. 56–57.
47. H.M. Treasury, *Government and The Arts 1958–1964*, HMSO, 1964, p. iii.
48. *The Listener*, 7 August 1958, p. 188.

that the new department's total budget and personnel complement would be relatively modest. A system of secondary or delegated responsibility through semi-independent bodies is imperative to insure adequate freedom of action and avoidance of interference by ministers or civil servants.

4 / THE ARTS COUNCIL: ADMINISTRATIVE ORGANIZATION

The Arts Council of Great Britain is still an experiment. . . .
Its history and the circumstances which gave it shape have altered
so quickly that any final and permanent pattern is still difficult
to see. I cannot help hoping that such a final pattern will *never*
emerge and that the freshness and enthusiasm which are kindled by
continuous experiment and a sense of pioneering will never wholly
disappear.
—Mary Glasgow, 1951

ary Glasgow, who as the council's first secretary-general had played an important role in establishing and shaping its administrative organization, was aware of the ever-present danger—an inevitable one for any growing concern—of undue crystallization. "With the best intentions," she wrote, "a body of people charged with the administration of public money is only too likely to create rules and regulations and the kind of safeguards which lead all too quickly to rigidity."[1] The crucial problem, as she saw it, was to maintain a system under which proper supervision of those who receive the council's funds can be reconciled with artistic independence on their part. This concern has continued to influence the countless persons concerned with the council's administrative organization and procedures.

Emergence of a Viable Arts Council Organization

Parkinson's Law has not been at work in the Arts Council. When it was constituted in 1946, the council took over the existing organization of CEMA, effecting only minor changes. Thus, in 1949 Miss Glasgow as secretary-general was assisted by three assistant secretaries, while the work of the council was carried out by three departments—music, drama, and art—each under a director. The country was divided into 12 regions, each, except for the London region, headed by a regional director. The activities of the council were largely decentralized. Persons employed by the council in 1949 numbered 167—administration (including messengers, caretaker, chauffeur, and cleaners), 43; visual art, 30; drama, 6; music, 11; regional offices, 73; and the 1951 Festival of Britain, 4.[2] By 1967 council employees had dropped to 110, despite the great expansion of its programs of support and encouragement. When in 1968 the council took over responsibility for administering the Hayward Gallery on the Thames in London, the art department's personnel grew from 24 to 49. Staff employed in other departments also increased. A breakdown of the council staff by department, as of September 1968, is set forth in table 3.

TABLE 3 Staff Employed by the Arts Council of Great Britain, 1968

Department	Number of Staff
Administration	32
Finance	24
Art	59
Music	28
Drama	12
Literature	5
Scottish Office	22
Welsh Office	18
Total	200

1. Mary C. Glasgow, "State Aid for the Arts," in *Britain To-Day* (London: British Council, 1951), p. 7.
2. *Nineteenth Report from the Select Committee on Estimates, Session 1948–49, The Arts Council of Great Britain*, no. 315 (HMSO, 1949), p. 156.

The discontinuation of the regional offices and changes in methods of operation permitted the council to discharge its responsibilities with fewer employees. When the council began to operate in 1946, the regional offices which had been set up by CEMA continued to act directly in many areas—handling the theater-touring companies, of which there were sometimes as many as fourteen; organizing thousands of concerts, large and small; encouraging the development of arts clubs; assisting the functioning of music societies; routing the art exhibitions. The council in subsequent years decided to withdraw from most of its direct activities and leave the provision of music, opera, and drama to self-governing, nonprofit companies. By 1952 it was clear that the financial burden of maintaining regional offices could no longer be justified, and several were closed down. The decline in direct provision continued. In 1955 the five remaining offices in England were discontinued, and other arrangements were made to keep in touch with artistic organizations in the provinces.[3] The council did not view these changes as moves toward greater centralization, as some critics maintained, for all along its policies had been determined by its committees in London, Edinburgh, and Cardiff, with regional staff implementing programs already decided upon. Today the only directly provided activities engaged in by the council are the organization and routing of art exhibitions, the sending on tour of arts films, the maintenance of a poetry library, and the administration of "Opera for All."

The present organization of the Arts Council is depicted in chart 2. The council under the 1967 charter is empowered, with the approval of the Secretary of State for Education and Science, to appoint the secretary-general who serves as its principal executive officer. He in turn is authorized to employ other officers and employees. Arts Council personnel are not civil servants; their employment is governed by the council's own set of regulations. Council positions are equivalent to established civil service ranks, and salary scales are maintained at comparable levels for each grade. Thus, the secretary-general position is equivalent to that of an under-secretary in a government department, and those of deputy secretary, assistant secretary, and director are on the civil service assistant secretary level. Until recently the council was permitted broad discretion by the Treasury concerning rates of pay, but as the size of its Exchequer grant increased, this freedom was curtailed. When the post of secretary-general becomes vacant, the vacancy is publicized, after consultations between Arts Council members and officials in the Department of Education and Science, and names of suitable applicants are solicited. An appointments committee is set up consisting of senior officials from Education and Science, the chairman and vice-chairman of the council, and one or two council members. The retiring secretary-general serves only as an advisor. A short list of candidates is prepared and one name recommended to the Secretary of State for Education and Science,

3. *The First Ten Years, The Eleventh Annual Report of the Arts Council of Great Britain 1955–1956*, pp. 18–19.

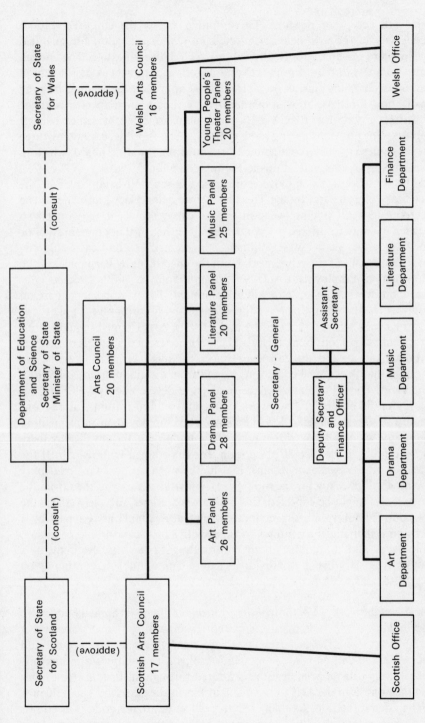

CHART 2 Organization of the Arts Council of Great Britain, 1968

who can accept or reject it. The employment on the council's staff of specialists in the arts fields is effected only with difficulty, for qualified persons are in short supply. Procedures are relatively flexible. The council must compete in the open market and negotiate contracts as best it can on terms as advantageous as possible. It may approach the leading training institutions for suggestions; sometimes it advertises in newspapers or journals. Positions paying less than £1,500 per annum are filled by senior council officers. For positions paying more than £1,500, a short list containing three to six names is sent up to a council personnel interviewing board, which in turn submits recommendations to the full council.

The Arts Council's employee compensation schedule is approved by the Secretary of State and by the Treasury before being placed into effect. The secretary-general is employed on a five-year contract; if the council so desires, he may be offered a second contract either of the same duration or for one or two years. W. E. Williams, the council's second chief adminis-trator, held office for twelve years. Until the enactment by Parliament of the Contracts of Employment Act, 1963, other employees did not receive con-tracts but worked under letters of appointment. Today all personnel are on contract. In the beginning the council possessed no promotions policy, for Lord Keynes believed that CEMA and later the Arts Council should recruit as executives persons of maturity and experience from the worlds of theater, art, and music, and utilize their services for relatively brief periods. He thought that the council could thus benefit from a continuing stream of new and creative ideas and at the same time avoid developing its own bureauc-racy. But this scheme did not work. Successful administration requires con-tinuity at the managerial level. Persons once employed in implementing programs which interested them did not voluntarily withdraw. Today there is no established ladder of promotion, for the council is too small. If the director of a department resigns, it is unlikely that an assistant or deputy director will be ready for the top post. Usually the vacancy is filled from the outside. As might be expected, this practice sometimes adversely affects the morale of employees at lower levels. Council personnel are covered by a pension system under a contract arranged with a private insurance company, employees and the council both contributing to its cost. Retirement is normally at sixty-five, but individuals can remain on the job, continuing on a year-to-year basis, if the council desires.

The Secretary-General Although the council's staff and its annual budget are modest compared to some of the great government departments, the secretary-general's task is a delicate and often difficult one, involving relationships with hundreds of nonprofit-distributing artistic organizations scattered throughout Britain. He carries out the policies of the Arts Council and in varying degrees exerts an influence in their determination. As chief executive officer he attends council meetings, providing members with details about organization and programs. He is

available to advise the council on alternative courses of action which may be taken and difficulties likely to be encountered. His role in the recruitment and supervision of key personnel has been mentioned earlier. Recommendations concerning office facilities, equipment, and supplies; budget documentation in support of the suggested request for the annual Exchequer allocations, staff proposals relating to grants and other forms of assistance to artistic bodies—all are presented to the council by the secretary. He serves as a two-way channel between the council and its professional staff. Ultimate responsibility for implementation of the council's programs rests on his shoulders. His job calls "for powers of organization, for patience and persuasion, for the sacrifice of leisure, for many hours spent in traveling the country, addressing audiences, confronting local authorities."[4] Together with the chairman, he seeks to make the council's policy known to and accepted by the public, a task which since 1965 has been shared by the Minister of State concerned with the arts.

Thus far, four persons have held the position of Secretary-General. Miss Mary C. Glasgow, who served until 1951, had become secretary to CEMA upon its establishment in 1940 and continued as chief executive officer for eleven years. Educated at Oxford, Miss Glasgow embarked upon a career with the Board of Education, becoming an inspector of schools in 1933, a post she relinquished when she became head of the government's wartime arts organization. Miss Glasgow dedicated herself to the work of the council, providing leadership in devising new ways of fostering the arts and bringing them to the people. Shortly after leaving the council she wrote an essay setting forth her views concerning government patronage as it had developed in Britain. She vigorously opposed the formation of a Ministry of Fine Arts, for she feared it would lead to rigidity and require conformity to statutory requirements. She extolled the freedom of the Arts Council to spend what Parliament gives it according to its own judgment. "It means that those who want help from the council must continually justify their claims, that no one is debarred from seeking help at any time, and that the Council having carefully chosen those whom it wishes to help is able to make the money available in any form, by loan, or outright grant, or guarantee against loss, for any period, and under whatever conditions or absence of conditions seem good to it."[5] Miss Glasgow advocated the withdrawal of the council from direct management and provision whenever possible, preferring that help be extended to independent bodies, even if this proved to be less efficient and more costly.

Miss Glasgow also defended the council's refusal to give direct aid to the creative artist—the individual composer, the poet, playwright, painter, or sculptor—a tenet which was to be abandoned in the 1960s. Better, she thought, that help be given indirectly, through orchestras, theater companies, and

4. *Ends and Means, The Eighteenth Annual Report of the Arts Council of Great Britain 1962/63*, p. 1.
5. "State Aid for the Arts," pp. 7–8.

other aided bodies. An official body would find it difficult to be daring in the choice of artists for patronage. Considerations other than merit almost inevitably exert influence—expense, orthodoxy, public appeal, as well as political consequences. She cautioned "that the result of choosing individual artists for financial help by the Council would soon be the appearance of a 'panel of State-approved writers, painters and musicians.' From there it would be but a short step to the State employment of selected artists to illustrate a party political programme."[6] She believed that the patron should be an individual, and the more eccentric the better.

It may be true that State support has succeeded private patronage in the modern world, but there is no real parallel between the two. . . . anyone desiring to commission a work of art must be prepared for the finished article to be wholly unlike what he intended, to take three times as long to finish as he had bargained for, and to cost ten times as much. That is as it should be; but they are impossible precepts for any Government organization to follow.[7]

In 1951, seeking to name a successor to Miss Glasgow, the council advertised the post but failed to find a suitable candidate. It then entered into negotiations with William Emrys Williams, a long-time member and pioneer in the development of government arts subsidy, inducing him to accept the office after resigning from the council. Williams had participated successively in various forms of popular education—staff tutor in the Extramural Department, University of London, 1928–34; secretary of the British Institute of Adult Education, 1934–40; director of the Army Bureau of Current Affairs during the war, and of its civilian counterpart until 1951. For many years he was chief editor of Penguin Books; he served as a trustee of the National Gallery, and beginning in 1963 has held the post of secretary, National Arts-Collection Fund. Williams was one of the handful of persons who founded CEMA and almost continuously held membership on it and its successor council between 1940 and 1951. For a portion of that time he was chairman of the art panel and on the executive committee.

Williams was known among his colleagues as a man with "continuity of purpose, strong convictions, an understanding of people, the gift of speech—and, rare in a Welshman, the gift of silence."[8] He was a successful administrator and provided leadership during a period of great expansion of the council's programs. Important changes which occurred during his tenure as secretary-general included the closing of regional offices, the discontinuance of almost all of the council's direct provision, a vast increase in the number of artistic bodies aided, the development of a limited number of programs to assist individual artists, and, most significant, increases in subsidy which permitted opera and ballet organizations, theater companies, and orchestras greatly to expand activities in response to increased public interest. Wyn Griffith, former vice-chairman of the council in paying tribute to the work

6. Ibid., pp. 12–13.

7. Ibid., p. 13.

8. *Ends and Means*, p. 2.

of Williams, asserted that "his unflinching devotion, his stubborn persistence in pursuit of the best, his sanity and his integrity, are largely responsible for the success the Arts Council has achieved during his stewardship."[9]

When the third secretary-general, Nigel J. Abercrombie, assumed office in 1963, he possessed a more diverse background than his two predecessors, having achieved success in three fields—university teaching, writing and scholarship, and the civil service. After graduating from Oxford with a degree in French language and literature, he remained at the university and lectured in French until 1936, leaving to become professor of French and head of the Modern Language Department, University College, Exeter. In 1940 he became an administrator in the Secretary's Department of the Admiralty, rising to the position of under-secretary in 1956, and moving to the Cabinet Office in 1962. During his years at the Admiralty he found time to edit the *Dublin Review*, write a biography, and produce articles and reviews for literary periodicals. Earlier he had written several scholarly books. His views concerning the professional arts were highlighted in a feature article which appeared in *The Times* when his appointment was announced. He also was interested in the amateur arts, believing that quality of performance, while important, should take second place to the personal enjoyment of the participants. Encouragement of greater cultural development among youth should, he thought, be an objective of the Arts Council. He commented that audiences were not exacting enough, either in London or in the provinces, and that they could do much to bring about improvement in professional artistic standards.[10]

When he entered office, some observers voiced the fear that his years in the civil service might inhibit him when he engaged in the annual jousting with Treasury officials to secure larger grants for the arts. In fact, experience at the higher levels in the civil service undoubtedly helped him to maintain harmonious relations with senior Treasury officials and, more recently, with top administrators in Education and Science.

It is interesting to note that no secretary-general has previously pursued a career primarily as a creative artist. All holders of the office have been administrators, either in government or in voluntary organizations. Without question, management experience, negotiating skill, and administrative talents are the qualities most needed in a council chief executive officer. During Abercrombie's five years as secretary-general, the Arts Council benefited greatly from increased government concern for the arts, backed by major expansion in its Treasury grants. The personal interest of Mr. Wilson, Miss Lee, and other Labour leaders helps to explain the increased appropriations, but such generosity in times of economic stringency would not have occurred if Parliament had had misgivings about the effectiveness of the council's management. New or expanded activities implemented since 1963 include housing for the arts, a broader program for literature, schemes

9. Ibid.
10. *The Times*, 15 October 1962, p. 5b.

for young people's theater, and additional programs for assisting individual artists.[11]

In 1968 the Arts Council named Hugh Willatt as its chief executive officer. The new secretary-general, a lawyer, had served as chairman of the Board of Directors of the Mercury Theater Trust, which is responsible for the operation of the Ballet Rambert Company; he had also been a member of the board of one of the more active provincial theaters. Willatt, long associated with the Arts Council, played an important role in the development of its diverse subsidy programs; appointed member of the drama panel in 1955, he was its chairman from 1957 to 1968; his service on the council itself dated from 1958.

Senior Officers and Departments The council's administrative organization is relatively simple. It consists of a deputy secretary and finance officer, an assistant secretary, directors of four program departments, a chief regional adviser, the accountant in charge of the finance department, all located in London, plus the director of the Scottish office in Edinburgh, and the director of the Welsh office in Cardiff. When the secretary-general is absent, the deputy—M. J. McRobert from 1950 to date—acts as chief executive officer, presiding at meetings and generally controlling the council's administrative machinery. Matters customarily dealt with by the deputy secretary include staff appointments, compensation rates, retirements and resignations, as well as office accommodation, furniture and supplies, and maintenance of the headquarters building. Legal documents are referred to him, including leases, contracts, agreements, and the constitutions of arts organizations applying for financial assistance. Parliamentary questions and inquiries from the public which cannot be readily answered by a specialist department are referred to him. The deputy secretary also handles arrangements relating to meetings of the council and supervises the preparation of the minutes. In his capacity as finance officer, he serves as a link between the top administration and the finance department. Under present accounting arrangements he also approves all invoices for payment and applications for subsidy assistance submitted by the staff to the council for final sanction.

Eric W. White, the assistant secretary, has worked in this capacity since the council was established in 1945, holding a similar appointment with CEMA beginning in 1942. He has published several collections of poetry and scholarly works.[12] In 1965 he was also named director of literature, when the council decided to expand its limited poetry programs to embrace the broader field of literature. White is also responsible for council programs relating to arts festivals, arts associations, arts centers, and arts clubs. He

11. Abercrombie, following his retirement from the post of secretary-general, was appointed to a new senior council post, chief regional adviser.

12. These include *The Rise of English Opera*, 1951; *Benjamin Britten*, 1948; and *Stravinsky: The Composer and His Works*, 1965.

acts as council assessor for subsidy recipient organizations in these subject fields. In addition, he is secretary to the literature panel, secretary to the council's poetry manuscripts committee, which is in charge of the National Manuscript Collection of Contemporary Poets, and acts in the same capacity for the Poetry Book Society, Ltd., an independent nonprofit-distributing company.

Three departments—art, music, and drama—have operated since the Arts Council was legally constituted in 1946, their counterparts having functioned successfully under CEMA during the war. Appointees to a departmental directorship are generally persons with considerable experience in the practice of one or more of the arts and possessing specialized professional insights. A few have worked previously as administrators but this type of experience is not deemed essential. The director of each of the three departments is responsible for the administration of Arts Council programs in his specific subject matter area and for the supervision of the personnel in his department. He is assisted by a deputy director and usually one or more assistant directors. Each director is legally the council's assessor on the governing bodies of all organizations receiving council financial assistance, but in practice he delegates much of this work to his staff. The internal organization of the art department is the most complex of the three because it engages in substantial direct provision. An assistant director is charged with implementing the work relating to regional art. Associated with him are three regional art officers, who maintain liaison with galleries outside London. They are primarily concerned with the circulation of council touring exhibitions and with organizations which receive grants from the council. Also functioning under the director and deputy director are four art assistants, whose job is to organize the council exhibitions for London and the provinces. A films officer is responsible for the program of art films. The administrator of the Hayward Gallery is in charge of the operations of the new gallery in the South Bank art complex, opened in 1968; he and his staff perform the day-to-day administration of the building only, all artistic and general policy questions coming within the province of the director of the department. Housed in the gallery building are the heads and other members of the installation staff and the United Kingdom transport staff. At council headquarters are the offices of the foreign transport officer, the librarian/exhibition receptionist, and a keeper of records who maintains an up-to-date roster of information pertaining to each of the works in the council's own collection and administers the reproductions loan scheme.

In 1968 the new senior post of chief regional adviser was created by the council. He advises the council on the activities and requirements of regional, district, and local arts associations; and advises arts associations, local authorities (including local education authorities), and other interested parties on the promotion and support of artistic activities in the region.

The Finance Department's functions are of two kinds. First, the department keeps all the accounts relating to the receipt of funds, principally the

Exchequer grant, and the expenditure of moneys day to day throughout the fiscal year, which begins 1 April. It prepares a series of year-end financial documents to be published in the Annual Report—balance sheet, statements of general expenditure and general operating costs, breakdown of grants and guarantees, income and expenditure accounts for art exhibitions, art films, the Wigmore Hall, the Hayward Gallery, and accounts of special funds. It also draws up the council's annual budget request, which is submitted to the Department of Education and Science and then to the Treasury. When approved by Parliament, this request becomes its estimates authorization. And second, it is heavily involved in the administration of various types of subsidy given by the council to over 1,000 different artistic organizations. The accountant, head of the department, holds membership on each of four finance committees—art, music, drama, and literature—made up of the department head and one or more panel members. These committees are directly answerable to the Arts Council and do not report to the individual panels. The present accountant, Anthony Field, a Chartered Accountant, employed by the Arts Council since 1956, had participated in commercial theater and cinema finance and administration, prior to joining the council's staff.

Scottish and Welsh Offices The Scottish Office as a distinct organizational entity was constituted in 1948. George Firth was named to the newly created post of director for Scotland, and Mrs. M. A. Fox, who previously had served as the Council's regional officer for Scotland, was appointed deputy director. Firth was also entrusted with special responsibility for music. Firth possessed intense shrewdness, personal charm, and unswerving dedication to a cause. The *Manchester Guardian* likened him to a field marshal presiding over an extensive and continuing military campaign:

"Opera for All" to St. Cuthbert's Church Hall, Kirkcudbright; the Glasgow Trio to the Old Gala House, Galashiels; "Two Strolling Players" to Papdale Infant School, Kirkwall; Eli Prins, with his lecture on "The Self-portrait," to Brechin, Wigtown and Ardrossan—their movements all meticulously charted on one of his "wondrous maps," shoulder-high boards studded with busy colored flags. And where the flag shows, in glen after glen, the message is the same: culture was here.[13]

His tactical strategy was grounded in two basic concepts—raising quality and increasing accessibility.

George Firth's successor and present director is Ronald Mavor, playwright and drama critic, and formerly a member of the Scottish Committee. The Scottish Office with a staff complement of sixteen is organized into five departments. Drama and Housing the Arts is headed by the deputy director. Drama expenditures on program totaled £237,123 in 1967–68, the bulk of the funds going to assist a half dozen theater companies; outlays for Housing the Arts amounted to £77,700. Literature, involving an expenditure of only

13. 2 January 1964, p. 6.

£12,367, is administered by drama personnel, but ultimately will become a separate department. Much needs to be done in the field of literature in Scotland, the council believes. Many important Scottish literary works are unobtainable, and publishing books of Scottish interest, other than tourist items, is difficult to arrange. There is a shortage of good critical writing, both literary and journalistic, and there is no critical literary magazine.[14] Music is headed by an assistant director as are the two other program departments. The bulk of the money allocated for music is used to support two bodies—Scottish Opera, Ltd., which received £78,010, and the Scottish National Orchestra, £105,000. A department of directly provided activities organizes and coordinates a varied array of tours featuring professional groups: opera, ballet, chamber music, theater, puppets, orchestral music, and vocal ensembles. The visual arts exhibitions and administration department organizes exhibitions, many of which go on tour. An effort is made to bring the arts to many of the small towns distant from the Edinburgh-Glasgow nexus, communities whose inhabitants are enthusiastic in their response. The fifth department maintains the office's accounts and performs other fiscal operations.

The regional office operated in Cardiff, Wales, by CEMA during the War was reconstituted in 1945 as the Welsh Office. Its director administered the council's activities under the general aegis of a separate Welsh committee. With its smaller program and more dispersed population, Wales was not at first accorded the same degree of administrative independence from the council's London Office as was Scotland. Its work was planned and supervised by the committee, but until 1953 that body could only make recommendations to the Arts Council and did not directly control expenditures. Today, the Welsh Office employs fourteen persons. The director and three assistant directors control subsidy administration and direct operations primarily in the fields of music, drama, and art.

Methods of Subsidy Since receiving its first charter in 1946, the Arts Council has developed a diversity of methods for providing needed encouragement and assistance to artistic organizations. Thus, the Drama Department in 1967–68 in England subsidized the theater to the extent of £1,705,609, partially underwriting various phases of theater operations in such a way as to produce maximum benefit. To supplement general revenues, £1,436,042 were allocated in the form of grants or guarantees; included in this sum were special grants to fourteen theaters to assist them in paying off accumulated debts. Touring grants or guarantees in the amount of £102,769 extended to eight theaters. Capital expenditure grants were small: total payments were £19,810. Sums granted to encourage the presentation of new or neglected plays amounted to £18,274 and subsidies to help underwrite training schemes, £20,299.

14. *A New Charter, The Arts Council of Great Britain, Twenty-Second Annual Report and Accounts Year Ended 31 March 1967*, p. 34.

Transport subsidies of £13,435 encouraged more people to attend theaters, thus increasing box office receipts.[15] Awards to individual artists were made by all four departments—commissions for composing new music, playwrights' and composers' bursaries, playwrights' royalties, bursaries for trainee theater administrators, sabbatical awards for artists, and literature prizes.

For some years persistent demands were made that the Arts Council be given a capital fund to implement some of the recommendations contained in the two reports, *Housing the Arts in Great Britain*, published by the council in 1959 and 1961. A Housing of the Arts committee was set up by the council which received about 200 applications in 1965–66 for aid to erect new opera houses, concert halls, theaters, arts centers, and art galleries, as well as to repair and improve existing structures in these categories. In that year £150,000 was paid out in grants and an additional £100,000 committed; in 1967–68, £300,000 more was expended and a balance of £600,000 was carried into 1968–69 as future commitments. In 1967–68, funds for new schemes amounting to £500,000 were made available. By 31 March 1968, £1,250,000 had been spent or committed in this program, broken down as follows: music, 7 grants, £63,750; drama, 26 grants, £755,100; art, 12 grants, £92,600; art centers, 21 grants, £147,050; Scottish Arts Council, 7 grants, £148,500; and Welsh Arts Council, 4 grants, £43,000. The council hopes that all of the repertory companies it now supports can be adequately housed in well-equipped theaters and that the nation's major symphonies will soon be able to play in modern and acoustically effective orchestral halls. Applications for building grants from organizations outside London generally receive the highest priority. Special interest has been shown in assisting the construction of provincial arts centers with integrated facilities for orchestral music, theater, dance, and art, serving a region rather than a single locality.

In 1950 the Comptroller and Auditor General, presenting evidence to the Public Accounts Committee, recommended that the subsidy granted to any grant-aided body should normally be a limited guarantee, since the outright grant method was considered rigid, wasteful, and no encouragement to economy. The council has continuously sought to retain freedom in selecting the method of subsidy and to preserve flexibility in choosing ways in which payment can be made. Its procedures had the support of the officers of the Organization and Methods Division of the Treasury in their report dated January 1951 dealing with control of expenditure. Extending an outright grant to an artistic body results in a minimum of control. The principal sanction for poor management is a council refusal to renew the grant. Under certain circumstances, requiring the recipient body to match the grant pound for pound with funds raised from local authorities or public subscription possesses substantial merit. Extending a guarantee rather than awarding a

15. Transport schemes provide that special Arts Council subsidies can be used to defray one-third of the cost of transportation to the theater from designated locations for parties of ten or more people.

grant is preferable, particularly with projects such as festivals and isolated performances where experience is lacking to permit accurate budgets. Were an outright grant made, which proved later to be excessive, the balance could not be recovered by adjusting future subsidies. But according a guarantee to a theater which has an overdraft from previous years and needs aid early in the current fiscal year is not as helpful as a direct grant, for payments under guarantee agreements are not made until the end of the year, when the extent of the loss can be computed. Also, an outright grant to assist an organization in meeting a specific, nonrecurring expense such as the purchase of equipment or special repairs to a building is a more desirable form of aid.

Most of the council's applications for subsidy are more complex than those cited. They come from repertory companies, orchestras, opera and ballet companies, regional associations, arts societies and clubs, all needing annual subsidies. The Treasury in 1955 observed that "a more extensive use of guarantees, or grants-cum-guarantees, would restore much-needed flexibility to the overall pattern of assistance." The type of assistance accorded is best determined by means of a careful assessment of each case, which evaluates specific factors shown by experience to be useful guides. The first factor is the size of the subsidy in relation to the estimated deficit. Thus, if the amount the council can provide is considerably less than what the organization needs, a fixed grant helps to stabilize the receiving body's financial position. Second, if an organization possesses strong reserves, it is advantageous to include a guarantee element in the subsidy. Third, the strength of the aided body's governing board, the trend in its box office takings, and the type of artistic programs undertaken all are important considerations. If the concert income or box office returns vary greatly, the inclusion of a guarantee in the total subsidy is advantageous. Also, if the theater can demonstrate that there is a strong possibility that plays will be transferred to London or film rights will be purchased, reliance on guarantees reduces the uncertainty. A fourth factor is the relationship of the Arts Council's assistance to local authority subsidies. Until local governments make available subventions that more nearly equal those accorded by the council, a strong case can be made for employing a partial guarantee. And finally, the system of assessorship offers the council, by advice and persuasion, a means of maintaining high artistic standards and ensuring that subsidies given are properly accounted for. The specialist directors bear the main responsibility for artistic standards. They, or staff members who act as assessors for them, must work closely with the finance officer and the accountant to make certain that financial considerations are kept in constant review. The designation of an assessor for finance would, ideally, strengthen the council's position, but this is not possible at present and, therefore, the guarantee system provides some safeguards. A theater or orchestra receiving a guarantee relates the subsidy more closely to the actual work being done than if it were given a lump-sum grant. Ordinary annual grants tend to be viewed by the recipient as fixed income, whereas a guarantee constitutes a

constant reminder throughout the year that all expenditures must be justified.

Performing organizations sometimes receive hidden assistance which does not appear in the council's annual financial statements. For example, a theater or orchestra may find itself in difficulties with its accounting system, and its board may ask the council's accountant to investigate its position and submit an advisory report. Or a subsidy recipient may need guidance or assistance of an artistic nature which can be met by council staff.

When an arts organization not previously aided by the council requests financial assistance, its application is sent to the appropriate department, which decides whether the documentation presented warrants further investigation and possible subsidy. A theater, for example, may be asked to make available copies of the company's accounts for the past three years and an estimated budget for the coming year. The Finance Department staff then examine the material, perhaps confer with the theater management, and decide upon a specified amount of aid to be made available in ways they think will promote high professional standards and good management.

Each of the more than 1,000 separate artistic organizations receiving financial assistance must conform to certain conditions specified by the council and enforced by its staff. Each must submit appropriate documentation indicating that it is a properly constituted nonprofit-distributing company or charitable trust. Meetings of its management board must be held not less than once in every three months, and a representative from the council is entitled to attend. He receives notices of all such meetings, together with minutes, reports, accounts, balance sheets, and the fullest possible information relating to the proposed activities of the organization.[16] Recipients must submit such returns of receipts and expenditures or estimates thereof as may be requested by the council, and supply full information pertaining to the terms of bookings negotiated with visiting companies.[17] In the field of labor relations, the terms and conditions of employment shall

16. While Arts Council staff are entitled to be present at meetings of the governing boards of all organizations which receive subsidies, in practice they attend regularly as assessors only the meetings of the larger bodies. Assessors work with smaller organizations when time permits or there is a special need.

17. To illustrate, theater companies must submit quarterly financial returns during the fiscal year, annual accounts at the end of the year, and estimates for the coming year, the latter to be filed six months prior to 1 April. All three documents are detailed. On the expense side, totals must be given covering basic production expenses, as follows: company salaries, stage staff salaries, insurance and pensions, fees to outside artists and directors, cost of scenery, hire of scenery, cost of costumes and properties, hire of costumes and properties, authors' royalties, artists' traveling expenses, transportation, and music. Under administration and front of house expenses are listed: salaries, insurance and pension costs, rent, taxes, and water, heating and lighting, telephone, repairs, and decorations, advertising and publicity, stationery, theater licenses, legal and professional charges. Income breakdown must include: box office receipts, net catering receipts, net bar trading receipts, net receipts from programs and advertising, cloakroom receipts, income from rental of costumes and furniture, theater lettings, interest from bank accounts and investments, royalties, broadcasting and television earnings. The net deficit is carried down to an appropriation account, to be offset by subsidies from local authorities, the Arts Council, and from commerce, industry, television, etc.

not be less favorable than those agreed upon between the appropriate trade unions and employers' associations for their members. The organization must agree not to permit a director, manager, or other employee, on his own behalf or on behalf of any other body with which he is connected, to acquire subsidiary rights in any work produced by the associated organization without permission in writing from the Arts Council. Performances for charitable purposes and overseas engagements cannot be given without the consent of the council, which, however, agrees not to be unduly restrictive. If the receiving body goes out of business or fails to fulfill the purposes for which the grant was offered, it is required to return to the council an agreed proportion of the subsidy. The organization also includes in all programs a statement acknowledging financial assistance from the Arts Council. The council forbids the use of any acknowledgment, on letter headings, contracts, or in other ways, which might imply that it accepts responsibility for the organization's debts or obligations.

A limited number of the larger theaters, orchestras, and other artistic organizations are permitted to enter into "association" with the Arts Council. This relationship carries with it substantial prestige; it is restricted to those bodies which enjoy a continuing relationship with the council, enabling them to plan over the years with a greater certainty of Exchequer subsidy. The conditions requisite to being in "association" are similar to those required generally for financial assistance, except that a higher degree of fiscal responsibility is expected. And since council officers attend the management meetings of these organizations, the council is better informed about their programs and problems.

Now that the government is making available to the Arts Council substantially larger sums of money, the volume of work performed by the finance department and other departments has greatly increased. Earlier, when the council was providing a theater or orchestra with a subsidy of only a few thousand pounds a year, it could not reasonably expect the recipient to alter its internal organization, change its accounting system, or in other ways improve its efficiency. Recently, the council has begun to insist that such changes be made where necessary. If an organization applies to the council for a total subvention of £60,000 in a given year and the appropriate department responds with a commitment of £40,000, the council now requires it to revise its operating budget to conform to the smaller amount. In the past the tendency has been for bodies to spend at the level originally projected, with the result that they ended the year with deficits. Vigorous efforts are being made to impel orchestras or theaters to live within their budgets. As reported earlier, the council is trying to scale down deficits—accumulated over the years by bodies that it subsidizes—to manageable amounts within a three-year period. Individual accumulated deficiency grants in 1966–67 for London were relatively large—£80,000 to the National Theater Board, £130,000 to the Royal Opera House, and £55,000 to Sadler's Wells Trust. Outside London, grants were smaller, and usually the council

required that moneys be matched pound for pound by local authorities or private industry.

Budget and Accounting Practices The council's budgetary procedures provide that in August/September of each year the four departments engaged in subsidy—Art, Music, Drama, and Literature—prepare detailed requests for funds to underwrite their operations for the fiscal year beginning 1 April. Earlier each has received applications from the artistic bodies within its jurisdiction, with detailed justification for requests made. The director and his staff study the requests and try to strike a balance between amounts asked for and amounts the government is likely to make available. The deputy secretary, the finance officer, and the accountant prepare the administration and finance portions of the budget. The Scottish and Welsh offices send in their own estimates, which are added to the tentative council budget. Adjustments may be effected under the guidance of the secretary-general and his deputy before the document is placed before the council's estimates subcommittee. The subcommittee, composed of eight voting members—the chairman of each panel, the chairman of the Scottish and the Welsh councils, the Arts Council chairman and vice-chairman—together with the accountant, the assistant secretary, the secretary-general, the deputy secretary, the directors of the Scottish and Welsh offices, and the directors of music, art, and drama, as advisors, examine and approve the budget. The budget estimate is then presented to the full council which usually accepts it without change; it is then forwarded to the Department of Education and Science. Later it is presented to the Treasury by the Secretary of State along with the estimates request of the department. Negotiations are entered into at various stages in the process with representatives of Education and Science and the Treasury. The Cabinet, acting for the government, ultimately sanctions the council's annual grant-in-aid, and this is included in a printed document prepared by the Treasury, *Civil Estimates, Class VIII, Museums, Galleries and The Arts*, which along with the other estimates is placed before Parliament for its approval. For some years the Arts Council was not permitted to determine the grants made to the Royal Opera House or, in its first year, to the National Theater, even though they were included in its Exchequer allocation and administered by its staff. Instead, they were fixed by the government independent of the council's budget. This practice arose because the Treasury desired to negotiate directly with Covent Garden, which received a large proportion of the council's funds. Thus, in 1962–63, £690,000 was given to Royal Opera, 31 percent of all moneys placed at the council's disposal for that year. A similar procedure was adhered to when the National Theater began operations in 1963. This practice was discontinued, an unpublicized recognition by the government that the Arts Council should be accorded jurisdiction free of such restrictions.

The success of any system of arts subsidy depends in part upon the extent

to which the administering body is accorded authority to plan its operations for several years in advance. Exchequer allocations on a year-to-year basis for almost two decades, initially forced on the council by the severe postwar financial stringencies, proved to be frustratingly restrictive. The council could not plan its own operations effectively, nor could it give assurances to aided bodies that they would receive specific amounts in subsequent years. It was compelled to adopt an excessively pragmatic approach, spending much of its time assisting orchestras, repertory companies, and other artistic bodies to survive from crisis to crisis, acting sometimes as cultural midwife, sometimes as nursemaid, maintaining deathbed vigils when the hope of survival was slender, and upon occasion assisting with postmortem disposals. The inadequacy of funds placed at its disposal by successive governments added to its difficulties. The Treasury, recognizing that something needed to be done, negotiated the council's allocation for 1963–64 and at the same time fixed the amount of its grant for 1964–65 and 1965–66. While admitting that this innovation imposed certain limits on the exercise of creative imagination, the council enthusiastically observed: "It means that we can help our clients to plan for the future with more confidence; it enables us to work out 'pump-priming' operations in support of viable enterprises that require outside assistance at first, but offer good prospects of eventual self-sufficiency; and it frees us from the old crippling uncertainty that vitiated to some extent all our work on new developments in their most important formative stages."[18]

Unfortunately, the advantages of the new triannual system were much eroded by general inflation and by a continuing increase in requests for funds from organizations whose programs were of high quality and merited aid. In the second year the council managed to scrape by, but at the beginning of the third year it informed the Treasury that it would be unable to operate unless the amount budgeted was increased. Additional funds were then made available. Beginning in 1966–67, the council has operated on an annual basis. Its experience with the rigid triannual arrangement was a bitter disappointment; for it was committed to estimates arrived at in the year prior to the beginning of the three-year period, though the purchasing power of the pound declined. And it had to be admitted that winning over the Department of Education and Science and the Treasury to the view that larger sums were needed in the second and third years was harder to accomplish than securing agreement annually to increased allocations. The Arts Council in 1967 favored a flexible and continuing type of triannual system under which it can at all times plan its operations for a three-year period. At the end of the first year of the original three-year span, an additional year is added, and this process is repeated annually, indefinitely. In negotiating with the Treasury, the amount set for the second and third years is tentative and can be increased.

Within a given year, funds are released to the council on a quarterly basis,

18. *Ends and Means*, p. 7.

TABLE 4 Arts Council Expenditures by Object for Selected Years 1944–45 through 1967–68

	1944–45	1949–50	1954–55	1959–60	1964–65	1965–66	1966–67	1967–68
Music (including opera and ballet)	£99,535 (63.1%)	£368,784 (56.7%)	£536,703 (67.8%)	£912,219 (74.8%)	£2,127,773 (66.8%)	£2,379,870 (60.7%)	£3,167,426 (56.5%)	£3,687,417 (51.6%)
Drama	29,556 (18.7%)	131,460 (20.2%)	87,618 (11.1%)	112,870 (9.2%)	637,504 (20.0%)	904,525 (23.1%)	1,573,836 (28.1%)	2,037,961 (28.5%)
Art	17,080 (10.8%)	44,150 (6.8%)	33,861 (4.3%)	41,485 (3.4%)	109,650 (3.4%)	148,957 (3.8%)	178,978 (3.2%)	333,620 (4.7%)
Festivals	…	7,686 (1.2%)	10,985 (1.4%)	16,695 (1.4%)	76,688 (2.4%)	56,720 (1.4%)	82,776 (1.5%)	88,619 (1.2%)
Literature (including poetry)	…	…	1,129 (0.1%)	3,318 (0.3%)	5,273 (0.2%)	12,048 (0.3%)	55,866 (1.0%)	81,216 (1.1%)
Art associations	…	…	…	…	40,270 (1.3%)	56,150 (1.4%)	97,174 (1.7%)	156,240 (2.2%)
Arts centers and arts clubs	…	4,493 (0.7%)	3,865 (0.5%)	7,733 (0.6%)	4,737 (0.1%)	3,335 (0.1%)	5,386 (0.1%)	5,225 (0.1%)
Housing the arts	…	…	…	…	…	150,000 (3.8%)	200,000 (3.6%)	300,000 (4.2%)
General operations	11,630 (7.4%)	71,248 (10.9%)	114,955 (14.5%)	124,913 (10.3%)	184,831 (5.8%)	210,025 (5.4%)	243,712 (4.3%)	318,937 (4.4%)
Other	…	23,265 (3.5%)	2,021 (0.3%)	…	…	790	…	41,078 (2.0%)
Total	£157,801 (100.0%)	£651,086 (100.0%)	£791,137 (100.0%)	£1,219,233 (100.0%)	£3,186,726 (100.0%)	£3,922,420 (100.0%)	£5,605,154 (100.0%)	£7,150,313 (100.0%)

Data include general expenditures on the arts and general operating expenditures.

with adjustments in the installment amounts to reflect program needs. The council operates on a cash-and-commitment basis, which means that money not actually spent during the fiscal year can be retained as reserves for use in succeeding years. Funds for the housing of the arts scheme are handled in a different way: the entire amount must be spent or committed prior to the 31 March deadline.

Total Arts Council expenditures have risen from £157,801 in 1944–45 to £7,750,000—almost fifty times as much—in 1968–69. The Exchequer grant-in-aid to the council in 1967–68 was £7,200,000. Table 4 sets forth Arts Council expenditures for selected years 1944–45 through 1967–68, together with percentages for designated categories. Sums expended in each of the categories have without exception steadily increased. However, the division of the council's pie, percentagewise, exhibits some interesting variations. Music, including opera and ballet, from the beginning, has accounted for more than half of the council's total expenditures due to the large subventions accorded Covent Garden and Sadler's Wells and to Britain's major orchestras. In 1944–45 music received 63.1 percent of the council's total budget, its allocation rising to 74.8 percent in 1959–60 and falling to 51.6 percent in 1967–68. Drama, after some initial fluctuations, has in recent years increased its proportion, being supported to the extent of 28.5 percent in 1967–68. The relative position of art has steadily declined, from 10.8 percent in 1944–45 to 4.7 percent in 1967–68. Expenditures on the nation's festivals have proportionately remained fairly constant, being 1.2 percent in 1967–68. Literature (at first only poetry) was not assisted until the early 1950s and today consumes only 1.1 percent of the council's budget. Art associations, a development of the 1960s, accounted for 2.2 percent, and arts centers and arts clubs, 0.1 percent, in 1967–68. The housing of the arts program, first undertaken in 1965, benefited to the extent of 4.2 percent of total outlays in 1967–68. The select committee on estimates in 1949, after carefully scrutinizing the operations of the council, concluded that the proportion of overheads to income was excessively high and recommended that a reduction be effected so that more money could flow into program subsidies.[19] The cost of general operations in 1949–50 was 10.9 percent of the total expenditures; these costs increased proportionately to 14.5 percent in 1954–55 and then gradually declined to 4.4 percent in 1967–68.

The Arts Council has occasionally been accused of spending an undue proportion of its funds in England, to the detriment of Scotland and Wales. In table 5, data are presented for selected years, 1949–50 through 1967–68, showing sums expended by the council in each of the three divisions of Britain, together with percentages. The 1961 census revealed that Britain, excluding Northern Ireland, had a population of 51,250,094 with 43,430,972 or 84.7 percent residing in England, 2,640,632 or 5.2 percent in Wales, and 5,178,490 or 10.1 percent in Scotland.[20] Using population as a criterion, in

19. *Nineteenth Report from the Select Committee on Estimates*, p. xiii.
20. Central Office of Information, *Britain, An Official Handbook* (HMSO, 1963), p. 16.

4

the 1960s (until 1967–68) expenditures in England have exceeded its population ratio by 3 to 4 percent; council expenditures in Wales have approximated its population percentage, and those in Scotland have lagged. Other yardsticks can be used in allocating subsidy moneys—local interest in the arts; willingness of local authorities to take the initiative in providing aid and the extent of their contributions; the existence of orchestras, theater companies, opera, ballet, and other artistic organizations adhering to high professional standards; the extent to which population is concentrated in urban areas or widely scattered in towns and villages, often hidden away in remote valleys or isolated by inadequate transport facilities.

TABLE 5 Arts Council Expenditures in England, Scotland, and Wales for Selected years 1949–50 through 1967–68

	1949–50	1954–55	1959–60	1964–65	1965–66	1966–67	1967–68
England	£601,994	£688,572	£1,085,589	£2,831,466	£3,437,786	£4,896,636	£5,998,984
	(92.5%)	(87.0%)	(89.0%)	(88.9%)	(87.6%)	(87.4%)	(83.9%)
Scotland	49,092	71,801	83,962	197,641	270,099	425,724	690,187
	(7.5%)	(9.1%)	(6.9%)	(6.2%)	(6.9%)	(7.6%)	(9.7%)
Wales	...	30,764	49,682	157,619	214,535	282,794	461,142
	...	(3.9%)	(4.1%)	(4.9%)	(5.5%)	(5.0%)	(6.4%)
Total	£651,086	£791,137	£1,219,233	£3,186,726	£3,922,420	£5,605,154	£7,150,313
	(100.0%)	(100.0%)	(100.0%)	(100.0%)	(100.0%)	(100.0%)	(100.0%)

Totals shown in table represent general expenditures on the arts and general operating costs taken from the Arts Council's annual reports.

The Arts Council has presented to Parliament and to the public a detailed account of its activities from year to year, an analysis of the problems and difficulties it has encountered, and full financial accounts depicting its fiscal affairs. Its record of public reporting is a good one and has undoubtedly won for it friends and supporters who have helped it to establish arts subsidy as a recognized and valued function of government today. In its first year, council accounts were audited by a private accounting firm. Beginning in 1946–47 the national Exchequer and Audit Department was asked to examine its financial affairs, and from that time until the present the Comptroller and Auditor General has certified each year that he has found the accounts in proper order. During the year council officials sometimes consult the Exchequer and Audit Department, and advice is given informally.

Outlook for the Future The Arts Council's administrative organization has functioned essentially in its present form since 1955, when the remaining field offices were closed down. Now that literature has been made a separate department, it appears unlikely that new units will be added to the council's administrative structure. The present organization is simple but adequate, with clearly delineated lines of responsibility. Most important, it operates effectively. Decentralization in Scotland and Wales is perhaps necessary under existing circumstances, but further fragmentation accompanied by delegation of responsibility would be unfortunate. The creation of a young people's theater panel in

1967, referred to earlier, unnecessarily complicates the council's advisory machinery; to go further and set up panels for young people's art, music, and literature would border on the ridiculous. While a case can be made for a second panel in theater, youth drama could be represented by appointing to the regular theater panel persons with these interests and orientation. Increased pressure is being exerted upon the government from various quarters to provide financial resources to assist amateur organizations in art, music, opera, ballet, theater, and other fields. At present a limited amount of aid is given amateur groups by local authorities, and activities are sponsored by local education departments. If the Arts Council were required to mount such a program, its focus on the professional arts and the encouragement of high levels of performance would probably be adversely affected. If a new national body were constituted to support amateur arts, sums needed would be quite large, and the Arts Council, at least in the foreseeable future, would face stiff competition in securing funds from the Exchequer.

Treasury allocations to the council in 1966–67 were £1,790,000 higher than in the previous year, and in 1967–68 the annual increase amounted to £1,500,000. However, in 1968–69 the level of support was raised by only £550,000. Substantially larger amounts of money are needed by the council within the next five years, not only to keep pace with inflation but also to further implement the goals of the white paper. Existing major theaters, orchestras, opera and ballet companies will undoubtedly receive the bulk of any new funds made available, for it is difficult to create in a short time an appreciable number of new organizations which possess high professional standards. Increased subsidization of the arts in the provinces has been repeatedly emphasized by the Labour government, but while total moneys spent outside London are much greater than they were, the proportion has been slow to change. An examination of available financial accounts reveals that in 1966–67 slightly more than 50 percent of all moneys went to support activities away from London.

The different methods used by the Arts Council in subsidizing such a varied array of artistic organizations have provided desired flexibility and, for the most part, have encouraged efficient management and forward-looking policies. As conditions change, new ways of extending subsidy will inevitably be devised. In the future greater emphasis will be placed upon providing assistance to living artists and to the housing of the arts. The need for longer-range planning of the Arts Council's support programs continues to be a pressing one, but satisfactory arrangements still have to be worked out with the Treasury.

5 / REGIONAL ARTS ASSOCIATIONS

The Government hope to see a great increase in local and regional
activity, while maintaining the development of the national
institutions. They are convinced that the interests of the whole
country will be best served in this way.

—*A Policy for the Arts*, 1965

During World War II, CEMA quickly perceived the advantages of regional offices, and when the German bombers began their destruction of London and other major cities, the council shifted much of its activity to the provinces. Decentralization was an obvious necessity. When peace returned and the Arts Council took over CEMA's responsibilities, regional offices were retained. Perhaps the Arts Council's initial philosophy was best enunciated over the BBC in the summer of 1945 by Lord Keynes, its chairman:

How satisfactory it would be if different parts of this country would again walk their several ways as they once did and learn to develop something different from their neighbors and characteristic of themselves. Nothing can be more damaging than the excessive prestige of metropolitan standards and fashions. Let every part of Merry England be merry in its own way. Death to Hollywood![1]

Decentralization, however advantageous, did not become Arts Council policy, for shortly after its establishment it began to liquidate the regional offices inherited from CEMA, a process that was completed in 1955. Local authority initiative was limited, due to postwar austerity and lack of stimulus. Although the Local Government Act, 1948, provided legal sanction to local support of the arts, the initial results were modest and disappointing. During the 1950s, the Arts Council's operations in England were highly centralized, and no sustained, energetic efforts were made to sponsor the emergence of true regionalism. There are some 1,500 local authorities in Britain, some quite small and isolated. No general regional authorities existed which could be utilized to promote and coordinate cultural activities throughout larger areas of the country. As a result a new type of organizational entity had to be created, the regional arts association.[2] In 1956 the South Western Arts Association came into being, and in 1958 the Midlands Arts Association was organized, but both, while regional, were essentially federations of local societies and clubs with circumscribed objectives. The first general-purpose regional association supported by local authorities, business, and industry, as well as local societies, was the North Eastern Association for the Arts, created in 1961.

The new Labour leaders who took their places on the front benches in Parliament after the 1964 general election were convinced by party planners and others that an imbalance existed in arts patronage, with the areas outside London relatively neglected while assistance was accorded organizations in the national capital. The government's white paper affirmed that "if a high level of artistic achievement is to be sustained and the best in the arts made more widely available, more generous and discriminating help is urgently needed, locally, regionally, and nationally."[3] If skillfully directed, even

1. Lord Keynes, "The Arts Council: Its Policy and Hopes," *The Listener*, 12 July 1945, p. 32.
2. See subsequent sections.
3. Cmnd. 2601, *A Policy for the Arts: The First Steps*, 1965, p. 5.

although backed by a mere handful of keen local enthusiasts, a small regional staff could elicit the cooperation of local authorities who, by contributing relatively modest sums, can finance concerts, exhibitions, film shows, lectures, and other cultural activities that few authorities by themselves could afford. Associations were urged to secure the goodwill and financial support of employers and trade unions, the cooperation of local universities, and support from every possible regional source. In its proposals for future action, the government declared that it wished to see a major increase in regional activity and promised that in subsequent years the Arts Council budget would permit it to allocate to regional associations more generous annual contributions.[4]

To date, four different organizational arrangements have been used to promote the arts on a regional or area basis. Viewed in terms of breadth of coverage and complexity of administrative mechanisms, these may conveniently be listed in ascending order, as follows:

1. A special-purpose group of organizations banded together to provide support for an individual project of more than local significance, such as a regional symphony orchestra, a repertory theater, or an arts festival. Thus, in 1947 five repertory companies in southwest England formed a loose association, with the Old Vic Company at the Theatre Royal, Bristol, as senior partner. A week's course in production was held, attended by producers, stage directors, and scene designers. Improved production standards at each of the participating theaters were the tangible results. More significant has been the Western Authorities Orchestral Association, comprising local authorities which contribute to the maintenance of the Bournemouth Symphony Orchestra (see Chapter 10 for details). A number of arts festivals, put on by specially constituted bodies and financed by contributions from groups of local authorities, have achieved international renown. Of particular interest is the Eastern Authorities Orchestral Association, which arranges for the presentation of numerous concerts in East Anglia and the Southeast, with subsidies contributed by a number of local authorities.

2. A local or area association constituted to promote the arts in or around a large city or in an area of limited size which forms a geographical entity. Citywide arts councils or associations functioning in several of Britain's larger cities are of this type. Others exist even in quite small towns and districts. Care must be exercised that such an association does not compete with, but complements, a larger regional association.

3. A general-purpose regional association organized to encourage and assist arts clubs and associations which constitute its membership, but not directly supported financially by local authorities. Two organizations of this type are the previously mentioned South Western Arts Association and the Midlands Arts Association.

4. A general-purpose regional association covering a substantial geographical area and supported financially by local member authorities,

4. Ibid., pp. 11–12, 17.

industry, and other bodies concerned with the arts as well as local societies. The outstanding example is the Northern Arts Association (formerly the North Eastern Association for the Arts), with headquarters in Newcastle; a second, involving a much smaller population and land area, is the Lincolnshire Association. Others recently formed include the North West Arts Association, the North Wales Arts Association, and the Greater London Arts Association; and proposals have been made for similar associations in Yorkshire, East Anglia, and Southern England.

The Scottish Arts Council, operating throughout Scotland from its headquarters in Edinburgh, and the Welsh Arts Council centered in Cardiff, cannot be considered an additional form of regional association. They do not possess two of the prime requisites of an association: organizational independence from the Arts Council, and a contributing membership from bodies other than the Arts Council.

The government is actively promoting the formation of regional arts associations of the general-purpose, local-authority-supported type (category 4 above), for it considers them an important means toward realizing the objectives set forth in the white paper.[5] No precise policy is prescribed for such associations, for the government believes that flexibility is essential. A regional association's specific objectives are to increase the accessibility of the arts to the public; to foster a better service of performances and exhibitions; to raise standards of performance; to intensify appreciation of the arts; to coordinate the efforts of organizations and individuals concerned with the arts; and to promote the development of arts centers. An association builds on existing foundations and relies upon stimulation, persuasion, and cooperation. The provision of central services is an important aspect of its work, but it does not ordinarily promote events itself directly, unless no one is available to promote them effectively. Its interests cover a wide range of artistic tastes, embracing the most popular as well as those with only a minority appeal.

The activities in which regional associations belonging to the fourth category can engage are exceedingly diverse, depending upon local circumstances, specific needs, and, especially, the creative imagination of the regional officials and leaders in the artistic organizations within the area. Bringing in theater, opera, and ballet touring companies from outside the region is just as important as aiding theaters, orchestras, and art exhibitions based in the region. For people living in rural areas or in small towns, associations can organize tours of small-scale dramatic and musical groups as well as implement schemes for paying a portion of the cost of transporting parties to the larger cities where major artistic events take place. Regional organizations can assist local amateur societies in promoting professional

5. The author wishes to acknowledge the assistance provided by M. A. Walker of the Department of Education and Science who made available an unpublished document, "Notes of Guidance on the Formation of a Regional Arts Association," July 1967, from which some of the material contained in the introductory section is derived.

events or in mounting their own productions by making available guarantees against loss. Other activities include short story and poetry competitions; the making of awards to novelists, poets, playwrights, painters, and sculptors; and the giving of grants to assist in the building of arts centers, the appointment of theater managers, and the purchase of equipment. A regional organization can issue a monthly arts diary and other publicity material. Not to be overlooked is its use as a clearinghouse for synchronizing program dates to avoid conflicts in individual areas or neighborhoods.

Arts associations can help to make a region more attractive to tourists and to incoming business firms and residents. They can cooperate with local educational authorities in arranging performances and concerts for school children and, in turn, receive assistance from the music, drama, and art advisers employed by some of the school systems. These advisers are familiar with local tastes and preferences and with the most suitable school and college halls for performances.

How large should the area covered by such a regional association be? The Department of Education and Science does not believe that there is an optimum size, though a few rules of thumb exist. For example a region should not be too small. First, the amount of assistance needed to support a balanced and artistically attractive program throughout the region, involving perhaps a repertory theater, a civic theater, a series of symphony concerts, and a major festival, can obviously be made available only by the largest cities. The maintenance of a provincial symphony orchestra requires a subsidy of at least £100,000 a year; a single symphony concert costs over £1,000, and a performance in a small hall, mounted by only a portion of an orchestra, may need a subsidy of £500. An association may have only £2,000 a week to spend for the whole area. Second, an association needs sufficient resources to support four or five executive officers, whose salaries are likely to total between £12,000 and £15,000 a year. A competent, imaginative, and energetic director demands a good salary. Specialist staff are needed for the various arts. But after an association is well established, it is difficult to justify spending more than 12 to 15 percent of its total budget on administration. If a grant averaging 40 percent of the budget can be expected from the Arts Council, then the region should be sufficiently large and affluent to obtain from local government and industry at least £60,000 per annum within three or four years of its establishment. Third, persons capable of serving as administrative officers are in short supply and could not be found if there were too many small regions. And, finally, the possibility of cross-fertilization of ideas is greater if the region contains a number of large towns and lesser communities and at least one university.

Conversely, there are dangers in setting up regions which are too large. The travel distance from home to performances and exhibitions in the major centers should not be too great; nor should the association's committee and panel members find it difficult to attend meetings and return home within the day.

To plan the artistic facilities as a part of the economic and social development of the region as a whole, involving industrial location, tourism, education, and recreation is the soundest policy. Cooperation between regions ensures greater benefits from existing resources. Thus, a region may be large enough to support a symphony orchestra and several repertory theaters, but cannot underwrite properly a ballet or opera company on its own. Two or perhaps three adjoining regions may pool their resources to support a symphony orchestra or repertory theater which plays in more than one region.

The government believes that in some areas the needs of the arts require a careful survey and analysis, not only to reveal existing deficiencies and suggest possible remedies, but to draw public attention to the region's needs and to encourage financial support. To approach only the larger local authorities permits the director and his staff to avoid the quagmire of excessive negotiation, so that they can focus upon developing substantive policies and activities. Local authorities are usually asked to contribute yearly a minimum sum calculated as a proportion of the product of a penny rate. (A penny rate may produce only £100 in a small authority or over £100,000 in a very large one.)

Some authorities, particularly the larger ones, will undoubtedly wish to continue their direct support of projects in their own localities as well as to subscribe to the association. Once they are convinced that shareholders, customers, and employees will benefit by an arts association's activities, industry and commerce (both management and trade unions), it is hoped, will contribute significantly to its financing both directly and through chambers of trade and commerce, working men's clubs, and other organizations. Efforts should be made to interest a variety of local organizations: universities; arts societies; professional bodies and institutions; men's, women's, and youths' organizations; social service councils; and churches. Acting as the government's principal agency in distributing funds for the arts, the Arts Council does not take the initiative but is responsive to local organizational enterprise. The council requires that applications submitted to it contain a statement of policy and a program of activities, together with cost estimates indicating the proportion of the budget which can be raised locally. Orchestras and theaters aided by the council prior to the formation of a region may wish to continue to receive grants directly from the council.

The organizational structure of an association will depend in part upon the size of the membership. Associations are likely to require an executive committee numbering fifteen to twenty-five members. In some cases, a council midway between the association, which would meet perhaps only once a year, and the executive committee might be formed to afford a larger number of contributors some say in the determination of policy. Subcommittees and specialist advisory panels may be necessary. Three important considerations should be kept in mind in creating an association: it should be neutral in relation to the competing claims of individual local authorities;

4*

it must be nonprofit-making, to qualify for Arts Council support; and it must register as a charity and be accepted by the Inland Revenue, to enable it to claim the benefit of taxes paid by donors under seven-year covenants.

The following sections contain a detailed analysis of associations representing the two types of general-purpose organizations, with special attention to their composition, the conditions which led to their formation, the nature of their programs and other activities, and some of their problems. These two types are illustrated by the South Western Arts Association and the Midlands Arts Association; the local-authority-supported type is illustrated by the Northern Arts Association.

The South Western Arts Association The South Western Arts Association goes back to 1954, when it was constituted to administer grants to delegates attending three conferences, convened by the Arts Council and designed to encourage and assist arts centers and clubs in the Southwest. When the Arts Council announced its decision to close its remaining regional offices, these societies, apprehensive that they might lose their highly valued tradition of local administration dating back to 1940, called a conference which met in January 1956. Here they forcefully presented the case for recasting the association so that it could accept a larger responsibility for the region's artistic welfare. Proposals were accepted by the Arts Council, and in April 1956, the association held a general meeting at Dartington, elected a management committee, and took steps to draft a new constitution, which was adopted a year later at the first annual general meeting. The association's objectives as stated in the first annual report are:

(a) to bring together Societies and people in all forms of the Arts;

(b) to establish relations of mutual benefit between Art Centres, Clubs, Societies and kindred organizations, and all persons interested in the Arts;

(c) to arrange meetings, conferences, and special occasions for its members and others, and to promote or assist activities connected with any of the Arts;

(d) to ensure for the South-West a regular service of music, painting, theatre, film, ballet, poetry, lectures, opera, etc. of the highest possible standard and designed for suitable presentation under the conditions prevailing in halls, galleries and theatres in the South-West;

(e) to provide opportunities for new young artists of all kinds; and to establish the South-West as a "nursery for the Arts";

(f) to serve as a channel of communication for the Arts Council of Great Britain; and to administer funds provided by them, together with income derived from its membership subscriptions or other sources for the use of constituent Member Societies and for promoting the objects of the Association.[6]

Provision has been made for three kinds of membership in the association. Full membership (the only category possessing voting rights) is open to any center, club, society, or other organization recognized by the association as constituted for the promotion of the arts, and from which the association is

6. The South Western Arts Association, *1957, First Annual Report*, pp. 1–5.

willing to consider applications for grants or guarantees. Full membership has risen from 26 in 1957 to 31 in 1966. Associate membership is accorded to any organization the association deems in sympathy with its objectives; the number has grown from 13 in 1957 to 44 in 1966. In addition, persons interested in the goals of the association can become individual members, whether or not they belong to a constituent organization. In 1966 their ranks included 329 persons, as contrasted with 104 in 1957. Membership fees due annually are nominal and in 1965–66 amounted to less than 7 percent of the association's total income. Overall direction of the association's affairs is exercised by a management committee, elected for three-year terms and consisting of a chairman, vice-chairman, treasurer, and an executive committee composed of six persons chosen by full members and one person by individual members. The Arts Council's assistant secretary serves as assessor and attends all committee meetings. The association normally meets once a year. Its offices are located in Exeter; the association's secretary and two additional full-time employees perform the day-to-day work. A large area is covered—5,872,944 acres; there are few cities, but a population of 3,583,088 lives in many widely scattered and sparsely populated communities, thus making more difficult the provision of a full range of artistic activities.[7] Financial accounts during the association's first ten years reveal a modest increase in income, but the resources at its command have always been exceedingly small. Arts Council grants for administrative expenses rose from £1,250 in 1956–57 to £3,250 in 1965–66 and were set at £5,000 in 1967–68. Membership subscriptions totaled £502 in 1965–66 as contrasted with £185 ten years earlier. The Gulbenkian Foundation contributed £3,000 for administration during the period 1959–60 through 1961–62 and £5,000 for special projects over a four-year span, beginning in 1960–61.

The association also serves as a channel through which grants and guarantees by the Arts Council are paid to member societies. Allocations distributed in 1967–68 to 21 different bodies totaled £5,885. The management committee carefully considers each application for grant aid before making its recommendations to the Arts Council. Local authorities do not directly allocate funds to the association but assist in some cases by making available center buildings and other facilities and contributing to their maintenance and upkeep. More significant are direct subventions in the form of grants and guarantees to member societies by local governments: thirteen were aided to the extent of £4,500 in 1965–66.

Twelve arts centers, full members of the South Western Association, play an important role in the artistic life of the communities they serve. The Bridgewater and District Arts Centre, the first to be established in England by the Arts Council, was perhaps plagued by being the first, for much was expected of it and not all has been realized. Housed in an impressive Georgian building bought by the Arts Council, with a theater seating more than 200,

7. The association covers Gloucestershire, Somerset, Devon, Dorset, Cornwall, and Wiltshire, plus the county borough of Bournemouth.

its operation has been marked by a series of financial crises. Often "it has seemed that the townspeople have been agog with indifference but, in the belief that this is not so, those responsible for the management of the center have continually provided the very best they could afford—entertainment of the highest standard in elegant and comfortable surroundings."[8] In June 1965 the Bridgwater Borough Council purchased the arts center and operated it directly for nine months, sponsoring an ambitious professional program and continuing to make the premises available to local organizations. At this time the Bridgwater and District Arts Guild was formed and subsequently became the tenant, managing the premises for the Borough and Rural District. In addition to providing grant support, the borough is entirely responsible for the repair and maintenance of the building, thus permitting the guild to concentrate on the artistic policy of the center. A federation of societies concerned with the arts, the guild also has individual members. Local authority interest is encouraging, for it shows that the arts are no longer considered marginal luxuries unimportant to the community.

During World War II, a Services Arts Club was formed in Plymouth. In 1947 the club passed into civilian control and was renamed the Plymouth Arts Centre. Although suffering from functional deficiencies, the building in which the center is housed is an attractive and historically prominent structure. The center has sponsored drama, painting, and music as well as literature. Other interests have been pursued, some temporarily: films, photography, pottery, sculpture, creative writing, poetry, and jazz. The center has become increasingly active in the area's artistic life through sponsoring activities elsewhere in the city, including the Western Theatre Ballet and Opera for All. Its Plymouth Subscription Concerts, now completing their ninth season, began as Plymouth's first series of regular chamber concerts featuring artists of national and international reputation.

The North Devon Arts Centre in Barnstaple, established in 1960, was first housed in a building that was once a local jail, now in an advanced stage of dilapidation. In 1963 the center shifted its operations to a modern building with concert hall and theater, owned by the North Devon Technical College and situated at nearby Sticklepath. It sponsors perhaps ten programs a year—plays, recitals, and art exhibitions—supported financially by the Devon Educational Committee; professional music and drama are supplemented by amateur concerts and productions, and by activities put on by an affiliated Junior Arts Society. In 1966 the arts center joined with the Barnstaple Borough Council in developing a cultural program for the town, subsidized by local taxes, and arranged to share its programs with a new and independent arts center founded by the Dartington Hall Trust at nearby Beaford.

One of the most recently established centers opened in 1964 in Bristol. It was created by a small group of enthusiasts who, starting four years earlier with only £34, displayed unusual ingenuity and industry in developing a

8. The South Western Arts Association, *The First Ten Years* (1966), p. 7.

comprehensive center now worth perhaps £50,000. Its members not only assembled the necessary materials but worked with their own hands to transform the shell of two old houses into attractive premises, building a theater seating 126, turning cellars into pleasant bars, and providing accommodation for a gallery, workshops, wardrobe, and offices. The Bristol Centre adheres to a plan of presenting, each season, five plays with a common theme. Other activities include art instruction, poetry readings, improvisation classes, and monthly exhibitions at the art gallery. Particularly exciting is the opening of a branch of the National Film Theater, the first to be housed in a provincial arts center.

The association's management committee chairman recently asserted that, were it not for the work of the association, the Southwest would become "an artistic desert."[9] But one must bear in mind that cultural irrigation can make parts of a desert bloom and leave others untouched, and that life-giving fluids can contain impurities which partially negate the beneficial results which are sought. Since the association began in 1956–57, it has constantly sought to create in the region a sense of cultural unity and awareness and has explored numerous aspects of the arts by convening conferences several times each year and sponsoring a limited number of forums. Provision of opportunities for young artists has been an objective consistently pursued by the association. For example, between 1959 and 1966 professional tours were arranged for sixteen groups of graduating students from the Royal Academy, the Royal College of Music, the Royal Academy of Dramatic Art, the London Academy of Music and Dramatic Art, and the Bristol Old Vic Theatre School. Seventeen newly qualified musicians were invited to take part in the lunchtime concerts sponsored by SWAA during the Cheltenham Festival in 1960, and since then, numerous musicians have acquired experience by playing in the region before facing the national critics in London. Also, drawings and paintings by students or young professional painters resident in the region have been sent on tour by the association.

The major thrust of the association is to ensure for the Southwest a regular service of music, poetry, ballet, theater, and painting. Of the seventy-five societies affiliated with SWAA in 1966, forty-five promoted professional events, while the remainder fostered a variety of amateur activities. Although Arts Council support is not provided for amateur work, the council encourages the improvement of amateur standards. Recently the association has become a more active sponsor of exhibitions. Its own traveling exhibitions—now five in number—have been rather modest, due to lack of money and difficulty in finding suitable premises. The showing of the Arts Council's regular touring exhibitions has been similarly inhibited, but the council's recent decision to dispatch smaller shows on tour should ease the problem. In 1966–67, thirteen different Arts Council exhibitions were held in sixteen towns.

9. E. Perry Morgan in *The First Ten Years*, p. 2.

Association sponsorship of touring theater has functioned under even greater difficulties. Of particular interest is the three-week tour in 1966 of William Francis's *Portrait of a Queen*, put on by the Bristol Old Vic Company, supported by £2,000 from SWAA and a 50 percent grant by the Arts Council. The council's generosity evoked a terse response from Frederic Smith, chairman of the Arts Group, Exeter, born in part out of the frustration of previous years. He remarked on

the sudden change of heart—to hear a representative of the Arts Council say in Bristol, "We are determined that this scheme shall succeed." And the scheme was *touring professional theater*, anathema to the Arts Council during some ten years of nagging and jockeying. (What changes hearts I wonder? Who changes them? Money? Money-plus-policy?) At any rate here at long last was touring theater with a difference —something the French had had for years—*regional* theater: a company within the region, serving it. Isn't that what the trial tour of *Portrait of a Queen* by the Bristol Old Vic means?[10]

In April 1967, Robroy Productions visited fourteen communities, presenting Somerset Maugham's *The Circle*, and Peter Ustinov's *Photo Finish*. The early years had been indeed discouraging: in 1957 the West of England Theatre Company, which had toured the region, closed down; the response of local authorities to the Arts Council suggestion of having a touring company based on the Salisbury Arts Theatre was negative; 1958 witnessed the failure to form a touring company based on Bristol Old Vic; and in 1961 Caryl Jenner Mobile Theatre Company, which had achieved considerable success, ceased to operate in the region partly because of cuts in Arts Council grants. Under a four-year contract with the association, Theatre West—a company based on the Hamstead Theatre Club, London—brought ten plays to the Southwest, only one of which was a failure.

The association has achieved its greatest success in musical activities. From the beginning it has enjoyed a close relationship with the Bournemouth Symphony Orchestra. When the Western Authorities Orchestral Association was formed in 1958 with the financial support of some three dozen local authorities, and the Bournemouth orchestra was officially proclaimed "The Orchestra of the West," SWAA's resources were much expanded. The Western Theatre Ballet has performed on numerous occasions, and Southwest audiences saw the Royal Ballet Demonstration Group from Covent Garden train a dancer and create a ballet. Opera for All, presented by the Welsh National Opera Company, has featured operas sponsored regionally by some seventeen different arts centers, societies, and other organizations. Other programs sponsored by the SWAA include recitals, chamber music, lectures, and poetry readings. A literary magazine, the *Cornish Review*, has been modestly assisted by the association.

The record of achievement of the SWAA is not unimpressive. But generally it has not played an active role in fostering the development of indigenous new cultural organizations—resident theaters, opera, and ballet companies,

10. *The First Ten Years*, pp. 21–22.

particularly. Moneys at its disposal have never been sufficient to permit it to accomplish a major portion of its stated goals. Heavy reliance has been placed upon the work of volunteers; the full-time staff has been too small to do the job alone. The Arts Council would prefer that the association be transformed, in the future, into a general-purpose regional organization enjoying substantial local government support and extending its operation to cover a full range of activities. The association, however, believes that "changes should be made only in response to real needs, possibilities and opportunities and not merely for the sake of change itself. . . . In an era of changing ideas and impulsive ventures it is not always the early ones which produce permanent and healthy growth."[11]

The Midlands
Association
for the Arts

The Midlands Association, like the South Western, was formed to fill a vacuum created by the closure of the Arts Council's regional offices. Constituted in 1958, it sought to spark a handful of arts clubs and centers in the Midlands that were struggling in the face of meager financial resources and other difficulties. From these relatively humble beginnings the MAA has grown and prospered; its society membership now numbers sixty-seven—arts centers, local arts councils, arts clubs, small theaters, local education committees, and district councils. Its principles and objectives today are essentially the same as they were at the beginning of its career. Its dominant function is to serve as a coordinating body and as an agent between the constituent societies and the Arts Council. Grant applications from member societies are channeled through the association, which also distributes the grants. Its specialized knowledge enables it to advise the Arts Council about the details of each society's work; it also supports those claims which it feels merit central subvention. While the association has succeeded in inducing the Arts Council to increase successively its level of support of the arts in the Midlands, the total outlays remain modest. In 1967–68 the Arts Council made available to member societies grants and guarantees in the amount of £4,000; also a grant of £3,065 toward the association's administrative costs, and a transport subsidy fund of £600, which has been used to operate the transport subsidy scheme for assisting society members to visit professional events outside their communities. Thus far, practically all of the association's funds have come from the Arts Council —in 1966–67, for example, £3,609, or 95 percent.

An important function of the association is to assist constituent societies in the planning and scheduling of programs: at a conference convened each February the societies select, at reduced rates and early enough to avoid scheduling conflicts, a number of tours for the coming season. A quarterly *Arts Bulletin*, circulating in excess of 3,000, records developments in the region and the activities of member societies and makes valuable suggestions for society programs. For some years the association has operated its own

11. Ibid., p. 17.

lecture service and has maintained a panel of speakers expert in a wide diversity of the arts, fees being kept at modest levels. Highlighting the association's year are an annual assembly, designed primarily as a social gathering, and the annual exhibition, held in one of the local art galleries in the autumn. There are no special programs to assist young artists although some aid is given them when they are performing on tour within the area. The association accords high priority to its "missionary activity," which helps individuals or groups form new local arts societies under the aegis of an experienced organization. A society faced with crushing problems is strenuously supported to ward off public apathy or administrative ineptitude. Efforts to bolster the professional arts generally receive the most attention in the local press, but the association is also vitally concerned with fostering the best in amateur and semiprofessional work. Located for some years at the Birmingham and Midlands Institute, MAA headquarters is now housed in its own building in Stafford.

The region served by the association, covers a ten-county area from Herefordshire and Shropshire in the west to Northampton and Lincolnshire in the east; it extends north to Derbyshire, embracing a large segment of central England, great in economic and cultural resources and with a massive population. In December 1965, the association vigorously declared that it wished to expand in emulation of the activities of the North Eastern Association (now the Northern Arts Association) and that it looked forward to the time when local authorities would join it in pursuing a regional policy for the arts along the lines set forth in the recently issued white paper. From its experience in serving its affiliated arts societies, the Midlands Association could recast its organization and enlarge its scope to meet the greater challenge. To do this it needs the enthusiastic cooperation and financial support of the local authorities and local industry.

Northern Arts Association The prototype of the general-purpose regional association enjoying the financial support of local governments and industry is the Northern Arts Association with headquarters in Newcastle. Often referred to by the government and the Arts Council as a model for new regional associations as they are established throughout England, the association was inaugurated as the North Eastern Association for the Arts at a meeting held in Newcastle on 24 November 1961. Its first head was Dame Flora Robson, the actress. The association's objectives are to promote and develop the understanding and appreciation of all forms of art—music, opera, ballet, theater, painting, sculpture, literature, and film—by increasing the accessibility of the arts to the public; improving standards of performance; coordinating the efforts of all concerned with the arts; encouraging the development of arts centers; and helping to provide a better service of performances and exhibitions.[12] The original region included the counties of Northumberland, Durham, and the northern

12. North Eastern Association for the Arts, *In Brief—NEAA and You*, 1967, p. 4.

part of the North Riding of Yorkshire. In 1967 Cumberland and Westmorland were added, thus making the association's boundaries nearly coincide with those of the Northern Regional Economic Planning Board and Council. The total area is now 7,400 square miles, much of it highly industrialized and with a population of some 3,000,000.

Association membership includes 84 local authorities (of the 111 authorities in the area), 67 industrial and commercial corporations, including some that are publicly owned, 45 labor unions and trade associations, 2 universities, more than 80 local arts associations and societies, and 800 individual members. Four county council education committees, 8 county boroughs, 13 boroughs, 37 urban district councils, and 23 rural district councils have contributed monetary support.

The entire membership convenes at an annual general meeting in October each year. In addition, a conference session is held each June, and an estimates meeting, attended by local authorities only, in December. The business of the association is conducted by an executive committee composed of thirty-one members, of whom eighteen are local government representatives, plus the association's president and vice-presidents and two independent members with the power to vote, nominated by the Arts Council. Recently constituted is a policy advisory committee, made up of six members of the executive committee and its chairman and vice-chairman (ex officio) who are expected to keep under continuous review the association's policy and administration and to advise the executive committee on these matters as well as on membership, fund-raising, and the appointment of the senior executive officer; it also appoints and dismisses other staff and is empowered to authorize emergency payments and action between executive committee meetings.

Particularly useful have been the five advisory panels—music (including opera and ballet), drama, visual arts, spoken and written word, and film (including radio and television). Panels consist of not less than nine nor more than twelve members, appointed by the executive committee. Members are selected as individuals rather than as representatives of particular organizations and are chosen for their personal qualities, ideas, ability, and experience, and each panel ideally comprises a wide cross-section of interests and background and a balanced geographical representation.[13] Panel meetings, at least four each year, are presided over by a chairman who is also on the executive committee. Major applicants for subventions are invited to attend panel sessions to explain their requests in person but must withdraw before a vote is taken. Limits as to the concerns of panels are largely self-imposed, for the terms of reference are broad. Each is authorized to examine the present position concerning its particular art form in the region, to formulate and recommend to the executive committee policies and proposals designed to achieve the association's objectives in its field, to advise the

13. The committee seeks, as far as possible, to see to it that at least two members are under the age of twenty-five. Panel members serve four years and are not eligible for immediate reelection.

executive committee on major applications (over £500), and to consider other matters specifically referred to it by the executive committee.[14] Since controversy is inevitable in all systems of arts support, efforts are made to consult quickly with the applicant concerned and to provide a comprehensive explanation of actions taken.

The NAA's operating staff is relatively small, the full-time complement consisting of seven executive officers, one administrative assistant, and clerical personnel. Until 1967 the chief officer was its secretary, a post held by Alexander Dunbar, who was responsible for overall administration, co-ordination, financial control, planning, and development, as well as for fund-raising. The other executives were an assistant secretary, an arts officer, an administrative officer, and an administrative assistant. In the summer of 1967 a reorganization took place, involving a modest staff expansion with more specialized assignment of duties. Dunbar became the director of the association. A deputy director was designated who, in addition to substituting for the director, discharges responsibilities relating to music, art center development, coordinated tours, and festivals. Other top personnel include an arts officer for drama and literature; a second arts officer for the visual arts; and a third for films; the administrator, charged with general management and supervision; and a development officer, most of whose energies are expended upon raising money from the private sector. The honorary treasurer continues to be the city treasurer of Newcastle.

The sources of the association's income from the time of its establishment in 1961 are set forth in table 6. A number of interesting trends can be observed.

TABLE 6 Northern Arts Association: Sources of Income, 1961 to 1967–68

Sources of Income	1961–63 (16 months)	1963–64	1964–65	1965–66	1966–67	1967–68 (Estimated)
Local authorities	£24,100	£33,400	£39,700	£41,300	£57,013	£59,000
Arts Council	500	22,000	30,000	40,000	60,000	70,000
Industry, commerce, and other members	8,000	7,900	8,500	5,000	8,387	7,765
Other sources	10,000	2,900	3,100	3,300	4,752	19,000
Total	£42,600	£66,200	£81,300	£89,600	£130,152	£155,765

The figures given in table 6 relate only to the association's original area. Though the area was extended in the second half of 1967–68, no adjustments have been made, thus permitting a fair comparison with earlier years.

Total income has risen more than 360 percent, from £42,600 to an estimated £155,765 in slightly more than six years; a remarkable achievement. Most important, contributions by local authorities in the region have more than doubled, totaling, in 1966–67 £57,013, a sum almost equal to the support accorded by the Arts Council. In 1967, 72 local authorities out of the 89 in the area provided some financial support, 10 giving at the product of ¼d

14. Discretionary authority is accorded administrative officers, subject to the approval of the panel chairman and the director, to recommend directly to the executive committee grants and guarantees for routine items of expenditure, included in the estimates and involving no new policy, up to a maximum of £500 for any one item.

rate, 6 from ⅛d to ¼d, 19 at ⅛d, and 34 at less than this rate. The association requests local governments to make allocations at a minimum level of ⅛d; in the near future it expects to raise this to ¼d, and in the early 1970s it hopes that the minimum will be ½d. For the original northeast area a levy of ⅛d yields about £47,000 (£53,000 including Cumberland and Westmorland), while one of ¼d would produce £94,000 (£106,000). Funds obtained from local governments in 1967–68 are not up to the desired level, due in part to economic restrictions placed into effect nationally to combat inflation. The largest contributions in 1967–68 were £11,520 from Newcastle; £7,775 from Sunderland; £4,172 from Billingham; and £3,940 from Middlesbrough.

TABLE 7 Northern Arts Association: Expenditures, 1963–64 to 1967–68

Items	1963–64	1964–65	1965–66	1966–67 Authorized Expenditures	1967–68 Estimated
Music	£25,364	£33,575	£37,017	£51,785	£53,550
Opera	2,900	5,600	6,950	9,530	11,000
Ballet	371	570	980	2,500	2,500
Drama	13,771	17,500	18,380	24,635	31,800
Visual arts	1,410	6,290	9,100	10,010	9,700
Spoken and written word	2,168	1,585	4,404	3,085	5,100
Film	...	195	1,500	850	3,750
Publicity, transport, and planning	...	4,225	5,840	7,920	7,800
General (including arts centers, tours, festivals, fund raising, and contingencies)	1,585	2,600	4,145	19,400	16,300
Administration	7,411	8,233	11,805	17,000	18,460
Total	£54,980	£80,373	£100,121	£146,715	£159,960

The figures given in table 7 relate only to the association's original area. Though the area was extended in the second half of 1967–68, no adjustments have been made, thus permitting a fair comparison with earlier years.

Arts Council support has risen steadily, its allocation for 1966–67 being one-third higher than the previous year, thus implementing the recommendations relating to regional expansion contained in the Labour government's white paper. The Arts Council does not adhere to the principle of matching pound-for-pound local authority contributions, but in practice has come close to it during most of the association's history. The association has not been entirely successful in inducing industry and private individuals to make contributions to its operating budget. By the year 1971, or sooner if possible, it hopes to operate with resources compatible with an "ideal" formula— 35 percent from local governments, 20 percent from industry and the private sector, and 45 percent from the Arts Council. How to increase the financial support of industry in the region poses a difficult problem. That the region's principal industries—coal, steel, shipbuilding, and heavy engineering—are not the most prosperous in the British economy is a serious handicap. On the other hand, corporate giving is dependent in part upon management attitudes, and the NAA must convince businesses that they will prosper if their employees work and live in communities possessing cultural and artistic facilities. Large corporations or a group of businesses could provide

needed impetus by sponsoring and partially underwriting specific perform-
ances of concerts, plays, or other events and encouraging their executives
and employees, particularly members of trade unions, to attend these events.

A breakdown of the association's annual expenditures for the five-year
period 1963–64 through 1967–68, is given in table 7. Amounts shown are
for authorized expenditures; actual expenditures are often less, due to
changes in plans, failure of certain categories of income to materialize fully,
and the fact that aided bodies do not always fully draw on their guarantees.
The proportion of funds spent for administration has remained fairly con-
stant, varying from 10 percent in 1964–65 to 13 percent in 1963–64 and
1966–67. Care must be exercised continually to keep administrative and
promotional costs within reasonable bounds; as the association's total
budget increases in future years, it should be possible to reduce the propor-
tion thus utilized. Approximately one-third of NAA's resources have been
expended each year to enrich the musical offerings available to the people of
the Northeast, with lesser sums being allocated for opera and ballet. The
Northern Sinfonia, the only permanent professional chamber orchestra in
Britain, continues to receive the largest single grant, amounting to £34,435
in 1966–67 and £35,000 in 1967–68, a sum constituting about one-third of
its total estimated expenditure and income. In recent years the Sinfonia's
program of activities in the region has been extremely varied, including in a
given year perhaps a hundred public concerts, forty educational concerts,
and a score of radio and television broadcasts; renowned guest soloists and
conductors have been featured. Lesser sums, amounting to £3,500 in 1966–67
and £3,000 in 1967–68 finance the visits of symphony orchestras to the
region; the Czech Philharmonic, the Hallé, and BBC Symphony, are among
recent performers. Small subventions are made to a dozen or more chamber
music societies, each of which presents a series of concerts each year. Concerts
arranged by a number of choral, orchestral, and other musical organizations
are also partially underwritten, as are the activities of Jazz North East and
several folk music groups. For some time assistance has been accorded
music festivals such as Durham Twentieth Century Music Festival, Middles-
brough Competitive Music Festival, Durham Music Festival, and the
Sunderland Festival. In opera, Sadler's Wells performs on tour each year
in several cities within the region and, recently, money has been allocated
to underwrite performances on tour of Glyndebourne, Opera for All, and
other companies. Semiprofessional groups within the region also receive
grants—Northern Opera Limited, Palatine Opera Group, Durham County
Opera, to mention the principal ones. As for ballet, visits by the Royal
Ballet, the Festival Ballet, the Georgian State Dancers, etc., and other major
companies have been assisted, as well as appearances by smaller troupes.

Beginning in 1964–65, the association's outlays for drama have totaled
approximately 20 percent of its annual expenditures. Since its establishment,
the association has aided the Sunderland Empire Theatre, which is owned
by the city corporation and used as a civic theater for drama, opera, ballet,

concerts, films, variety, music hall, pantomime, and pop music. Subventions are given to professional theater at Billingham. At Sunderland grants are made to help underwrite specific activities or projects: installing new equipment, employing a publicity organizer, and sponsoring the North East Theatre Festival and the visits of the National Youth Theatre. NAA's grants to the Empire amounted to £4,500 in 1966–67 and approximately £5,000 in 1967–68. The Middlesbrough Little Theatre, though built, owned, and operated by amateurs, is suitable for professional drama. It has received aid since 1962, with funds earmarked, among other things, for the employment of a professional manager, and for the support of professional productions. At Darlington the Civic Theatre has received NAA subventions for similar purposes. In Newcastle, the Playhouse, using a theater recently purchased by the city and depending on its box office receipts, relies principally upon subvention underpinning: in 1967–68 it received approximately £30,000 from public sources—£8,250 from Newcastle Corporation, £8,250 from NAA, and £13,500 from the Arts Council. In 1967 an agreement was entered into with Nottingham Theatre Trust whereby John Neville, director of the Nottingham Theatre, took over the artistic direction of a company of professional actors working at the Newcastle Playhouse, an instance of cooperation between two theaters both aided by the Arts Council and their respective local authorities. As envisaged, a local trust called the Tyneside Theatre Trust has been constituted in Newcastle to operate the theater, and plans are under discussion for the city to erect a new theater building. Other recipients of NAA assistance include the eighteenth-century Georgian Theatre, Richmond; the Spa Theatre, Whitby; People's Theatre Arts Group, Newcastle; and several amateur theater groups.

Activity in the area of visual arts is limited, for traditionally, local authorities have owned art galleries and libraries. For some years the association has allocated £1,000 a year toward the operating expenses of the Billingham Arts Centre, a small gallery located in the new town center. Smaller sums are given to encourage public galleries to put on art exhibitions; recent recipients are galleries in Newcastle, Gateshead, Sunderland, Middlesbrough, and Bowes. Since a number of private galleries face an uncertain future, the association has been induced to make modest aid available.

Of particular interest is the case of the Stone Gallery in Newcastle, which achieved the reputation of being one of the best private art galleries outside London during its seven-year existence. It had managed to avoid asking the association for monetary assistance until, in late 1964, it found itself deep in financial problems. With its back against the wall, it sounded the alarm, and the association and the Newcastle Corporation each contributed £1,000 to forestall immediate closure. Substantial continuous support from both bodies was obviously the only solution; the association and Newcastle offered to make available jointly £15,000 over a three-year period, provided the gallery would become a nonprofit-distributing body. The directors rejected the offer and closed the gallery. Much heated controversy ensued, the

NAA adhering to the position that "no public body can offer subsidy entirely on the recipient's own terms."[15] In 1966 the Stone Gallery reopened as a limited company instead of a trust, a dozen local people participating. The continued existence of the few remaining private galleries in the provinces which adhere to high artistic standards is uncertain.

Although quite properly not seeking to become the organizer of numerous exhibitions in competition with the Arts Council, the association has paid for some special exhibitions. In 1964 the Northern Young Artists Exhibition, with prizes for artists under thirty, was organized and shown in Middlesbrough and Sunderland. In 1966 a Northern Painters Exhibition and in 1967 a Northern Sculptors Exhibition were held, each with prize money of £1,000. Both received a favorable response from the public.

As for the Spoken and Written Word, the publication of the *North East Arts Review* constituted for some years the association's main commitment —a journal which afforded an outlet for the best of local talent in prose and verse as well as for articles dealing with topical issues of artistic or social importance. In 1964 the *Review* was merged with *Stand*, a literary magazine possessing an established national reputation, and its editorial office moved to Newcastle. The NAA publishes *Arts North*, an attractive illustrated guide listing some 200 artistic events and exhibitions held throughout the region each month, plus selected feature articles. A circulation of 16,000 testifies to its value. Small grants are given to other magazines. Several poetry and prose competitions for young people have been sponsored jointly with local newspapers. Of the poetry readings assisted, perhaps the most interesting are the series begun in 1964 in the Morden Tower, Newcastle. These enjoy tremendous popularity, particularly among young people, and maintain such high standards that poets come from other parts of the world to participate.[16] In 1965–66, twenty poets—including Allen Ginsberg and Lawrence Ferlinghetti—gave readings. Associated with the Tower is a poetry magazine, *King Ida's Watch-Chain*.

Grants of up to £750 in 1967–68 were made to the Teesside Film Theatre, and smaller sums were placed at the disposal of local film societies. And in the same year £2,000 was earmarked for grants to film makers.

In the North, as in other parts of Britain, arts festivals have become increasingly popular. Festivals which have been assisted by the association include the Newcastle Festival, Hexham Abbey Festival, North East Theatre Festival in Sunderland, Durham Music Festival, Durham Cathedral Festival of Light, Durham Twentieth Century Music Festival, Richmondshire Festival, North East Trade Union Exhibition and Arts Festival, and the Teeside International Eisteddfod. Some of these festivals are held annually.

Local arts associations play an important role in towns where there are no regular concerts or plays. From the beginning, the association has fostered contacts between local groups and national companies. Today more

15. North Eastern Association for the Arts, *Annual Report 1964–65*, p. 16.

16. Manchester *Guardian*, 18 March 1966, p. 3.

than 150 professional events coordinated and supported by NAA are promoted by forty arts centers and societies and put on by groups or individual artists on tour in the fields of opera, ballet, music, drama, lecture recitals, poetry, and puppets. Several new arts associations have been formed, encouraged by the availability of association financial and professional assistance.

The association maintains a close relationship with the People's Theatre Arts Center of Newcastle, operated by the People's Theatre Arts Group, an amalgam of the Theatre Group, the Tyneside Film, and Tyneside Music societies, whose membership totals approximately 4,000. During a given year, professional events held in the center are likely to include two operas, two orchestral concerts, six chamber concerts, three ballet performances, a jazz concert and a poetry reading, forty-five films, three lectures, and a dozen exhibitions—paintings, sculpture, and ceramics. Each art exhibition is viewed by some 5,000 people. On the amateur side, some ninety plays and twelve light operas may be performed.[17] NAA subsidy to the center and the organizations operating in close partnership with it amounted to approximately £3,000 for 1967–68. Believing that vigorously administered arts centers enjoying cooperative relationships with numerous locally based artistic organizations constitute one of the most effective ways of stimulating the arts at the "grass roots," the association encourages their formation whenever possible. Today there are some nineteen arts centers operating in the region.

Believing, too, that professional artists in the regions, isolated as they are from the mainstream of artistic life in London, greatly need encouragement and assistance, especially in the early years of their careers, the association has instituted bursaries and commissions for musicians; awards for writers, painters, and sculptors; a writers' fellowship, and a special film-makers scheme. The NAA's total program, if developed further, may reduce the "artists' drain" to the nation's capital and in time bring about a change in the local cultural landscape comparable in some respects to that which has occurred in the physical landscape following the application of programs to control soil erosion.

To what extent should a regional association try to encourage artistic activity by amateurs? NAA accounts are kept in such a way that expenditures on amateur activities cannot be neatly separated from professional. It appears that perhaps 80 percent of its subventions support professional work, a proportion considered by some to be excessively high. The reason for this high proportion, however, is that in order to exist, the professional arts require greater financial assistance than do the amateur arts. The assistance needed by amateur arts is not so much straight operating subsidy, but professional advice and help, training, buildings, and equipment.

Most observers throughout Britain consider the NAA's initial years a remarkable success. Yet, ironically, it suffers periodic crises of public con-

17. National Council of Social Service, *Arts Centers in England and Wales* (1967), pp. 65–66.

fidence within the region. Thus, in early 1967 a barrage of critical barbs was aimed at its expenditure of £17,000 for professional assistance in a fund-raising campaign.

The targets of criticism are many; the masses of reports; the amount spent on survey; the time spent by officers visiting festivals and other events here and abroad; the judgement shown in giving support to one event and denying it to another. The general theme is that the association spends too much on overheads and too little on actually supporting artistic activity.[18]

The difficulty seems to derive from differences in understanding of the basic purposes of the association. Some people feel that it ought to be just a banker, channeling money between those who give it and those who spend it. The association did not agree to this role when it was established in 1961, nor does it agree to it today. It has not yet succeeded, however, in making a watertight case for the more positive role of organizer and promoter of the arts.

Ronald Mavor, director of the Scottish Arts Council, speaking at the association's annual general meeting in October 1966, characterized the association as the cynosure of Great Britain.

I suspect, simply because this is the way things happen, that over the next five years of your life things are going to be harder for you. People who have praised you idly up to now, are going to criticize you, for any reason or no reason, simply because once one has got to this stage people become critical and jealous. I suspect that a good deal of over-ripe fruit will be picked up and flung at you during the next five years. I hope very much that when this happens you will continue to exhibit the confidence and courage which you have had in and with your permanent staff in the past because I am sure that in the field of artistic administration this is an absolute necessity. If one is going to move with every blowing of the wind, if one is going to tremble under the criticism of why one gave a grant to this artist and not to that artist, one is going to do a thoroughly bad job.

In evolving its plans for the next few years, the association seeks to continue to raise standards in the professional arts while guaranteeing people of the area access to a greater range of artistic activity. Opera is exceedingly expensive; a company requires a minimum subsidy of £350,000 a year, a sum which the association cannot afford to underwrite alone. One solution might be to join with Manchester and the Northwest in supporting a full-time company. More likely is an arrangement with Scottish Opera, a well-established company with an excellent reputation. A deficiency of theater and other buildings suitable for the arts must be dealt with. In 1967 a new multipurpose complex, erected by the local authority at a cost of £1,000,000, was opened at Billingham, housing under one roof swimming pool, ice-skating rink, gymnasium, rifle range, theater, concert auditorium, and restaurant. For medium-sized communities, the advantages of this type of structure are compelling: it is more economical to operate than a number of separate buildings; people who come to pursue other interests may find

18. Manchester *Guardian*, 30 January 1967, p. 3.

themselves drawn to the arts; and where there is no permanent repertory company, the facilities can be used for many other purposes. New theaters are being planned for several towns.

More resources will be devoted to encouraging individual writers, playwrights, painters, sculptors, and composers. Greater efforts will undoubtedly be made to cater to the interests of young people, and new ways will be devised for reaching additional audiences. As for amateur activity, the intention is to increase the organizational coverage so that even in the smaller communities people will have ample opportunity to explore new interests. On the cautionary side, the temptation to proliferate the number and size of committees and panels must be resisted. Projections by the NAA of income needed to implement its goals have, thus far, not been fully realized; the key to success lies in mobilizing greater support by local authorities and inducing industry to invest more heavily in the cultural life of the region.

Future Regional Developments The Arts Council looks with favor upon an England organized into nine or ten regional associations, each properly financed and equipped with a well-trained staff, for a proliferation of associations, perhaps at the county level, could easily result in the draining off of funds to meet high administrative costs.[19] Developments at present are very much in a state of flux. The Arts Council, although it exerts significant influence and is the major source of income, wisely prefers to wait for local initiative. Considered by many too large for one region, the Midlands may be divided into two regions; already a North West Arts Association has been organized with headquarters in Manchester.[20] The Lincolnshire Association, launched in 1965 and comprising a large area with a small population, may find it advantageous to enlarge its region or merge with another association. Other possible groupings include Yorkshire, East Anglia, the southern counties, and the Southeast.

In Wales a new regional pattern is evolving as a result of the recommendations contained in a report published by the Council for Wales in 1966. The three principal weaknesses in Wales are the dearth of suitable buildings, the inadequacy of local organization and finance, and lack of coordination. Recommended is the formation of three regional associations (along the lines of the Northern Arts Association) covering the entire area of Wales which would permit the council "to concentrate its efforts on coordination, advice and financial help and on important developments on a national scale; on the other hand, through the associations, a heightened sense of local responsibility and sharpened aspirations would be developed."[21] Though Wales possesses about the same population and taxable resources

19. *Key Year, Twenty-First Annual Report 1965–66, The Arts Council of Great Britain*, pp. 23–24.
20. Manchester *Guardian*, 14 October 1966, p. 5.
21. Cmnd. 2983, The Council for Wales and Monmouthshire, *Report on the Arts in Wales*, 1966, pp. 92–93.

as the original Northeast region, its area is twice as large. Even so, the council feels that it would be wrong to treat Wales as a single unit, for to do so would dissipate the advantages of local identification, sacrifice the benefit of healthy competition, and ignore the geographical divisions and problems of communication within Wales. Under the proposed plan, the North Wales Association would aim at raising annual sums of £23,000, while the West Wales and South Wales associations would seek to operate on budgets of £32,000 and £51,000 respectively. These amounts could be secured if all local authorities contributed at least the product of one-eighth of a penny rate and if proper supplemental support came from the Arts Council, industry, and charitable trusts.[22] The constitution of the North Wales Arts Association was drafted and operations begun in 1967. The use of an association to stimulate local interest and financial support is obviously advantageous; but to fragment such a small area into three or even two separate regions appears open to serious question. One association could be constituted for all of Wales, perhaps lessening the need for a Welsh Arts Council and the office in Cardiff.

Thus far no effort has been made to regionalize arts administration in Scotland. Concentration of population in the southern portion, especially in Edinburgh and Glasgow, and the dispersion of the remainder of the Scottish people over a large area inhibit any moves in this direction.

The picture of developing regionalism is not complete without mention of the Greater London Arts Association, which came into being at a conference of local authorities, arts councils, and arts organizations held at Caxton Hall on 2 July 1966. The formation of the association brought to an end twenty-two years of work of the Standing Committee on the Arts of the London Council of Social Service. The new organization will seek to coordinate arts activities and to assist liaison between local authorities, amateur and professional arts organizations, and artists and other individuals. Membership will include local authorities, arts councils of the London boroughs, arts and cultural organizations concerned with the whole or a substantial part of London, and individual co-opted members. For 1967–68 the association received support in the amount of £7,500 from the Greater London Council and £2,500 from the Arts Council of Great Britain. Proposed activities include the establishing of a headquarters information department; the setting up, cooperatively, of a number of major centers around London's outer area capable of housing orchestras, ballet, opera, and international exhibitions; tours in Greater London of first-rate professional exhibitions, concerts, and drama; and the providing of greater opportunities for young professionals to gain experience.[23]

In June 1967, representatives of the existing arts associations and of

22. Ibid., p. 120.

23. Lily Atkins, *Arts and Leisure in the London Community, The History of the Standing Committee on the Arts of the London Council of Social Service* (London: London Council of Social Service, 1968), pp. 55–57.

proposed regional arts associations met and discussed regional developments, common problems, and possibilities for interregional cooperation. It was decided to convene further meetings, to be held twice each year at Arts Council headquarters in London.

6 / LOCAL AUTHORITIES AS PARTNERS IN ARTS PATRONAGE

There is no common pattern among local authorities when it comes to support for the arts. Some are generous, some have no regard for art at all. . . .
Some local authorities will need a good deal of persuading before they are convinced that the money it is in their power to spend on arts and amenities is money well spent and deserving a much higher priority than hitherto. But it can be done. All new social services have to fight long and hard before they establish themselves. Only yesterday it was the fight for a free health service. The day before it was the struggle to win education for all.
—*A Policy for the Arts*, 1965

British local governments, like the national government, have been reluctant to abandon traditional laissez faire attitudes toward the arts and to institute programs of subsidy. Based upon provisions of the Local Government Act, 1948, and other enabling statutes, the average expenditure by local authorities to assist the professional arts has remained relatively modest.

Awakening of Interest

In a Commons debate on the Museums Act of 1845, Sir Robert Peel spoke for an influential segment of British opinion when he admonished his colleagues not to increase unduly the burden on local taxes since "it will be necessary in the present session to confer powers of local taxation for the purposes of ventilation and improving the salubrity of the dwellings of the people." Doubts concerning the propriety of permitting town councils to establish museums and libraries were widespread and influenced parliamentary discussion preceding enactment in 1850 of a Public Libraries and Museums Bill. Opponents, including Disraeli, advanced various arguments against the bill: one speaker "considered 'town councils,' of all bodies, the least proper to be entrusted with these powers, while another feared that 'by the introduction of lectures hereafter, these libraries might be converted into normal schools of agitation.'"[1] The bill's sponsors were forced to accede to an amendment debarring town councils from acting until they had the approval of a two-thirds majority of the local taxpayers (or "ratepayers" in British usage, "rates" being taxes levied by local government).

Although response to this legislation was limited, some local authorities did provide museums, but a few accorded much emphasis to painting, drawing and sculpture. In the decades that followed, powers of local authorities were gradually augmented. The Local Government Act, 1888, the Municipal Corporation Act, 1894, and the London Government Act, 1899, sought to improve the moral, mental, and physical condition of the masses; little emphasis went to the provision of entertainment, particularly professional music and drama. After 1900 local provision of public entertainment was given further parliamentary sanction. The Public Health Amendment Act, 1907, authorized contributions to underwrite band concerts and other musical performances in public parks or pleasure grounds, as well as for the renting of buildings for entertainment purposes. In 1925 a new Public Health Act expanded a council's powers to permit it to provide "concerts and other entertainments" not only in parks but also in its own buildings. Notable was the act's specific prohibition of stage plays, variety entertainments, and motion pictures unless these were "illustrative of questions relating to health or disease." Private bills, sponsored usually by seaside resorts and inland

1. S. K. Ruck, *Municipal Entertainment and the Arts in Greater London* (London: George Allen and Unwin Ltd., 1965), p. 20. This book includes a comprehensive account of local government interest in the arts.

holiday centers, authorized specific authorities to sponsor concerts and other forms of entertainment, but did not permit direct presentation of stage plays; these could be provided only by renting the pier or theater to professional companies or by devising a profit-sharing scheme.[2]

British practices in the late 1920s stood in sharp contrast to practices then adhered to by local governments in most European countries.[3] In France, municipalities assisted local theaters by means of annual grants. Paris owned several theaters, some of which were rented to private directors responsible for the management, control being retained by the city. Municipal theaters, operated along similar lines, were found in a large number of French provincial towns. In Germany, support arrangements were diverse. The city of Berlin owned an opera house which was managed by a municipal opera company, all of whose shares were held by the municipality. The city also had a theater, which was leased to a private company. Dresden possessed two municipal theaters—one for opera and the other for drama—its treasury underwriting 35 percent of the costs. In Munich there were three state theaters, the city bearing one-third of the annual deficits incurred. In Belgium, subsidies, direct or indirect, were extended to local theaters by Brussels and a half dozen other municipalities. And in Holland, most of the larger cities owned a municipal theater and paid subventions to theatrical companies to enable them to give inexpensive operatic performances.

William A. Robson, writing in 1931, sought to arouse public opinion so that corrective action could be taken.

The most obvious defect in English Local Government at present is the almost complete neglect by the municipality of the cultural elements in social life. We have no municipal theaters, no municipal opera-houses, scarcely any municipal concerts of the first rank, and hardly a municipal picture gallery or museum worthy of a great city. The whole force of municipal enterprise has been concentrated into the utilitarian channels of public health and police, roads and housing, gas and water, while all the finer aspects of civic life have been persistently ignored.[4]

He and others holding similar views were instrumental in the eventual passage, in 1948, of Labour's Local Government Act.

World War II substantially changed public attitudes toward local governments and the arts. The birth of CEMA in 1939 and its subsequent development have been described in an earlier chapter. London and other large cities cooperated with CEMA and ENSA in providing entertainment for people in shelters during air raids. Local governments participated in the "holidays at home" program, designed to bring relaxation to war workers. When peace was restored, local authorities had become much more closely associated with the arts.

2. Legislation was enacted at the request of Cheltenham, Bournemouth, and Harrogate prior to 1900; during the 1920s Colwyn Bay, Eastbourne, Buxton, Bognor Regis, Stoke-on-Trent, Wakefield, the London County Council, and other authorities were accorded special powers.
3. William A. Robson, *The Development of Local Government* (London: George Allen and Unwin Ltd., 1931), pp. 221–22.
4. Ibid., p. 212.

When the Arts Council was constituted in 1946, some of its supporters hoped that, through it, Exchequer funds could be made available to local authorities. But the Treasury quickly ruled that the council could not make direct contributions to local governments. Arts Council spokesmen, nevertheless, have frequently urged local authorities to devote a larger portion of their resources to the arts. Understandably, this action has engendered some resentment, and critics have assailed the Arts Council for not extending financial support to local governments. In 1961 Sir William Emrys Williams, then secretary-general of the Arts Council, addressing a municipal entertainment managers conference in London, advocated direct grants to local authorities. Exchequer funds have not been given them, but the Arts Council itself provides direct assistance to theaters, orchestras, opera and ballet organizations, and other artistic enterprises, a large proportion of which are simultaneously aided by local governments.

In 1944, Middlesex County Council obtained more extensive powers of entertainment for district councils in its area, and legislation relating to Manchester, Cardiff, Southend, and Swindon was enacted in 1946 and 1947. In 1946 the Association of Municipal Corporations urged the Minister of Health, Aneurin Bevan, to introduce legislation which would permit municipalities to construct and operate theaters and concert halls and to promote the arts in other ways. Specific permission to incur expenditures in excess of the proceeds of a local tax of one penny in the pound, set by the 1925 Act, was requested. These representations met with no immediate response, and it was not until a year later that the Labour government suddenly decided to take action. A new clause, patterned on the Association of Municipal Corporation's proposal, was inserted in the Local Government Bill then before Parliament, becoming law as Section 132 of the Local Government Act of 1948.

Local Authorities and the Arts Today The 1948 Act is a milestone in the development of local government support for the arts, providing new powers for county boroughs, noncounty boroughs, urban and rural districts, and the City of London. County councils were conspicuously omitted. Such allocation of powers represents a unique reversal of the trend particularly evident since 1920: authority has been steadily shifted from smaller authorities to the counties and county boroughs and from local governments to the central government in Whitehall. A government spokesman explained to the Commons: "This is not a matter which can be subject to any kind of remote control. . . . We take the view that this kind of work can be done much better by the district councils which are on the spot, in touch with their own people." Section 126 empowers county councils to contribute to the expenditure of district councils for the purposes authorized by Section 132. Both the Greater London Council and the new London boroughs were permitted to participate by a subsequent act of Parliament.

The scope of activity allowed under the 1948 act is broad: authorities "may do, or arrange for the doing of, or contribute towards the expenses of the doing of" entertainment of almost any nature. Specifically enumerated are provision of theaters, concert halls, or premises suitable for presenting other entertainments or the holding of dances, and the maintenance of orchestras and bands. Authorities can levy charges for the programs they present, and can rent theaters, halls and other facilities to private individuals or organizations. Expenditure by local authorities for entertainment, excluding capital outlay but including loan charges, cannot exceed in a single year the product of a 6d. rate in the pound plus the net amount of any receipts earned.[5]

The Education Act, 1944, accords local education authorities general powers that they have used to contribute to the support of theaters, orchestras, and other cultural organizations, usually to defray the costs of programs especially designed for young people. Section 41 dealing with further education decrees that they have a responsibility to provide adequate facilities for cultural training and recreational activities, and Section 53 permits them to cooperate with voluntary organizations functioning in these fields.[6] More recently, the Local Government (Financial Provisions) Act, 1963, permitted local authorities to "incur expenditure for any purpose which in their opinion is in the interests of their area or its inhabitants."[7] Such a broad grant of power can serve as the legal basis for arts subsidy. However, total sums spent each year under this section cannot exceed $\frac{1}{5}$d in the pound for parish councils and 1d. for other authorities.

During the 1950s, local governments began to provide much-needed support for the arts, although the amounts given were modest. Aid for music and drama was mainly in the form of subsidies to orchestras and repertory theaters, with a few cities undertaking the construction of concert halls and playhouses. In 1961, the Arts Council observed that many of Britain's largest and richest cities "remain lamentably negligent of their duties to the arts."[8] In 1948 the product of a local tax of 6d. in the pound in England and Wales was some £8,000,000; subsequently, taxable values were adjusted upward, and by 1963 a 6d. tax yielded £50,000,000. In 1963, the Arts Council estimated that local authority expenditures on the arts were probably not much greater than the council's Treasury grant of £2,700,000.[9] If this estimate was accurate, local arts expenditures amounted to approximately $\frac{1}{3}$d. or between 5 and 6 percent of the maximum permitted under the 1948 act. No exact data relating to local authority expenditures existed until April 1964,

5. In Scotland, authorities designated include counties, towns or districts, the maximum allowable expenditure being $4\frac{4}{5}$d.

6. The Education Act, 1944, sections 41–47 and 53.

7. Local Government (Financial Provisions) Act, 1963, section 6.

8. *Partners in Patronage: The Sixteenth Annual Report of the Arts Council of Great Britain 1960–1961*, pp. 5–6.

9. *Ends and Means: The Eighteenth Annual Report of the Arts Council of Great Britain 1962–1963*, p. 6.

when the Institute of Municipal Entertainment published *A Survey of Municipal Entertainment in England and Wales for the Two Years 1947/48 and 1961/62*. The survey revealed that net expenditures by 847 local authorities for 1961–62 on all forms of entertainment were just over £2,500,000 or approximately what was then the product of a 1d. tax.[10] However, it was not possible to isolate the exact portion expended in support of the arts.

Precise information relating to current levels of expenditure by local authorities is not available. Evidence at hand suggests that, though more local governments now allocate money to the arts, and sums given are substantially larger than those reported in the 1964 survey, city and town councils do not generally accord the arts a high priority in their budget planning. This is hardly surprising. Opposition to expenditure on the arts locally comes not only from those who wish to keep tax levels down but also from those who believe that taxes should be spent on housing or other "practical" programs rather than on "leisure." Scrutiny of subsidy activities in all local authorities or a survey on a sample basis of what is being done by governments representing each type of local authority is not feasible here. Instead, support programs operated by a limited number of the larger authorities are examined in an effort to obtain insights into the kinds of cultural activities assisted, difficulties experienced in developing viable subsidy provision, policy and administrative problems encountered, and the adequacy of the schemes undertaken.

The City of London The City of London, a square mile in the center of the nation's capital, is the headquarters of a large number of Britain's industrial and financial institutions. Sponsorship of the City Waits, a colorful musical band which played and sang at Livery Company dinners, was an early corporate undertaking. Of major significance was the erection by the City of the Guildhall Library and Museum, opened in 1873, and of the Guildhall Art Gallery, in 1886: a portion of whose collection had been acquired as early as 1667. City initiative resulted in the founding of the Guildhall School of Music and Drama in 1880. The "holidays at home" programs led to City support in 1945 of band performances at lunchtime, an activity still being sponsored. Other patronage was perfunctory until the beginning of the 1960s, for the City was regarded primarily as a place where more than a half million people worked but only a few thousand actually lived. Proximity to national institutions such as Covent Garden, Sadler's Wells, and the National Theatre undoubtedly predisposed the authorities to view the arts in the City as not being in urgent need of substantial subsidy.

The City's legislative body is unicameral, a Court of Common Council, consisting of the Lord Mayor, twenty-five appointed aldermen, and 159 elected common councilmen. Committees dealing with the arts are Coal,

10. *A Survey of Municipal Entertainment in England and Wales for the Two Years 1947/48 and 1961/62* (London, Institute of Municipal Entertainment, 1964), pp. vii–xi.

5

Corn and Rates Finance, which controls all expenditures; Music, which initiates and gives preliminary approval to proposals for assistance to music and theater; Library, which focuses on the art gallery and the museum; and the Barbican, which has fostered the Barbican redevelopment project. Officially, the Court of Common Council is nonparty, for members run for office without regular party designations.[11]

Subsidy funds allocated by the music committee have gradually increased in recent years, rising from £2,980 in 1959 to £4,735 for 1964, to £9,860 for 1967 and to £13,235 for 1968.[12] The quality of supported activities varies considerably. Of the two concert series which have long been aided by the corporation, that of the City Music Society has received more generous treatment, having been given annual guarantees up to £500 in 1964 and 1965, and £750 in 1966, 1967, and 1968; it presents lunch-time concerts. The London Bach Society, giving two or three concerts a year in City churches, is awarded £100 annually; in 1968, it received a special contribution of £500. For some years the corporation has granted free use of the Guildhall to the BBC for a monthly lunch-time promenade series; it contributed to operating costs in 1968 a sum not exceeding £500. The Mermaid Theatre, since it opened in 1959, has been the recipient of indirect subsidy in the form of reduced ground rents; in addition, for 1965 and 1967 the City made a direct grant of £2,500 toward general expenses, and in 1968 £5,000 was allocated for the same purpose. In 1966 the City gave the Mermaid £24,000 to pare down its accumulated deficit of £35,000. For several years small guarantees enabled the theater to assist in presenting intimate opera at lunch-time; today, support is accorded programs of lunch-time films. The City subsidizes lunch-time band concerts at Saint Paul's Cathedral and elsewhere, estimated costs not exceeding £5,000 from May to September 1968. Small sums help to defray the costs of poetry readings, of performances by the British Puppet and Model Theatre Guild, and concerts by the City of London Choir and by the Blackfriars Singers. Beginning in 1966 the City supported the Royal Shakespeare Company's productions of Theatregoround held in its precincts; in 1968, £300 were made available for this purpose.

The most spectacular enterprise assisted by the Music Committee is the City of London Festival, begun in 1962 and repeated in 1964, 1966, and 1968. Details relating to the Festival are set forth in chapter 13. City moneys expanded for the 1966 Festival totaled £35,000; in 1968, £35,000 were

11. Data are unavailable as to actual party allegiance, but it is unlikely that the Labour group is large. Excluding the Barbican, committees dealing with the arts have identical makeup—four aldermen and twenty-nine commoners.

12. To make comparisons meaningful, funds allocated to the City of London Arts Festival held every two years are not included in these totals, nor are the £5,000 given to the City Arts Trust in 1967 for a series of concerts between festivals. Costs of operating the Guildhall School of Music and Drama, which is primarily an educational institution, are also excluded; these amounted to £62,906 for 1966–67. Plays, operas, concerts and recitals sponsored by the school are open to the public without charge; fifty-one events took place during the year.

allocated as a grant, plus £7,000 in guarantee support and £1,500 for publicity. The Arts Trust, as festival promoter, was given £5,000 in 1967 to enable it to put on a series of orchestral concerts between festivals.

The Barbican Arts Centre is one of Britain's important municipal arts developments and will serve as a guide for other British cities, highlighting the advantages to be gained by effective integration of the arts. The center is being erected as part of the City's Barbican Redevelopment Scheme, which is located in a sixty-three-acre bombed out area north of the Guildhall. The scheme, originally projected in a report, *Barbican Redevelopment 1959*, included the creation of a new business area as well as modern apartments which are expected to house between four and five thousand persons.[13] As originally envisioned, the arts center would have included the Guildhall School of Music and Drama, plus theater, concert hall, art gallery, and lending library—all constructed as one entity. In 1963, the Common Council approved a joint report prepared by the Rates Finance and Barbican Committees containing revised proposals and financial estimates. New premises for the Guildhall School of Music and Drama will contain a theater seating about 500 and a concert hall accommodating 400, to be used primarily for student training but also to be available for public plays and chamber concerts. Proximity to the Royal Shakespeare Company and the London Symphony Orchestra is expected to benefit the school in a number of ways. Music students will serve as apprentices to leading players, thus receiving not only instrumental tuition from a member of the orchestra but also close exposure to the actual orchestral repertoire played under eminent conductors.[14] The center's art gallery is to be modest in size and used principally for art society exhibitions.

The new separate concert hall, as projected, would seat 1,300 and be operated directly by the corporation, users paying a rental fee amounting to 40 percent of box office takings. Anthony Besch, artistic administrator, employed as expert advisor, proposed that the hall's seating capacity be increased to 2,000 and that it become the permanent home of a major London orchestra, with annual subsidy from the City. The theater should be enlarged from 800 to 1,500 seats and become the base for a permanent company; if the latter should not prove feasible, the theater could be used for theater, ballet, opera, and so forth. Yearly subsidy should be £20,000 to £40,000. The Rates Finance, Music and Barbican Committees carefully considered Besch's report, recommending in February 1966 that the London Symphony be the resident orchestra. The hall's construction costs were estimated at £924,000, with loan charges, repairs, and insurance amounting to £67,500 each year; £20,000 rent paid by the orchestra would leave a yearly deficit of

13. Construction of the new residential buildings is expected to mitigate the City's housing shortage and reverse the population drift, which in the past hundred years, has reduced the City's population from 100,000 to 3,800.

14. City of London, Court of Common Council, *Barbican Redevelopment—Concert Hall* (Joint Report of the Rates Finance, Music, and Barbican Committees, 3 March 1966), p. 7.

£47,500, which the corporation agreed to bear. The London Symphony, encouraged by the Goodman Report on the London orchestras, declared that Arts Council subventions were likely to range between £90,000 and £100,000 a year, thus obviating the need for City operating support. This prognosis appeared over optimistic.

As for the theater, the three committees were generally in accord with Besch's recommendations, although a £74,250 operating deficit, plus a possible subsidy to a resident company of £40,000, appeared unduly burdensome. The suggestion that the theater become the permanent home of a major company resulted in the negotiation in 1965 of an agreement between the City and the Royal Shakespeare, under which a permanent home for the company would be constructed at an estimated cost of £1,307,500. The City's yearly expenditure on the building, including capital repayment, was expected to total £92,000, of which the Royal Shakespeare would pay as rent one-half, or £46,000. The City would thus subsidize the Royal Shakespeare to the extent of the remaining £46,000. Since 1965, construction costs have risen. Estimates of costs for the entire center as of January 1968, covering buildings, equipment, and furnishings, totaled £9,857,000, including the Guildhall School of Music and Drama, £1,271,000; theater, £2,210,000; concert hall, £1,524,000; library, £416,000; and art gallery, £288,000.

The City of London's art gallery at the Guildhall and a portion of its collection were destroyed during World War II. Since 1939, the gallery has been forced to keep the bulk of its art works in storage, mounting limited exhibitions in temporary quarters. A new art gallery, independent of the Barbican Centre, will be erected adjacent to the Council Chamber to permit a portion of the collection to be put on display. Of the more than 3,000 pictures owned by the gallery, some are of high artistic merit, but the collection as a whole is not outstanding, for it did not benefit from a systematic purchase program financed by wealthy patrons or by the City.[15] Corporation policy today seeks to make the gallery a unique center for the collection of paintings old and new that depict the London scene; however, the £10,000 allocated for acquisitions are insufficient to permit purchase of works by the more famous painters. Independent of the Guildhall Art Gallery, 28,000 prints are housed in the Guildhall Library, many depicting historic happenings within the City and the London area.

Parliament, in 1965, sanctioned the creation of a Museum of London by providing for the eventual merger of the existing London and Guildhall Museums to form a new institution focusing largely upon London history from Roman times to the present.[16] The new museum's operating expenses

15. Twelve exhibitions are held each year, one featuring works from the permanent collection, another of artists who live or work in the City. Others are mounted by art societies and other organizations.

16. The Guildhall Museum is administered by the Corporation of London, while the London Museum, a national institution, is financed by Parliament. The Museum of London's board of governors will have eighteen members, six named by the prime minister, six by the Corporation of London, and six by the Greater London Council.

are to be borne initially by the City; the central government and the Greater London Council will reimburse it to the extent of one-third each. Erection of the museum's new building is due to be completed in the early 1970s. In the meantime, a Guildhall Museum has been established on an interim basis on the Barbican podium in leased premises.

The opening of the Barbican Arts Centre and the installation of the Royal Shakespeare and the London Symphony in their new facilities will enrich the cultural life not only of the people who live or work in the City, but of residents in the entire London metropolitan area. Once the programs of artistic support as presently envisioned are fully implemented, the Common Council may decide to increase its operating subventions and embark upon new patronage undertakings. The financial resources of the City are great and it could well afford to dip into its coffers to provide even greater support for the arts. In 1967, the product of a penny rate produced approximately £190,000. Total expenditures as projected, once the center is in full operation, may exceed £250,000 per year.

Greater London Before World War II, the London County Council did little to patronize the arts. At the end of the nineteenth century, London accorded token support to band music in the parks; but it was not until 1935 that a music director was employed by the Parks Department. In the following year, a program of music concerts was inaugurated. In 1937 the 118 park performances, given at a deficit of almost £600, were received with marked enthusiasm— 43,350 people paid modest admission charges and another 100,000 listened from outside the enclosures.[17] In 1939, the council's role was enlarged by the inauguration of the "holidays at home" programs. Construction of the Royal Festival Hall, which opened in 1951 for the Festival of Britain, constituted the council's first major commitment to the arts, involving expenditure of substantial sums each year to underwrite net operating losses: in 1960–61 these amounted to £65,000 and in 1967–68, to £280,000.[18]

Today the Greater London Council (GLC), created in 1965 as the successor to the London County Council and the Middlesex County Council, is heavily involved in supporting artistic enterprises. The division of responsibility between it and the London boroughs within its boundaries rests upon an agreement entered into with the London Boroughs Association which provides that grants to cultural organizations serving London generally are the responsibility of the GLC, while those to organizations serving primarily local interests should come from the Borough Councils. Greater London's policy, enunciated in 1966–67 and largely influenced by the government's Prices and Incomes policy, specified that unless there were special circumstances, no appreciable increases in grants should be considered beyond the

17. London County Council, *Annual Report of the Council*, 1937, vol. 1, pt. 1 (London, 1940), p. 77.

18. The £280,000 expended in 1967–68 includes the Queen Elizabeth Hall and the Purcell Room.

average permissible rate of growth of public expenditure. Expenditure increases which reflected expansion of service were limited as long as the economic situation remained difficult. Most important, subvention recipients were urged to reexamine the level of admission charges. Procedurally, regular grant applicants were asked to present by 1 September estimates for the financial year beginning the following April. Increases in excess of approved budgets would be considered only under special circumstances. Criteria for evaluating each application would include: the significance of the activity to London culture, the degree to which it benefits London as a whole, artistic quality, extent of financial need, and economic viability of the cultural organization.

As a result of the April 1967 elections, the Greater London Council became overwhelmingly Conservative (91 to 25), and so brought to an abrupt end the Labour Party's rule of more than thirty years at County Hall. Some observers insisted that change in party control would result in smaller allocations for the arts, but after a year of Conservative rule no great changes in arts policy have become apparent. In fact, a modest increase in allocation for the arts occurred in 1968–69. London operates through thirteen permanent committees, the most powerful being the General Purposes Committee, which, in addition to controlling arts subsidy, possesses an extremely varied general jurisdiction.[19] The General Purposes Committee, the better to inform itself about cultural affairs, has constituted a Special Development and Arts Sub-Committee whose membership consists of twelve members of the parent committee, five other council members, and three from outside the council. It oversees and reports upon developments at the South Bank Arts Centre and recommends the annual allocation of arts subsidy funds. Final decision concerning smaller grants is taken by the subcommittee, but recommendations for grants of over £5,000 are referred to the committee. Applications are considered twice yearly.

Of all the arts, music has been most generously supported by the LCC and its successor, the GLC. Of the £798,550 total allocated for grants to the arts for 1967–68 (£870,000 in 1968–69), £431,650 were earmarked for music (£463,000 in 1968–69). Particularly outstanding is its record of subsidy to the London Philharmonic Orchestra. In 1946–47, the Philharmonic received a subvention of £10,000, which was gradually increased to £25,000 by 1950–51. The Philharmonic and the other orchestras benefited greatly when the LCC constructed the Royal Festival Hall as the capstone of its participation in the 1951 Festival of Britain. Erected on the south bank of the Thames, within easy walking distance of Westminster, the Festival Hall was an immediate success. In the two years after opening, 1,066 functions were held

19. Other matters which are the concern of the General Purposes Committee include: questions of overall policy, matters of common interest to all or several services, appointment of chief officers and other senior personnel, research and intelligence organization, and information services. Its membership of twenty-eight includes one elected representative from each of the other standing committees, two from the Inner London Education Authority, and fourteen appointed by the council.

there and over two million people paid admissions to its varied array of entertainment. Erected at an initial cost of £2,200,000, exclusive of site, with funds derived directly from local taxes, the hall possesses a complex of facilities, including a main auditorium seating 2,900. It is also used for conferences, and its vast foyers frequently house exhibitions. After 1951 the Philharmonic was assisted in two ways: (1) the orchestra was employed at commercial rates for a certain number of performances, some sponsored by the London County Council in the hall and others arranged for school-children or held in the open in Finsbury Park; and (2) with other orchestras it benefited from the rent rebate system in effect at the hall. Its allocation for educational and industrial concerts in 1955–56 totaled £11,000. In 1962–63, the Philharmonic was accorded assistance in the amount of £9,000, based on twenty-nine concerts, exclusive of the educational and industrial series. Beginning in 1960, the Philharmonia Concert Society and the London Symphony Orchestra were given subventions by the LCC; in 1962–63 these amounted to £9,000 each. The Royal Philharmonic Society and the Haydn Mozart Society also profited from the council's rent rebate scheme and, in addition, by 1960–61 were aided directly in the amount of £1,500 each.

Beginning in 1963–64, the LCC and the Arts Council each placed £36,000 in a special fund administered by a committee representing the two organizations: the Arts Council/London County Council Joint Orchestral Committee. Guarantees against loss amounting to £24,000 each were extended to the London Philharmonic Society, London Symphony Orchestra and Philharmonia Concert Society. The recipients were expected to coordinate their programs. The financial position of these three orchestras and a fourth, the Royal Philharmonic, continued to be unsatisfactory, and in December 1964 the Arts Council appointed a committee on the London orchestras to devise a rational and coordinated orchestral policy that would insure programs and performances of the highest metropolitan standards. The committee's published report, analyzed in a subsequent chapter, recommended creation of an independent autonomous body, the London Orchestral Concert Board, to be established jointly by the Arts Council and the Greater London Council. This body would coordinate and approve concert arrangements made by the four orchestras, both at Festival Hall and elsewhere in London, sanction budgets and program plans proposed by each, and allocate subsidies for approved concerts.[20] Government response was immediate; the new board was incorporated in December 1965. For 1966–67, the GLC gave the board £137,500, which, with £212,500 from the Arts Council, provided a total income of £350,000. After reviewing a report of the board's activities, the General Purposes Committee renewed the grant of £137,500 for 1967–68. In 1968–69 the London Orchestral Concert Board received a total of £392,500 for grants to the four main orchestras. Of this amount, the Arts Council contributed £242,500, and the GLC, £150,000. The GLC's support was actually somewhat larger, for it included an indirect contribution

20. Committee on the London Orchestras, *Report*, 1965.

in the form of Royal Festival Hall operating expenses amounting to £75,000 annually for 1966–67, 1967–68, and 1968–69.

The Queen Elizabeth Hall, seating 1,100 persons, and the Purcell Room, with a capacity of 370, were erected by the GLC, together with a separate Hayward Gallery.[21] These additions of nearly £6,000,000 to the South Bank Arts Centre raised the council's total investment in physical plant to approximately £8,250,000. Operating expenses for Festival Hall, Queen Elizabeth Hall and the Purcell Room in 1967–68 aggregated about £600,000 (£670,000 in 1968–69). Net cost to the council amounted to about £280,000 (£310,000 in 1968–69), after income was deducted. Events held in the three facilities are promoted primarily by outside organizations, the local management merely collecting gate receipts, which are turned over to the sponsors. The GLC is compensated by rental payments. The Festival Hall does, upon occasion, act as promoter. Recently, between 450 and 500 separate events have been held in the Festival Hall each year, with attendance at orchestral concerts alone running to approximately 450,000.

Two opera and ballet organizations received major subventions from the LCC—Sadler's Wells and London Festival Ballet. In 1958 the Wells Trust faced a severe financial crisis, which threatened to close down its operations permanently. In response to an urgent appeal, the council made an emergency grant of £25,000, at the same time launching an investigation by a committee of inquiry into the need for continuing support. In its report, the committee emphatically urged that opera be accorded permanent subsidy, observing that such action "should not be regarded simply as first aid to prevent a well known and well regarded London institution from dying," but rather considered "as a deliberate contribution from the municipality towards an adequate provision in the metropolis of opera as a cultural amenity for the benefit of the people of London."[22] Sadler's Wells was to be encouraged to attain the highest of professional standards. Arts Council inability to provide sufficient funds was the most practical justification for subvention by the LCC. LCC grants to Sadler's Wells have fluctuated: £25,000 for 1958–59; £50,000, 1959–60; £35,000, 1960–61; £45,000, 1961–62, 1962–63 and 1963–64 each; £60,000, 1964–65. GLC allocations have been somewhat more generous: £75,000 in 1965–66; £100,000 each for 1966–67, 1967–68, and 1968–69.

In 1952 the London Festival Ballet began performing in the Festival Hall, offering both summer and Christmas seasons. The LCC provided a specific guarantee each year to permit the Company to meet its operating expenses.

21. In 1963 the LCC agreed to rent the Hayward Gallery to the Arts Council from year to year at a peppercorn rent. The Arts Council is entitled to use the gallery full time, except for a few occasions when the GLC would have priority. The GLC is committed to make external repairs, but the Arts Council bears responsibility for management, staffing, interior decoration, cleaning and upkeep. The Queen Elizabeth Hall and the Purcell Room opened in 1967; the Hayward Art Gallery held its first exhibition in 1968.

22. Committee of Inquiry on Sadler's Wells, *Report* (London: London County Council, 1959), p. 16.

Maintaining fiscal solvency involved the ballet in continuous struggle, making it difficult to launch new productions which it thought essential to the achievement of high performance standards. To assist it in realizing this goal, the LCC in 1960 granted it £5,000; further subventions of £7,500 each were given in the two following years, and an additional sum of £5,000 was allocated for the 1962 Christmas season. The company found it impossible to meet normal operating costs. To prevent its collapse the Arts Council, in January 1963, advanced an additional £15,000. Grants in 1963–64 totaled £59,600, and in 1964–65, £96,000. The GLC's subventions to the Festival Ballet continued to increase, being set at £123,900 in 1965–66 and £149,000 in 1966–67. Allocations were reduced to £133,000 in 1967–68 and to £128,000 in 1968–69 because of increased Arts Council subsidies.

The National Theatre Company benefited from GLC assistance to the sum of £40,000 in 1964–65. By 1966–67 its subvention stood at £90,000, a level which was maintained in 1967–68 and 1968–69. When in March 1966 the GLC requested the South Bank Theatre and Opera House Board to proceed with the erection of the new National Theatre on the South Bank near the Royal Festival Hall, it did not come to a firm decision concerning construction of a new opera house, for the Arts Council was then reassessing the needs of London and the provinces for opera and ballet subvention. Subsequently, the board was asked to proceed with the erection of the theater alone. The government then announced that it would not assist with the building of an opera house on the South Bank, nor substantially increase its annual subsidy to Sadler's Wells. Since a new opera house would cost at least £6,000,000, exclusive of furnishings and equipment, the GLC felt that it could not ask the local taxpayers to shoulder this additional burden. Plans have been made to locate the theater immediately downstream from Waterloo Bridge. Its construction will cost an estimated £7,500,000, to be borne equally by the Greater London Council and the national government, and the GLC is making the site available free of charge. The board is now proceeding to implement the scheme to the degree moneys permit.

The World Theatre Season, sponsored by the Royal Shakespeare Company at the Aldwych Theatre, first received London County Council assistance in 1966. Its initial guarantee of £6,000 proved inadequate and necessitated an additional contribution of £2,080 toward the deficit incurred. The 1967 season guarantee was set at £6,000 with a clear stipulation that during the year no additional support would be forthcoming. The council has since decided to support the Theatre Season only every three years; no guarantee was offered in 1968 and 1969.

Smaller subventions in music, opera, drama, and ballet totaled £18,200 in 1966–67 and £20,000 in 1967–68, with £20,000 again being set aside for this purpose in 1968–69. Ballet Minerva was accorded £1,000 in 1967–68 and again in 1968–69 to implement expansion of the company as recommended by the Arts Council. £1,500 were given for opera productions featured in the 1967 Camden Arts Festival, sums going to Opera Viva,

5*

Irwell Concerts and Opera Concerts. The 1968 Camden Festival also benefited from a £1,500 subsidy, funds going to Opera Concerts, Handel Opera Society, and for a triple bill of works by Kurt Weill. Since 1961 annual grants have been accorded the English Stage Company at the Royal Court: £2,500 were given in 1967–68 and again in 1968–69. £1,500 went to the New Opera Company in 1967 to assist its productions at Sadler's Wells and Southwark Cathedral; in the same year, £2,250 were provided as a grant (£2,250 in 1968–69) to the New Shakespeare Company for its summer productions in the Regent's Park open air theater, £200 to Opera Piccola performing at Camden Town Hall, and £200 (£200 in 1968–69) to assist with a program by Philopera Circle in Saint Pancras Town Hall. The Poetry Festival, convened by the Poetry Book Society in Queen Elizabeth Hall in July 1967, was given £1,000 by the GLC. Also benefiting from GLC generosity were: Repertory Players, a society affiliated with the English Stage Company and formed to encourage promising playwrights, designers, and directors and to give assistance to young actors, £500 (£500 in 1968–69); Youth and Music, which makes tickets available to youth at reduced prices and presents operatic concerts at Sadler's Wells and elsewhere, £4,500 (£4,500 in 1968–69).

Other organizations that receive subsidies from the GLC are the British Institute of Recorded Sound (£1,000 for 1967–68) and the British Film Institute (£2,350).[23] GLC support of art galleries has remained limited, for London is generously endowed with art museums maintained by the central government, but the Dulwich College Art Gallery receives £2,000 a year from the council, and the Whitechapel Art Gallery, some £6,000 a year.[24]

Funds budgeted in 1967 for summer open air programs sponsored by the Parks Department totaled £87,250; some possessed relatively little artistic content. Light music included concerts by bands and orchestras given twice daily at Victoria Embankment Gardens and lunch-hour concerts at Lincoln's Inn Fields. Concert parties, folk dancing, and Scottish country dancing are featured at numerous locations throughout the metropolitan area.[25] Kenwood, a GLC-owned mansion, provides a setting for recitals, poetry readings, and lakeside concerts featuring major British orchestras. Since 1948 an openair exhibition of sculpture has been held every three years in a London park, usually Battersea.

The Inner London Education Authority provides grants to the London Schools Music Association and the London Schools Drama Association, voluntary bodies of teachers, to assist them in fostering these arts in schools.

23. No general subsidy is given to the British Film Institute or the National Film Theatre, although the council is planning to construct additional and improved facilities for the theater, a substantial part of the cost to be recouped from rents.

24. The 1967–68 subvention was approved contingent upon the adoption by the gallery of a more effective budgetary system.

25. In 1967 at Concert Pavilion, Battersea Park, frequent appearances were made by the Isy Geiger's Viennese Concert Orchestra and by leading jazz bands. There was also a four-week drama program designed for children.

Funds also are given to assist school groups who wish to take part in European music and drama festivals, and to the London Schools Symphony Orchestra, which features public concerts in London and elsewhere. In addition, the authority maintains a drama center at Toynbee Theatre, which is used free of charge by schools and drama groups. The Jeanetta Cochrane Theatre, a part of the Central School of Art and Design, is also available to drama groups.[26] And the authority sponsors for children some fifteen special concerts by the London Philharmonic Orchestra each year and helps to arrange special matinee performances for schoolchildren by the National Theatre and Sadler's Wells at their home theaters.

Funds expended by the various borough councils in Greater London in support of the arts are relatively modest. S. K. Ruck, in his *Municipal Entertainment and the Arts in Greater London*, assembled data showing amounts spent by each borough for 1960–61, totals including not only moneys used to support culture and entertainment as defined in the 1948 act, but also expenditures incurred in relation to museums and galleries and amateur arts. Ten boroughs spent £10,000 or more: Camberwell (£13,155), Croydon (£28,763), Edmonton (£11,460), Enfield (£10,030), Fulham (£10,039), Saint Pancras (£14,730), Tottenham (£13,442), Walthamstow (£21,708), Wembley (£10,527), and Willesden (£27,805). Ten spent no money for these purposes. Expenditures by all London boroughs totaled £334,818. Expressed as a proportion of their taxes, 3 spent 2d. or more in the pound, 11 between 1d. and 2d., 12 between ½d. and 1d., and another 12 between ¼d. and ½d. The remainder spent less than ¼d. In 1963, 43 authorities supported or provided popular concerts, music hall and band shows; 28, town shows or carnivals; 27, dances; 26, old people's entertainment; 26, athletic events; and 24, horticultural shows. However, 31 authorities supported or provided orchestral and celebrity concerts; 20, ballet; 18, professional drama; 17, opera; 16, musical festivals; 16, drama festivals; 39, art exhibitions; and 23, local arts councils.[27] Information pertaining to the present extent of support accorded the arts by the London boroughs is not available. Some authorities have made important advances since 1963, but many appear to have neglected the cultural needs of the citizens who reside within their boundaries.

The patronage provided by the borough of Camden illustrates creative and imaginative participation.[28] Resources allocated for 1967–68 aggregated £90,000. Of this, approximately £27,000 went to maintain the Camden Arts Centre whose facilities are made available to a variety of cultural groups and art societies. First held in 1946, the Camden Festival, formerly the Saint Pancras Arts Festival, has enjoyed national renown; it was aided to

26. A third center, the Gateforth, is being constructed in Westminster, with emphasis on drama; it is to be used primarily by young people, but will also be available for school and adult groups.

27. Ruck, *Municipal Entertainment and the Arts*, pp. 33–37.

28. Camden, formed as a result of the reorganization of London's government in 1965, includes the former boroughs of Hampstead, Saint Pancras, and Holborn.

the extent of £17,000. The Hampstead Theatre Club, seating 156 persons, received £10,000, subsidy having been accorded it since 1963. The club's productions, experimental and avant-garde, have evoked much interest and sometimes bitter controversy. The borough, which owns the building, seeks to allow complete freedom to the club in its operations, though on one occasion it refused to permit presentation of a particularly controversial play. The Hampstead Festival, managed by the local authority, received £8,000. Other cultural activities assisted have included concerts by the Royal Philharmonic Orchestra and other groups, art exhibitions, and poetry readings.

For some years the arts subsidy programs of the Greater London Council, particularly in music, opera, ballet, and theater, were highly successful, permitting an expansion of cultural activity in central London and a rise in artistic standards. However, as recently as 1965 Ruck observed that the situation was very different in outer London. Among the outlying boroughs, only Croydon offered a regular program of quality productions in pleasant surroundings, utilizing its Fairfield concert halls and Ashcroft Theatre, both constructed since the war.[29]

As of 1968 the situation in Greater London had substantially improved. First, GLC support of cultural organizations, including operating subsidies of the Royal Festival Hall, the Queen Elizabeth Hall and the Purcell Room, reached a new high—£798,550 for 1967–68. To this must be added a figure of about £465,000 to reflect the "notional" loan charges incurred in the construction of the three buildings plus the Hayward Art Gallery. Although the cost of the buildings was in fact paid directly from local taxes, the GLC has insisted that the "notional" loan charges be computed to show what the expenditure on repayment of loans each year would have been had the customary practice for capital works borrowing been employed. Thus, the council's full contribution to the arts was about £1,250,000 in 1966–67 and £1,263,550 in 1967–68. Impressive as these totals were, the sums expended represented less than the product of a 1d. in the pound rate (£2,550,000 for 1966–67 and £2,580,000 for 1967–68). Secondly, nearly all of the London boroughs had set up local arts councils, and these organizations served as channels through which increased subsidies were extended to cultural organizations.

Success achieved by local authorities in Greater London in creating viable arts support programs was due in no small part to the work of the Standing Committee on the Arts of the London Council of Social Service mentioned in the previous chapter as the predecessor of the Greater London Arts Association. Constituted in 1945, the committee, composed of representatives of specialist bodies, youth organizations, community associations, and private individuals, with advisory members from education authorities and the Arts Council of Great Britain, for twenty-two years acted as a pressure

29. Ruck, *Municipal Entertainment and the Arts*, p. 109.

group, fostering the growth and development of the arts and urging local government participation in arts activities.[30]

Birmingham Birmingham, Britain's second largest city, participates actively in encouraging and supporting the arts. Its town hall serves as the city's principal meeting place and concert hall; Mendelssohn's *Elijah* was given its first performance there in 1846, and since then many of the world's great orchestras and concert celebrities have appeared upon its stage. Corporation support of the arts was first undertaken on a modest scale in 1867 with the establishment of the Birmingham Art Gallery. The other arts did not receive appreciable assistance until after the passage of the 1948 act, aside from the provision of £2,500 annually to the Birmingham Symphony from 1919 to 1944.

Birmingham's city council is today firmly controlled by the Conservative Party, although like many other municipalities it was in the hands of Labour until 1966.[31] Primary responsibility for the arts is lodged with a twelve-man subcommittee of the general purposes committee; the Art Gallery benefits from special oversight by the libraries and museums committee.[32] Expenditure in direct support of the arts in 1967–68 amounted to £321,000, equivalent to 1.5d. in the pound; in the previous year, it totaled £263,708 or 1.3d. in the pound.[33]

A Festival of Entertainments, presented annually in the town hall and city theaters by the city of Birmingham, originated in World War II as part of the "holidays at home" program. During the late 1940s and early 1950s, the festival experienced serious financial difficulties. In 1957, the city council decided that it would continue to hold the festival subject to the requirement that the proposed program together with cost estimates be submitted in advance. The programs differ from those of the Cheltenham and other festivals, in that Birmingham seeks to cater to both the sophisticated connoisseur and the man in the street. Subsidies amounted to £3,228 in 1966, £3,500 in 1967, and £6,000 in 1968.[34]

30. For a history of the committee, see Lily Atkins, *Arts and Leisure in the London Community: The History of the Standing Committee on the Arts of the London Council of Social Service* (London: London Council of Social Service, 1968).

31. As of May 1968, the city council membership of 156 consisted of the following: councilors—83 Conservative, 28 Labour, and 6 Liberal; aldermen—22 Conservative and 17 Labour. In 1965, councilors were 42 Conservative, 74 Labour, and 1 Liberal; aldermen included 17 Conservative and 22 Labour.

32. Two other committees are, to a limited degree, concerned with the arts: the education committee, which employs sections of the symphony orchestra to visit the schools, and the parks committee, which sanctions the presentation of plays and other entertainment in the parks.

33. Losses incurred in the operation of the town hall and other municipal buildings are not included, since accounts kept do not distinguish between arts events and other uses.

34. The program for the 1966 Festival, included Mantovani and his orchestra, with a concert of light music; a one-man show by David Kossoff; a concert by the Birmingham Symphony; a recital by Karl Ulrich Schnabel; an All Night Rave for younger people, with popular bands and entertainers; an Old Time Music Hall for popular entertainment; a concert of popular orchestral music by the Hallé Orchestra; and a performance by the Modern Jazz Quartet. For

In the field of music the corporation provides two subventions, the largest of which supports the City of Birmingham Symphony Orchestra. Since the end of World War II subsidies made to the orchestra have grown steadily, enabling it to expand its activities and raise its professional standards. In 1966–67 Birmingham gave £37,000 to the orchestra; in 1967–68, £48,000.[35] For some years, £1,000 have been set aside to employ on a part-time basis a city organist, who presents a full season of free recitals in Birmingham. £500 are also available to employ visiting organists. As for the visual arts, the corporation's principal contribution is the maintenance of the Birmingham Museum and Art Gallery, net support (excluding the Department of Science and Industry) being estimated at £199,885 in 1966–67, £216,831 in 1967–68, and £329,387 for 1968–69.

Financial aid has been accorded several dramatic organizations. The Birmingham Repertory Theatre, well known for the quality of its productions, is the recipient of continuing corporation support: £8,000 were given it in 1966–67 and a similar sum in 1967–68. A new theater, the future home of the repertory company, is to be constructed by the city at an estimated cost of nearly £700,000. The Alexandra Theatre, featuring entertainment by a resident company as well as by touring groups, often selected for their cultural value, in 1965 was granted an interest-free loan of £30,000, repayable at the rate of £2,000 per year, to finance the installation of new lighting, a modern heating system, and other improvements. Although not subsidizing the theater on a continuing basis, the council has been reluctant to see it close down. Both theaters were plagued with serious financial difficulties, and in the summer of 1968 the city council proposed to their boards of management that a merger be effected. This suggestion, as might be expected, was not received with enthusiasm, but at the time of writing, no decision had been reached.

The Hall Green Little Theatre, whose president is Sir Laurence Olivier, has achieved a respected place in the world of amateur theater. Its history is unique. It was erected in the early 1950s on the site of a rubbish dump by a group of youthful drama enthusiasts who did much of the construction work themselves at a time when materials were in short supply. Loans from the City to the theater, amounting to £3,000, permitted completion of the structure and purchase of needed equipment. In 1967, £1,400 still owed to

a two-week period the Alexandra Theatre interrupted its normal repertory schedule to present the D'Oyly Carte Opera Company.

The 1968 Festival presented classical music exclusively. It commemorated the founding of a Triennial Music Festival in 1768, which occupied a significant place in the city's cultural life until its demise in 1912. The City of Birmingham Symphony Orchestra, the City of Birmingham Choir, and the New Philharmonia Orchestra participated, and Sviatoslav Richter gave a piano recital.

35. Detailed analyses of Birmingham's support of the City of Birmingham Symphony, the Museum and Art Gallery, and the Birmingham Repertory Theatre are included in chapters 9, 10, and 12.

the corporation were written off by the general purposes committee. No operating subsidies have been accorded the theater. Home of a well-known amateur drama society, the Crescent Theatre was erected with the aid of a £55,000 grant from the corporation. In 1957 a city-owned building with a well-equipped stage, auditorium and other facilities was made available as a theater center, and subsequently utilized by numerous amateur drama societies. Net expenditures by the corporation for the center totaled £5,118 in 1966–67; in 1967–68, £5,067, rents charged being purposely set at below-cost levels.

The Midlands Art Centre for Young People, an imaginative enterprise, is now being developed. On a fourteen-acre site, leased by the City to the Cannon Hill Trust, an extensive complex of buildings and facilities are to be erected: two connecting theaters for plays, opera, and ballet; a film theater; pavilions for music and dance; galleries for the visual arts; studios and workshops; and an arts club, swimming pool, and restaurant.[36] The center wishes to serve the needs of young people from earliest childhood to age twenty-five, but in practice, its clientele will embrace more age groups, as many activities are planned for families. Under a ten-year plan, the trust hopes to spend annually £100,000 on new buildings and set aside a further £50,000 for an endowment fund.[37] In 1967 the city council sanctioned a subvention to the Cannon Hill Trust not to exceed £175,000 spread out over a five-year period, 1966–70. For 1967–68 the sum of £35,000 was paid to the trust.

Birmingham, with its ample tax base, is empowered to spend larger sums of money in support of the arts. Greater operating subsidies are needed by the Birmingham Repertory Theatre and the Birmingham Symphony Orchestra; the decision whether or not to provide annual operating grants to the Midlands Arts Centre for Young People is yet to be made. Little is done in the fields of opera and ballet.[38] In 1967, the general purposes committee was approached informally concerning possible subsidy for a proposed Midland Opera and Ballet Company based in Birmingham which initially would present an opera season of six weeks followed by a week of operetta and two weeks of ballet. Its request for an annual grant of £19,970 was not approved by the committee at this time. Long-range projects likely to be aided by the city include the construction of a new orchestral hall and of a new exhibition hall.

36. At the beginning of 1968, facilities completed included the headquarters, studios, workshops, and arts club; Swan and Cygnet Theatres and the Visual Arts Gallery were in the design stage.

37. Young people pay directly for most of the services provided, but fees cannot cover the entire costs of operation. Money is raised by subscription rather than by borrowing. Funds are solicited from donors large and small, the plan being to obtain capital and operating funds, one-third from private individuals, business and trade unions, one-third from the national government, and one-third from Birmingham and other local authorities.

38. Sadler's Wells visits Birmingham once or twice each year, the corporation providing a subsidy of £200 for each week of performances.

Liverpool Liverpool, England's third largest city, has in recent
years been extremely active in fostering the arts. In
1965 the corporation commissioned its town clerk to survey the existing
provision for cultural subvention, focusing upon possible new developments
and reassessing the adequacy of the existing committee and administrative
structure. The resultant white paper, presented to the city council early in
the following year, recommended a four-point program. Liverpool, in the
future, should forge a program of artistic patronage which would (1) make
available to its people art of the highest quality, in painting, sculpture,
music, drama, opera, and ballet; (2) cultivate in more and more people the
capacity to enjoy the arts; (3) encourage the specially gifted who are capable
of earning a livelihood as professionals; (4) provide greater opportunities
for amateur participation in the arts. Liverpool had, over the years, con-
cerned itself primarily with two artistic fields: the visual arts, involving the
Walker Art Gallery, which the city council owns and operates; and music,
for which substantial subsidies were made available to the Royal Liverpool
Philharmonic. Until 1965 the city had not provided subventions for theater.
However, Liverpool had been chosen as one of several centers in the country
for the celebration of two major national festivals—the Festival of Britain
in 1951 and the Commonwealth Arts Festival, 1965. As for the other arts,
assistance had been modest. After the war, the city, engaged in rebuilding
and redeveloping a major portion of the central environs, sought with the
moneys at its disposal to strengthen existing artistic provision and to expand
cultural facilities to serve not only the people of the Merseyside, but those
inhabiting a much wider region.

The white paper recommended no changes in committee and city adminis-
trative structure. It did, however, urge that greater expenditure be incurred
in support of both professional and amateur arts, that an officer be named
to undertake research relating to the city's artistic needs, that special atten-
tion be given to the desirability of establishing an arts center or centers, and
that a representative organization be constituted, to be made up of persons
engaged in the arts and of individuals whose support was deemed desirable.
In addition, an executive officer to administer Liverpool's arts programs
should be appointed either by the corporation or by the representative
organization. Without question, the council would wish to retain control of
broad policy decisions involving the municipality and to determine the
precise level of its own financial contributions. The new representative
organization could be accorded an overall grant by the council and, itself,
in turn, allocate moneys to artistic groups.[39] Since 1965 the level of city
subventions has increased, but no action has been taken on the other
recommendations.

39. Such a representative organization could discharge the following responsibilities: (1) raise
money for the arts from local authorities, the Arts Council, industry and commerce, trusts and
other sources; (2) allocate money for artistic efforts; (3) provide liaison with and advice to the
local authority; (4) coordinate artistic activities and raise standards; (5) seek to create new
artistic opportunities and enterprises.

With its population of 705,310, Liverpool is governed by a council now controlled by the Conservative Party.[40] Three committees are concerned with the arts: General Purposes allocates subsidies for drama, opera, music and festivals and is by far the most important; Libraries, Museums and Arts exercises overall supervision of the Walker Art Gallery; and Parks and Recreation sponsors limited arts activities in the parks. Expenditures in support of the arts in 1966–67 totaled £234,887 or 2.3d. in the pound; in 1967–68 they amounted to approximately £257,000 or 2.4d.[41]

The Walker Art Gallery is one of the leading provincial art galleries in Britain today. In fact, it is the only provincial art institution to be accorded Treasury assistance toward the purchase of a painting. In 1960, when the *Holy Family* by Rubens was acquired, the requisite £50,000 were raised through the combined efforts of the city council, private donors, trusts, and the Treasury. The latter contributed £25,000.[42] Since 1945 the gallery has acquired important art works, mounted a number of significant exhibitions and provided educational services to nearby schools. Serious gaps in its collection exist, however, and the city needs to make available more money for acquisitions. The recent drive for economy dealt the gallery a serious blow, for its Purchase Fund allocation was cut from £11,500 in 1966–67 to £5,000 in 1967–68. In 1968–69, most of the funds were restored, £9,120 being made available. Appropriations for gallery operating expenses jumped from £98,152 in 1965–66 to £111,969 in 1966–67, only to be reduced to £109,768 in 1967–68.[43] The estimate for 1968–69 was £116,792.

Corporation support of the Royal Liverpool Philharmonic is widely recognized as having been a key factor in the creation of this first-class orchestra. Subsidy is given to the orchestra through the Philharmonic Society. The corporation contributes to the Local Authorities Joint Orchestral Scheme, designed to elicit regionwide support for the Hallé and the Philharmonic: £8,408 were made available in 1966–67 and in 1967–68, and £9,248 in 1968–69. Liverpool's direct contributions to the society are much larger—£51,293 were given in 1966–67, and £67,265 in 1967–68. Included in these totals are an annuity of £4,000, payments for school concerts, free use of the hall (estimated at £10,000), and most important, the assumption of any annual operating deficits which may be incurred.

In recent years the corporation has assumed major responsibilities in the field of drama. Late in 1964 the Liverpool Everyman Theatre Company was

40. Following the municipal elections held in May 1968, council members totaled 120, of whom 79 were Conservative, 33 Labour, and 8 from other parties; of 40 aldermen, 21 were Conservative and 19 Labour. Liverpool was governed by Labour from 1963 to 1967, when they were supplanted by the Conservatives.

41. For 1966–67, the product of a 1d. rate was £103,984; in 1967–68, it was estimated at £106,758.

42. Other contributions consisted of: Liverpool City Council, £10,000; private donors, £10,000; trusts, £5,000.

43. Further information relating to the contributions made by the Walker Art Gallery and the Philharmonic to the cultural life of Liverpool and the extent of corporate support is set forth in chapters 10 and 12.

founded to produce plays with minority appeal not usually available at other local theaters. The small company operates in a former cinema whose seating capacity is 650. Corporation subsidies have, from the beginning, been necessary; they amounted to £6,864 in 1964–65, £12,135 in 1965–66, £13,636 in 1966–67, and £8,360 in 1967–68.[44] Another enterprise, the Liverpool Playhouse, is the home of the oldest repertory company in Britain which, until 1963–64, received no direct subsidy from the city. Beginning in 1965, the corporation guaranteed the repertory an annual subvention of £7,500 for seven years. The theater is being rebuilt and enlarged, with its construction financed in part by an outright capital grant from the corporation of £25,000 and an interest-free loan of £45,000, repayable in equal installments over a six-year period.[45] Also assisted is the Crane Theatre, with subventions in 1966–67 of £571 and in 1967–68 of £8,547; allocation for 1968–69 was estimated at £15,000. Its building, containing a small theater, is leased to the city; its facilities are used by some twenty-five amateur groups. The corporation employs staff to operate the building and leases the auditorium and meeting rooms at reduced rates.

In other art fields, the city council has provided only modest financial assistance. In 1966–67 allocations included £100 to an amateur operatic group, £500 and £250 respectively to Sadler's Wells and to the Ballet Rambert, to help finance local appearances. Grants to Sadler's Wells and Ballet Rambert were not renewed in 1967–68. A number of other organizations received small grants. [46] The Bluecoat Arts Forum, established in 1961, coordinates the activities of numerous arts clubs and societies. Corporate support in 1966–67 amounted to only £500; however, in 1967–68, it was raised to £2,500. The forum presents its own programs and helps to finance events sponsored by member societies—including concerts, art exhibitions, and experimental films. In mid-1968 the Bluecoat Arts Forum and the Liverpool Neighbourhood Organizations Committee decided to sponsor the formation of a community arts center. As for the city's parks, limited sums are available to underwrite music: £3,197 in 1966–67 and £3,700 in 1967–68. The 1967 summer season featured band concerts and occasional beat groups.

How has Liverpool responded to the conflicting demands of "the sewers and the symphonies?" Not possessing the wealth of Birmingham, for a long period its industrial base failed to expand appreciably, and the corporation was reluctant to undertake desired redevelopment and modernization projects. Its record of supporting the arts compares favorably with that of

44. The 1966–67 subsidy included £3,330 to liquidate an accumulated debt, £8,666 to defray rental costs, £400 for building improvements, and the remainder to subsidize attendance of schoolchildren.

45. Under this arrangement the corporation is not actually providing any operating subsidy, for its annual grant of £7,500 is offset by the £7,500 paid to it to liquidate the £45,000 loan.

46. These included the Liverpool Youth Music Advisory Council, Merseyside Youth Orchestra, Liverpool Mozart Orchestra, English Folk Song and Dance Society, and Saint George's Hall Organ Recitals.

other British cities, although it is not by any means commensurate with needs. It is one of the few cities that has thoroughly examined its current support programs and has then projected subsidy requirements for the future. Support has been most generous for art, drama, and music; relatively little has been done to assist opera, ballet, literature and poetry. No action has been taken by the city to establish arts centers as suggested in its 1965 white paper. Possessing an outstanding art gallery, a concert hall, and three theaters, it is not likely to construct a massive complex. In 1968 Liverpool decided to support the formation of the Merseyside Arts Association, which it hoped would provide for one and one-half to two million people. This new representative organization will raise money for the arts from local authorities, private organizations, and the Arts Council, and will allocate its funds to specific cultural organizations. Discussions have been held with representatives of the Northern Arts Association in an effort to ensure that the two regional associations will work together whenever possible. Earlier, Liverpool had refrained from joining the Northern Arts Association, for it felt that the resulting regional association, covering six million people, would be too large; it preferred to be a part of a smaller, more flexible grouping.

Coventry Stimulating and progressive, the city of Coventry, with a population of 333,830, exhibits remarkable industrial and commercial expansion, which took place following widespread destruction in World War II. The city's center was rebuilt as a pleasant traffic-free precinct. New civic buildings include an art gallery and museum, the Belgrade Theatre, and colleges of art and technology.[47] Dominating the scene is the new cathedral, consecrated in 1962.

Since 1945 Coventry has evolved a distinctive and comprehensive program of arts subsidy. City expenditures in support of cultural activities in 1966–67 totaled £117,254, or 2.1d. in the pound; in 1967–68, £112,543 were expended, constituting 2d. in the pound. Control of the city council rested with the Labour Party from 1938 until 1967, when Conservatives took control.[48] The significance of this shift to the right, as it relates to city arts subsidy, cannot yet be assessed, for the 1967–68 budget was set by Labour prior to their leaving office. National economic stringencies are likely to limit budgetary increases in most subject areas during the next several years. Two council committees are concerned with arts support: the recreation committee keeps a watchful eye on the Herbert Art Gallery and Museum,

47. Buildings planned for future erection, when funds become available, include a new central bus station, a public library, additional civic offices, a civic hall, a new fire station and an annex to the Belgrade Theatre.

48. After the 1967 election, the council consisted of 41 Conservatives and 23 belonging to other parties; the aldermanic lineup was 10 Conservatives and 7 others. In 1968 the Conservatives gained one council seat.

and the policy committee deals with matters relating to the Belgrade Theatre.[49]

The City Museum was a private, local folk museum, established in 1920 and housed in an unused school building that was taken over by the Coventry Corporation in 1930. When hostilities began in 1939, the museum was closed and its contents were placed in storage. In 1938 Sir Alfred Herbert, a wealthy businessman, had presented the city with a sum of £100,000 to finance the construction of an art gallery and museum on a site to be provided by the corporation. At the outbreak of war, only a portion of the basement had been completed; it was used as an air-raid shelter. In 1949 the basement was reopened to house art exhibitions and token museum displays for a decade. In 1954 the foundation stone for the new building was laid; the completed structure opened in 1960.[50] The art gallery is engaged in slowly building up its permanent collection. For the present, its principal function is to house loan exhibitions. Since the museum and art gallery are situated in the same building, the corporation does not keep separate financial accounts of expenditures. For 1966–67, the net cost to the city was £96,407; in 1967–68, net expenditures rose to £99,218.[51] Funds for the purchase of art have been grossly inadequate, amounting to £1,500 for 1965–66 and for 1966–67; this sum was reduced to £500 for 1967–68 and remained at that level for 1968–69.

The Belgrade Theatre is dealt with in detail in chapter 9, below. Suffice it to report here that the theater is operated by a trust, independent and non-profit-making, and presided over by a nineteen-member council of management, ten of whose members are also on the city council. The theater, together with adjoining apartments and shops, was erected by the city at a cost of £347,256, which was repaid by annual recoupment charges. For a number of years the city's basic grant to the Belgrade was £9,000. In 1966–67, the theater received £9,000 as a regular grant; in addition, £8,197 were given to eliminate an accumulated deficit and £3,500 to finance an intensified publicity program. The basic grant for 1967–68 was £12,500 and a similar sum was allocated in 1968–69; no special grants were sanctioned.

Coventry provides a token subvention of £150 per year to the Coventry Philharmonic Society to assist it in presenting a limited number of concerts. Also aided is the Coventry Orchestra and Chamber Music Society, established in 1960. Musicians are employed ad hoc for the several concerts it sponsors each year. Finding that the best players continually left Coventry to accept higher-paid employment in London, the society reorganized in

49. In 1968, recreation committee members numbered 18—10 Conservatives, 4 Labour and 4 co-opted members (for Art Gallery and Museum purposes). The policy committee consisted of 8 Conservatives.

50. By 1960 Sir Alfred's gifts and accumulated interest totaled some £250,000.

51. For 1966–67, expenditures for museum and gallery totaled £98,679; income amounted to £2,272, leaving a net cost of £96,407. In 1967–68, gross costs totaled £100,013; income amounted to £795, making net expenditures £99,218.

1964 and engaged established groups, many with international reputations.[52] The corporation grant in 1967–68 was £250. For some years the city subsidized the Coventry Festival Society; in 1963 its grant amounted to £1,000. At the end of 1963 the society ceased to exist, having accumulated a deficit of £4,346. Fiscal disaster stemmed from a number of causes, the most devastating, perhaps, being direct competition from the Coventry Theatre, which staged three weeks of ballet and opera immediately prior to the 1963 festival's opening. Most important, the festival possessed no flavor of its own; over the years its programs failed to attract sufficient attendance from the surrounding region. No city funds go to assist Coventry Cathedral in financing its quality programs of drama and music. The Umbrella Club, presenting distinctive programs of music, drama, literature, films, visual arts, jazz, and current affairs, is aided by being required to pay only a modest rental for its city-owned premises. Thus far, Coventry has done little to support ballet, opera, and orchestral music; nor has it joined other cities in financing a Midlands orchestra. The Coventry council's capital construction program for 1968–69 onward includes plans for the erection of a civic hall with an auditorium large enough to accommodate symphony concerts. Also high on its list of priorities is the Belgrade Theatre Annex, designed to contain facilities for "the theater in education project," a small studio theater to be used for the presentation of new and controversial plays, offices, and workshop and storage facilities. The erection of these buildings under both the council's and the national government's policy of financial restraint is deferred to an indefinite date after 1971.

Brighton A colorful seaside resort located on Britain's south coast, Brighton is a county borough of 162,500 with unusual entertainment facilities and cultural resources. Dominating the scene is the Royal Pavilion, created in the late eighteenth century by the then Prince of Wales (later George IV). The palace has been used by the town for some years as a cultural center.

In 1968, Brighton County Borough is controlled by the Conservative Party. Two of its council committees are concerned with the arts—Entertainments and Publicity, and Royal Pavilion, Museums and Libraries. Financial accounts are not kept in a form which reveals the exact sums expended on the arts each year; however, it appears that in 1967–68 some £75,000 to £80,000 were spent in support of the arts, an amount equivalent to slightly less than 2d. in the pound.

A special three-month summer exhibition is held annually in the Royal Pavilion to show numerous pieces of furniture and art objects. The art

52. Between 1965 and 1967 participants included The Budapest Piano Trio, Tel-Aviv String Quartet, The Camden Wind Quintet, Netherlands Quartet, the Drolc String Quartet and the Prague String Quartet. Six concerts are given annually. Income derived from annual subscriptions of some 200 members and from ticket sales is augmented by small annual guarantees from the National Federation of Music Societies and by grants from the Coventry Corporation.

gallery and the museum are housed in the same buildings with the library, structures once a part of the royal stables. The gallery collection includes one of the larger provincial holdings of European old masters, chiefly Flemish and Dutch, and English paintings of the eighteenth and early nineteenth centuries. Temporary art exhibitions are mounted frequently. A picture lending library, established to stimulate individual interest and appreciation, has some 350 pictures, mostly reproductions but with a few original works.[53] Since 1951 Brighton has staged an open air art exhibition on the sea front to display local work, both professional and amateur. All exhibits are offered for sale.

The Dome serves as a theater, seating more than 2,100 persons, with a huge stage. Equipped with a large four-manual organ, it is used for orchestral and choral concerts, organ recitals, jazz and popular concerts, summer variety shows, conferences, and ballroom dancing.

The Brighton Festival, first held 14–30 April 1967, has elicited much favorable comment. Sponsored by the Brighton Festival Society Ltd. and directed by Ian Hunter, it was initiated by the Brighton Corporation. Expenditures incurred by the festival totaled £41,000; financial support received included an initial corporation grant of £10,000, private donations of £7,000, and an Arts Council subvention of £5,000. The deficit of £4,000 was later offset by a supplemental grant from Brighton. The National Theatre played an important role in the Festival with performances of three plays; a Brighton Festival Ensemble gave three concerts, seeking to effect innovations in the manner of presenting contemporary music; concerts were given by the Warsaw Philharmonic, and leading British orchestras and ensembles; and numerous art exhibitions were held. The second Brighton Festival was held in 1968, its objective being to highlight contemporary and future developments in the arts against a background of Brighton's history and traditions. The corporation contributed £14,000 towards a total cost of approximately £30,000; the Arts Council gave £5,000.

The Brighton Philharmonic Society presents orchestral and occasional chamber concerts in the Dome. The 1966–67 season featured concerts by the Brighton Philharmonic, the Bournemouth Symphony, the Hallé, the London Philharmonic, the London Symphony and the New Philharmonia. Although it received a grant of £1,250 from the corporation and £4,000 as a guarantee against loss from the Arts Councils, the society ended the year with a deficit on concerts of £1,575. For 1965–66, Brighton had made available £1,250, and the Arts Council had paid £3,000 on its gurantee, leaving the society with a loss of £2,780 on concerts.[54] The Brighton Philharmonic is a fully professional orchestra drawn primarily from London; players are

53. Total annual attendance at the museum and the art gallery has averaged almost 400,000 during the past several years.

54. Corporation support amounted to £1,000 for 1962–63 through 1964–65, and Arts Council guarantees totaled £1,473 for 1962–63, £2,117 for 1963–64, and £2,500 in 1964–65. Deficits on concerts written off against accumulated reserves were £1,176 in 1962–63; £1,846 in 1963–64; and £3,012 in 1964–65.

employed on a per concert basis. Public response has been enthusiastic; average attendance at the Dome concerts in 1966–67 was 83.5 percent of seating capacity, and in the previous year, 87 percent of seating capacity. Since its inception in 1925, the society has shown imaginativeness and managerial persistence, but at times it has encountered overwhelming difficulties—mainly financial. Corporation support, begun after World War II, was excessively modest, and it was not until 1958, when the society's continued existence was in grave doubt, that Brighton increased its grant from £500 to £1,000. Nor was the Arts Council assistance adequate.

Edinburgh With a population of 468,965, Edinburgh is governed by a town council of sixty-eight members, the majority of whom belong to the Progressive Party, which has controlled the city for more than twenty-five years.[55] Many observers have suggested that the Progressives are Conservatives under another label. Policy relating to the arts is formulated by the Lord Provost's Committee—similar to the general purposes committee found in other local authorities. Subventions to artistic and cultural organizations in 1964–65 totaled £121,170. Expenditures in this category for 1966–67 were £130,127; in 1967–68, they totaled £139,979 in grants to thirty-three different bodies. Support for the arts was provided by Edinburgh at the level of 1.9d. in the pound in 1966–67 and 2.0d. in 1967–68.[56]

Edinburgh's Festival of the Arts, has attracted international attention since it was inaugurated in 1947. From the beginning, the corporation played a key role in its management and financing. The society council operating the three-week festival is composed of twenty-one members, with the city represented by the Lord Provost as chairman, the treasurer, two baillies, and eight councilors. Its subsidy to the festival was initially £22,000, but after the 1947 program produced a considerable profit, aid was reduced to £15,000 the following year and remained at this level until 1958, when an increase to £26,250 was sanctioned. In 1962 and 1963 the grant was pegged at £50,000 annually; city support for 1964 through 1967 was £75,000. In 1968 a drive to reduce overall municipal expenditures resulted in a cut to £50,000, but increased costs of production induced the council to agree to an additional allocation of £25,000. Details of the Edinburgh Festival are set forth in chapter 13.

Edinburgh gives financial support to the Scottish National Orchestra. During 1966–67 the orchestra made 208 different appearances in Scotland

55. After the elections of May 1968, the Edinburgh Town Council consisted of 34 Progressives, 21 Labour, 8 Scottish Nationalists, 3 Conservatives, 1 Independent and 1 Liberal.

56. Four museums are operated by the City—Huntly House, Canongate Tolbooth, the Museum of Childhood, and Lady Stair's House—none of which is a gallery. Edinburgh provides summer entertainment in its parks: programs include dance performances, bandstand concerts, and children's entertainment, little of which can properly be classed as professional art. £24,560 were budgeted for parks committee activities in 1966–67. These sums are excluded from the annual totals for corporation arts subsidy.

and traveled over 15,000 miles, playing in major cities and smaller communities and accompanying the Scottish Opera; it also gave forty concerts especially for schools. The corporation's subsidy to the orchestra in 1967–68 was £21,000, and in 1966–67, £16,000. Other local authorities help to underwrite its operations: in 1966–67 Glasgow paid £34,000; Aberdeen, £5,136; Dundee, £4,370; and Lanark County Council, £1,000; approximately £5,000 were received from more than 140 smaller authorities.[57] Aid in the amount of £200 is extended to the Edinburgh Youth Orchestra, formed in 1963. The Edinburgh Musical (Competition) Festival Association is assisted to the extent of £400; annual competitions stimulate amateur performances in vocal and instrumental music, and Scottish dancing. In 1967–68 grants of £100 or less were made to eight other musical organizations.[58]

The Scottish Opera Company, organized in 1962, has benefited from continuous Edinburgh Corporation subsidy. During the 1966 season the Opera Society received £3,000 from Edinburgh and an equal sum from Glasgow; for 1967 these subventions were increased to £5,000.[59] Ten performances are given in each city annually. Grants of £100 or less are made to the Edinburgh Grand Opera Group, the Edinburgh Opera Company and the Edinburgh Churches Choir. In the field of dance relatively little is done. The Edinburgh Ballet Club, organized in 1945 and supported in the amount of £250, affords its amateur members an opportunity to study and practice ballet and gives one public performance a year, which employs professional artists. Edinburgh recently has accorded support to films: the Edinburgh Film Guild, with close to 700 members, receives £150 annually. The National Film Theatre established one of their "regional" theaters in Edinburgh in 1967, renting for a portion of the year the cinema owned by the Film Guild. The corporation made a special grant of £1,250 in 1967–68 toward the cost of improving the theater: in addition, £1,600 were provided for this purpose by the British Film Institute in London. In 1967–68, a £700 grant plus a guarantee of £500 were given to the Edinburgh Film Festival Council by the Lord Provost's Committee to help finance a two-week film festival.

Thus far, Edinburgh has not established a municipal art gallery, since three major galleries are maintained within its precincts by the national government—the National Gallery of Scotland, the Scottish National Gallery of Modern Art, and the Scottish National Portrait Gallery. The corporation has, however, acquired a considerable number of works of art, and the question inevitably arises whether it should at some future time construct a gallery of its own.

57. Orchestra subventions are based on local authority population, Edinburgh paying at the rate of 8d. per person.

58. These went to the Edinburgh Symphony Orchestra Society, the Martin Chamber Orchestra, Edinburgh Pro Musica, Leith Community Association, Pentland Youth and Community Centre, Connoisseur Concerts Society, New Town Concerts, and the Edinburgh Royal Choral Union.

59. In 1966–67, other local authority support totaled £1,200—Aberdeen, £750, Perth County, £150, and Perth, £300.

Major national and local government support of theater in Edinburgh was slow to emerge. The Gateway Company, performing in a small, converted cinema, in 1960–61 was accorded a subsidy by the corporation of £1,000; by 1963–64, this grant had doubled. As early as 1960 plans were formulated to establish a civic theater. In 1963, the corporation purchased the Lyceum Theatre, and from then until May 1965 this antiquated structure (seating capacity 1,600) was operated directly by a subcommittee of the Lord Provost's Committee; it was let to touring companies and other organizations. Rejecting proposals that the city itself constitute a permanent company, the Edinburgh Civic Theatre Trust Ltd. was formed and immediately began to assemble a professional company. Corporation control has been retained, however; the trust's twelve man board of management includes eight members of the city council. In 1965 the council sanctioned a plan calling for the redevelopment of the Lyceum Theatre–Castle Terrace area to include the erection of a hotel, a conference hall, and two theaters, the large one to seat up to 1,600, and the smaller one, 800. In 1968, construction costs of the two theaters were estimated to total £4,000,000, a portion of which, it is hoped, will be borne by the Arts Council. The corporation grant to underwrite the Royal Lyceum Theatre Company's current operations amounted to £32,000 in both 1966–67 and 1967–68.

Corporation grants to the Traverse Theatre Club are £350 annually. Founded in 1963 by a group of artists, actors, and business and professional men, the club, with a membership of 1,500, maintains a theater and an art gallery and sponsors concerts and poetry readings. Although possessing only sixty seats, the theater has attracted some of Britain's finest directors and actors and has staged more than thirty premieres during its first three years. Emphasis is upon experimentation and innovation. The corporation owns the Church Hill Theatre, a former church converted at a cost of £72,000, which is used by amateur groups presenting plays, operas and ballets.

Aside from its role in the creation and support of the Edinburgh Festival the city has been slow to evince interest in the arts, and the aggregate of its annual subventions, while for the most part on a par with those of other major cities, are not yet adequate. Completion of the Lyceum Theatre–Castle Terrace complex will undoubtedly stimulate significant new interest in drama and music; and discussions are now being held looking to the formation of a new opera company based in Edinburgh. Progress, however, has not been achieved without painful incidents. In August 1966, Tom Fleming resigned as director of the Royal Lyceum, asserting that he could not continue without the complete confidence of the Civic Theatre Trust. During the theater's first season, attendance had been disappointingly small, and £13,245 were lost, in spite of corporation and Arts Council subsidies. The trust, through a small program advisory panel, declared that plays of wider popular appeal should be presented. Fleming replied: "I would not have thought this to be in the best interest of the theater." He had

not started out with the idea of being "popular." "The level at which one starts is the level you will have for all time," he said—an assertion which hardly conforms to the experience of other British theaters.

The Future In its 1959 report on problems encountered in arts subsidy in Britain, the Gulbenkian Foundation concluded rather pessimistically that "so long as local authorities as a whole spend less than a twentieth of the 6d. rate permitted, they can be regarded as only marginal instead of major patrons of the arts."[60] This adverse judgment took into account expenditure by local governments of additional sums for museums and galleries under powers granted to them independent of the 1948 act. The report accorded recognition to the few large cities which had made more ample provision for arts support, contrasting them with the bulk of the nation's local authorities. How valid is this judgment today? Data depicting the extent of current local government arts patronage are not available, the most recent factual survey having been made for 1961–62. Fragmentary evidence indicates that the level of local arts subsidy has risen modestly in the intervening years. In making comparisons, however, it is important to remember that reevaluations of the tax base have taken place throughout the country so that the yield of a 1d. rate in the pound produces substantially more actual moneys than previously. Today, most of the major municipalities spend less than a third of the permissible 6d. maximum. Of those examined in this study, excluding the Greater London Council and the City of London, the most generous allocated no more than 2.5d., and one as little as 1.3d., including expenditures for art galleries. Local support is indispensable if the arts are to be readily available to all the people; more vigorous efforts need to be made to increase subsidies by the larger governments. However, urban and rural districts, with smaller populations and limited fiscal resources, cannot be expected to provide significant financial support for the professional arts.

Today, appreciable local authority support is accorded professional theater, and much is done to assist symphony orchestras and other musical undertakings. Subsidy of opera and ballet outside London is minimal; if discussions now under way should lead to the establishment of several provincial opera companies, a major portion of the subsidies required will have to be derived locally. Municipal support of art galleries is for the most part restricted to provision of buildings and their maintenance; funds appropriated by councils to finance the acquisition of works of art are pitifully small. Most serious is the inability of local galleries to halt the "art drain," principally to America. Priceless treasures are being exported because local councils are unwilling to spend the money to keep them in the country. Local councils have failed to assist individual artists by using Arts Council techniques such as subsidies for performance or exhibition, or bursaries to

60. *Help for the Arts: A Report to the Calouste Gulbenkian Foundation* (1959), p. 26.

free creative artists temporarily from financial anxieties. Local financial support, in a number of instances, has permitted arts centers to develop imaginative and well-rounded programs that appeal to the interests of an appreciable number of local residents. More could be profitably done in this area. The needs of literature have received little notice; relatively small sums given by local authorities to literary organizations could produce gratifying results.

Changes in organizational arrangements as they pertain to local authority arts subsidy have been suggested from time to time. Direct management of theaters, orchestras, and other artistic enterprises has been undertaken to a limited extent by local governments. The Arts Council once observed that certain local authorities "have shown an excess of zeal by providing concerts and plays under their own management, an endeavour which could seem to be—even if not designed as such—a movement towards *l'Art Officiel* and, on that ground, as dangerous as similar provision by a central quasi-governmental body such as the Arts Council."[61] The council prefers that subsidies be made to nonprofit trusts with local council representation on their governing bodies. The dangers of interference do not seem to have materialized—for example, in the Festival Hall in London, the Fairfield Halls in Croydon, and the Library Theatre, Manchester.[62] Another proposal —that the Arts Council institute direct grants to local authorities in support of the arts—has thus far not been adopted, although, if sufficiently large, such subventions would be most helpful. Were grants of this type to be introduced, the local governments should, without question, be required to match them pound for pound. Suggestions for extending the powers of the 1948 act to county councils in England and Wales, thus increasing their authority to spend money in aiding the arts, were raised in the 1965 white paper. No action has been taken. Most important, perhaps, is the recommendation that local governments could subsidize the arts more adequately, if they were to abandon their "go-it-alone" philosophy and join with other authorities in providing cooperative support. The Gulbenkian Report asserted:

The only way in which the provision of artistic facilities in the provinces can be raised to a high standard is by the creation of some kind of provincial network. The greatest service to the arts in this country would come about, and perhaps can only come about, from the recognition, by the citizens and civic authorities of, say, the twelve largest provincial cities in this country, of the enrichment which the arts can give to the life of the community as a whole.[63]

A spirit of rivalry between these cities could develop which would lead each to provide the best of artistic activities for itself and the surrounding authorities in its own concert hall, theater, museum, and picture gallery. The

61. *The First Ten Years: The Eleventh Annual Report of the Arts Council of Great Britain 1955–1956*, p. 27.

62. Ruck, *Municipal Entertainment and the Arts*, pp. 23–24.

63. *Help For the Arts*, pp. 29–30.

Eastern Authorities Orchestra Association, the Midlands and the South Western Associations for the Arts, and the Northern Arts Association, though not adhering precisely to the Gulbenkian model, represent varying degrees and patterns of cooperation. The founding of a Merseyside Arts Association, now in process, is a further step in this direction.

7 / POLITICAL PARTIES AND THE ARTS

Indeed, we have now established that the arts . . . must be
sustained by everyone, whatever their political point of view. . . .
—Jennie Lee, 1965

Addressing the House of Commons at 6:36 a.m. on 3 August 1965, Jennie Lee reminded her sleepy-eyed colleagues that subsidy of the arts was not a partisan issue.[1] The occasion was a sharp debate following the publication earlier in the year of the white paper *A Policy for the Arts*. A Conservative had asserted that since the Labour Government had come to power in 1964, its efforts to assist the arts had embraced little that its predecessors had not previously undertaken and that it was trying to make political capital out of the arts. This accusation Miss Lee characterized as unmitigated nonsense.

In this chapter an effort will be made to compare the arts subsidy policies of the three British political parties, primarily on the basis of pronouncements set forth in election manifestos and party literature and financial data obtained from the annual estimates. Meaningful comparisons can be made only at the national government level, for information pertaining to local party differences is unavailable.

Labour Party Policies

J. B. Priestley, in an address to the Fabian Society in London shortly after World War II, asserted that the creation and appreciation of the arts is one of the important ends toward which the socialist state is the means. To make this objective a reality, the state must create a favorable condition for the artist.

The musicians will need plenty of good concert halls and opera houses and fine orchestras and well-trained instrumentalists and singers. The dramatists and actors and ballet dancers cannot function properly without numerous well-equipped playhouses and theatrical organizations on both a national and municipal scale. The painters and their like need . . . special materials and implements, together with studios, galleries and shops for their particular art.[2]

Admitting all this to be elementary and dreary common sense, he pointedly observed that artists' needs were not being met, that he knew of no plans for their fulfillment. Although the Labour Party in subsequent years did develop a relatively comprehensive policy of arts support, it had, oddly enough, almost completely ignored the problem before 1939.

Annual reports published by the Labour Party from 1900 to 1945 contain no reference to the arts. Nor did the election manifestos of this period alert the voters to the plight of Britain's theaters, orchestras, and opera and ballet organizations, or the inadequacy of provision for the visual arts. *The New Charter for the Workers*, appearing in 1917, urged government action to broaden opportunities for British citizens to enjoy life, but did not refer specifically to the arts.[3] A pamphlet entitled *Labour and the New Social*

1. H. C. Debates, vol. 717, col. 1584, 4 August 1965.

2. J. B. Priestley, *The Arts Under Socialism* (London: Turnstile Press, 1947), p. 9.

3. The "good life" was envisioned as involving freer social relations; greater participation in sports, clubs, and public houses; and improved government services in health, housing, employment services, and education.

Order: A Report on Reconstruction, issued the following year, mentioned briefly the need of music for local authority assistance.

The Labour Party holds, moreover, that the municipalities and county councils should not confine themselves to the necessarily costly services of education, sanitation, and police, nor yet rest content with acquiring control of the local water, gas, electricity, and tramways, but that they should greatly extend their enterprise in housing and town planning, parks, and public libraries, the provision of music and the organization of popular recreation.[4]

Greater concern for the arts was expressed in a sixteen-page broadside, *What Socialism Will Really Mean to You*, issued in 1935. References to music and theater were couched in the somewhat stereotyped language of traditional socialist doctrine.

At present, because practically all land and buildings are privately owned, the rent of theatres and concert-halls . . . is extremely high. Consequently the greater part of the seats they contain (stalls, dress and upper circles) are expensive. In fact, concerts and plays are at present the resort of the rich and well-to-do. The present profit from them goes first in rent to the private owner of the land—the landlord, and secondly, to the private so-called "producer" and to the private advertising and other agents. The *real* producers—the musicians and actors—come third. Only the very well-known actors and musicians get large salaries. For the remainder, life is often very difficult. Their pay is not too splendid and they are often out of jobs. And yet the mass of the people greatly want, and rightly want, to go to concerts of music and plays.[5]

The paradox was frustrating, with musicians wanting to give concerts, actors, to perform plays, and the people, to hear and see them. The villain, quite obviously, was the private owner. Reforms were needed to enable the working masses to profit from the creative contributions of professional musicians and actors and in turn to generate box-office demand to insure that artists enjoyed a fair share of the nation's economic wealth. Under socialism, concert halls and theaters would belong to the community and new facilities would be opened, so that all musicians and actors could be profitably employed and the masses could enjoy attending concerts and plays. Profits would no longer go to theater and concert-hall owners and producers but would accrue to the real "producers"—the actors and musicians. Since the working population's incomes would increase under socialism, modestly priced seats would draw large audiences. Significantly, the desirability of patronage in the form of central and local government subventions to non-profit artistic bodies was not foreseen. And, most important, the party appears not to have carefully investigated the economics of the performing arts, for it assumed that music, opera, ballet, and theater could pay their way under public ownership without substantial annual operating subsidies.

Labour's interest in the professional arts proved to be somewhat ephemeral, for its 1937 pamphlet *Labour's Immediate Programme* contained no

4. *Labour and the New Social Order: A Report on Reconstruction* (London: Labour Party, 1918), p. 15.
5. *What Socialism Will Really Mean to You* (London: Labour Party, 1935), p. 10.

reference to public ownership or subsidy.[6] Throughout this period, Labour M.P.'s and local councilors supported efforts to make financial provision for museums and art galleries, but the party did not try to capitalize on this in its appeals to voters.

The Fabian Society, which performed an exceedingly important role in educating the British public on the need for a comprehensive welfare state and a socialized economy, amazingly exhibited no interest in the arts. Between 1884 and 1945, the society, as an important adjunct of the Labour Party, concerned itself with almost every other aspect of British society, publishing 261 tracts, 107 research pamphlets, and some 79 books and other documents. The intellectuals who guided its activities—Sidney and Beatrice Webb, G. D. H. Cole, Harold Laski, Clement Attlee, and Leonard Woolf, to mention only a few—confined their efforts to devising methods by which governments could assist the people in improving their material well-being. Education was the focus of their attention, but not the arts. Even George Bernard Shaw, one of the most active Fabians, did not advocate Treasury subventions to artistic bodies.[7]

Labour's participation in the coalition government during World War II induced it to change its policy toward the arts. CEMA's programs of encouragement and support revealed the potentialities of an effective system of public patronage. Its program for postwar reconstruction, issued in 1943, declared:

War-time experiments have shown how wide and eager is the audience that is anxious for [the arts'] sustaining vigour. The Labour Party is opposed to allowing these experiments to end with the Peace. On the contrary, it urges that means should be taken to make the theatre and music, painting and sculpture, the cinema and dance, a living part of our social experience. The necessary adjustments in the powers of Local Authorities should be made now to enable them to bring the Arts into the daily lives of the citizens they serve.[8]

During the general election of 1945, Winston Churchill and the Conservatives accorded priority to foreign affairs, and Labour, to domestic concerns. Labour's principal policy declaration, *Let Us Face the Future*, did not, however, heartily endorse arts subsidy. National and local authorities were urged to cooperate to enable people to enjoy their leisure to the full. "By the provision of concert halls, modern libraries, theatres and suitable civic centres, we desire to assure to our people full access to the great heritage of culture in this nation."[9] Once in power, Labour, understandably, devoted its energies primarily to rehabilitating the nation's bombed cities, establishing a comprehensive social welfare system, creating a National Health Service, and nationalizing key industries. However, Hugh Dalton, the party's first

6. *Labour's Immediate Programme* (London: Labour Party, 1937), p. 6.

7. See St. John Ervine, *Bernard Shaw: His Life, Work, and Friends* (London: Constable and Company, Ltd., 1956).

8. *Labour's Win-the-Peace Programme* (London: Labour Party, 1943), p. 4.

9. *Let Us Face the Future* (London: Labour Party, 1945), p. 9.

6

postwar Chancellor of the Exchequer, at a time of severe economic privation, presided over CEMA's reconstitution as the Arts Council, and his successor, Sir Stafford Cripps, made limited resources available to reestablish Covent Garden as an internationally famous opera house. Interest in the arts increased, although government funds for their support remained limited. In 1948, the party, looking to the 1950 election, issued a pamphlet alerting the British public to the need for more generous state provision. On the local level it asserted that "the municipalities have already been given powers to operate theatres and cinemas, and under these powers and some new ones they might reasonably extend their activities to the production of plays, films, pageants and other art-forms. . . . Theaters and film-studios lend themselves naturally to the technique . . . of government ownership of installations which are leased out for municipal or private operation."[10] Enactment of the Local Government Act of 1948 by Labour opened the way for local authorities to spend up to the product of a 6d. in the pound rate in support of arts and entertainment.

The party in 1949 produced a comprehensive policy document, reviewing progress achieved and projecting future steps. As for the arts, it asserted that Labour had added greatly to opportunities for full enjoyment of leisure. The Arts Council had brought the arts within reach of the people in every part of Britain. The government, after decades of delay under the Tories, fully supported the project for a National Theatre. In addition, it was planning the erection of a new concert hall on the South Bank in London and scheduling a Festival of Britain for 1951, which, it was hoped, would revivify the arts. Labour pledged that it would do all it could to encourage the arts "without interfering in any way with the free expression of the artist."[11] Labour's 1950 election manifesto, *Let Us Win Through Together*, however, contained only brief mention of the arts.

Labour's victory in 1950 was paper thin, and it was obvious that a new election would soon be called. In 1951, the Conservatives, under the leadership of Churchill, returned to power. During its six years in office, Labour had increased Treasury grants-in-aid to the Arts Council from £235,000 for 1945–46 to £675,000 in 1950–51.[12] Annual increases were, in most instances, relatively modest, greater priority being given to health, education, welfare, and economic rehabilitation. But at no time did the Conservative opposition urge the Labour government to increase subsidy allocations substantially.

In December 1953, Labour published a booklet, *Challenge to Britain*, containing specific proposals to meet problems facing the nation; no reference was made to government arts patronage. The 1955 Labour manifesto, *Forward With Labour: Labour's Policy for the Consideration of the Nation*,

10. Ian Mikardo, *The Second Five Years* (London: Labour Party, 1948), p. 8.

11. *Labour Believes in Britain* (London: Labour Party, 1949), p. 21.

12. Arts Council grants from the Treasury during Labour's tenure in office were: £235,000, 1945–46; £350,000, 1946–47; £428,000, 1947–48; £575,000, 1948–49; £600,000, 1949–50; and £675,000, 1950–51.

also neglected to specify what, if anything, the party would do to meet the needs of the arts.

The Future Labour Offers You, published in 1958, while Labour was still out of office, did contain a section on recreation and the arts. The people, particularly the youth, it asserted, urgently needed greater facilities for constructive utilization of increased leisure. What happens to the arts concerns everyone, but "it is especially a matter for young people who in this age of radio and television can acquire at home a taste for arts, ballet, music and the theater."[13] These arts had been accorded niggardly provision by the Conservatives. Labour promised to make available more money for the arts, a pledge it was not destined to redeem until almost a decade later.

The party's unsuccessful appeal at the October 1959 general election was based on a restatement of policy entitled *Britain Belongs to You*. Major emphasis was given to the need to expand industrial production greatly and to raise living standards. When this occurred, people would increasingly be able to choose between more money and more leisure. "How the balance is struck is largely a matter for the trade unions in negotiation with the employers. How leisure is spent is a matter for the individual. Governments should not interfere in either. The individual, however, can only have real freedom to use his leisure as he wants to if proper facilities are available to all and not merely to a privileged few; and this is where both the Government and the local authorities can help."[14] It promised to make much better provision for the enjoyment of sport, the arts, and the countryside. The pledge to establish the National Theatre was renewed, and the party promised to raise the Arts Council grant by £4,000,000, this being the first election in which it had committed itself to a specific increase.

In 1959 Labour issued *Leisure for Living*, fifty-two pages in length, the first major statement ever made by a British political party on the use of leisure and the support of the arts. The *principle* that public money ought to be spent in encouraging the arts and in providing for many kinds of recreation was now universally accepted, the report declared, and the crucial issue was the *application* of this principle, the determination of the *extent* to which it was to be applied. Labour proposed to place into effect more coherent, imaginative, and generous programs, yet avoid the pitfall of making the state an official "nanny," trying to run everybody's private lives.[15] However, freedom of choice could not be exercised unless the best in the arts were available and reasonably accessible to all. J. B. Priestley was quoted as expressing this view most effectively:

. . . art is not really like the icing on the cake, it is far more like the yeast in the dough. It is not something added, for decoration and fancy-work, when the solid job has been done; it is much nearer the leaven, permeating and then aerating and lifting the

13. *The Future Labour Offers You* (London: Labour Party, 1958), p. 8.

14. *Britain Belongs to You* (London: Labour Party, 1959), p. 2.

15. *Leisure for Living* (London: Labour Party, 1959), p. 7.

doughy stuff of life. The true artist . . . when we have understood him . . . has immensely enriched our lives, sharpening our eyes and ears, broadening our sympathies, quickening our imagination, and enlarging our experience. . . . never did men need the artist more than they do today.[16]

"Public support for the arts ought not to be an issue of party politics," Labour reminded its readers, "and we gladly acknowledge the enthusiastic interest shown in it by some Conservatives in both Houses of Parliament; but we are entitled to emphasize a real difference between the general attitude and practical conduct of the two parties when in office, and to say that in our opinion . . . the Tory Government has handled this problem with almost doctrinaire niggardliness."[17] As long ago as March 1956, *Leisure for Living* observed, Labour had urged substantial increases in the purchase grants of the national galleries and museums, but it was not until 1959 that the government responded. Characterizing the Conservative action in increasing subsidies as a deathbed repentance rather than a considered attempt to meet the true needs of the arts, the pamphlet asserted that these increases were inadequate in view of rising costs. It also complained that little had been done to bolster the arts outside London. The Labour Party proposed to create a more coherent pattern of patronage, with the Arts Council remaining the principal instrumentality; the size of its grant, the party declared, ought to be increased, and the government should cease to dole out funds on a short-term basis but should plan ahead for a period of at least five years.

Sections of the report dealt with architecture, theater, opera, ballet, orchestral music, cinema, television, and sports. Major emphasis was given to prevailing conditions; proposals were advanced to strengthen and expand artistic provision, although frequently the suggestions put forward were not spelled out in detail.

In May 1964, the party issued a mimeographed document, *The Quality of Living*, which commented on changes effected in arts subsidy since 1959. It accused the Conservatives of having made no serious attempt to meet the needs of the arts as outlined in *Leisure for Living*, although the proposals made then remained as relevant as when first put forward. Promising to accord the Arts Council adequate funds, if returned to power, Labour also stipulated three changes which needed to be effected, all of which were made when the party returned to office. First, a senior Cabinet minister should be assigned responsibility for public organizations principally involved—an enlarged Arts Council and a new Sports Council. Second, greater emphasis should be accorded adequate housing of the arts, a prerequisite for their survival. And third, impressed by the success of the North Eastern Association for the Arts, the party endorsed the formation of new regional bodies which could mobilize financial support from a diversity of sources. *Let's Go*

16. Ibid., p. 9.
17. Ibid., p. 12.

With Labour for the New Britain, the party's manifesto for the 1964 general election, contained only a brief reference to the arts: a Labour government would "give much more generous support to the Arts Council, the theatre, orchestras, concert halls, museums and art galleries."[18]

Labour's 1964 election victory permitted it to alter government policy and to implement proposals advanced by it during its years in opposition. Although Harold Wilson had no personal interest in the arts, he immediately agreed that the party should reexamine the role of government as patron and make more generous provision for arts support. In February 1965, Labour issued its white paper, *A Policy for the Arts*, specifying in considerable detail steps which Labour proposed to take.[19] Asserting that "if a high level of artistic achievement is to be sustained and the best in the arts made more widely available, more generous and discriminating help is urgently needed, locally, regionally, and nationally."[20] In some parts of the country, professional companies were nonexistent, and often a lack of suitable buildings made it impossible to bring leading national companies—orchestral, operatic, ballet, or theater—into those areas. Museums and art galleries were often underfinanced and cheerless in appearance, and possessed meager collections. If the nation was concerned to win a wider and more appreciative public for the arts, drastic changes needed to be effected, and a new social as well as artistic climate was essential. All too many working people had been conditioned by their education and environment to consider the best in music, painting, sculpture, and literature beyond their reach. Hope rested with the younger generation, which, as a result of educational practices, was beginning to develop greater interest in the arts.

The proposals contained in the white paper are, for the most part, dealt with in subsequent chapters. A few of the more important, however, need to be set forth here. Government and local authority aid to the arts had thus far been relatively modest and accorded in response to spasmodic pressures rather than as a result of a comprehensive plan. Urgently needed was a more coherent, generous, and imaginative approach to the whole problem.[21] The government promised to shift responsibility for the arts from the Treasury to the Department of Education and Science, and such action was in fact taken shortly after the report's publication. The grant-in-aid to the Arts Council (excluding Covent Garden) should be increased by £665,000 for 1965–66 over sums spent in 1964–65; more generous provision would be made in subsequent years. Increased appropriations should permit the Arts Council to "make a larger contribution to regional associations, to increase their assistance to the leading artistic enterprises in Scotland and Wales, to ease the financial burdens of provincial repertory theatres, to give a much needed impetus to the development of arts centres and to provide additional ·

18. *Let's Go with Labour for the New Britain* (London: Labour Party, 1964), p. 18.

19. *A Policy for the Arts: The First Steps*, Cmnd. 2601 (London: HMSO, 1965).

20. Ibid., p. 5.

21. Ibid., p. 16.

assistance for first-class orchestras."[22] Labour promised to increase the purchase grants of the national museums, provide funds to encourage the living artists, develop programs of assistance to literature, and make funds available for housing the arts.

When Labour sought to increase its majority in the Commons in March 1966, it did not reiterate commitments previously made concerning the arts. The party manifesto merely reminded the voters that "access for all to the best of Britain's cultural heritage is a wider part of our educational and social purpose, and is one hallmark of a civilized country."[23]

The picture of the Labour Party and its policies concerning the arts would not be complete if mention were not made of the Arts and Amenities Group, set up in the late 1940s and composed of members of the Parliamentary Labour Party who have a special interest in the arts. At the beginning of each session, Labour M.P.'s are requested to indicate which of the party's parliamentary groups they would like to join. Generally thirty or forty M.P.'s designate Arts and Amenities, although less than half this number attend group sessions, which are held at irregular intervals. The Labour group, like its Conservative counterpart, serves a number of useful functions. Its basic aim is to inform itself concerning the arts and to consider proposals designed to assist the arts. Once each year the chairman or the secretary-general of the Arts Council talks with the group about the council's work. The exchange of views which takes place is exceedingly useful. The Minister of State for Education and Science meets with the group periodically; representatives of the National Trust, the national art galleries, and other cultural organizations appear before it to discuss programs and needs and to answer questions. The group also visits national institutions in the London area; recently it conferred with officials of the National Gallery, the British Museum, and the Tate Gallery.

While the group is advisory and its activities are informal, there is no question that it influences party policy. Its members customarily take the initiative in Commons debates relating to the arts. Thus, when the debate on the 1965 white paper took place, most of the participants were Arts and Amenities members; the same was true on the Conservative side. Members confer with Cabinet ministers, request funds for certain purposes, or ask that specific action be taken relating to the arts. The group defends the party's position when attacks are launched by the opposition; it also facilitates general acceptance of Labour's policies by affording interested bodies and individuals an opportunity to present their views.

Treasury provision for arts patronage was greatly expanded and a number of important changes in subsidy arrangements were effected after Labour returned to power in 1964. The Arts Council's Exchequer allocation was significantly increased at a time when Britain was experiencing serious economic difficulties and the Wilson Government was forced to apply

22. Ibid., p. 17.
23. *Time for Decision* (London: Labour Party, 1966), p. 17.

numerous unpopular belt-tightening measures to various sectors of the economy. The council's annual grant-in-aid during the five-year period, 1963–64 through 1967–68, graphically reflects the change of policy: £2,730,000 in 1963–64, £3,205,000 in 1964–65, £3,910,000 in 1965–66, £5,700,000 in 1966–67, and £7,200,000 in 1967–68. Most generous were the council's 1966–67 grant, an increase of £1,790,000 or 45.8 percent over that of the previous year, and the 1967–68 grant, an increase of £1,500,000 or 26.3 percent. Appropriations in support of museums and galleries and other arts organizations rose during the same period but at a less spectacular rate.[24]

The Conservative Party

Until 1900, the Conservative Party, like Labour, took no official cognizance of the arts in Britain. In fact, until the end of World War II, party literature was devoid of references to the arts and their need for public subsidy. Although a number of prominent Conservatives were actively involved in the arts as members of governing boards of theaters, orchestras, and art galleries, most Conservative M.P.'s pursued other interests. Treasury subsidy was contrary to the Conservative philosophy of limited government; nor did the party wish to add to the tax burden in order to underwrite new functions. And, undoubtedly, some shied away from involvement with the arts in the spirit expressed by Sir Alan Herbert:

> As my poor father used to say
> In 1863,
> Once people start on all this Art
> Goodby, moralitee!
> And what my father used to say
> Is good enough for me.[25]

Conservative initiative, as depicted earlier, contributed to the Coalition government's establishment of CEMA as a wartime instrumentality. When the 1945 general election took place, the party focused upon rehabilitation of the nation's cities and industrial plants and upon social and economic issues, and made no mention of the arts. The party in subsequent years accorded the arts low priority; indeed, its 1950 platform, *This Is the Road*, and its 1951 election manifesto, *Britain Strong and Free*, contained no reference to the arts. Interest remained at modest levels during the 1950s, no significant change being evident until the end of the decade. When the voters went to the polls in 1955, the Conservatives in their election document, *United for Peace and Progress*, took no position relative to arts subsidy. Six different policy statements issued during this period, several of which were quite comprehensive in length, completely ignored the arts.[26] Thus, *The*

24. Treasury allocations for museums and galleries and arts organizations other than the Arts Councils were as follows: 1963–64, £5,200,000; 1964–65, £5,881,000; 1965–66, £6,312,000; 1966–67, £6,266,700; and 1967–68, £6,940,000.

25. H. C. Debates, Vol. 598, col. 636, January 23, 1959.

26. David Clarke, *The Conservative Faith in a Modern Age* (London: Conservative Political Centre, 1947, 38 pp; *Conservatism, 1945–1950* (Ibid., 1950, 248 pp; *A Tory Approach to Social*

New Conservatism, a 200-page anthology of postwar Conservative thought, failed to deal with the increasingly urgent need for more generous public patronage. The only party publication to mention the arts was *The Conservative Future*, by L. S. Amery, issued in 1946.

Last, but not least, in any scheme of social policy comes the problem of the right opportunities for leisure. To guide and elevate the pleasure of the people, to enrich their lives as well as to increase their livelihood, is surely not outside the duties of an enlightened State. Why should there not be public provision, not by a monopoly but by subsidy, of the best in every field of art? Our people enjoy the best when they can get it, and independent enterprise is not going to suffer by improvement in the public taste.[27]

By 1959, Conservatives began to give serious attention to the arts. On 23 January, J. E. S. Simon, Financial Secretary to the Treasury, concluding a debate on the financial requirements of the arts, announced the allocation of additional grants to the national museums and galleries, the Arts Council, and other cultural bodies, and asserted:

No Government has ever done more in a single operation in this field. We believe that we shall be putting on a new, firm basis those branches of the arts in Britain which look to the Government for support. We are doing this not only because we feel that the interest of the people of Britain in the arts has greatly increased and that we are thereby reflecting their general wishes, but also because we believe that our action will enhance the richness and variety of our national life.[28]

In the 23 February issue of *Notes on Current Politics*, published by the party's research department, a small section was devoted to the state and the arts, summarizing what the party had done in this sector since it assumed office in 1951.[29] Shortly before the October general election, the Conservative Political Centre released a discussion pamphlet, twenty-three pages in length, entitled *The Challenge of Leisure*, summarizing policy proposals relating to the youth service, sport, and the arts. The results, though limited, represented the first concerted attempt by Conservatives to spell out in writing party policies relating to arts subsidy.[30]

While appreciating what Conservative governments had done in this field, *Challenge of Leisure* declared that contributions by the state were too small in relation to the needs of the arts. Since large-scale private patronage no longer existed, the state should be prepared to "support an essential mini-

Problems: One Nation (Ibid., 1950), 96 pp.; *The New Conservatism* (Ibid., 1955), 203 pp.; *Work for the Nation: Conservative and Unionist Record, 1951–1957* (London: Conservative Research Department, 1957), 132 pp.; *Onward in Freedom* (London: Conservative and Unionist Centre Office, 1958), 27 pp.

27. Amery, *The Conservative Future: An Outline of Policy* (London: Conservative Party, 1946), p. 20.

28. H. C. Debates, vol. 598, cols. 650–51, 23 January 1959.

29. Conservative Research Department, *Notes on Current Politics*, 23 February 1959, pp. 21–24.

30. A critical evaluation of *Leisure* is found in Timothy Raison, "Patronage, Prestige and Principles," *Crossbow, A Quarterly Journal of Politics*, Autumn 1959, pp. 58–59. *Crossbow* is published by the Bow Group, a research organization sponsored by young Conservatives.

mum of what is best in the arts, to consolidate successful ventures and to foster long-term planning."[31] Most important, as standards of performance improved, it would become necessary to effect a corresponding increase in the level of state subsidy. Specific remedies to existing deficiencies were considered to be numerous and complex, requiring extended further study. Attention, however, was given to a few of the more urgent requirements.

The performing arts were suffering from financial blight, unable even to maintain present performance standards, for Arts Council grants were, in effect, actually annual deficit payments. To permit the government to insure even minimum provision of "the best" in the performing arts, some specific proposals were advanced. First, the Exchequer allocation to Covent Garden should be separated from the general Arts Council grant, thus permitting more balanced consideration of the subsidy needs of other organizations.[32] The government should acquire the freehold of the Royal Opera House building, which would be administered by the Ministry of Works. Second, raising performance standards and diffusing the living arts as widely as possible required a marked increase in the Arts Council's grant, assistance to be rendered at least on a quinquennial basis. Third, a considerable portion of these increased funds should be earmarked for drama, an art medium which was receiving only one-tenth of the money allocated to opera, despite the fact that Britain's greatest contribution to the arts was in theater. Immediate action should be taken to erect a National Theatre and to create an outstanding theater company. Fourth, the Arts Council should possess sufficient funds to underwrite for the first time a reasonably adequate dramatic program in the provinces. And fifth, the Arts Council ought to be accorded an opportunity to develop further the nation's resources in music, opera, and ballet, and the visual arts. "The artistic enterprises themselves would be well advised to use a 'pound for pound' approach in seeking extra subsidies from industry, including TV companies, and local authorities. It helps to counteract the tendency for too much central control."[33]

Recommendations relating to arts preservation were less wide-ranging. Support was given to the Standing Commission on Museums and Galleries' recent findings that an urgent need existed for a definite program to strengthen staff and reequip buildings. The circulation department of the Victoria and Albert Museum should be expanded to permit the display of its art treasures more widely in areas away from London. Serious consideration should be given to the creation of a comparable department at the National Gallery. To assist provincial museums and galleries, an emergency fund should be set up to facilitate improvement of building accommodations and staffing, the money to be administered by a joint committee representing the Standing Commission and the Museums Association.

31. *The Challenge of Leisure* (London: Conservative Political Centre, 1959), p. 14.

32. Covent Garden, in effect a national institution, was receiving regularly nearly half of the Arts Council's total appropriation.

33. *The Challenge of Leisure*, p. 17.

6*

The Macmillan government, when it appealed to the British electorate in 1959, accorded relatively little emphasis to arts patronage. Its manifesto, *The Next Five Years*, merely contained a short paragraph on the use of leisure, calling attention to progress achieved in sports, holidays away from home, and youth activities. "We shall do more to support the arts including the living theatre. Improvements will be made in museums and galleries and in public library service. Particular attention will be given to the needs of provincial centres."[34]

A booklet published in 1958 by the Treasury, *Government and the Arts in Britain*, though not a party document, was designed to acquaint the citizens of Britain with the accomplishments of the Conservatives in expanding the role of the central government as an artistic patron. A similar report was issued by the Treasury in 1964, *Government and the Arts, 1958–1964*. Both were descriptive and factual, but neglected to cover the myriad of difficulties encountered by the various artistic bodies assisted. And, understandably, both refrained from directly evaluating the efficacy of the subsidy programs undertaken.

In December 1959, the Conservative Political Centre, on behalf of the Bow Group, published *Patronage and the Arts*, a research study prepared by Richard Carless and Patricia Brewster. The most comprehensive analysis of arts patronage yet to be undertaken, it did not hesitate to criticize the Conservatives when the authors felt that mistakes had been made or that programs undertaken were inadequate. "If we can persuade members of the Party now to speak out for greater generosity towards the arts at the Annual Conference and on other occasions, we feel sure the leaders of the Party will act and that the parsimony and suspicion still in evidence in some local government circles can likewise be dispelled."[35] The Conservative Party was urged to adhere to a set of guiding principles in framing its policies relating to the arts: (1) more adequate financial support from the central government and local authorities was required; (2) care should be exercised to see to it that subsidies made available did not lead to a measure of bureaucratic control, and that reliance should be placed upon the safeguards of decentralization and diversification of patronage; and (3) the decline of private patronage had in no way diminished the need for private enterprise in relation to the arts.

Of the more-than-a-dozen specific recommendations advanced, several merit attention here. Appreciably larger sums should be allocated to underwrite intensified efforts to maintain and improve the buildings of the national galleries and museums. A Treasury emergency fund should be constituted to maintain and improve provincial museum buildings, moneys to be administered through the Standing Commission with grants matched pound for pound by local authorities. State patronage channeled through the Arts Council should be greatly expanded and Treasury grants accorded triennially

34. *The Next Five Years* (London: Conservative and Unionist Party, 1959), p. 3.
35. *Patronage and the Arts*, p. 12.

or for longer periods. Covent Garden's subsidy should be increased to at least £500,000 per year for the next three years, and the opera house should be purchased by the government. The National Theatre should be erected on the South Bank without further delay at a cost to the state not to exceed the £1,000,000 already voted and the necessary continuing operating subsidies provided. Utilizing powers contained in the 1948 act and other legislation, local authorities should accord further help to all of the arts, particularly by constructing new buildings for the performance of music, drama, opera, and ballet and by providing interest-free loans for the redecoration and furnishing of existing structures. Civic arts trusts could advantageously be constituted and given annual grants by local authorities. To encourage patronage by business and industry, an arts bureau might well be established, either independently or under the aegis of the Federation of British Industries, to act as a link between business and the arts. Self-help for arts organizations was strongly urged: by the creation of a lapsed copyright fund to which those performing musical, dramatic, and other literary works now out of copyright would pay a levy; by effecting modest increases in admission prices; by improving publicity; and by the creation of supporters' clubs.[36]

The Conservatives in 1964 suffered a modest defeat at the polls. The party manifesto *Prosperity with a Purpose*, which was presented to the electorate by Prime Minister Douglas-Home, contained only a brief reference to the arts. Asserting that since 1951 the government had trebled the amount of money provided for the arts, it declared:

Recently we have helped to bring the National Theatre into being, multiplied several times over the grants to museums and galleries for purchasing works of art, and done much to preserve and open to the public old and lovely houses. We shall continue to expand this support and to increase the resources of the Arts Council. We shall also seek to promote higher standards of architecture and civic planning, and commission works by contemporary artists for public buildings.[37]

In October 1965, Edward Heath, the new Conservative leader, in an effort to strengthen the party's position, issued a statement of Conservative aims entitled *Putting Britain Right Ahead*. The arts were virtually ignored, the text merely stating: "We want to see much more choice opening out for people in leisure pastimes, in entertainment and in pursuit of the Arts."[38] During the 1966 election, which resulted in the loss of fifty-one seats in the House of Commons, the Conservative Party, in its program to create a better society, included a commitment to "encourage the arts, particularly in the provinces."[39]

The Conservatives, like Labour, have maintained a committee of M.P.'s

36. Ibid., pp. 141–42.

37. *Prosperity with a Purpose* (London: Conservative and Unionist Central Office, 1964), p. 26.

38. *Putting Britain Right Ahead: A Statement of Conservative Aims* (London: Conservative and Unionist Central Office, 1965), p. 20.

39. *Actions, Not Words: The New Conservative Programme* (London: Conservative Central Office, 1966), p. 14.

in the House of Commons with a special interest in the arts. Originally called the Arts and Amenities Committee, it has been known since 1966 as the Arts and Public Buildings and Works Committee.

The Liberal Party Major criticisms have been leveled at Labour by the Liberal Party for its lack of direction and its failure to recognize the radical issues or to pursue them with zeal. Liberals represent themselves as strong contenders for the radical mantle. Time and time again, it is asserted, the Liberal Party produces the desired new policies or proposes significant changes in existing programs.[40] The validity of these claims is a matter of dispute. There is, however, no question that the Liberals, like third parties in many Western democracies, have sponsored new ideas and programs which, conveniently, have been borrowed by the dominant parties, often without the courtesy of proper acknowledgment. Interestingly enough, this has not been the case with arts patronage. That question has been completely ignored by the party in its election manifestos except in its *People Count* (1959) which did contain a pledge that Liberals would "help and encourage the Fine Arts."

The handful of Liberal M.P.'s sitting in the Commons since 1945 have not been in a position to determine public policy directly.[41] Joseph Grimond, Liberal Party leader from 1956 to 1967, in his book, *The Liberal Future*, set forth some of his thoughts concerning the more important issues facing the British people in the latter half of the twentieth century.[42] His suggestions were dependent, in part, upon the creation of a more liberal society, in which people would be left with more money in their pockets and would enjoy greater opportunities for self-expression.

We must revolt against the immense prices put upon fashionable works by a few well-endowed galleries and a handful of millionaire investors. We must stop prestige buying, or the filling of galleries with works for the benefit of curators and art students. . . . now that travel is much more common it is unnecessary that every gallery should consider it essential to show the whole gamut of art. They should be first and foremost patrons of living and national art . . . and by so doing show to their visitors that pictures of their contemporaries can be rewarding.[43]

Observing that imaginative literature, the novel and poetry, appears to be in eclipse, and that television has taken the place of a Scott or a Dickens, he urged that provision for financial aid to authors be effected as soon as possible.[44] Rejecting the claim by some party colleagues that the nation should not be taxed to assist the arts, Grimond declared that a liberal society should find the money requisite to the support of the arts. The Arts Council,

40. *High Time for Radicals* (London: New Orbits Group, 1960), pp. 14–16.
41. After the 1966 Election, twelve Liberals sat in the House of Commons.
42. *The Liberal Future* (London: Faber and Faber, 1959).
43. Ibid., p. 134.
44. This could be accomplished by levying a small tax every time a book is borrowed from a public library and the funds thus derived paid over to the author. Ibid., p. 135.

through its diversified activities, and the city of Edinburgh, by means of its annual festival, have been at least as effective as many nineteenth-century arts patrons. He called upon Liberals to support generously the subsidy programs of the Arts Council and other similar bodies. But serious thought should be given to "the methods by which they should be run and ideally they should encourage such bodies by educating public taste to dispense gradually with official financial support."[45] Grimond's knowledge of the economics of the performing arts appears limited for he does not spell out precisely how public subsidy could ultimately be terminated. Public bodies and voluntary organizations need to cooperate, he emphasized, to insure that a good liberal society will treat its artists well and accord them honor. Artists must be free. "And it is here that I fear that in a field which is of great importance we are failing."[46]

In conclusion, the policy pronouncements of Britain's two major parties as they relate to the arts, and their records of performance while holding office, have differed, but not radically. When the Conservatives took office in 1951, they continued, with minor modifications, their predecessor's arts patronage programs. Tory provision of Treasury support during the ensuing decade could, without question, have been more generous. On the other hand, Churchill and his successors, Eden, Macmillan, and Douglas-Home, certainly did not view the arts with Scrooge-like hostility. Nor did they succumb to aimless and endless cheese-paring, as a few of their more vociferous critics alleged. Without question, Labour's expansion since 1964 of government arts support activities and its policy of more generous Exchequer allocations constitute a new and much-desired development. Should the Conservative Party be returned to power at the next general election, it is unlikely that any diminution will be effected in the nation's programs of arts encouragement and support.

45. Ibid., p. 136.
46. Ibid., pp. 137–38.

8 / OPERA AND BALLET

No man's talents, however brilliant, can raise him
from obscurity, unless they find scope, opportunity, and also a patron
to commend them.
—Pliny the Younger, *Epistles*

Few observers of contemporary Britain will deny that, of all the arts, those most urgently in need of patronage are opera and ballet. Individual artists—no matter how talented—can perform effectively only under the aegis of large and well-established professional companies. Maintaining opera and ballet of quality is exceedingly expensive and requires continuous large-scale subsidization. On the Continent these arts have long been supported by generous infusions from public treasuries, both national and municipal. Opera in Italy, France, and Germany has been particularly successful; in Britain it has developed slowly. During the nineteenth century and, indeed, down to 1945, indigenous opera was accorded little support by wealthy individuals and no regular allocation by the Treasury or local governments. Relatively few among the British public were afforded an opportunity to attend operas and then only intermittently. In London, short celebrity seasons were mounted at Covent Garden, but the major performers were imported from abroad. Principal reliance was placed upon a succession of companies organized and run by "singer-managers" and dependent on the profits resulting from their productions. A number of touring opera companies functioned during the nineteenth and early twentieth centuries, with important provincial cities such as Liverpool often enjoying extended seasons. Little experimentation and innovation were undertaken, and fewer than a dozen operas enjoyed wide popular acceptance. Ballet in Britain was similarly undeveloped.

Government subsidy of opera and ballet, although not begun until 1945, has been remarkably successful. During the first twenty years of its operation the Arts Council almost invariably devoted at least 50 percent of its annual Treasury grant to this purpose.

The Royal Opera House Becomes a National Institution Theaters have successively stood on the same site in Covent Garden since 1732, and have been used for numerous kinds of public entertainment—opera and ballet, drama, pantomime, circus, concerts, and lectures.[1] Audiences in the eighteenth and nineteenth centuries, for the most part limited to the upper classes, were subjected to a variety of inconveniences. Chief among these was fire: the first building was destroyed in 1808, and the second in 1856. Covent Garden was officially designated an opera house on 6 April 1847, when Rossini's *Semiramide* was performed. The present theater opened on Saturday, 15 May 1858, with Meyerbeer's opera *Les Huguenots*.[2]

Down to 1939, opera was presented in short international seasons, usually

1. Harold Rosenthal, ed., *The Royal Opera House, Covent Garden, 1858–1958* (Royal Opera House, 1959), p. 3; see also Harold Rosenthal, *Opera at Covent Garden: A Short History* (London: Victor Gollancz Ltd, 1967).

2. *Royal Opera House, Covent Garden, from 1732 to the Present Day* (Royal Opera House, 1956), p. 3.

of five weeks' duration, a pattern which was interrupted by the first World War. The majority of the artists, including most of the great singers of the time, were imported from Europe and performed in Italian, French, or German, thus making it impossible to form a permanent indigenous company. Choruses were similarly recruited from abroad, and it was not until 1919 that an all-British chorus sang at Covent Garden. Opera, exceedingly costly under these conditions, had to be financed by private syndicates, usually created ad hoc.[3] A permanent company, the British National Opera Company, was constituted in 1922, but serious fiscal difficulties forced it to close down after only two years of operation. Government assistance to opera did not actually begin with the Arts Council. Parliament, acting directly, allocated a small subsidy for a two-year period to the Covent Garden Opera Syndicate to aid it in presenting opera at Covent Garden and in the provinces. A total of £40,000 was contributed by the government before it was forced by the financial crisis to discontinue assistance at the end of 1932.[4]

The Arts Council, wisely supporting a limited number of institutions capable of developing exemplary standards, has devoted a major portion of its funds to the creation of a national theater for opera and ballet at the Royal Opera House, Covent Garden. In 1945, the music firm of Boosey and Hawkes leased the theater building and rented it to the newly formed Covent Garden Opera Trust headed by Lord Keynes, by then chairman-designate of the Arts Council. The trust immediately set out to insure that the opera house was run as a national lyric theater with full-scale opera and ballet companies. It was to be kept open during the entire year, except for a few weeks in the summer, thus permitting each company to play while the other was on tour, though for certain periods both companies might share the stage, each giving three or four performances a week.

The establishment of a permanent opera company was effected, but not without difficulty. The famous resident companies of France, Germany, and Italy had developed over long periods, using a basic repertory of native opera; but this option was not immediately available to Britain, since English operas in most instances were unsuitable for production at Covent Garden.[5] The prospect of continuing to present imports from abroad, sung in a foreign language, was viewed unenthusiastically. The trust decided on a different course: to present foreign operas in translation, with the hope that, if a genuine national style of operatic presentation were thus created, native composers and librettists would write for the company, gradually building up a body of English operas which would command respect both at home and abroad.

3. *Royal Opera House, A Review, 1946–1956* (Royal Opera House, 1956), p. 4.

4. Short seasons and high prices resulted in a restricted and exclusive public for Covent Garden, and during the late 1930s the house was not usually filled. "The Opera in Britain," *Planning*, vol. 15, no. 290 (8 November 1948), p. 148. *Entertainment and the Arts in Great Britain* (London: British Information Services, 1950), p. 13.

5. *Royal Opera House, A Review*, pp. 4–5.

After the new resident company made its first appearance in *Carmen* on 14 January 1947, progress toward creating an indigenous British opera proceeded without interruption and with increasing success. During its first nine years, the company presented 46 operas, 6 of them for the first time on any stage; 9 were English, 18 German, and 11 Italian. All but six were produced in translation, though the quality was not satisfactory in every instance. Today, singers are under contract to the opera house exclusively for a forty-two-week season and can perform elsewhere only with permission; this helps to insure a high quality of performance. From the beginning, guest artists—both British and foreign—were welcomed, including such great singers as Kirsten Flagstad, Maria Callas, and Ebe Stignani. Musical standards improved steadily. Among internationally known conductors who performed at Covent Garden were Sir John Barbirolli, Sir Thomas Beecham, Benjamin Britten, Erich Kleiber, Otto Klemperer, Rafael Kubelik, Constant Lambert, Karl Rankl, Sir Malcolm Sargent, and Georg Solti. The experience of Covent Garden in presenting English operas was, on the whole, successful. In 1952 the queen granted Benjamin Britten permission to write the opera *Gloriana*, commemorating her coronation which took place the following year. English operas, some of which have been performed a number of times, include: *Peter Grimes, Billy Budd,* and *A Midsummer Night's Dream* by Britten; *The Olympians* by Sir Arthur Bliss; *The Pilgrim's Progress* by Ralph Vaughan Williams; *Troilus and Cressida* by Sir William Walton; and *The Midsummer Marriage* and *King Priam* by Michael Tippett. Covent Garden has been criticized for not giving sufficient emphasis to modern and lesser-known works. However, when five such operas were presented in 1963–64, the average attendance was disappointing. The management concluded sadly that "despite the enthusiastic critical notices given to nearly all the productions in question, the public were unwilling to risk broadening their musical experience."[6]

Touring opera in Britain has been handicapped by a scarcity of large theaters and the reluctance of provincial audiences to pay the same prices for admission as charged in London. Tours have been undertaken intermittently, with visits to Britain's larger cities. In 1963–64, Covent Garden opera presented four performances on provincial tours and at festivals, earning a net profit of £39; in 1964–65, forty-one performances were given at festivals and on provincial tours, resulting in a net loss of £62,999; and in 1965–66, no appearances were made in Britain outside London. The company also has occasionally undertaken tours overseas, to Europe and Africa. Foreign companies have performed at Covent Garden.

In 1961 the Royal Opera House issued a statement of policy designed to serve as a guide for future operations. Five not always compatible claims were delineated:

(a) the presentation of established masterpieces which are needed to build the foundation of a wide repertory without which no metropolitan opera house

6. Royal Opera House, *Annual Report, 1963–64,* p. 9.

can fulfill its duty, and no opportunity can be provided for the development of a national tradition;

(b) the revival of interesting and beautiful works outside the regular repertory;

(c) the performances of new works, with special attention to our native composers;

(d) the discovery and development of British artists for the strengthening of our own company, and the promotion and maintenance within it of the highest international standards;

(e) the appearance before the London public of artists, whether singers, conductors, producers, or designers, of international fame and achievement.[7]

Decisions made at Covent Garden since then have sought to implement these principles.

Ballet on a permanent basis began at Covent Garden on 20 February 1946, when the Sadler's Wells Ballet as the resident company presented its initial performance, an entirely new production of *The Sleeping Beauty*. The company, founded in 1931, operated for some years as Vic-Sadler's Wells Opera Ballet.[8] Its director, Ninette de Valois, sought to create a national school of ballet in Britain—a task requiring much painstaking labor. Associated with her was Constant Lambert, composer and conductor, who exercised a profound influence upon the development of ballet. Partly because of a lack of financial resources, the Wells Ballet was unable to emerge as a professional company of high quality. When war came in 1939, the company set up headquarters for two years in Lancashire and began to perform in various parts of Britain, gradually evolving into a truly national institution. In 1941, it began to return to London for short periods, dancing at the New Theatre. Early in 1942, increased attendance at last enabled Sadler's Wells to make a profit, a happy condition which persisted down to 1945. The Wells governors were generous in sanctioning the ballet's transfer to Covent Garden in 1945, for they gave up the income it earned, which was badly needed to offset future deficits to be incurred in opera. To have returned to Islington, performing only two or three times a week, would have undermined the remarkable progress made during the war. Sadler's Wells retained the Ballet School and immediately embarked upon the task of building a second ballet company under the direction of Ninette de Valois.

During 1946–56, the Sadler's Wells—later renamed the Royal Ballet— performed forty-six different works, many of them acclaimed as outstanding productions. The classics were accorded major emphasis, particular attention also being given to works with scores by contemporary composers such as Malcolm Arnold, Lord Berners, Benjamin Britten, Constant Lambert, William Walton, and Ralph Vaughan Williams. The succeeding decade witnessed further growth and increased professional competence. In 1957,

7. Royal Opera House, *Annual Report, 1960–61*, p. 5.

8. Mary Clarke, *The Sadler's Wells Ballet: A History and an Appreciation* (London: Adam and Charles Black, 1955), p. 3.

a second company, Sadler's Wells Theatre Ballet, formerly controlled by Sadler's Wells Trust Limited, was permanently transferred to the Royal Opera House. During 1965–66, thirty-one different ballets were staged at the Royal Opera House for a total of ninety-four performances; in the same period, 217 performances were mounted at arts festivals or on provincial tour.[9] Although it does have a short season in London, a special touring company of the Royal Ballet is primarily responsible for provincial appearances, while the resident company is usually absent from London only for tours abroad.

Begun in 1947 as the Sadler's Wells School, the Royal Ballet School was incorporated as a nonprofit institution in 1955 and is managed by its own governing body. The Junior School, with an enrollment of about 135, offers secondary level academic courses and basic dance training; the Senior School, with about 175 students, offers intense professional ballet training, usually for a two-year period. Fifteen Senior School graduates joined the Royal Ballet during 1965–66.

Policy decisions at the Royal Opera House are made by a board of directors whose eleven members serve for five-year terms, vacancies being filled by vote of the existing membership. Up until 1965, proposed board appointments were discussed informally with representatives of the Treasury, but since then consultations have taken place with the Department of Education and Science. Board meetings are held monthly, much business having been carefully considered in advance by its three subcommittees—ballet, opera, and finance. The general administrator is empowered to make all personnel appointments except to three top posts named by the board. In 1965–66, employees of Covent Garden—including 358 singers and 147 orchestral players—numbered 1,080.[10] Covent Garden's opera company has a permanent strength of about thirty resident soloists, plus a chorus of sixty-eight. The number of performances staged or sponsored in any given year by Covent Garden is impressive. In 1965–66 the following number were given: 148 house opera, 17 visiting ballet, 94 house ballet, 217 festivals and provincial tours ballet, and 121 overseas tours ballet.

The Royal Opera House is not owned by the national government, as is widely believed, but is the property of Covent Garden Properties, Ltd., a private London real estate concern. The Ministry of Works, in 1949, signed a lease covering the use of the property until 1991, subletting it to the nonprofit operating company, the Royal Opera House, Covent Garden, Ltd. The opera house possesses excellent acoustics, and a large stage, and a maximum seating capacity of 2,230. It is an expensive building to maintain; its operation in a normal year costs between £70,000 and £80,000, plus rent, taxes, and insurance, which in 1966 amounted to £65,934. A strong case can be made for government purchase of the Opera House and the placing of it

9. Royal Opera House, *Annual Report, 1965–66*, p. 34.

10. The number on the payroll at Covent Garden has remained relatively constant in recent years: 940 in 1963–64, and 1,077 in 1964–65.

under the control of the Ministry of Works.[11] Expenditures for all purposes by the Royal Opera in 1965–66 totaled £2,118,051, while income aggregated only £1,193,438, the difference of £924,613 being made up partially by an Arts Council general grant. The net deficit was £117,863.[12] Net deficits have frequently been incurred: those for 1963–64 and 1964–65 were £52,516 and £53,875, respectively. The long-established policy is to set ticket prices at levels to attract patrons with a wide range of incomes.

Starting with an initial subvention of £25,000 in 1946–47, the Arts Council aid to Covent Garden increased gradually, amounting to £145,000 in 1950–51 and £250,000 in 1955–56, the latter allocation constituting 30.5 percent of the Arts Council's total Treasury grant. Despite substantial audiences, the opera house was unable to function effectively because of financial stringencies; deficits accumulated; new productions were limited; and a sense of insecurity became all-pervasive. Sadler's Wells encountered similar difficulties. Covent Garden, using profits from its successful American ballet tours, managed to struggle through, but Sadler's Wells, in desperation, suspended all new productions for a year. The Arts Council pointed out the possible advantages of effecting some measure of integration or association between existing opera companies—Covent Garden, Sadler's Wells, Carl Rosa, and the Welsh National. In early 1957, to avert a crisis, the Arts Council discussed with Covent Garden and Sadler's Wells a proposal that the two companies amalgamate. Although the proposal was accepted in principle by Covent Garden, negotiations broke down over how the new joint enterprise was to be administered.[13]

To further complicate matters, the Welsh National Opera suggested that an association be formed with the Carl Rosa Company, whose activities were restricted primarily to touring; Carl Rosa's representatives, though unwilling to accept the major proposal, indicated an interest in considering experimental forms of cooperation. The Welsh National, unwilling to participate on this basis, broke off negotiations. Somewhat later, Sadler's Wells approached Carl Rosa, suggesting that a partnership be formed. The Arts Council endorsed the voluntary amalgamation, offering to make available £215,000 to support the new enterprise, a sum slightly larger than the total currently received (£142,000 by Sadler's Wells and £63,500 by Carl Rosa). The two companies concluded that a subvention of this size would not permit them to operate at existing levels and that they would be forced to curtail their programs—in the initial year, perhaps eighteen weeks of opera could be given at Sadler's Wells and thirty weeks in the provinces. While the breaking of the continuity of Sadler's Wells as a permanent company on

11. At the time of writing, the possibility of expanding the facilities of Covent Garden to include space for the Royal Ballet School and the London Opera Centre is being considered, contingent upon the moving of the Covent Garden Market.

12. Royal Opera House, *Annual Report, 1965–66*, pp. 40–41.

13. *A New Pattern of Patronage: The Thirteenth Annual Report of the Arts Council of Great Britain, 1957–1958*, pp. 14–17.

annual contract was regretted, it was viewed as preferable to closure. This plan was accepted by the Sadler's Wells Trust, but immediately several senior officers resigned, declaring that the curtailment of the Wells program was retrograde and intolerable. Expressions of public support, stimulated by dramatization of the situation, resulted in Sadler's Wells' losing interest in the amalgamation. A limited increase in the grant from the Arts Council, plus moneys from the LCC, enabled it to survive.

The Arts Council rejoiced when it learned that Sadler's Wells would continue to operate, but the council remained convinced that some integra- · tion between existing opera companies was desirable and pointed out ways of cooperating advantageously. Press comment and correspondence alleged that this crisis was the result of an effort by the council to effect a shotgun marriage between Wells and Rosa, a scheme happily frustrated.[14] The council stoutly maintained that it had not sought to impose union upon any of the companies concerned, that the proposed amalgamation of Sadler's Wells and Carl Rosa had in fact been accepted by the Wells governors and only subsequently endorsed by the council.

A sequel to the Sadler's Wells crisis in the spring of 1958, was a deterioration of Carl Rosa's operations in the summer. Its board was badly divided on policy, and five members and the artistic director, Professor Procter-Gregg, resigned. The six remaining board members submitted plans for an autumn tour to the Arts Council, which, lacking confidence in their competence, withheld approval. The board then proceeded to invite Professor Procter-Gregg to organize an "emergency" twelve-week autumn tour by a company to be known for the one tour as "Touring Opera 1958." Its performances were well received, for the company had been able to draw on the resources of Covent Garden, Sadler's Wells, and Glyndebourne. Thereafter, the Arts Council channeled the assistance previously given to Carl Rosa largely to Sadler's Wells to enable it to provide additional opera on tour. Carl Rosa, deprived of Treasury subsidy, ceased to exist in 1961.

Although the Royal Opera House, from the beginning, received the Arts Council's largest single subvention, it was not adequate to meet the true needs of a national opera house. Conferences with representatives of the council, the board of Covent Garden, and the Treasury induced the Chancellor of the Exchequer to announce in January 1959 that government support would be increased. A special formula would be utilized for 1959–60 and the two succeeding years: the grant was set at 43 percent of approved expenditures with an upper limit of £500,000. For 1959–60 the grant amounted to £453,000; in addition, the Treasury made available £20,000 to reduce a bank overdraft. Under the new scheme the box office had to produce 57 percent of operating costs, which meant that attendance had to average at least 80 percent. Nor could ticket prices be set as low as desired.[15] In January 1962, a different

14. Ibid., p. 16.
15. *The Struggle for Survival: The Fourteenth Annual Report of the Arts Council of Great Britain, 1958–1959*, pp. 16–17.

basis for aiding Covent Garden was adopted; the government agreed to provide 17s. 6d. for every pound of reckonable receipts earned by the opera house.[16] Although designed to encourage the production of opera at a high level, thus insuring maximum attendance, the new formula possessed serious disadvantages: it provided a built-in incentive to raise ticket prices progressively; the use of last year's receipts as a base meant that grants could lag behind increasing costs; presentation of experimental works might be inhibited; and, finally, epidemics or adverse weather could reduce the amount of aid. Critics asserted that too large a portion of the Arts Council's budget was allocated to the Royal Opera, although this was not the case, for the council's grant for all other objects had been fixed by the Treasury for a three-year period prior to the decision on the size of the separate grant for Covent Garden.[17] The subvention for Covent Garden was negotiated directly with the Treasury, a practice open to serious criticism since almost a third of the Arts Council's funds were not subject to its independent discretionary authority. The Labour government, beginning in 1965–66, has followed a different method. The Royal Opera's allocation is based on estimates, submitted to the Arts Council, which are evaluated on the basis of performance and need and in competition with other artistic bodies. Miss Jennie Lee, in announcing the change in the Commons on 16 December 1965, asserted that the government sought to encourage the maintenance of the highest standards and to place the company's finances on a sound basis; funds would be made available to liquidate gradually the accumulated debt, £50,777 of which was the result of an operating deficit incurred in 1964–65.[18] Royal Opera was given a general grant of £806,750 and a capital grant of £15,000 for the year 1965–66, a sum representing 21 percent of the Arts Council's Treasury allocation. Funds allocated to the Royal Opera House in 1966–67 totaled £1,225,000, and in 1967–68, £1,280,000. The 1967–68 allocation (maximum commitment) constituted 17.5 percent of the Arts Council's Treasury grant. In presenting its requests to the Arts Council, the Royal Opera makes available supporting documentation in considerable detail, listing individual positions, salaries paid, equipment and material needs, and other information.

The Royal Opera House received a grant of £9,850 from the Calouste Gulbenkian Foundation in 1963 to assist it in sponsoring a program of professional lecture demonstrations mounted by Ballet for All, a small group drawn from the Royal Ballet at Covent Garden. Beginning in September 1964, this unique educational enterprise in ballet, by means of performances given at schools, colleges, art and music societies, public theaters, and arts

16. *A Brighter Prospect: The Seventeenth Annual Report of the Arts Council of Great Britain, 1961–1962*, p. 48.

17. *State of Play: The Nineteenth Annual Report of the Arts Council of Great Britain, 1963/64*, p. 16.

18. *Key Year: Twenty-First Annual Report, 1965–66, The Arts Council of Great Britain*, p. 59; *The Times*, 17 December 1965, p. 12.

festivals, has sought to broaden public understanding and enjoyment of ballet throughout the nation. Programs have been well received.[19] In 1965–66, the group traveled 17,000 miles during a period of thirty-five weeks, presenting some 175 performances before audiences totaling 88,500. £1,000 was earmarked by the council for the support of Ballet for All in 1965–66; the following season, a subsidy of £12,000 was budgeted for the group.[20]

How successful has the Royal Opera House been in achieving the goals it set in 1961? Articles by music critics in the British press during the past ten years reveal a high degree of unanimity concerning Covent Garden's remarkable progress. "Twenty Marvellous Years at Covent Garden," a 1967 article in *The Times*, presents a comprehensive evaluation of operatic achievement at Covent Garden during the period, 1947–67: "Patrons of Covent Garden today automatically expect any new production, and indeed every revival, to be as strongly cast as anything at the Met. in New York, and as carefully presented as anything in Milan or Vienna. . . . the international stars of opera prefer to work at Covent Garden where everybody knows his job and helps you to get on with yours."[21] Success has crowned efforts to build up at the Royal Opera House a resident opera company and orchestra capable of presenting the world's best.[22] Despite the policy adhered to until 1957 to present opera in English, a gradual policy shift toward presenting operas in their original language took place in the Royal Opera's second decade, for it was found that insistence upon the use of English was restrictive artistically; further, the number of outstanding operatic singers from abroad willing to learn roles in a language of limited use elsewhere was disappointingly small. Covent Garden's orchestral conductors have been outstanding; standards of production and scenic design have consistently risen. The Royal Opera has nurtured a substantial number of such leading singers as Geraint Evans and Joan Sutherland. In ballet, its resident company occupies first place in the Western Hemisphere. The touring ballet company, however, is not universally held in high esteem.[23] The directors of the Royal Opera have repeatedly pointed out that support received from the Exchequer has not been sufficiently generous to permit the management to remedy recognized deficiencies and that the level of subsidy in relation to Britain's national income was appreciably below that provided by a number of European nations. The substantial increases in subsidy allocations to Covent

19. *The Times*, 15 October 1967, p. 9.
20. Royal Opera House, *Annual Report, 1965–66*, pp. 16–17.
21. *The Times*, 13 January 1967, p. 14.
22. Manchester *Guardian*, 4 August 1966, p. 7.
23. *Observer Weekend Review*, 12 June 1966, p. 25. Britain's artistic relations with France are not always harmonious. Some Frenchmen were not satisfied with the highly successful performances of Margot Fonteyn and Rudolf Nureyev at the Théâtre des Champs-Elysées, for they believed that these stars should be accompanied by something better than the touring troupe of the Royal Ballet. "This is the way England treats France," one quite eminent Frenchman said bitterly. "The Royal Ballet would send its best company to America, but it thinks anything is good enough for Paris." *Christian Science Monitor*, 4 December 1963, p. 14.

Garden, beginning in 1963–64, have, in spite of rising costs, eased its financial position and permitted the development of an increasingly varied repertoire and the achievement of progressively higher standards of artistic excellence.

Sadler's Wells Sadler's Wells is the recipient of the Arts Council's
Opera Company second largest subvention for opera and ballet, which
 enables it to provide London and the larger provincial centers with a varied repertory that emphasizes both unfamiliar and popular new works. The site occupied by Sadler's Wells in Islington was used for theatrical purposes as early as 1683, when Mr. Sadler discovered a mineral water well on the grounds of his "Musik House." With a sharp eye for money, he erected a rustic grotto around it and enticed hundreds of people to come each morning to drink the waters and listen to music.[24] Unquestionably, the theater's greatest artistic successes in the nineteenth century occurred between 1844 and 1862, when under the direction of the talented actor-manager, Samuel Phelps, no fewer than thirty of Shakespeare's plays were produced. Subsequently, the theater's artistic fortunes declined and it was being used as a cinema before it closed in 1916.

The origin of the modern Sadler's Wells can best be understood in relation to the founding in 1880 of the Old Vic as a temperance music hall, the chief objective of which was to keep the audience out of the pubs. Later the Old Vic undertook the responsibility for providing London with high-class drama, opera, lectures, and music, with admission prices that artisans and laborers could afford. When Lilian Baylis assumed direction of the Old Vic in 1912, she undertook systematically to lay the foundations for both an opera and a theater company. When in the 1920s it became apparent that two thriving companies could not function successfully using the limited facilities of the Old Vic, it was decided to rebuild the derelict Sadler's Wells and to operate it as the "Old Vic of North London." On 6 January 1931, the present theater opened with the drama and opera companies giving alternating performances at Sadler's Wells and the Old Vic. Five years later, when it was deemed more economical to specialize, Sadler's Wells became the home of opera and ballet and the Old Vic continued with drama only.[25] The theater at Islington has been owned since 1931 by the Sadler's Wells Foundation; the Sadler's Wells Trust, Ltd., is empowered by charter to present opera, ballet, and other forms of entertainment—both in London and on tour.

During World War II, CEMA made available substantial sums to assist Sadler's Wells in providing entertainment. Sadler's Wells Theatre reopened in June 1945 with an opera season that included the world premiere of Britten's *Peter Grimes*. (Twenty-three years later, on 15 June 1968, Sadler's Wells terminated its operations in its home theater on Rosebery Avenue with a performance of *Peter Grimes* before moving to its new base at the

24. Sadler's Wells Theatre, *Gala Performances* (1956), p. 2.
25. Sadler's Wells Theatre, "A Short History of Sadler's Wells" (mimeographed, 1958), p. 1.

Coliseum Theatre.) Ballet was also undertaken. As indicated earlier, Sadler's Wells shifted one ballet company to Covent Garden in 1946 and a second in 1957. Since then Sadler's Wells Trust has presented opera only.

Sadler's Wells Trust, Ltd., is a nonprofit company with a membership not exceeding fifty and a board of ten directors who are responsible for the management of the opera companies and related enterprises. Vocationally, only three of the directors in 1967 were professionally involved in the arts; three were business executives; two had been government administrators; and one, a former member of Parliament. Four represented areas outside metropolitan London. Two subcommittees—Opera, concerned with the selection of works to be performed, and Finance—report to the parent body. A consultative committee consisting of eight to ten persons, renders advice concerning Sadler's Wells' activities in the provinces: tour plans and time schedules are discussed and opinions solicited concerning the quality of performances. Sadler's Wells employs approximately 520 persons, including administrative personnel, singers, musicians, and dancers; these are organized into two opera companies, each with its own music director and separate orchestra, chorus, and opera/ballet group.

Arts Council subsidy for Sadler's Wells dates from 1945–46, when £10,000 was made available to assist the company in making the difficult transition from war to peace. In the ten years which followed, operating deficits frequently occurred: by 1957–58, a reserve fund of some £50,000, built up prior to 1945, was replaced by accumulated debts totaling approximately the same amount.[26] The Arts Council grant was set at £100,000 for 1953–54, and remained at that level through 1955–56 in spite of mounting financial difficulties. Opposition to the proposed amalgamation of Sadler's Wells and Carl Rosa was a factor in inducing the London County Council to make available to the company an emergency grant in July 1958, appointing at the same time a committee of inquiry, which after extensive investigation submitted its findings in March 1959. The policy of Sadler's Wells had been formulated empirically; it was designed to build up a permanent company that presented performances in English of the highest possible quality by British singers exclusively. It has from the beginning consistently sought to create a company of maximum collective strength rather than to rely unduly upon the brilliance of individual stars.

The LCC committee report considered the need for two opera houses in London, concluding that Sadler's Wells and Covent Garden were, in fact, complementary to each other. Both possessed a considerable repertory in common and relied in part on a core of popular works certain of box office success, although significant differences between the two still existed. Covent Garden, being larger physically and wealthier, could more effectively undertake large-scale productions. Ticket-pricing policies varied, Sadler's Wells possessing a larger proportion of seats at lower- and middle-range price levels. However, Covent Garden and Sadler's Wells attracted largely different

26. Committee of Inquiry on Sadler's Wells, *Report* (London County Council, 1959), p. 4.

audiences and did not compete with each other to any appreciable extent.[27] The committee's conclusions concerning ways of strengthening Sadler's Wells' position were constructive. Sadler's Wells, it believed, was efficiently and by no means expensively run. Advantages could accrue from greater coordination of programs between Sadler's Wells and Covent Garden, though this would not produce substantial economies. The Arts Council should guarantee its grant for a three-year period, an arrangement recently agreed upon with Covent Garden, thus helping to eliminate financial uncertainties and insure more efficient planning. The maintenance of a permanent national opera at Covent Garden was the proper responsibility of the central government, while provision of assistance to Sadler's Wells could be justified as an appropriate function of the LCC, whose objective would be not merely to insure its survival but also to permit it to achieve standards appropriate to a respected metropolitan opera house.

The committee urged the LCC to make available to Sadler's Wells £35,000 annually for an initial period of three years, contingent upon assurances from the Arts Council that its support would continue "at such a rate as will not render its contribution in respect of Sadler's Wells Theatre less adequate in future than it was in the past."[28] County Council support should continue on a permanent basis, the precise size of subsequent grants to reflect the company's needs, its general position, and results achieved. The recommended assistance was designed to "enable Sadler's Wells, operating with confidence from a firm base, to concentrate its energies on artistic development and so render even greater services to London than it now does."[29] LCC aid would be earmarked to underwrite expenses incurred by the company in its London operations, with support of touring left to the Arts Council.

The Arts Council in 1959 carefully considered the operative needs of non-metropolitan Britain and concluded that the provinces could support touring for a minimum of thirty weeks. Sadler's Wells reformulated its policy to permit it to maintain two permanent companies of equal strength and to provide in 1959–60 for twenty-six weeks of touring outside London. Tours undertaken during that year were artistically and financially rewarding.[30] In 1960–61 the council increased its grant from £200,000 to £275,000, and this, with the LCC's £25,000, enabled Sadler's Wells to present a program more comprehensive than any it had mounted up until that time. The two companies provided a full season in London and, in addition, were on tour for forty-two weeks. Audience response to the new policy was enthusiastic, and local press reports were generally appreciative.[31] Difficulties, however,

27. Ibid., pp. 7–9.
28. Ibid., pp. 21–22.
29. Ibid., p. 17.
30. *The Priorities of Patronage: The Fifteenth Annual Report of the Arts Council of Great Britain,* 1959–1960, p. 29.
31. *Partners in Patronage: The Sixteenth Annual Report of the Arts Council of Great Britain,* 1960–1961, p. 42.

remained unresolved: the heavy schedule imposed a severe strain upon a few principal singers, conductors, and other key personnel who divided their energies between the two companies; despite satisfactory box office receipts, the cost of opera away from London continued to rise; and the shortage of talented and experienced British operatic singers persisted.

Local authorities outside London began to provide modest support for opera, their contributions helping to defray the touring costs of Sadler's Wells. For the first time special performances for school children were arranged by the LCC, and in the Youth and Music programs, efforts were made to cater to the interests of young people between sixteen and twenty-five. Touring was considerably simplified by the purchase of a fleet of vehicles specially designed to transport scenery, wardrobe equipment, and other luggage.

However, Sadler's Wells' financial condition continues to be precarious. Stephen Arlen, administrative director, in 1964 called attention to the "out-of-focus" thinking characteristic of much of the discussion concerning Sadler's Wells. The excitement of planning for the new theater on the South Bank to house Sadler's Wells was contagious. But the struggle for survival remained the central problem. Increased subventions from the Arts Council and the LCC have been largely offset by rising labor and other costs. Expenditures have exceeded earned income and receipts from grants and donations since 1963–64: net deficits incurred stood at £43,288 for 1963–64, £67,937 for 1964–65, £29,314 for 1965–66, and £7,785 for 1966–67.[32] Arts Council subventions for the four years amounted to £400,000, £425,000, £520,000, and £575,000. Greater London Council aid increased from £45,000 in 1963–64, to £100,000 in 1966–67; £100,000 was given to the company in 1967–68. Assistance from local authorities other than the Greater London Council constituted a limited source of additional revenue, the number contributing rising from twelve, in 1962–63, to fourteen in 1966–67, and eight in 1967–68; the amount received in the latter year was £4,483. Many local governments in areas served by Sadler's Wells refused to contribute. Special allocations from the Arts Council were made available to Sadler's Wells to liquidate the company's accumulated deficit of £165,000 as of 31 March 1965, the first portion, £55,000, being paid in 1966–67.

Subventions from the Arts Council and the GLC have enabled the Sadler's Wells companies gradually to improve the quality of operatic performance. In 1967–68, Sadler's Wells mounted 29 operas and operettas with 238 performances; comparable statistics for 1963–64 were 195 performances of 24 operas and operettas; for 1964–65, 208 performances of 30 works; for 1965–66, 206 performances of 27 operas and operettas; and for 1966–67, 182 performances of 21 works. Paid admissions for each of the five years up to 1 April 1968 totaled 218,998, 233,697, 250,890, 219,970, and 259,601,

32. In 1966–67, Sadler's Wells' expenditures amounted to £999,140, while income from all sources totaled £309,305, leaving a working deficit of £689,835. This was offset by grants to the extent of £682,050, leaving a net deficit of £7,785.

respectively. Average attendance during 1962–63 was 79 percent of capacity, as compared with 72 percent for 1966–67 and 65 percent for 1967–68. Performances on tour were given in 26 provincial towns in 1962–64; in 1964–66, 28 different towns were visited; in 1966–67, 18; and in 1967–68, 11. Sadler's Wells' initial tour outside Britain took place in 1960, with visits to Brussels, Antwerp, and Paris. In 1962, the British Council sponsored a short tour on the Continent, with appearances in Stuttgart and Hamburg; in 1963, it subsidized a more elaborate Sadler's Wells tour to five cities in Germany. Audience response in these long-established centers of European opera was most encouraging. Both companies appeared under British Council auspices in 1965, one in the Contemporary Music Festival at Zagreb, and the other in Amsterdam, Geneva, Lausanne, Vienna, Bratislava, Prague, and Hamburg. A highly successful eight-day European tour was mounted in the spring of 1967, with performances in Bordeaux and Lisbon; in the autumn, Sadler's Wells dispatched a company to Brussels. Sadler's Wells maintains other activities also—organized instruction for young stage designers, radio broadcasting of operatic performances, television presentations, and gramophone recordings of opera in English.

Discussions were initiated in the 1950s on ways to provide Sadler's Wells with more adequate housing. The Treasury in 1961, working closely with the Arts Council and the LCC, carefully considered a scheme designed to house Sadler's Wells on the South Bank of the Thames, next to County Hall on one side and the yet-to-be-erected National Theatre on the other. A South Bank Board, constituted to oversee the erection of the new cultural buildings, undertook the task of implementing the decision, hoping to have the new Wells theater ready for occupancy by the early 1970s. But counterpressures ultimately led to the indefinite postponement of the project. In March 1966, the government, reacting to the desire of the provinces that a larger proportion of Arts Council funds be allocated to enterprises outside London, announced that it was unwilling to contribute the projected £3,500,000, representing one-half of the capital costs. The GLC, on its part, was hesitant to undertake the £7 million project on its own, particularly since it had only recently experienced a substantial expansion and reorganization and was facing an election on narrow margins. This decision was bitterly criticized, for many observers believed that ultimately a second opera house would have to be erected in London, and the longer it was delayed, the greater would be the cost. One suggested means of obtaining money for its construction, unacceptable to the Arts Council and the GLC, was by public lottery—Sydney, Australia, raised millions of pounds for their opera house in this way. The Greater London Council's Labour leadership announced in March 1967 that it was not prepared to go forward with the project. The Conservatives, subsequently swept into office with a large majority, thus far have not reversed this decision. Undoubtedly, the Labour government's white paper, with its emphasis on the provinces, helped to establish priority for opera houses erected outside Greater London. Stephen Arlen, Sadler's Wells'

managing director, attributed the decision in part to the results of the company's own extensive touring activities, observing "that the very pressures which have built up regarding the operatic development outside London have probably been due in some measure to the fact that for the last five years Sadler's Wells has been sweating out its lifeblood to provide the viper with his venom, and that the metropolitan activity from which it emanated has suffered to a degree in consequence." Sadler's Wells, he asserted, deserved a decent theater in which to work, and the Arts Council committee of enquiry had to recognize that if Sadler's Wells was to survive as a viable entity, it had to have a new home. Sadler's Wells was no longer content to rely entirely upon elected legislative bodies, he reported, but intended to produce in the near future "a scheme which we know will have the overwhelming support of everyone who loves his theatre and which we believe will weld our audience into such a fighting body that even a matter of £5 millions may seem like gathering daisies."[33] Except for the land, the company hoped to retain the entire responsibility for financing and construction, thus avoiding having "to go cap in hand to those whose practical help, for all their good intentions, has proved inadequate in the recent past."

Fortunately, Sadler's Wells has not been forced to continue to operate in its grossly inadequate home on Rosebery Avenue. On 24 April 1968, Wells officials announced at a press conference that the company would move to the Coliseum Theatre in Saint Martin's Lane, with a seating capacity of 2,558, and with facilities more suited to its needs.[34] The governors of Sadler's Wells Foundation and Sadler's Wells Trust, Ltd., with the help of the Arts Council and the GLC, signed a ten-year lease of the Coliseum Theatre from the Stoll Theatre Corporation. The Arts Council, in sanctioning the move, stipulated that there be no change in the company's policy of presenting opera in English, with British singers, in a wide repertory both in London and the provinces, and that Sadler's Wells Theatre in east central London be maintained for use by ballet, opera, and dramatic organizations both from Britain and abroad. The Coliseum will be remodeled into an opera house, costs being met in part by the owners of the building; two private grants have been received: £50,000 from the Gulbenkian Foundation and £5,000 from Sir Robert and Lady Mayer. The Arts Council agreed, at this time, to raise its grant by £75,000 for the current year.

Arts Council support has been indispensable to the continued growth and development of Sadler's Wells. As has been shown, without the council's desperately needed fiscal transfusions and its policy advice, Sadler's Wells as we know it could not have survived for any appreciable length of time. Although not possessing the professional resources and international reputa-

33. Sadler's Wells, *Annual Report, 1964–66*, p. 3.
34. The London Coliseum was officially opened in 1904, and for almost three decades largely concentrated upon variety shows. Diaghileff's Russian Ballet gave seasons there in 1918, 1924, and 1925. In 1931, the Coliseum abandoned variety and functioned as a regular theater. In May 1961, the theater was leased for use as a cinema.

tion of the Royal Opera House, Sadler's Wells has done much to assist in the creation of an indigenous British opera.

Other London
Opera and Ballet
The New Opera Company and the Handel Opera Society are closely associated with Sadler's Wells. The New Opera Company, founded in 1955, presents modern and unfamiliar works, many of them for the first time, in Sadler's Wells Theatre, which it rents for a week each year. The Arts Council assisted the company initially in 1957–58 with a subvention of £500. The size of its grant has remained modest: £2,000 from 1960–61 through 1963–64; £2,500 for 1965–66; and £1,000 in 1966–67. In staging its operas the company may employ up to a score of professional singers, using an amateur chorus of perhaps fifty. Operas that are exceptionally well done may be taken over by Sadler's Wells, which employs the New Opera Company's singers and other personnel. The company also features, every two or three years, informal Sunday-night workshops, performing operas not suitable for its main seasons and employing young conductors, producers, and singers.

The Handel Opera Society's annual appearances at Sadler's Wells Theatre cater to a specialized public. In its first decade, 1955–65, twelve different operas or dramatic oratorios were presented, some of which had not been given on stage in London since Handel's death in 1759.[35] With professional singers and orchestra and semiamateur choruses, the society has helped to revive an interest in Handel as one of the greatest composers for the theater. The Arts Council first assisted the society in 1955 with a small grant for its first production in the Saint Pancras Town Hall, and has provided modest aid since then (£2,500 in 1966–67). Support has also been forthcoming from the LCC (now the Greater London Council) and from the Gulbenkian Foundation. The society presents special programs in addition to its week at Sadler's Wells, with some concerts and operas by composers other than Handel. In June 1960, *Rinaldo* was performed at the Komische Oper in East Berlin, and in Halle—the composer's birthplace—during its thousandth anniversary celebrations; 1962 witnessed the performance of *Jephtha* at the Liège Festival; for some years, the society has taken part in the Saint Pancras Festivals, with operas by Haydn, Rossini, and Mozart. The society's first appearance in the new Queen Elizabeth Hall took place on 23 April 1967, with a concert performance of *Semele*; in October of the same year, it staged *Scipio*, a work not hitherto performed in Britain; and in December, it presented *Samson* with the Royal Philharmonic Orchestra.[36]

Associated with the Royal Opera House is the English Opera Group, which was set up in 1946 to present opera in an adventurous way. Its objectives differ from those of the existing operatic organizations: "(1) Its stage and orchestral resources are deliberately limited to those suitable for

35. *Policy Into Practice: Twentieth Annual Report, 1964/65, The Arts Council of Great Britain*, p. 72.

36. *The Times*, 25 March 1967, p. 7.

'chamber opera.' (2) It performs the works of past and present British composers. (3) It commissions new operas and other musical works."[37] This policy reflected circumstances existent at the time—the dilapidated condition of theaters available, the difficulties of holding together a permanent company, and the desire to keep office overhead to a minimum. Today, the group is run by an independent board of ten members, five of whom are nominated by Covent Garden, whose assistant general administrator acts as its executive officer. Singers and musicians are employed only when needed, company size varying with the work presented.

Arts Council assistance to the group began in 1947–48, with £3,000. Exchequer subventions remained fairly constant until 1962–63, when the grant was substantially increased. In 1966–67, council subsidy totaled £40,000. During its first decade, 1946–56, the group, as the only opera company devoted exclusively to the production of works by British composers, presented fourteen operas, nine of which were commissioned by it, in a total of 700 performances at home and fifty-two abroad.[38] Particularly outstanding was *The Turn of the Screw* by Britten, made possible by unusual cooperative efforts of composer, librettist, designer, and producer. Britten wrote three of the other operas—*Albert Herring, Let's Make an Opera*, and *The Rape of Lucretia*—and provided new versions for two—*Dido and Aeneas* and *The Beggar's Opera*. The group effected two significant policy changes in 1957–58: it decided it would concentrate on producing new operas; and to reduce overhead expenses, it combined its administration with that of the Aldeburgh Festival, in which it had participated since 1948. In 1960, the Royal Opera House took over the management of the group, thus insuring more frequent performances; the new arrangement also permitted the group to draw more easily upon the personnel and technical resources of Covent Garden. In September 1962, the English Opera Group made its first appearance at the Edinburgh Festival, returning again the following year. An important milestone was its 1964 tour in the Soviet Union—Moscow, Leningrad, and Riga. During the past several years the English Opera Group has expanded its activities. Its presentation of Britten's church operas—*Prodigal Son*, *Curlew River*, and the *Burning Fiery Furnace*—have elicited considerable critical comment.

Provision of advanced operatic training has been a major concern of those responsible for the development of opera in postwar Britain. In 1959, Covent Garden, Sadler's Wells, and Glyndebourne requested the Arts Council to assess the existing arrangements for opera training and to submit recommendations. A committee chaired by Lord Bridges recommended that a new school for advanced opera training be established in London. Though the National School of Opera, founded in 1948, had done good work, the committee felt that the time had come to make new arrangements. The

37. Colin Graham, ed., *The English Opera Group, 1946–1956* (London: The English Opera Group, 1957), p. 1.

38. Ibid., p. 2.

report was accepted by the Arts Council, and a board of governors was constituted to establish a new London Opera Centre for Advanced Training and Development. The two principals of the former National School, Joan Cross and Anne Wood, consented to serve as director of studies and as warden. Opening in September 1963, the new center enjoyed close relations with Covent Garden, which shared its rehearsal and other facilities and assumed major responsibility for its management. Within a few months a bitter internal dispute developed, resulting in the resignation of the director of studies, the warden, and three of the governors—all formerly associated with the National School. Critics maintained that the center's connection with Covent Garden was unhealthy, an unwarranted extension of an alleged Covent Garden empire—an allegation vigorously denied. The closure of the National School had been a bitter pill for those who had given so much to it.[39]

After this unfortunate initial setback, the center developed a quality program of postgraduate training for opera singers, répétiteurs (opera pianists), and stage managers. Association with the Royal Opera House is close: the general administrator of Covent Garden is also general administrator of the center; the center's building is used for Covent Garden rehearsals; and technical assistance is made available from the Royal Opera House, Sadler's Wells, and Glyndebourne. The center's small permanent staff is assisted by part-time personnel from the three associated opera companies. The regular curriculum has from time to time been supplemented by classes taught by well-known musicians and singers. Students, numbering between forty and fifty, are mainly graduates of British colleges of music, but a few come from abroad. The normal period in residence is two years. Operas presented by students are open to the public, and, most important, to music critics.

Arts Council support—£23,900 in 1963–64—jumped to £36,500 (of which £9,500 was a capital grant) the following year and has been subsequently increased, until it amounted to £44,500 (£9,500 capital grant) in 1965–66 and £59,500 (£9,500 capital grant) in 1966–67.

The London Festival Ballet, performing in the Royal Festival Hall, caters more to popular tastes than does the Royal Ballet. During its three-month residence in London, the ballet presents summer and Christmas seasons, often attracting almost 2,400 persons nightly. The company's existence dates from 1948, when a small group of dancers headed by Alicia Markova and Anton Dolin toured Britain and were received so enthusiastically that the group's founder, Julian Braunsweg, decided to set up a permanent organization. Relying on popular stars, many from abroad, the new enterprise gained

39. The board of the London Opera Centre set up a committee under the chairmanship of Lord Robbins to assist it and the Arts Council in investigating the operations of the center. The Committee's report, published by the Arts Council in July 1964, supported the director and his plans for the center's development, rejecting the majority of the criticisms leveled against him. London Opera Centre, *Report of the Committee Appointed by the Governing Body to Investigate Recent Criticisms of the Centre*, 1964. See also Manchester *Guardian*, 10 September 1964, p. 6.

a foothold in London and over the years proceeded to tour Britain regularly. The ballet went on to win international recognition, performing in Europe, the United States, Canada, South America, and the Middle East.

The Festival Ballet, like other ballet companies, eventually found it impossible to function without substantial outside aid. Encountering serious financial difficulties for the first time in 1956, it went into liquidation in 1962 and was reconstituted the London Festival Ballet Trust, a nonprofit-making enterprise. The LCC first provided assistance in 1960–61 to the amount of £5,000; by 1965–66, its subvention had increased to £85,000. In the summer of 1965, the Festival Ballet faced dissolution, the new crises stemming from the premature closing of its £40,000 production of *Swan Lake* at the New Victoria Theatre, London; poor attendance earlier in the season had weakened its financial position. The Arts Council, although it had made no grants to the Festival Ballet, persuaded several private benefactors to contribute £20,000 to help keep the company afloat. The company's forty-five dancers agreed to forgo their entire salaries for two weeks to help ease the strain. The Arts Council felt that the Festival Ballet had a useful role to play and believed that it could be placed on a firm and permanent footing. Lord Goodman, council chairman, declared: "This rescue operation carries the stipulation that there should be changes in the management of the Festival Ballet, with a view to bringing about economies and introducing new personalities and ideas into the running of the organization."[40] The Two Ballets Trust was set up to provide a mechanism by which the GLC and the Arts Council could coordinate their subsidy efforts to both the Festival Ballet and the Ballet Rambert. The new scheme did not, however, operate successfully. Donald Albery, a manager and producer experienced in ballet administration, was named director, and without delay proceeded to effect changes in the Festival Ballet's organization and internal management. Today, the standards of production have markedly improved, although emphasis continues to be on international stars; and the repertory remains classical and conservative. The GLC subsequently increased its support to the ballet, its grant in 1967–68 amounting to £133,000; in the same year the Arts Council for the first time provided a subvention, of £50,000. The GLC has sought to convince the Arts Council that the two bodies should participate equally in the future, each contributing half of the estimated annual deficit.

Opera and Ballet in the Provinces
After its establishment in 1946, the Arts Council accorded first priority to the creation and development in London of major opera and ballet organizations. Such a policy was, however, at odds with the council's charter-imposed mandate to increase the accessibility of the arts to the public in all parts of

40. The poor summer season was felt to be the result, in part, of the fact that London had been "saturated" with ballet—the Bolshoi at the Festival Hall; the Royal Ballet touring company, with another production of *Swan Lake* in its repertoire, at Covent Garden; the Ballet Rambert at Sadler's Wells; and Ballet for All at Stratford East. *Sunday Telegraph*, 22 August 1965, p. 3.

7

Britain. In the immediate postwar years, many theater buildings were torn down or permitted to fall into disrepair, with the result that opera and ballet could be presented only under severe handicaps. The council, during its first decade, financed limited tours by Carl Rosa Opera, Sadler's Wells Theatre Ballet, Ballet Rambert, and the Welsh National Opera Company; it also provided funds to permit Covent Garden and Sadler's Wells to undertake the expensive and complicated task of taking on tour productions often ill-adapted to road conditions. More recently, both the Royal Ballet and the Sadler's Wells Opera undertook to expand their touring operations in Britain. Other solutions were sought by the Arts Council. Thus, Opera for All was organized and operated directly by the council, with the specific aim of introducing opera to people living in small towns without theaters. "Is there a place for more opera in the provinces on a scale which is larger than Opera for All but smaller than, say, Sadler's Wells?"[41] has been a question frequently discussed. The Arts Council, in 1964, concluded that if supply created demand in the arts, there was no question but that additional opera facilities were needed. Practical difficulties, aside from finance, were great. Existing repertory theaters were usually too small and could be made available for opera only a few weeks each year; further, most popular operas require production and orchestra on a scale at least comparable to that of Sadler's Wells. The council endorsed the need "for establishing full-scale permanent opera in the North of England, inspired perhaps by the example of ventures already established in Wales and Scotland."[42] The creation of a new opera company, even with generous Exchequer support, would necessitate the cooperation of several major communities if proper professional standards were to be adhered to. In 1966, a committee was named by the council to consider the needs of Britain for opera and ballet. Manchester set aside an eighteen-acre area for an arts center which its city council hoped would contain an opera house. Concerted efforts have been made to establish a Yorkshire Opera Company; thus far its activities have been limited, with two performances in 1967 and two in 1968. Edinburgh has produced plans for a new opera house, and Glasgow recently purchased the King's Theatre, enlarging its orchestra pit. Both developments are designed to assist the Scottish Opera Company.

Ballet performed in small towns also faces special problems, chiefly of staging and lighting. Minerva and Harlequin have energetically sought to bring high-class ballet to these communities. Provincial interest in ballet has also been catered to by Ballet Rambert and Western Theatre Ballet.

Professional opera was slow to develop in Scotland; it was not until 1962 that the Scottish National Orchestra launched the Scottish Opera. The initial five-day season, held in June at the King's Theatre, Glasgow, and underwritten by a £1,000 grant from the Arts Council, consisted of Puccini's *Madame Butterfly* and Debussy's *Pelleas et Melisande*. The management

41. *State of Play*, pp. 26–27.
42. Ibid.

decided to engage singers of international reputation, employing Scottish professional singers for the smaller parts, and amateurs for the chorus.[43] Success has crowned Scottish Opera's efforts; it has set up a permanent administrative organization and has achieved higher professional standards of production. Its successful 1966 season, featuring four operas, was surpassed by the 1967 season, when attendances at five operas rose to over 90 percent.[44] The *Stagione* system is followed, whereby an opera is carefully cast and produced, put on for a limited period, and dropped from the bill, thus ensuring freshness of presentation and the exposure of opera-goers to a greater variety of works. Scottish Opera plays in Edinburgh, Glasgow, Aberdeen, and Perth for periods of a week or more. The size of the Arts Council's subvention has steadily increased, rising from £4,500 in 1963–64 to £15,000 in 1965–66, and to £51,670 in 1966–67.

Since the early 1950s, Sadler's Wells has visited Scotland each year; thus, between 1964 and 1966, it presented a repertory of popular operas, appearing for a week or more in Aberdeen, Edinburgh, and Glasgow. The Royal Ballet, Ballet Rambert, and the Intimate Opera have also toured Scotland.

In Wales, visits by Covent Garden, Sadler's Wells, Ballet Rambert, and other national companies to Cardiff and to the more remote areas, sponsored by the Welsh Council, served a useful purpose but were not adequate. The council's "ultimate aim must be to encourage major promoting organizations within Wales itself. It is only then that Wales can make its own special contribution to the cultural well-being of Great Britain."[45] The origin and development of the Welsh National Opera Company illustrates how this goal was implemented. Before the company's establishment in 1948, there was little grand opera in the region. Initial Arts Council support given to the company in 1950–51, amounting to £1,800, helped to underwrite a successful two-week season in Swansea as well as performances in Cardiff, Aberystwyth, Llandudno, and at the Royal National Eisteddfod. Modest grants were made available during the 1950s by the Cardiff, Swansea, Glamorgan, Monmouth, and Carmarthen local authorities. By 1964–65, local government grants totaled £12,500.

The Welsh National Opera's existence has been a precarious one, financially; on several occasions, its demise appeared imminent. Arts Council subventions slowly increased over the years, rising from £25,228 in 1960–61 to £60,460 in 1965–66; only in 1966–67, when the council's allocation jumped to £100,449, did it possess sufficient resources to develop a company of truly national stature. In Cardiff operas were for a long time mounted in the New Theatre, whose facilities were far from adequate. By 1961, an amateur chorus was performing; some of its singers came from as far as fifty miles

43. *The Times*, 6 June 1962, p. 5; 15 June 1962, p. 6.

44. *The Sunday Times*, 22 May 1966, p. 5.

45. *Policy Into Practice: Twentieth Annual Report, 1964/65, The Arts Council of Great Britain*, pp. 55–56.

from Cardiff. A new scheme was launched in 1962 to train young opera singers who, after completing their course, joined the company's new Opera for All touring group.[46] By 1964–65, Welsh National possessed a full-time director of productions, a part-time music director, and a full-time administrative staff; professional soloists and a professional orchestra were engaged for each season. During the year the company operated for seven weeks: three in Cardiff, two in Swansea, one in Llandudno, and one in Bournemouth. In 1967 it had a repertory of thirty operas. Performances were frequently of excellent quality although the company's rehearsal rooms were in one building, its wardrobe was in another, its workshops were in yet another, and its scenery store was more than five miles away from the other buildings.[47] Funds contributed by the Arts Council from its Housing the Arts Fund and moneys from local governments have permitted the acquisition of a four-story warehouse, which, after being remodeled, will serve adequately as a headquarters. A five-year development plan, presented to the Department of Education and Science early in 1966, may enable the company to become one of the nation's major opera companies. Essential to this "leap forward" is the acquisition of a fully professional chorus. To become economically feasible, the new company must perform for at least thirty-six weeks each year.[48]

Opera for All is an enterprise designed to bring opera to British people living in isolated small towns and villages. Since its initial season in 1949, Opera for All has been one of the few programs operated directly by the Arts Council, its participants being employees of the council. No voluntary nonprofit organization existed which was willing to undertake a program to meet this need. Opera for All drew its inspiration from a remarkably successful tour early in 1949 made by four refugee Lithuanian singers who, with piano, gave operatic excerpts in their own language and costume. Later in the year, a "Grand Opera Group" of six with a manager-compère took to the road, presenting excerpts from well-known operas. In the fourth year, complete operas were given, costumes and properties being used for the first time. By 1958, the group numbered ten—including pianist, stage director, and stage manager—had a repertory of four operas, and owned its own transport, costumes, and multipurpose scenery.[49] Public reception was enthusiastic, and performances sold out. A second, London-based group was constituted in 1960 and a third, presented by the Welsh National Opera Company, was created in 1963. A total of 2,000 performances was passed on the evening of 12 November 1965, when the three groups played simultaneously in England, Scotland, and Wales. Today, using twelve members each,

46. By 1968, the Welsh Opera for All group was no longer so closely attached to the National Opera's training scheme.

47. Cmnd. 2893, The Council for Wales and Monmouthshire, *Report on the Arts in Wales*, 1966, p. 26.

48. *The Times*, 15 January 1966, p. 5.

49. Ibid., 18 September 1962, p. 13.

the groups put on some 250 performances in English during the six-month season.

Opera for All has depended to a major degree upon young talent, some of its singers later pursuing distinguished careers at Sadler's Wells and Covent Garden. When the London Opera Centre for Postgraduate Training was set up in 1964, the Arts Council accorded it the responsibility for the two London-based groups; in 1966, Scottish Opera made its Glasgow facilities available as a base for one of these. During 1966–67, a three-pronged administrative system functioned: Group E was produced by the London Opera Centre; Group S, made up in part of Scottish singers, was controlled by Scottish Opera; and Group W, based in Cardiff, was predominantly Welsh. The arrangement of tours is by the Arts Council, which seeks to ensure that all three groups to some degree serve in all three regions.[50] One new work featured by the London group was commissioned by the Arts Council in 1966–67, *The Man from Venus* by Philip Cannon. The financial accounts of Opera for All bear testimony to its growth over the years, even when the effects of inflation are taken into account. Thus, in 1955–56, £7,368 were spent on Opera for All; revenues were £6,068, leaving to the Arts Council a deficit of £1,300. Comparable figures for 1966–67 were gross expenditures, £41,099; revenues, £15,276; and net cost, £25,823.

Intimate Opera, a miniature opera ensemble organized in 1930, has received assistance since shortly after the Arts Council was established in 1946. The small subsidies given it—£1,000 in 1950–51, rising to £2,000 in 1966–67—suggest that the council seeks primarily to lend encouragement and to associate its name with Intimate Opera, rather than to undertake full provision for its financial requirements. Intimate Opera's touring activities, while fluctuating from year to year, have of late become less extensive— programs given throughout Britain to music clubs, schools, and festivals in 1948–49 numbered more than 200, while in 1965–66, the company's thirty-fifth year, only fifty performances were given.

A new operatic enterprise to serve the provinces was launched in March 1968, when the Glyndebourne Touring Opera, composed mainly of young British singers from the Glyndebourne Festival, undertook a six-weeks tour that visited five cities. Emphasis was upon high artistic standards. Subsidy from the Arts Council consisted of a grant of £20,000 awarded on a trial basis, plus a guarantee of £9,000; the Northern Association for the Arts contributed £2,000, and the Gulbenkian Foundation, £15,000.[51]

Arts Council subventions to the Western Theatre Ballet began in 1957–58, shortly after the company was established, when a modest grant of £500 was extended to it. The Western Theatre Ballet has specialized for the most part in experimental, contemporary works, thus appealing to new and younger audiences. During 1958–59, it danced for two weeks at the Lyric Theatre, Hammersmith, and for a week at Sadler's Wells, and was enthusiastically

50. *Key Year*, pp. 32–33.
51. Manchester *Guardian*, 13 May 1967, p. 3.

received by critics at both; in addition, it toured for an extended period, mostly in the west country. In subsequent years, under the artistic direction of Peter Darrell, the company toured in Britain, particularly the West and Southwest, making one- and two-night stands under the sponsorship of arts clubs. By 1963–64 the Arts Council subvention had increased to £12,000, thus permitting the ballet to spend eight weeks on tour in the Southwest, five weeks in the Northeast, two weeks in Northern Ireland, plus four weeks in London. Two new ballets were highly successful: *Houseparty*, specially created by Peter Darrell for television, and *Mods and Rockers*, also by Darrell, with music by the Beatles.[52] In the following year, "Ballet in the Round," a new experience for British audiences, was presented.

In 1966 the Western Theatre Ballet entered into association with Sadler's Wells, thus acquiring a London home and increased opportunity for regular appearances. Its two-week London season for 1966 consisted of four different programs that included London premieres of six ballets.[53] During 1965–66, it played in provincial centers for twenty-two weeks, participated in the opening of the new Swan Theatre at Worcester, presented the first ballet at the Yvonne Arnaud Theatre in Guildford, and performed in Helsinki during the Sibelius Festival. In 1967 and 1968 Western Theatre Ballet danced in Switzerland, Belgium, Holland, and Germany.[54] Western's repertory contains mostly ballets especially written for it; the music is predominantly modern; the subjects are consciously, sometimes modishly, in line with contemporary ideas; and dancers are required to act as well as dance.[55]

As for the company's financial problems, the Arts Council took the view that the company had to prove its worth before being accorded substantial aid. The council's grant amounted to only £4,500 for 1961–62, rose to £7,000 in 1962–63, and to £13,000 in 1964–65; more generous support by the Labour government enabled it to raise this figure to £20,500 for 1965–66, and to £30,000 in 1966–67. The tie-in with Sadler's Wells was encouraged by the Arts Council.[56] Under this arrangement Western Theatre is responsible for training and directing two groups of twelve dancers each, who perform with Sadler's Wells' two operatic companies. In addition, its own eighteen-member dance company continues to perform separately, spending most of its time on tour. Afternoon productions are carefully chosen to appeal to youth. An effort is made to avoid ballets containing undue overt reference to sex, a restriction not generally observed in evening performances.

Ballet Rambert pioneered British ballet and has been the source of numerous innovations. It is regarded by many as the rallying ground of opposition to the Establishment. Its founder, Marie Rambert, a woman of

52. State of Play, p. 87.

53. *The Times*, 14 May 1966, p. 15.

54. In 1962, the Company performed in Germany and Norway; in 1963, it revisited Germany and Norway, toured Finland and Sweden, and traveled to the United States; and in 1964, it participated in special observances in Denmark.

55. Manchester *Guardian*, 17 August 1966, p. 7; *The Times*, 3 July 1966, p. 47.

56. *The Times*, 6 January 1965, p. 5.

amazing creative talents and tenacity, was associated with Diaghilev's *Ballets russes* until they came to Britain in 1914.[57] After the war she opened a ballet studio in London, attracting a number of talented students.

Ballet Rambert was organized in 1931 in London as the Ballet Club, with its own theater, the Mercury, and a permanent company of dancers. Financial support came solely from Ashley Dukes and Marie Rambert. Operating funds were severely limited; and the theater was small, with restricted rehearsal facilities. However, ballets produced were attractively done, and some of the dancers, training under the personal supervision of Marie Rambert, became great artists.

In 1940, the London Ballet and the Ballet Rambert merged under the management of Harold Rubin, for reasons of economy. In 1941, British Actors' Equity requested more money for its dancers (three performances were given daily, wages remained modest), but Mr. Rubin was unwilling to accede to compensation adjustments. The company was thereupon dissolved, and, because of legal restrictions it could not resume production for some eighteen months. Charles Landstone, then associate drama director of CEMA, depicts the revival of the company:

> Early in 1943, three pretty little girls came to see Lewis Casson and myself at the CEMA offices. . . . The Ballet Rambert, of which they had been leading dancers, was (after its lunchtime performances at the Arts Theatre during the "blitz"), quiescent. They wanted us to reorganize it and to use it on the hostel tours, of which they had heard. We jumped at the chance, and I became personally responsible for the company.[58]

CEMA funds permitted the company to operate with some degree of security. Pioneering activities undertaken by Ballet Rambert and the Arts Council included not only visiting wartime hostels of armament workers but also performing at service camps and dancing before civilian audiences in provincial towns. Public response was enthusiastic, though at times theater conditions were almost impossible. "Sometimes the dancers had to compress their movements until they were almost motionless in order to avoid treading on the girl behind. Sometimes they could hardly see the girl in front for the distance. At Grimsby, the stage was extended by fishboxes."[59]

The company was hoping to establish a London home when Sadler's Wells ballet moved to Covent Garden in 1946, for it had outgrown the Mercury Theatre. But Ninette de Valois' second group—the Sadler's Wells Theatre Ballet—took the space instead. The lack of an adequate London home proved to be a serious handicap for the next two decades. Nevertheless, it enjoyed a highly successful year. When accounts were balanced for 1946–47, however, the Arts Council found that a loss of £6,990 had been

57. Mary Clarke, *Dancers of Mercury: The Story of Ballet Rambert* (London: Adam and Charles Black, 1962), pp. 1–35.

58. Charles Landstone, *Off-Stage* (London: Elek, 1953), p. 61.

59. Clarke, *Dancers of Mercury*, p. 136.

incurred.[60] Beginning 1 April 1947, Ballet Rambert operated independently, and, managed by its own board of directors, it functioned "in association with the Arts Council," with a grant of only £1,013. Although its performances were greeted with critical acclaim, attendance declined. By the end of the season, the financial situation had become precarious. The Arts Council felt impelled to reduce its grant to £500 for 1949–50.

During the 1950s, Ballet Rambert undertook extensive touring in the provinces, performed each year in London, and participated in summer festivals held in various parts of the country. In 1957, it toured China for nine weeks, performed at the Baalbeck Festival in Lebanon, and danced at the Jacob's Pillow Festival in Lee, Massachusetts. By 1961–62, the company was helped by a grant of £20,450 from the Arts Council, which permitted it to improve its orchestra and develop young artistic talent. Arts Council subsidy rose to £37,000 in 1964–65; with the advent of the Labour government, its grant almost doubled—£67,000 for 1965–66.

Analyzing the company's contributions to ballet, Clive Barnes, executive editor of *Dance and Dancers*, observed in 1963:

> The Ballet Rambert's past is undeniably glorious. With only one or two exceptions every major British choreographer has worked with the company at some time or another, and three of British ballet's senior choreographers—Ashton, Tudor and Howard—were among Rambert's earliest discoveries. Nor was it only choreographers who were brought to life by Rambert; designers, a few composers and dancers by the dozens, have all been inspired, influenced, prodded, bullied and taught by this remarkable woman. Looked at in the present perspective of ballet history, it seems fair to say that no director has had a greater effect on ballet's creative forces, probably not even Diaghilev.[61]

The company's role in British ballet changed slowly over the years. Initially, it was the "cradle of British ballet," and created a remarkable number of significant ballets. Its policy in the early 1960s aimed at consolidating a classical repertory augmented with good modern ballets. Rambert's range and direction undoubtedly entitled it to first-rank status, but no company can achieve its maximum artistic potential if it is almost continuously on tour. Desperately needed was a permanent home where it could present a London season of perhaps three months, which, if successful, would greatly enhance its reputation and enable it to attract larger audiences while on tour. In 1965, some 60 persons were employed by Ballet Rambert, including 33 dancers and an orchestra of 21. Thirty weeks were spent on tour in 1964–65; the season at Sadler's Wells lasted two weeks.

The possibility of using, jointly with the Royal Shakespeare Company, a

60. One explanation, not universally accepted, was that the orchestra which had accompanied the ballets at Sadler's Wells and at Hammersmith "had been no more than adequate but Sir Steuart Wilson, then music director of the Arts Council, insisted that it should accompany the Ballet Rambert when it went on tour. . . . Proving, in many instances, of inferior quality to the admirable pianists who had traveled with the ballet before, it added vastly to expenses." Clarke, *Dancers of Mercury*, pp. 152–53.

61. *The Ballet Rambert* (London: Printerman, Ltd., 1963), p. 2.

new theater in the City of London's Barbican development was considered, but failed to materialize. Early in 1965, at the instigation of the Arts Council and the GLC, the Two Ballets Trust was formed to permit more effective control of the finances of the London Festival Ballet and the Ballet Rambert. This match proved unacceptable and after a short period was disbanded. Some observers felt that Britain possessed too much traveling ballet, with companies stepping on each other's heels, due to the absence of proper central-government planning.[62] Struggling to attract audiences, all the companies have tried to present popular programs. For Rambert, a steady diet of *Coppelia* and *Giselle*, as well as continual traveling, reduced company morale. No other ballet, it was argued, possessed the scope and resources to enable it to serve as a strong alternative to the Royal Ballet in the same way that the National Theatre profits from the vigorous competition of the Royal Shakespeare. Greater financial support was needed to permit it to fulfill this role. The Arts Council, however, decided otherwise. By the summer of 1966, Rambert's management concluded it was no longer feasible to tour the country with a small number of popular ballets to which people were accustomed. The company reorganized, reducing its dance complement to eighteen and its chamber orchestra to sixteen, and resolved to pursue objectives more in line with those of its pioneering days.[63] Using the Jeanetta Cochrane Theatre in London, choreographers, both new and established, were now given an opportunity to experiment, presenting public seasons as well as special workshop performances. Its repertory in mid-1967 contained fourteen works, mostly new; the classics were left to the Royal Ballet and the Festival Ballet. Two London seasons are held each year; in 1967–68, the company was on the road for twelve weeks. Because of the nature of its repertory, losses on tour are substantial; almost half of the local authorities visited provide grants ranging from £100 to £300. The Arts Council's subvention for 1966–67 was raised to £97,500 to help offset losses incurred. The first of the new workshop performances took place in March 1967. It presented new works by young choreographers, the result of a collaboration between Ballet Rambert and the theater department of the Central School of Art and Design.[64]

The Arts Council for some years has awarded modest grants or guarantees to several small groups who bring intimate ballet presentations to theaterless towns and remote areas of the country. The Harlequin Ballet was assisted to the extent of £2,475 in 1965–66 and £1,875 in 1966–67; Ballets Minerva (Balmin Production, Ltd,), which received £3,988 in 1965–66, was accorded a more generous allocation, £14,000, to facilitate expansion of its activities in 1966–67. Readers of *The Times* on 18 July 1967 were treated to a front-

62. The Arts Council was vigorously criticized for not according the Ballet Rambert larger subsidies more in line with those allotted to Covent Garden and Sadler's Wells. *Sunday Telegraph*, 3 July 1966, p. 3.

63. *New York Times*, 15 June 1966, p. 43; *The Times*, 15 August 1966, p. 7; 29 August 1966, p. 2.

64. *The Times*, 26 January 1967, p. 6a.

7*

page photograph of ballerinas from the Harlequin Company protesting, at the House of Commons, the Arts Council's decision to terminate their modest subvention. Their efforts, however, proved unsuccessful.[65]

Since the establishment of the Arts Council, small sums have been given to amateur operatic groups and societies to permit them occasionally to employ professional singers. Token subventions are also accorded other organizations in the fields of ballet and opera. In 1966–67, the council made grants and guarantees, each amounting to less than £1,000, to twenty-nine organizations; slightly more than half received £200 or less. Quality of performance has varied greatly.

Assessment and Outlook The Arts Council decided in early 1966 that significant changes in the pattern of patronage for opera and ballet were required; however, it did not wish to initiate specific proposals in these two complex fields until it had at its disposal more adequate information. A twenty-two-member committee, composed of experienced professionals as well as representatives of the general public, was constituted "to consider the existing and to estimate the potential public demand for opera and ballet in different parts of Great Britain; and to consider how far, under existing policies, these demands are being or are likely to be met; and to make proposals regarding future policy, indicating the scale of financial support, both in respect of capital and recurring expenditure, which might be required to give them effect." Under the joint chairmanship of Lord Goodman and Lord Harewood, the committee received a wealth of verbal and written testimony on the plight of these "hand-to-mouth" arts. The committee submitted an interim recommendation late in 1966, urging that a new opera house be erected in Manchester, with regular programs of opera and ballet; construction costs were estimated at £2 to £3 million to be met by allocations from the Arts Council, Manchester Corporation, northern local authorities, industry, and commerce.[66] The committee also supported the proposal that an opera house be erected in Scotland.

To deal with some of the serious deficiencies in opera and ballet during the next ten years, substantially greater financial support and comprehensive long-range planning are needed, but neither is easy to achieve. The fiscal requirements of Covent Garden and Sadler's Wells have already been depicted. Sadler's Wells urgently needed a new theater—one located in London, not in the provinces as some had suggested. It remains to be seen whether its new home in the London Coliseum will, in reality, provide the

65. Council support of the Harlequin Ballet was withdrawn in 1966 because of poor artistic performance. Critical reception was, upon occasion, exceedingly negative. *The Times*, 2 May 1966, p. 5.

66. A Manchester opera house, seating 1,600 people, was first suggested in February 1965, as part of an arts center, including a new commercial theater and film center, on a site near the city art gallery. Permanent opera and ballet companies were envisioned as well as visiting companies. Manchester *Guardian*, 11 November 1966, p. 22.

requisite facilities for the kind of productions the company envisions, or whether later it will need a new building designed specifically for opera. London, with more than a quarter of the nation's population, merits two opera companies of national stature, adequately financed, providing a healthy competition for each other. The creation of a second major ballet, comparable to the Royal Ballet, would also be beneficial. The decision to cancel the construction of an opera house on the South Bank is regrettable. The Labour Party's thrust to augment the provision of opera and ballet in the provinces should be pursued with vigor. Whether or not London and the rest of Britain can simultaneously be provided with opera and ballet of high quality is not a question actually at issue. Rather, what is needed is a well-thought-out, long-range blueprint, which should result in a marked improvement in provision of these arts throughout the entire country. It is estimated, for example, that the erection of a new opera house in Manchester will require up to ten years to complete.[67] Additional costs, if pro-rated over a period of years, would not place an excessive burden on the Treasury, especially if the large cities can be persuaded to make substantial contributions. In spite of her recent economic difficulties, Britain can afford the required financial outlays, if they are carefully planned and budgeted over the next decade.

Touring opera as it existed in the twenty years after World War II appears to be on the wane. Today's more sophisticated audiences are accustomed to recordings and television presentations; their response is becoming less enthusiastic to even the best-intentioned, London-based company on tour with a large group of singers and musicians, tired from constant travel and lacking the opportunity to rehearse properly.[68] A carefully planned expansion of regional opera and ballet can satisfy the desires of the British people more effectively. The proposed Manchester opera company constitutes one new undertaking, already well advanced; Arts Council resources will also be used to make greater provision for opera in Scotland and Wales and perhaps in other parts of the country. Year-round operations by the Welsh National Opera Company will permit it to serve the larger population centers in Wales and perform in cities scattered throughout the West of England. Scottish Opera faces serious problems in its expansion and further professionalization, and thus far has not acquired adequate opera house facilities in Edinburgh. The creation of regional ballet companies is yet to come. Meanwhile, provincial touring of opera and ballet will continue on a more limited scale, but it needs to be subjected to additional coordination, so that visits to small provincial towns are spread more evenly throughout the year and programs framed to avoid duplication.

67. Manchester *Guardian*, 21 April 1967, p. 22.
68. *Sunday Telegraph*, 22 May 1966, p. 13.

9 / THE LIVE THEATER

Getting patronage is the whole art of life.
A man cannot have a career without it.
—George Bernard Shaw, *Captain Brassbound's Conversion*

Few observers of the British theater would dispute the fact that if governments—national and local—had not come forward in the nick of time with desperately needed financial assistance, few first-class noncommercial theaters would exist in the nation today.

Until 1939, Parliament, as well as local authorities, gave little attention or financial support to the nation's theaters. During World War II CEMA assumed limited responsibility for the theater, thus helping to provide employment for actors while simultaneously furnishing entertainment on the home front. Moneys spent by the council for drama in 1944–45 totaled £29,555 or 16 percent of all expenditures; by 1950–51, funds allocated to theater rose to £103,465, but the proportion of the council's budget remained relatively constant, 15 percent. The Arts Council immediately set about devising the best system for perpetuating the dramatic efforts of wartime tours and gradually replaced its nationwide touring from London with good local provincial-based companies. Postwar dislocations and financial stringencies inhibited quick solutions and induced the council to experiment with a number of administrative mechanisms. By early 1950 the Arts Council was using five different subsidy devices to assist British theater.[1] First, two theater buildings were under the direct management of the council. Theatre Royal in Bristol had been leased by CEMA in 1942, and at the end of the war the council invited the Old Vic in London to establish a company in Bristol to present classics, outstanding modern plays, and first productions of new works. The Arts Theatre in Salisbury, a small cinema which had been used as a garrison theater, was opened by the council in 1945. Another device involved three theater buildings, designated as "in association" with the Arts Council, which received limited grants toward operating costs: the Arts in Cambridge, Princess's in Glasgow, and Playhouse in Kidderminster.

Most important of the devices was the provision of grants and guarantees totaling £44,777, to some twenty-five theater companies "associated" with the Arts Council. Agreements were signed with each of these companies, which shared the council's objectives, "to spread the knowledge and appreciation of all that is best in theater, and thus to bring into being permanent educated audiences all over the country."[2] Only nonprofit-sharing companies and charitable trusts were eligible for association, the council making available advice and assistance and such financial aid as it deemed desirable and practicable. The drama director or his representative could attend all meetings of a company's management body as assessor, receiving minutes, reports, and financial statements as well as detailed advance information relating to all of its activities; also, the company's general policy had to be approved in advance by the council. During this period numerous significant theatrical enterprises were launched. In 1946 the governors of the

1. *The Arts Council of Great Britain, Fifth Annual Report 1949–50*, pp. 51–58.
2. Ibid., p. 47.

Old Vic and the committee of the National Theatre merged forces to press for erection of a National Theatre. In 1948–49 the new repertory Civic Theatre opened in Chesterfield; the building belonged to the corporation, which reconditioned and equipped it, though it had its own manager and producer, and was administered by a board representative of the town council and local art societies. At the same time the Nottingham Playhouse was established, some of its theater performances being sponsored and paid for by the county and city education authorities. Other companies associated with the Arts Council included Avon Players, Colchester Repertory, Dundee Repertory, Guildford Theatre, Ipswich Arts Theatre, London Mask Theatre, Oldham Repertory, Perth Repertory, and Sheffield Repertory.

Direct management of companies constituted the fourth method by which the council aided British theater. The Arts Theatre Company of Salisbury in 1946 mounted plays for ten days each month, touring smaller towns for the remainder of the time. Later two companies were set up, thereby increasing the amount of professional theater offered at the home base as well as on tour. The Arts Council's Midland Theatre Company, constituted at the same time, immediately encountered difficulty and moved from temporary quarters in Coventry to the newly opened Kidderminster Theatre, where, it was hoped, enlarged resources would permit it to play on circuit in a number of nearby towns. Unfortunately, these efforts were not productive, and the Midland Theatre Company had to return to Coventry, though by 1950 its financial position was improved. Both companies achieved high standards of performance. The third directly managed company, the Swansea Repertory, presented twenty-six different plays in 1949–50, its operations costing the Arts Council £10,709. This experiment in direct management ended in 1957 when the last of the council-operated companies became an independent, nonprofit trust, aided by council subventions.

Finally, the Arts Council, hoping to strengthen the theater through directly managed tours, in 1949–50 arranged visits by each of the three council-operated companies to the mining districts of Wales, Northumberland, and the Midlands, but with disappointing results. Audiences were smaller than in the previous year and, although the plays were well received, striking evidence of new or even sustained interest was lacking. The council concluded that its directly provided pioneer tours, so successful during the war and immediate postwar years, had developed no firm roots. Rather, it felt that it was "in the resident repertory theaters of character and distinction, supported by Corporation funds, by local enthusiasm and by the Council's subsidy where required, and which could themselves send out local tours, that the best promise for the future in the provinces lies." Today the council encourages theaters to mount local tours; subsidies to transport regional audiences to nearby theaters are considered much more economical and are given in modest amounts to almost all non-London repertory theaters.

Arts Council theater activities expanded during the 1950s, but sufficient

money was never available to accomplish what needed to be done. Expenditures on drama for 1960–61 amounted to £192,140 or almost 13 percent of the council's total budget, a proportion slightly less than in 1950. In 1956, after ten years, the council reported that in spite of increased costs and competition from television, the number of provincial repertory theaters in England had steadily increased, estimating their number at one hundred, of which perhaps forty were nonprofit. Of the latter, twenty-three received grants from the Arts Council ranging from £250 to £5,000.[3] By 1960 the number receiving assistance had risen to twenty-six, with subsidies varying from £500 to £10,000. The council highlighted the difficulties yet to be overcome in the mid-fifties, pointing out that existing companies varied widely in quality, were afflicted as a rule with harassing economic problems and, almost without exception, were not strictly "repertory" at all, possessing no anthology of productions.

The Arts Council, beginning in 1946, accorded much-needed support to the Old Vic, which for many years was the sole provider of noncommercial theater in London. Of great importance was the birth in April 1956 of the English Stage Company at the Royal Court Theatre, London, and with it the offering of contemporary plays presented in true repertory. In 1959 the Mermaid Theatre, created out of the remains of a warehouse on the Thames in the City of London, under the guiding genius of Bernard Miles, supplemented the dramatic bill of fare available to discriminating London audiences.

From 1950 onwards the number of tours directly managed by the Arts Council was steadily reduced, and was finally restricted to six or seven weeks in Wales and a briefer period in the Northeast. The cost of directly managed tours became exorbitant, with a four-week tour in the Northeast in 1959 attracting fewer than 5,000 patrons and costing £1,000 above gate receipts. This apparently unpopular method of diffusion was dropped, although the Welsh Committee continued its six-week tour to towns which had no theater. The New Drama Scheme, designed to encourage the production of new plays, was launched by the council in 1952, achieving considerable success. A New Designers Scheme was initiated in 1961 to encourage theater managements to employ new designers.

The theater in Britain took a substantial leap forward both in London and the provinces during the 1960s, largely because of more generous subsidies by the Arts Council and local authorities. In 1965–66 the council allocated £904,525 for drama support, the proportion of its total budget earmarked for theater increasing to 23 percent, and in the following year, dramatic activities in England, Scotland, and Wales were aided to the extent of £1,573,836, 28 percent of the council's total expenditure. Without question, the most spectacular development of the decade was the creation of the National Theatre. On 3 July 1962, the Chancellor of the Exchequer

3. *The First Ten Years: The Eleventh Annual Report of the Arts Council of Great Britain, 1955–1956*, p. 40.

announced in the Commons that the government had agreed to proceed with the creation of a National Theatre, to be a part of an arts center located on the South Bank of the Thames. A National Theatre board was appointed and a company constituted with an initial subvention of £131,000 from the council. The opening production was given in London on 22 October. In 1962 for the first time the Royal Shakespeare Theatre Company received financial assistance from the council in the form of a limited touring guarantee. In addition to its program at Stratford-on-Avon, the company mounted a full-scale operation at the Aldwych Theatre, London, emphasizing classical and modern plays. However, progress toward the erection of a National Theatre building was slow.

Space does not permit a comprehensive analysis of the entire range of Arts Council and local authority activity in theater subsidy. In the following pages, a number of case studies are presented, designed in each instance to highlight special problems and detail how public funds were used to strengthen the theater and improve its artistic quality.

The National Theatre As he turned the sod to the accompaniment of madrigals sung by the Fleet Street Choir at a 1938 ceremony marking the acquisition of a London site for the projected National Theatre, George Bernard Shaw commented on a peculiarly English characteristic. *The Times* of 23 April reported some of Shaw's observations:

> People sometimes asked him: "Do the English people want a national theatre?" Of course, they did not. They never wanted anything. They had got the British Museum, the National Gallery, and Westminster Abbey, but they never wanted them. But once these things stood as mysterious phenomena that had come to them they were quite proud of them, and felt that the place would be incomplete without them.
>
> What they had to do was to start the phenomenon, because, although they could go ahead for some distance, in the long run the Government would have to keep on its feet this great national institution. . . . They had to carry this project to the point at which the Government would be up against it. . . .[4]

At the reception which followed, great hope was expressed for the theater's future. If drama were to grow and flourish, it could not be left entirely to the hazards of private enterprise. A national theater could accomplish what private theaters are not always able to achieve: it could adhere to predetermined standards of selection and excellence.

Shaw's analysis of British cultural evolution was shrewd, but it is doubtful whether he realized twenty-four years would elapse before the National Theatre could present its first play. Actually, a national theater conforming to European standards had been proposed in 1848 by Effingham Wilson, a London publisher, and favorably commented upon by Charles Dickens and

4. *The Times*, 23 April 1938, p. 9.

other notables. Comprehensive plans for a national theater had been drawn up as early as 1904 by William Archer and Harley Granville-Barker.[5] It was evident that private generosity would not provide the needed construction funds, and yet many looked upon the government with suspicion, fearing some form of state control and a nationalized theater that smacked of socialism. Advocates of a national theater joined those who urged a national memorial to William Shakespeare, and in 1909 the Shakespeare Memorial National Theatre Committee was constituted with the aim of opening a theater in 1916. Throughout the 1920s and 1930s the idea was kept alive as limited funds were raised.

After World War II, negotiations with the London County Council resulted in the exchange of the existing South Kensington site for a new location on the south bank of the Thames between the Royal Festival Hall and Waterloo Bridge. In 1946 the Old Vic Theatre wished to associate itself with the National Theatre movement, and as a result, a Joint Council of the National Theatre and the Old Vic was formed. Without division, Parliament sanctioned a national theater bill in 1949, empowering the government to use its discretion in making available funds up to £1,000,000.[6] No action was taken during the next decade, largely because of postwar economic stringencies. In 1958, in its report on the housing of the arts, the Arts Council recommended that the highest priority be accorded to the National Theatre.[7] With the addition of representatives of the Shakespeare Memorial Theatre, the new council thus constituted urged that the government act to open the theater in 1964, the 400th anniversary of William Shakespeare's birth. In 1960–61 the Treasury tentatively offered £230,000 as an annual grant for the theater project. When the Royal Shakespeare opted out, the National Theatre's grant was fixed at £130,000. The Royal Shakespeare's decision to withdraw, reflecting a desire for continued independence, created considerable controversy. In the long run, however, the move was undoubtedly advantageous, for it ensured greater diversity within the British theater. At this juncture, the LCC suggested that Sadler's Wells be rehoused in an opera house under the same roof as the National Theatre.

On 3 July 1962, the Chancellor of the Exchequer announced approval in the Commons not only for the National Theatre, but also for the arts center on the South Bank. With the agreement of the LCC he named Lord Chandos as first chairman of the theater board and appointed nine additional members. Also constituted was a South Bank Theatre and Opera House Board, to be responsible, under the government and the LCC, for building the National Theatre and a new opera house. The activities of the Old Vic were terminated in 1963, and the theater was leased to serve temporarily

5. A detailed account of the history of the national theater movement is presented in Geoffrey Whitworth, *The Making of a National Theatre* (London: Faber and Faber, 1951); see also "As Granville-Barker Saw It," *The Times*, 15 February 1962, p. 14.

6. National Theatre Act, 12 and 13 Geo. 6, chap. 16.

7. The Arts Council of Great Britain, *Housing the Arts in Great Britain, Part I* (1959), pp. 30–38.

as the home of the National Theatre.[8] The National Theatre Company began its first season on 22 October 1963, with *Hamlet*, presenting during the succeeding five months *Saint Joan, Uncle Vanya, The Recruiting Officer, Hobson's Choice*, and *Andorra*. Both critical evaluation and public response were most enthusiastic; during the period ending 31 March 1964, there were 156 performances with attendance averaging 86 percent of financial capacity, 126,796 persons paying to be admitted. The company also undertook its first provincial tour, four weeks in length. Expenditure of the theater board from 8 February 1963 to 31 March 1964 amounted to £268,490, income totaled £114,924, and Arts Council subventions were £131,000; a deficit of £22,566 was carried forward.[9]

The board's Memorandum and Articles of Association, issued in January 1963, empowers it to "promote and assist in the advancement of education," to procure and increase "the appreciation and understanding of the dramatic art in all its forms as a memorial to William Shakespeare," specifying an exceedingly broad range of permissible activity, including not only drama but opera, ballet, and music as well. Twenty-five company members were named by the Chancellor of the Exchequer for terms not to exceed five years, ten being designated to serve as the board of management, to meet once a month and discharge most of the functions of the company. Beginning in 1965, board members were designated by the Secretary of State for Education and Science. Chairman Viscount Chandos, a prominent businessman and long a leader in British cultural affairs, had guided the operations of the board with skill and finesse, assisted by the secretary, Kenneth Rae.[10]

Two committees are exceedingly useful: the finance committee, which scrutinizes the budget and reviews income and expenditure developments; and the drama committee, which concerns itself with overall matters relating to artistic direction and the choice of plays. The full board, which gives final approval to the annual budget, receives from the finance committee monthly reports. Its members are kept fully informed by the drama committee concerning personnel policies, and they grant final sanction to the drama committee's plans for plays to be presented during the London seasons and approve arrangements for tours, though they do not concern themselves

8. In spite of the lack of adequate financial resources, the Old Vic at the time of its closing was regarded by drama critics as the most important theatrical institution in Britain. "Farewell to the Old Vic," *The Times*, 25 April 1963, p. 16.

9. The National Theatre Board, *Report and Accounts for the Period 8th February 1963 to 31st March 1964*.

10. Major credit for the government's decision to create a National Theatre in 1963 has been accorded Lord Chandos. As Oliver Lyttelton, he served in both of Winston Churchill's cabinets and held important posts in business. He was chairman of Associated Electrical Industries when named to the National Theatre Board. *Christian Science Monitor*, 15 October 1963, p. 9. Also serving on the board initially were two businessmen, Lord Wilmot and William J. Keswick; two theater managers, Hugh Beaumont and Derek Salberg; Kenneth Clark, author and former director of the National Gallery and ex-chairman of the Arts Council; Douglas Logan, principal of the University of London; Ashley Clarke, retired diplomat; Henry Moore, sculptor; and Freda Corbet, chairman of the General Purposes Committee of the LCC.

with artistic direction and production details. Top posts—director, administrative director, literary manager, general manager, and secretary—are filled by the board, while senior management makes all other appointments.

Answering only to the board, the Executive Group (director, administrative director, general manager, secretary, and literary manager) exercises overall coordination. Artistic direction is by Sir Laurence Olivier, who contributed outstandingly to the almost immediate success of the new theater. Under the administrative director, the general manager is responsible for all day-to-day administration and, therefore, controls the executive manager, the stage manager, the production manager, the costume manager, and the house manager. Other officials include the accountant, the public relations officer, and the press representative. Approximately 300 persons are employed by the theater; between seventy and eighty of these are actors and actresses on contract—some for three years, many for one year, and a few for a month at a time.

Until July 1965, a complicated sales system with a priority list and voucher scheme brought severe criticism from those unable to obtain tickets. Complaints of favoritism have all but disappeared with the innovation of a simple system under which postal bookings can be made three or four weeks before the opening of box-office sales. But for the most popular plays, tickets remain difficult to obtain, since, unfortunately, the size of the Old Vic Theatre (878 seats) is severely restrictive. Average attendance, measured in terms of percentage of financial capacity, has been consistently high: 86 percent, 79 percent, and 87 percent, respectively, for the first three years; and 83 percent in 1966–67 (92 percent paid admissions) with total attendance in the latter year being 267,706.

The variety and quality of the National Theatre's contributions to British drama are readily apparent. Its repertory has included a mixture of the classics and the modern, of comedy and of tragedy, with three or four different plays presented weekly. During 1964–65, the London season lasted a total of forty weeks. It included Shakespeare's *Othello*, Becket's *Play* and Sophocles's *Philoctetes* in a double bill, Ibsen's *The Master Builder*, Peter Shaffer's *The Royal Hunt of the Sun*, Marston's *The Dutch Courtesan*, Noel Coward's *Hay Fever*, Arthur Miller's *The Crucible*, and Shakespeare's *Much Ado About Nothing*. Seven plays were introduced into the repertory the following year, and in 1966–67 Sean O'Casey's *Juno and the Paycock*, John Osborne's *A Bond Honoured*, Ostrovsky's *The Storm*, and Strindberg's *The Dance of Death* were added. During the latter season 330 performances were given at the Old Vic; then, to satisfy customers unable to obtain tickets, an additional ten-week season, August through October, was arranged at the Queen's Theatre. During 1963, 1964, and 1965 the National Theatre also presented summer seasons at the Chichester Festival Theatre in southern England.

The National Theatre engages in limited touring. For 1965–66 an Arts Council guarantee of £12,000 sent a tour to the provinces for four weeks in

the fall and again in the spring. In 1966–67 the company played eight weeks visiting six cities, the Arts Council guarantee amounting to £20,000. Tours abroad are partially financed by the British Council. In the summer of 1965 the National Theatre spent more than two weeks performing in Moscow, with a one-week stopover in West Berlin. In the fall of 1967 the company toured for six weeks in Canada, with a two-week stopover at the Montreal Expo. Audience response there as well as in western Europe and the Soviet Union was consistently enthusiastic. One company of actors generally remains in London performing at the Old Vic.

Since its establishment, the National Theatre, a semi-independent state enterprise, has received from the Treasury and the GLC increasingly large annual subventions. Government policy has favored limiting grants to sums determined prior to the opening of the fiscal year. Thus, in 1965–66 the National Theatre received through the Arts Council £188,000 or approximately 25 percent of the £766,066 given in that year to the support of all theaters in England. Earlier it was allocated £130,000 by the Arts Council for 1963–64 and £140,000 for 1964–65. For the year ending 31 March 1967, the Exchequer subsidy totaled £219,860. Expenditures amounted to £644,423 with no operating deficit incurred. The council began in 1966–67 to make the first of a series of annual contributions (£80,000) designed to reduce the theater's accumulated deficit, which stood at £241,994 in March 1966.[11] Arts Council support in 1967–68 consisted of a basic grant of £240,000 plus a touring guarantee of £20,000.

During its early years the National Theatre often negotiated directly with the Treasury, bypassing the Arts Council, a privilege it shared with Covent Garden. But in September 1964, this practice was discontinued when the Arts Council questioned the propriety of an assisted organization going directly to the Treasury. Today the National Theatre is encouraged to discuss its problems and needs with the Arts Council rather than directly with the Department of Education and Science. Both the Arts Council and the department send assessors to the meetings of the theater board. In 1964 the LCC decided to make available subsidies to assist the National Theatre, giving £40,000 for 1964–65. Its successor, the Greater London Council, put up £51,431 in 1965–66 and £90,000 in 1966–67 and 1967–68. For 1965–66 the method for determining grant size, previously based upon a detailed examination of program plans, budget, and accounts, was altered. Under the new formula, the Arts Council contributed 10s. for every pound of reckonable receipts, while the Greater London Council paid five-seventeenths of the sum ultimately made available by the Arts Council. The new system was not entirely satisfactory, for by keying grants to receipts, it could inhibit the presentation of new or less popular plays by the theater, which would

11. Lord Chandos, board chairman, in commenting upon the recurring overdrafts, observed that "in spite of remarkable box-office success and very accurate costing of productions, the theatre could not pay its way without greater subsidies." Manchester *Guardian*, 11 October 1965, p. 5.

not wish to jeopardize its subvention by limiting attendances. The following year the council reverted to the earlier system of grant allocation.

Government policy relating to the construction of the National Theatre building has been somewhat confused and slow to emerge. In 1962, the Chancellor of the Exchequer, in consultation with the LCC, proposed the appointment of a South Bank Theatre and Opera House Board to supervise the building of a theater and a new opera house to replace the Sadler's Wells present building. Named to the board by the Chancellor were eleven members, with Lord Cottesloe, head of the Arts Council, designated as chairman. The government was prepared to make available a capital sum not exceeding £1,000,000 for the erection of the theater, while the LCC agreed to contribute up to £1,300,000 toward the cost of building the theater and opera house. Many observers were convinced that these sums were far too small.[12] By 1964, proposals for the basic theater design were prepared, but several contemporary developments—the change in government from Conservative to Labour, the enlargement and transformation of LCC into the Greater London Council, and the shifting of the Arts Council from the Treasury to Education and Science—made it difficult to obtain answers to key questions.

When in June 1965 Denys Lasdun, architect of the South Bank Board, presented an outline plan for the new National Theatre and opera house, Lord Cottesloe envisioned new structures that at night would present "a fairyland picture by the side of the Thames." Less than a year later it appeared that only a part of the scheme would be implemented—the erection of the opera house was to be postponed. By this time, the total estimated cost of a new theater and opera house had risen to £13,000,000. The government was committed to sharing the cost of constructing the theater with the GLC, but it had never agreed to help build the opera house. Regional spokesmen argued that priority should be given to improving facilities in one or more provincial cities. This meant that responsibility for building the opera house would fall squarely on the GLC, and the advantages of a joint architectural concept would thus be sacrificed. The Treasury was unenthusiastic about the original plan, fearing that, once on the South Bank, Sadler's Wells would be in a position to claim a larger annual grant than if it remained in Islington. In March 1966, the government announced that a decision on the opera house would be deferred; subsequently, it decided not to participate and, as a result, a new opera house will not be erected on the South Bank.[13]

On 9 March 1966, the South Bank Board announced its hope that construction of the National Theatre could begin soon, thus making it possible for the company to occupy the theater by the end of 1971. In 1967 the GLC offered the board a better site immediately east of Waterloo bridge, resulting in further delay. Estimates of construction costs total £7,500,000, half to be borne by the government and half by the GLC. Two main auditoriums are

12. *The Times*, 4 July 1962, p. 12.
13. *The Sunday Times*, 16 January 1966, p. 8.

planned—one with an open stage and 1,000 seats, and the other with a proscenium stage and 900 seats—plus a small experimental theater seating about 350. Lord Cottesloe reassured the nation that the designs were not extravagant, as some critics had alleged, and that the buildings would be comparable to those of the best municipal theaters on the Continent.[14]

On two occasions the theater board has refused to approve plays recommended by Sir Laurence Olivier and Kenneth Tynan, literary manager, which raises the issue of censorship. In 1967 the board unanimously rejected Rolf Hochhuth's play, *The Soldiers*. Upon being questioned concerning the board's responsibilities in this area, Lord Chandos, as chairman of the theater board, observed:

It should give the artistic director the greatest independence possible—and I repeat, *possible*—in a modern society. This cannot be absolute because certain questions arise which bring wider considerations into play. Now suppose you had a satire on the present Government—well, only a Board can decide if it's harmlessly amusing T W T W T W stuff or concerted propaganda to win a few Conservative votes.

We represent a pretty good cross-section of opinion. . . . now is it not just possible that such a body may be right and the other wrong? Democracy's reached such a pitch that any majority is always assumed to be wrong.

With this Hochhuth play, there's no question of *censorship*. No theatrical management has an obligation to put on a play about cucumber sandwiches if it doesn't want to.

The play is a grotesque calumny on a great statesman. It's too ridiculous; the poor old Prof. is made out a sort of Mephistopheles and the Paymaster-General is shown as running the country. There's this *absurd* Cabinet meeting where Winston says, "I think it's better to bump Sikorski off," and they bring in Victor Cazalet and Anthony Eden as accomplices. . . .

Now with a National Theatre you've got to remember foreigners, the sort who think the *Times* newspaper is compiled by the Government. . . . If we'd put on this play some poor Italian gentleman might say, "Ha ha, so that's what went on in England during the War." If they choose to put it on at some theatre club in Hampstead, that's a different matter—it's fantasy then.[15]

Although he would die for "freedom of speech," Chandos asserted, this did not mean that you could "just libel anyone." He felt that it was very odd that Tynan should conduct a libel campaign against his chairman and board, while retaining a salary.

Board member Nancy Burman declared:

It's a frightful job. And this business has highlighted the whole problem of a subsidized theatre. When I was running Birmingham Rep. which was partially supported by grants from local authorities (for which we were very grateful), one was rather inhibited by angry letters from complaining ratepayers. After all, they paid their rates.[16]

Hugh Willatt, Arts Council member, asserted that "it is essential for the lay board to recognize that the theater must be run by professionals. . . . But as

14. Manchester *Guardian*, 10 March 1966, p. 1.
15. *The Sunday Times*, 30 April 1967, p. 2.
16. Ibid.

more and more theaters are partially supported by public money, the Governors become trustees of the public interest. The problem has not yet been solved."[17] Sir Kenneth Clark strongly supported the Board's action, stating that there comes a point when art passes over to the realm of public policy, and then a board of normally intelligent people from different walks of life must assume responsibility. This fact is sometimes overlooked by people who live only for their art. Clark observed that the board had previously refused permission to put on Wedekind's *Spring Awakening*, one of the reasons being that it contained an "objectionable scene."[18]

The Royal Shakespeare Company One of the most significant developments in British theater is the emergence of the Royal Shakespeare Company. The Arts Council did not provide regular monetary support for the company until 1963, when the Royal Shakespeare Company, which had added year-round operations in late 1960 at the Aldwych Theatre in London to its long-established activities at Stratford-on-Avon, faced a serious financial crisis and a reluctant but drastic curtailment of its programs. After a careful evaluation of its plight, the Arts Council came to its rescue with a basic grant of £40,000 and a touring guarantee of £7,136; its subventions were increased to £88,136 the following year and stood at £93,273 for 1965–66. Thus, the Royal Shakespeare became the second most heavily subsidized theater in Britain. Higher production expenses in 1966–67 again placed the company in a serious financial position, forcing a cutback of a number of revivals scheduled at Stratford and the restriction of productions at the Aldwych to small-cast plays. The Arts Council subsidy of an outright grant of £153,000 (with no tours undertaken), though more than 50 percent larger than the previous year, fell nearly £100,000 short of the amount requested. In January 1967, the company announced that it would embark upon the most ambitious program yet undertaken, financed in part by an increase in Arts Council support, involving a basic grant of £180,000 plus a £20,000 touring guarantee.

The Royal Shakespeare Theatre, known as the Shakespeare Memorial Theatre until 1961, originated at Stratford in 1875. In 1926 the small riverside Victorian playhouse was destroyed by fire, six years later to be replaced by the present building, costing £306,000, all raised from private sources. The company, performing seven months each year, came to be highly regarded and attracted visitors in large numbers from all parts of the world. Today the theater, with seats for 1,400, possesses a library, picture gallery, and river-terrace restaurants. At the Aldwych theatre, the Royal Shakespeare's London home since 1960, seating 1,028, the company presents a year-round repertory, consisting mainly of non-Shakespearean classics and new plays.

Peter Hall, who at age thirty-two was appointed director in 1960, has greatly influenced the program and artistic emphasis of the Royal Shake-

17. Ibid.

18. *Spring Awakening* was presented at the Royal Court Theatre in 1963.

speare, as have Peter Brook and Michel Saint-Denis. Believing that the Elizabethan theater offers unequalled dramatic richness, the company seeks to acquaint the British public with the major plays of the period. The company is formed around "a core of actors under long-term contracts, playing constantly together, and so able to explore a modern Shakespeare style." Its productions seek to recapture "something of the Elizabethan fullness of expression by challenging accepted forms of production, acting and writing." Distrusting all set methods and dogmas, Hall aims for popular theater. He declares:

Accept a theory and you'll by-pass the creative process and the theory will sit on you like an unlikely false nose. . . . We don't want to be a "square" institution supported by middle-class expense accounts. We want to be socially, as well as artistically, open, and we want to have schemes to get people who have never been to the theatre (particularly the young) to see our productions.[19]

The Royal Shakespeare's sixty-two-member board of governors, self-perpetuating by charter, performs limited functions. The board's principal powers are exercised by its executive council, composed of 15 governors who scrutinize all financial reports, analyze evaluations of plays presented, consider plans for future operations, and sanction proposed solutions to more serious problems. A finance committee confers monthly with the director and his senior associates concerning their activities.

Actors and actresses employed in London and at Stratford constitute a unified organization, their numbers in 1967 averaging between 130 and 140. More than forty are on three-year contracts, the remainder on a "run of play" basis. All other personnel at both theaters number more than 500.

The Royal Shakespeare's annual programs are known for their diversity. The 1967 Stratford season presented *The Taming of the Shrew, Coriolanus, All's Well That Ends Well, As You Like It, Macbeth,* and *Romeo and Juliet,* plus Tourneur's *The Revenger's Tragedy.* At the Aldwych in 1967, a varied repertory included: *Ghosts* by Ibsen, *Little Murders* by Jules Feiffer, *As You Like It,* Vanbrugh's *The Relapse, The Taming of the Shrew,* and *The Revenger's Tragedy.*

Specially featured has been a three-month world theater season, held for the first time in March 1964, at the Aldwych to honor Shakespeare's 400th anniversary, thirteen works being presented by seven leading foreign companies. Total attendance reached 86,000. A second world theater season in the spring of 1965 attracted 64,000 people over a nine-week period, attendance exceeding 90 percent of capacity. The 1967 world theater season included companies from Poland, France, Japan, West Germany, Israel, Greece, Italy, and Czechoslovakia.

Despite the desirability of supplying high-quality theater to rural Britain, especially in view of generous Treasury support, the theater management has not been enthusiastic about touring. Run-down theaters and apathetic

19. *Crucial Years* (Royal Shakespeare Company, 1963), pp. 14–19.

audiences have been discouraging factors, although both home and overseas tours are undertaken.

A short summer school at Stratford for teachers of English, founded in 1948, enrolls up to 200 persons annually. It offers, through scholarly analyses of Shakespeare, insights into problems encountered in presenting his plays.

Of particular interest is the Royal Shakespeare Theatre Club, set up in 1964 to win new audiences for theater. The club's more than 35,000 members find theater-going easier and less expensive as a result of reduced-price performances, special club previews, and priority bookings. Members are recruited both individually and in groups of twenty or more drawn from colleges, local branches of the Worker's Educational Association, schools, factories, hospitals, banks, and youth clubs. Club members constitute "a distinctive audience, mostly young in age, always young in outlook, vocal and articulate in both praise and criticism."

Several "outreach" programs have been undertaken to bolster RSC attendance and promote interest in the theater generally. One, known as "Actors Commando," involved perhaps a half-dozen actors who visited club groups, providing glimpses of an actor's life and depicting highlights of dramatic history. The "Human Trailer," undertaken in 1965, sought to interest Londoners by sending teams of actors and directors on tour to business firms and factories, their visits preceded by mobile exhibitions explaining the work of the theater. Beginning in early 1966, "Theatrego-round" took actors and directors to audiences all over the country, and performances were given in schools, colleges, community centers, and other places where little or no live theater was available.

The Studio for Experiment and Training, begun in 1962, is designed to mould the company into a working entity, insuring maximum artistic development and effecting professional renewal for actors, directors, and playwrights. It seeks to devise "the ways and means and to conduct the experiments through which a contemporary way of producing Shakespeare and the Elizabethans, and other styles as a consequence, can be prepared."[20] It tries to provide actors, particularly those starting their careers, with additional training in the technical aspects of their work and to stimulate their creative imaginations by sponsoring group classes and private instruction in movement, fencing, choral group singing, verse, and voice. In 1966 the studio closed down because of financial stringencies, but in the following year was able to operate its program on a limited scale.

To play to widely drawn popular audiences, as they have done at Stratford, RSC deems it desirable to leave Aldwych and locate outside the West End, and it is now scheduled to occupy a new theater, seating 1,500, being erected by the City of London as a part of its Barbican Arts Centre, to be ready for use in 1972. Surprisingly, the Royal Shakespeare has never in its long history

20. *Crucial Years*, pp. 23–25.

received financial assistance from local authorities, though the City of London may subsidize its operations once the new theater is occupied.

Increased Exchequer support for the Royal Shakespeare Company has been widely acclaimed. Indeed, the company's success in London and at Stratford, patronized by three times the audience of the National Theatre in its one inadequate facility at the Old Vic, brought to the fore in 1966 and 1967 the delicate question of whether or not Arts Council subsidy should be equal to that of the National Theatre—whether, in effect, two "national theaters" should be subsidized.[21]

The English Stage Company George Devine, founder of the English Stage Company and its artistic director from 1956–65, was once asked by a young aspirant which theater he should join. The wisdom of Devine's response helps to explain the establishment of the English Stage Company at the Royal Court Theatre.

> You should choose your theatre like you choose a religion. Make sure you don't get into the wrong temple. For the theatre is really a religion or way of life. You must decide what you feel the world is about and what you want to say about it, so that everything in the theatre you work in is saying the same thing. This will be influenced partly by the man who is running it, and the actual physical and economic conditions under which he works. . . . For me, the theatre is a temple of ideas and ideas so well expressed it may be called art. So always look for quality in the writing above what is being said. This is how to choose a theatre to work in, and if you can't find one you like start one of your own.[22]

Devine, distinguished actor and director, spearheaded the formation in 1956 of the English Stage Company, an enterprise which has transformed the British theatrical scene. Royal Court policy was designed to foster contemporary drama vigorously, to bring new writers to the British theater, and to encourage wide experimentation. Not seeking to form a permanent company, it drew into close association a group of young actors, directors, and designers who grew and matured there. During its initial ten years, the company presented 170 productions; of these, eighty-six were new English plays, many specially written for the company. Prominent among British playwrights were John Osborne, Samuel Beckett, John Arden, Arnold Wesker, N. F. Simpson, Ann Jellicoe, and Harold Pinter; those from abroad included Bertolt Brecht, Eugene Ionesco, Arthur Miller, William Faulkner, and Tennessee Williams.

The theater also has presented Sunday night performances—inexpensively produced, sometimes without scenery—for the English Stage Society, a supporting group organized as a club. The society's special contributions have been the discovery of new authors and the training of young directors. Since it is a private club not subject to censorship, its membership fluctuates according to the popularity of the plays being given: it rose to 9,000 during

21. *The Sunday Times*, 8 January 1967, p. 8.
22. English Stage Company, *Ten Years at the Royal Court 1956–66* (1966), p. 2.

the run of Osborne's *A Patriot for Me*. Edward Bond's *Saved*, sharply criticized on moral grounds, avoided in a similar way the pruning shears of the Lord Chamberlain.[23]

Such an adventuresome program, staged in a theater seating only 407 persons and, at first, inadequately supported by the Arts Council, could be mounted only because a number of its productions were transferred to the West End, where they earned substantial profits. To illustrate, the company derived major income from the commercial exploitation of John Osborne's plays, *Look Back in Anger, The Entertainer, Luther,* and *Inadmissible Evidence*. Leading actors were willing to accept challenging roles at the Royal Court in spite of low salaries; Sir Alec Guinness, Sir Laurence Olivier, Dame Peggy Ashcroft, and Rex Harrison were conspicuous examples. The necessity to shift plays frequently to the West End greatly enhanced the popularity of the Royal Court type of play, with its distinctive production emphasis. Some of its plays with gutter-level themes were popular for short periods, but the Royal Court's lasting contribution was the introduction of plays of a type previously found only in small experimental undertakings. Nor was there undue concentration on left-wing social criticism as some observers have alleged. On the negative side, the English Stage did not win for itself a regular audience. The most successful plays were transferred to larger theaters elsewhere, while plays of limited appeal played to a very small audience at the Royal Court. Urgently needed was a sizeable body of supporters willing to attend regardless of the play being featured.

William Gaskill replaced Devine as artistic director in 1965, and shortly thereafter a searching reappraisal of the company's basic policy was undertaken. Unquestionably, some of the creative energy had been lost with the departure of a number of the original participants, and fewer new playwrights seemed to be contributing to the theater. Other influences could be more positively identified. Royal Court innovations had been adopted by other theaters—the National Theatre and the Royal Shakespeare in London and selected theaters in the provinces. In outlining the new policy, Gaskill asserted that the theater's basic aim must still be to develop new writers, directors, and designers, but that major organizational changes were needed. A company working on a repertory basis would be created, consisting of a permanent group of some twenty-five actors, employed on short-term contracts; additional personnel to be engaged on a temporary basis. As for choice of plays, the Royal Court took risks which the two larger London theaters could not afford, the assumption being that its relatively moderate costs made this feasible. Although the repertory system fostered the creation of a more regular audience, at the same time it also rendered impossible the transfer of productions to the West End. Due to excessively high costs, the company, late in 1966, reverted to its earlier policy, under which actors were engaged for each production, usually four weeks. Today, perhaps a third of

23. In 1968 Parliament enacted legislation divesting the Lord Chamberlain of authority to censor plays.

the works presented are revivals of classics or well-known plays produced in the distinctive way characteristic of the Royal Court.

Royal Court annual financial statements reveal that the company from the very beginning experienced serious financial difficulties. Continuing annual operating deficits were partially offset by Arts Council grants and private gifts; however, the key to its survival through 1963–64 was the income it derived from transfers to commercial theaters, tours, and film rights productions.[24] Arts Council subventions, relatively modest in the early period, jumped from £8,000 in 1961–62 to £20,000 the succeeding year, rising to £32,500 in 1964–65 and £50,555 in 1965–66. That the theater cannot exist in its present form without major Exchequer aid is beyond dispute—the grant for 1966–67 was £88,650, and for 1967–68, £100,000.

The place of the English Stage Company in the British theater of the future is not clear. It seems unlikely that it will achieve the dazzling successes of the years when it was directed by George Devine, not because of lack of ability and inspiration on the part of the present director and staff, but because the world of the theater has drastically altered. Today, numerous companies throughout the country engage in experimentation—less influenced by commercial necessities than the Royal Court. Particularly important, the National Theatre and the Royal Shakespeare both offer stiff competition. However, the extent to which these two national institutions can innovate and experiment is subject to obvious limitations. The Arts Council believes there is a need for the English Stage Company—that a small organization can assume greater risks and surmount failures in a way not possible for the Royal Shakespeare and the National Theatre. Its ability consistently to attract audiences large enough to justify present high subsidy levels will undoubtedly be a factor of crucial importance in determining its future.

The Mermaid Theatre The establishment of the Mermaid Theatre, supported by Arts Council and City of London subventions, represents a striking example of dramatic creativity and entrepreneurial daring. The City Corporation in October, 1956, leased at a token rent to "Bernard Miles and other poor players of London" a site near Blackfriars on the Thames, then occupied by a bombed-out warehouse. On 28 May 1959, at six o'clock in the evening, the bells of Saint Paul's Cathedral signaled the opening of the new Mermaid Theatre, the first to be built in the City since the Lord Mayor, considering actors to be rogues and vagabonds, drove them from the precincts nearly 300 years before. The Mermaid actually originated eight years earlier when Bernard Miles with a small company put on a four-week season in Saint John's Wood. During the coronation celebration in 1953 the Mermaid mounted a thirteen-week season in the piazza of London's Royal Exchange. The enthusiastic response encouraged Miles to seek a permanent home at Puddle Dock, across the river from where Shakespeare's own Globe Theatre had once stood.

24. *Ten Years at the Royal Court 1956–66*, p. 5.

Raising the £125,000 needed to construct the theater was undertaken with dispatch. Half the amount was collected, not without difficulty, from trusts, foundations, banks, industry, personal friends, and the general public.[25] A "buy-a-brick" campaign launched in 1957 carried the Mermaid's appeal around the world, with almost 60,000 people purchasing a "brick" for half a crown. However, by opening night a debt of £51,000 remained. Luckily, the first production, Fielding's *Lock Up Your Daughters*, enjoyed a nine-month run, reducing substantially the debt. The structure, unique in its functionalism and simplicity, influenced theater construction in Britain in subsequent years. Its stage conforms in many respects to the Elizabethan style, with no prosceneum and no orchestra pit separating players from audience; the auditorium seats only 500 persons. Additional facilities are the restaurant and bars.

That the Mermaid was founded and immediately became a national institution while many other theaters throughout Britain were closing was in large part the result of its basic policy. The Mermaid, Miles observed in 1961, is "a repertory theater, presenting for short runs plays that would never be put on by commercial managements, but which nevertheless deserve to be seen, neglected English classics, foreign plays in translation, promising new plays, and so on. It offers a wide range of dramatic goods at popular prices."[26]

The Mermaid, controlled by a board of governors numbering ten to twelve, employs approximately 120 persons, of whom 25 to 30 are actors and actresses. Its operating expenses total £2,500 a week, with revenues amounting to £3,500 if all seats are sold. Ticket price increases have not kept pace with rising operating costs; the impulse to increase prices has generally been resisted in an effort to attract less affluent patrons. The original plan to cater to the working public, with a daily performance at six as well as at 8:40 p.m., had to be reconsidered after a few years, for it placed too great a strain on the actors. Today, two performances in one day are given only twice a week. Until recently, nine or ten different plays were presented annually, a play running continuously for four or five weeks before being replaced.

The Mermaid Association, with a membership of approximately 4,000, strives to attract regular audiences of various age and income levels. Groups of twenty or more can obtain tickets at reduced prices, and, at Christmas, plays designed to appeal to children and young people are featured. Large businesses use their welfare and recreation funds to purchase blocks of seats for their employees' family use.

25. Commenting on the reasons why individuals and organizations helped to underwrite the costs of constructing the Mermaid, Miles said that "I think the people who gave me money . . . did so for the fun of it. I think they said to themselves, 'This fellow is a bit of a lunatic, but he seems convinced he can do it, and he has some delightful friends, and they all seem to work like demons. Let's give them a few quid to be getting on with.' Or maybe it was just to get rid of me." *The Director*, January 1961, p. 90.

26. Ibid.

Theater-goers in London are impressed with the quality, variety, and experimental nature of the plays at the Mermaid. A partial listing of works presented between September 1965 and July 1967 includes: *He Was Gone When They Got There* and *Spring and Port Wine* by William Naughton; *The Trojan Wars*, four plays by Euripides; Shaw's *Trifles and Tomfooleries, The Man of Destiny, O'Flaherty VC*, and *Fanny's First Play; The Shadow of a Gunman* and *A Pound on Demand* by Sean O'Casey; *Let's Get a Divorce* by Sardou and de Najac; Gerhart Haupmann's *The Beaver Coat; The Shoemakers' Holiday* by Thomas Dekker; and *On the Wagon* by Bernard Miles.

The Mermaid's Molecule Club, an experiment initiated in 1967, attempted to bridge the arts-sciences gap, to bring science to the theater by dramatizing the physical properties of matter. Catering to the interest of children between the ages of eight and twelve, the first production, *Lights Up*, was attended by more than 4,000 during the initial week. Focusing upon the properties of light, theatrical pantomime demonstrated numerous experiments—even revealing to the youngsters how the perfect murder could be committed by using the rays of the sun, passing from the window in one's home through a fish bowl resting on a table, to trigger a pistol cleverly propped up by books from the family library.

From the beginning the Mermaid's emphasis upon quality and experimentation, combined with its limited seating capacity, created an urgent need for public support. The City of London still asks only a token rent for the site, about £1,200 annually for an area worth at least £15,000. Although the City contributed £3,000 to the Mermaid's construction fund, subventions to underwrite operating costs were nonexistent until 1965–66, when £2,500 was given. The City fathers refused to appropriate £24,000 requested by Bernard Miles in May 1966, though they agreed to it in December 1966, and permitted the theater to reduce its accumulated debt.[27] No operating grant was forthcoming for 1966–67, but in 1967–68 the City resumed its annual subsidy of £2,500.

The Arts Council was enthusiastic about the Mermaid, declaring prior to its opening that "The patience, persistence and ingenuity of Bernard Miles in realizing this dream deserve the profoundest admiration of everyone who cherishes the survival of the living theater."[28] They at once contributed £5,000; but aid was subsequently reduced to £2,500 by 1961–62, rising to £7,000 in the following year and remaining essentially at that level until Labour assumed office. Larger Treasury grants for the arts permitted a jump to £21,000 for 1965–66; £20,000 was made available for 1966–67. However, Mermaid officials contend that a minimum subsidy of £40,000 is needed at present price levels.

27. Miles reported in early 1966 that only seventeen of the sixty-seven plays produced in the previous seven years had made a profit and that a success could mean at best but £250 a week gain while a failure could result in a loss of £1,500 a week. During the first seven months of the fiscal year, the theater lost money at the rate of £1,000 a week. *The Times*, 20 May 1966, p. 17.
28. *A New Pattern of Patronage: The Thirteenth Annual Report of the Arts Council of Great Britain 1957–1958*, p. 22.

In 1965, Miles observed that, ideally, the local authority should have acquired the site and transferred it to the theater, cost of theater construction being met by the local government, with generous assistance from businesses and foundations. Most important, continuing support should be pledged by local authorities to create adequate reserves so that less popular plays, which incur substantial losses, can be mounted. Miles felt that profits acquired by the initial play and used to liquidate the construction debt should have gone into an operating fund to sustain future productions.

That the company was founded at all—in an era when Britain was beset with balance-of-payments problems, the Suez crisis, and other difficulties—is truly remarkable. It is hoped that government assistance will be further increased to permit the Mermaid to employ more highly qualified actors as well as other personnel, with an increase in the level of compensation and improved working conditions.

Other London Theaters The only other major theater in London which has received substantial Arts Council support was the Old Vic in Waterloo Road, its subsidy dating back to 1945. As indicated earlier, the Old Vic was recognized as the theatrical enterprise from which a national theater might possibly emerge, and in 1946 a Joint Council of the National Theatre and the Old Vic was constituted.[29] The proportion of the drama department's budget going to the Old Vic remained consistently high; in 1950–51 it received £27,500 of the £42,330 available for all drama grants and guarantees in England, and twelve years later, just before it closed, its allocation was £83,000 out of a total of £335,892.

Although general support has been extended to a variety of other London enterprises, the amounts, in most instances, have been relatively small. The Bankside Players, performing in the open air theater in Regent's Park, became a council "associated" company in 1945 and subsequently received guarantees, the largest being £2,750. But bad weather during the 1953 season followed by the council's decision that the Players were not providing drama of sufficiently high quality, was disastrous financially. Without council subsidy, the company managed to keep going until 1960, when it was closed down. In 1963 the New Shakespeare Company was formed and since then has presented summer seasons with limited guarantees from the Arts Council and local authorities. Some consider open-air theater merely an amenity for tourists, more properly supported by local authorities. Council policy today is that assistance to open-air theater can be justified under certain conditions. In the New Shakespeare's case, this will depend upon the collaboration of the Ministry of Works in improving the park's physical facilities.

On the other hand, the experience of Theatre Workshop, begun in 1953 under the artistic direction of Joan Littlewood, points up some of the difficulties encountered in public subsidy. It presented in Theatre Royal, Stratford East, a varied assortment of rare classics and unusual new plays with a

29. *The Listener*, 31 January 1946, p. 136.

preference for left-wing themes in spite of recurring financial crises. Then in 1955 the Arts Council gave it £500 on condition that grants from local authorities and other sources aggregate twice that sum; by 1958 the council had raised its contribution to £1,000. Theatre Workshop's continued existence was in grave doubt, but its fortunes brightened when three plays were transferred to the West End—*A Taste of Honey* by Shelagh Delaney, *The Hostage* by Brendan Behan, and Frank Norman's *Fings Ain't Wot They Used T'Be*. Insisting on more generous local support, the Arts Council by 1961 was providing £2,000 while ten borough councils in the area were helping to the extent of £1,450, and the London County Council, £1,500. However, in 1964 the workshop's manager issued a general appeal for stepped-up subsidies:

We have used all the money we have saved up in the past and unless we can guarantee £30,000 a year we shall have to leave the Theatre Royal. . . . we have been losing £18,000 a year. We have managed to keep going on the money we made while we were in the West End, but now there is none left.[30]

The response was disappointing with the result that Miss Littlewood left and the company ceased to operate. In August 1966 the Theatre Workshop, again under Joan Littlewood's direction, indicated that it would return to Stratford East if subsidies totaling £53,000 could be made available. After conferring with local authorities, the council concluded that funds of this magnitude could not be found. Failure stemmed from several causes: audiences were middle class, drawn largely from other parts of the city, while workers domiciled in East London failed to exhibit sustained interest; and operating costs were excessively high, constituting a constant drain. Miss Littlewood, although very talented, was strong-willed and impulsive and occasionally alienated those from whom support was derived.

Fringe and experimental theaters have played an important part in London theatrical life, serving as vehicles for introducing new talent in modern plays together with classics which otherwise would not have been seen in the West End. Most of these small, often ill-equipped and uncomfortable theaters have short lives, frequently because of lack of subsidy. Freedom from long-term obligations permits them to do unusual or outrageous things, which, if valuable, may be adopted by others or, if useless, lead only to the death of small companies. Their emergence and fading certainly creates much-desired opportunities for new individuals, policies, and ideas. The Arts Council recently decided to offer small, general revenue grants to assist such theaters, but emphasized that each case must be reassessed annually. In addition, these small theaters are eligible for guarantees under the New Drama and Neglected Plays Schemes.

Two London companies of this type merit brief mention. The Hampstead Theatre Club, founded in 1963, enjoying substantial support in the Hampstead area, has produced new plays of interest together with a number of

30. *The Times*, 18 February 1964, p. 14; *New York Times*, 20 March 1964, p. 27.

revivals. In receipt of general grants from the Arts Council, the club has also benefited from New Drama guarantees totaling £646 in 1964–65 and £750 in 1965–66; £1,348 were made available during 1966–67. Another, the London Traverse Theatre Company, now inoperative, presented new, small-scale plays, catering especially to students and young people. In 1966–67 the Arts Council accorded it a £1,500 general grant plus subsidies of £1,384 under the New Drama Scheme, and £322 to underwrite training activities; and the Borough of Camden contributed £500 toward the cost of one of its productions.

Subsidy of the Provincial Theaters Arts Council assistance to the London theater, while constituting a major thrust, should not be viewed out of perspective. The provinces, and Scotland and Wales, are not neglected; in 1965–66 approximately 63 percent of the council's drama grants and guarantees went to theaters outside London, and in 1966–67 the proportion was approximately 65 percent.[31] The drama panel in a 1964 survey of the needs of the theater in England outside London disclosed that thirty-four companies received council subsidies, eleven more than in 1959. Four were touring with no permanent bases, the remainder being resident and fairly evenly spread throughout the country. Only six were classified as "major theaters," in full association with the Arts Council —Birmingham, Bristol, Coventry, Nottingham, Oxford (Meadow Players), and Sheffield. In 1967 a new inquiry was begun, designed to evaluate the condition of all theaters in Britain—commercial and noncommercial.

Arts Council-supported companies have achieved substantial gains; more are housed in better buildings, with higher standards of performance and play selection than before subvention. Live drama is slowly becoming accessible to a larger proportion of the population. Locally sponsored and enjoying close links with their communities, most theaters have profited from opportunities to develop in individual ways and become centers for a wide range of activities. Touring, so popular earlier, has declined drastically. Most important, the drama panel's committee felt that increased assistance was urgently needed for the provision and improvement of buildings, the strengthening of local relationships, and, above all, the maintenance and improvement of dramatic standards.[32] Local authorities, the committee believed, should concentrate upon buildings, as well as provide significant sums to defray operating costs. The council recognized an increasing and much welcomed willingness on the part of local authorities to accept responsibility for the acquisition or building of theaters, but proposed a change in financing. Companies over a period of years had been repaying theater costs to local tax funds with Arts Council money given to them to improve the

31. In computing these percentages, one-half of the subsidies given to the Royal Shakespeare Theatre are included in the total of Arts Council grants and guarantees allocated outside London.

32. *Policy Into Practice, Twentieth Annual Report, 1964/65, The Arts Council of Great Britain*, p. 76.

8

quality of their plays. Such transfers from one public pocket to another were contrary to the intention of the central government and falsely implied that the local authority was providing the theater building. Unfortunately, critics often stressed that a local authority subsidy, covering part of the principal and interest, suggested that the company was losing money or was poorly managed. A twofold solution was proposed: first, that a special fund be set up nationally, from which grants could be made to assist local authorities contemplating the building or improving of theaters; and, second—to avoid any suggestion of concealed subsidy in municipal bookkeeping—the annual local authority contribution for building or improvement should be the equivalent of the annual repayment figure until the debt thus incurred is paid.[33] Local authority subsidies to underwrite current theater operating costs were, in reality, disappointingly small.

Improvement of artistic standards in provincial theaters was viewed primarily as the Arts Council's responsibility, to be accomplished mainly by the injection of money into the repertory bloodstream. Also of great importance are the provision of guidance and encouragement, "placing local theaters in touch with metropolitan sources and standards," and supporting theater directors working in isolation. Little waste or extravagance was found in the budgets of the theaters examined: for the years 1960–63, subsidy from all sources amounted to an average of 24 percent of income by trading—this addition making "all the difference not only between survival and extinction but between adventurousness and playing for safety, between quality and mediocrity." Sums recommended for provincial theater in 1965–66 totaled £953,000; for 1966–67, £1,156,800. To counter possible objections, the drama panel's 1964 report asserted that existing grants "have been enough, but only just enough, to allow more than 30 or so theaters to establish themselves and strike their roots, some over a long period, the greater majority since the last war. This has been achieved with very small resources and at the cost of self-sacrifice on the part of many artists."[34] For major theaters, aid should be increased from £17,000 to about £50,000 to permit higher salaries for key personnel and the recruiting of actors from London for short engagements. Salaries for actors at intermediate and lower ranges, managers, designers, and technical and other staff could be raised to ensure the employment of good personnel. Fourteen theaters then receiving around £6,000 should be accorded £20,000. The thirteen smaller theaters receiving £750 to £4,000 could be given up to £10,000 on a selective basis. Increased sums were recommended for touring companies, training schemes, and new drama and transport subsidy, with a contingency fund to aid new companies.

Local government subsidies in support of theater outside London have remained limited, contributions provided by local authority councils in most instances set at levels substantially lower than those received from the Arts

33. Ibid., p. 77.
34. Ibid., p. 81.

Council. Data relating to the financial operations of thirty-nine provincial theaters for the three-year period 1963–66 were published by the council in late 1967.[35] Total local authority support amounted to £84,677 in 1963–64. In 1964–65 it rose to £160,839, and in 1965–66 it stood at £225,377. During 1965–66, nineteen theaters were assisted by local authorities to the extent of £5,000 or less. In the same period, seven received between £5,000 and £9,999, two between £15,000 and £19,999, and three more than £20,000. Subsidy data for eight theaters were unavailable. Only six of the thirty-nine were given amounts equivalent to a local rate of ½d. or more—Canterbury, Crewe, Edinburgh, Nottingham, Perth, and Watford.

Insights concerning the development of the provincial theater, problems encountered, and the often painful struggle to effect their solution can best be acquired by focusing upon the experiences of a few selected companies. Of particular interest is the Bristol Old Vic, appropriately characterized as "the supreme example of a Company fulfilling the dual aims of Repertory: the provision of first-class entertainment for the citizens, and the nursing of talent on its way to the top." The Bristol Old Vic was founded in 1946, when the Arts Council asked the Old Vic in London to set up and administer a company resident at the Theatre Royal, Bristol, an eighteenth-century theater seating 690 persons, the oldest working playhouse in Britain. The Bristol Company has achieved signal success in presenting the classics, outstanding modern plays, and first productions of new works. Some of Britain's most accomplished actors developed and matured at the Bristol Old Vic. When the National Theatre was created in 1963, replacing the London Old Vic, a new company—the Bristol Old Vic Trust, Ltd.—was formed.[36] It sought to assemble on long-term contracts a group of actors who could develop a distinctive style. In 1963 the city council invited it to present plays in the Little Theatre, seating 459 persons, and now the Bristol Old Vic operates concurrent seasons at the two theaters, only a few hundred yards apart, united under one artistic policy. Important also is the close association of the company with the Bristol Old Vic Theatre School.

Arts Council aid allocated to the Bristol Old Vic in 1965–66 amounted to £23,758; in the following year it was £44,976, and in 1967–68, £46,728.[37] Bristol Corporation assisted in several ways: its general grant has in the past five years more than trebled, being £1,500 in 1963–64, £5,943 in 1966–67, and £5,150 in 1967–68. The city is also financially responsible for the Little Theatre, providing to the trust a guarantee for productions and underwriting the running expenses of the building: in 1966–67 the guarantee was £21,590; support in 1967–68 remained at approximately the same level. Box

35. *A New Charter: The Arts Council of Great Britain, Twenty-second Annual Report and Accounts Year Ended 31 March, 1967*, pp. 74–76.

36. The city council became the Theatre Royal leaseholder.

37. The Arts Council subvention for 1966–67 comprised the following: revenue grants or guarantees, £40,000; grant to reduce accumulated operating deficiency, £2,500; touring subsidy, £1,136; assistance for new drama or neglected plays, £400; transport subsidies, £450; and training schemes, £490.

office receipts are retained by the corporation. Special productions to interest young people are put on in school classrooms; themes dealt with have included the Cyprus upheaval, the great train robbery, and tensions arising between a teen-age boy and his parents concerning his choice of a career. The Theatre Royal building is to be enlarged to provide new offices, dressing rooms, workshops, and other facilities, plus a small auditorium.

The Belgrade Theatre in Coventry, opened in 1958, was the first professional theater to be built in Britain for over twenty years and the first ever to be constructed entirely at the expense of a municipal authority. With a seating capacity of 911 and costing approximately £245,000, it was erected in the center of the city as part of a large-scale redevelopment scheme occupying an area severely bombed in World War II.[38] The Belgrade Theatre Trust, formed to lease the theater from the city, is controlled by a council of management of fifteen persons appointed by the city council, two-thirds of whom are city councilmen.

From the beginning, the Belgrade was envisioned not as merely a playhouse to be used only during the evenings, but as "a center of theatrical interest and activity for all those who love the living theater," with ample lounges and foyers for meetings, lectures, and discussions. Company policy called for the presentation of a varied range of drama with emphasis on new plays and playwrights and the commissioning of special works. The desire to stage relatively unknown plays has been inhibited by an inability to attract larger audiences: attendance as measured in percentage of box-office receipts declined from 55 percent in 1958 to 41 percent in 1966. A new director was employed in 1966, and further efforts were made to attract larger audiences, with the result that attendance for 1966–67 rose to 47 percent. During the year twenty-three plays were presented. The dramatic company is young by intent and is strengthened by the employment of guest actors and designers, usually from London.

A concerted effort was launched in 1965 to integrate the theater's work with a comprehensive program of community service—Theatre in Education, Youth, and Community Contacts. Theatre in Education, financed by the Coventry Education Committee, is mounted by a team of nine youthful professionals who view their work as "inspirational teaching." Programs include mime and choral-speaking classes, discussion of plays—sometimes following first-night performances—free lunchtime entertainment at the theater, and other activities designed for youth or adult groups. Response has, on the whole, been limited.

Government subsidy has grown greatly since 1958; grants to the Belgrade by the Arts Council, Coventry, and Nuneaton Borough Council rose from 13 percent of total expenditures in 1959 to 24 percent in 1963 and more than 40 percent in 1967–68. Arts Council subvention increased slowly from £5,000

38. The total cost of the Belgrade Theatre complex was £347,256: land, £39,500; theater building, £245,919; twenty-one flats, £33,535; and six shops, £28,302. *Belgrade Theatre Annual Report and Accounts 1966–67*, p. 1.

in 1959–60 to £18,050 for 1964–65, to £30,761 for 1965–66, and to £41,413 for 1966–67. Nuneaton gives a nominal £250 a year. Coventry's direct grants remained relatively constant—£5,074 in 1959 and £6,500 in 1964—then increased to £9,000 for 1966–67 and 1967–68. Operating deficits have upon occasion evoked special grants: in 1964 Coventry contributed £6,400 and in the following year a special allocation of £4,500 was made by the Arts Council. When a new director reported for duty in 1966, the corporation made a special grant of £8,197 "to wipe clean the slate," strongly endorsing a policy of no further deficits. To complete the picture, mention must be made of payments by the theater to the city: in 1967–68, approximately £16,380 were paid to Coventry in rent, taxes, and insurance, plus a recoupment charge of £14,485 to liquidate (over a forty-year period) the cost of erecting the building. While Coventry is responsible for theater maintenance, these costs are actually borne by the Belgrade.

The Belgrade's management views the future with confidence. Artistically, its operations have been highly successful. Financial difficulties encountered have stemmed from audience size, which at Coventry is lower in relation to theater seating capacity than at other major provincial theaters. Some observers believe that a theater half the size would be preferable to playing to banks of empty seats, which adversely affects the morale of both producers and actors. A smaller theater, it is felt, would diminish the risk of incurring annual deficits, thus making City Council support less difficult to obtain. However, altering the present building to permit use of extra space for other purposes would be difficult. The Belgrade is, however, making an effort substantially to increase theater attendance.

The Birmingham Repertory Theatre, seating fewer than 500 persons, built by Sir Barry Jackson and opened in 1913, has occupied an important place in British theater.[39] Jackson observed that his theater's policy in the early years was "to enlarge and increase the aesthetic sense of the public in the theater" and "to serve an art instead of making that art serve a commercial purpose." Lacking an adequate Birmingham following, he encountered untold difficulties and, in spite of productions of high quality, lost £100,000 of his own money over a period of twenty-one years. On three occasions he was forced to threaten closure in order to shock the public into providing support. He died in 1961 unaware of how far Birmingham was to go in making support available. During the Birmingham Repertory's first half-century, Sir Cedric Hardwicke, Dame Edith Evans, Noel Coward, Sir Laurence Olivier, Sir Ralph Richardson, Paul Schofield, and Albert Finney appeared, in their formative years, on its stage. The works of new playwrights were presented; producers, designers, and musicians perfected their skills; and exciting experiments were undertaken. In 1934 Jackson handed the theater over to a trust, which after World War II was accorded modest subsidies by the Arts Council and by the city, the latter not before 1949–50.

39. See J. C. Trewin, *The Birmingham Repertory Theatre, 1913–1963* (London: Barrie and Rockliffe, 1963).

In 1955 he observed: "Should the future permit the foundation of a Birmingham Civic Theatre, the goodwill and reputation of our small one is at the City's service."

In April 1964, the city council, aware that the theater's condition, size, and location demanded action, approved preliminary plans for a 900-seat building in the heart of the new civic center area with the most modern equipment and adequate offices, workshops, and auxiliary facilities. In 1963 construction costs were estimated to be £500,000, of which the corporation needed to make available £468,500, subject to repayment over forty years, with annual loan charges in the region of £31,000. Adding to this an estimated operating deficit of £17,000, plus loan and rent charges and taxes, the theater's annual deficit would exceed £58,300. Significantly, the corporation, whose grant was £5,000, agreed to provide the major part of the sum needed to liquidate the deficit, subject to increase in Arts Council subventions (then £14,000). This pledge stood in sharp contrast with the commitment of Coventry and other cities, which, by insisting on repayment of construction costs from current income, seriously undermined the usefulness of their own aid and that of the Arts Council. The Birmingham Repertory Company plans to operate on a true repertory cycle once the new building is completed, giving a different play each night during the week. The building will be available all day for forums, guest speakers, lunchtime recitals, poetry readings, chamber music, jazz concerts, and other activities. A larger auditorium for Britain's second most populous city might have been projected, but since the repertory will be varied, both traditional and avant-garde, the bulk of the seats will be occupied. However, it was not until 1969 that the corporation gave final approval to the project, construction costs by this time having risen to approximately £900,000. While the city subvention of £8,000, accorded in 1966–67 and again in 1967–68, represents a modest increase over preceding years, Arts Council allocations have risen sharply—£40,588 for 1966–67 and £48,265 for 1967–68. The size of the local authority's subsidy, once the new theater is in full operation, is yet to be determined.

Unlike the other theaters, the Liverpool Repertory, the oldest company in Britain, did not need to ask for public subsidy until 1962–63; in that year it received a capital grant of £5,000 from the Arts Council. It then turned to the Liverpool City Council for aid, not for day-to-day operations, but for reconstructing and expanding its Playhouse Theatre. The City responded in 1963–64 with a capital grant of £7,500; the Arts Council made available £5,000 for operating purposes. Further, the corporation agreed to provide the Playhouse with an annual subvention of £7,500 for a seven-year period beginning April 1965. It also gave the theater outright a capital sum of £25,000 and an interest-free loan of £45,000, repayable in equal installments over six years, both to become available upon the completion of the building. The Arts Council, for its part, extended grants or guarantees for the years 1963–66 amounting to £5,000, £7,300, and £14,275; in 1966–67 it provided revenue grants and guarantees of £30,000 as well as £1,175 under the New

Drama and Neglected Play schemes, £100 in transport subsidies, and £583 for training schemes.

Development of provincial theaters under stimulus of public subsidy is sometimes accompanied by acrimonious controversy. The resignation of John Neville as Director of the Nottingham Playhouse in 1967 is a classic example, involving a surprisingly broad spectrum of personalities ranging from Jennie Lee (the "Minister for the Arts") to teen-age members of the affiliated theater club. The Nottingham Playhouse, originally opened in 1948, became during the 1950s one of the more successful repertory theaters. A new theater seating 750 was built by the Corporation in 1963 at a cost of £370,000, replacing a converted cinema as the home of the Theatre Trust. In addition to modest grants from the Arts Council, Nottingham provided subventions annually, beginning in 1963–64. Under the direction of John Neville, the theater prospered, artistic standards were high and productions well-attended.

Neville proceeded to initiate a vigorous campaign to induce the Arts Council and the local authority to raise their subsidies, but their response failed to satisfy his expectations. The corporation provided a £22,000 annual grant to the Playhouse, charging the theater a yearly rental of £27,000. Arts Council subventions totaled £50,000, the largest allocation of any provincial theatre. On 27 April 1967, Neville, in protest, submitted his resignation to take effect in July 1968. On 8 August 1967, the trustees officially accepted his resignation, but on the twelfth, Neville withdrew it. After acrimonious—and well-publicized—controversy, the trust maintained its position and did not invite Neville to remain.

What were the main points at issue? The Board asserted that Neville with his public utterances had marred its desire to "move out of an era of controversy which has existed since the new theater was conceived." Neville declared that "a theater which moves out of an era of controversy is likely to be dull and therefore unsuccessful. . . . Controversy has not done the theater harm. It has thrived on it." The board thought a change of directors every five years desirable to maintain artistic impetus. Neville observed that most great theaters had been built up by outstanding individuals employed for considerable periods of time and, besides, the theater had not lost impetus under his guidance. The crucial issue was money: not only how much but from which sources and in what amounts it should come, and how much pressure should be exerted on those sources. Also in dispute was the question of the relative responsibilities of the director and of the theater trustees.

What can be learned from this unfortunate incident? *The Times* pointed out that comparable clashes have occurred at other theaters: "Friction between artistic directors and governing boards is a price the theater is paying for being run on public money; and the more support it receives from the Arts Council and local authorities the more that friction is liable to increase."[40] Although Neville had been successful in expanding the Notting-

40. *The Times*, 30 August 1967, p. 7.

ham theater's activities, the board's action apparently stemmed from its belief that by pressing for more money Neville was undermining the friendly relationship between itself and the Arts Council. Grants are made to institutions and not to individuals, no matter how brilliant they may be.

Neville, in an article in *The Sunday Times*, explained that the peculiar relationship between a director and his board tends to build up tension to a degree that almost invariably results in the resignation or dismissal of the director. "What is it in the way we organize our publicly subsidized theaters which decrees that in any dispute, the scales are weighted in favor of the amateur and not the profession; which pre-ordains that in cultural cricket the gentlemen always beat the players?"[41] A major factor, he asserted, is the policy of awarding subsidies to trusts composed of laymen as opposed to managements staffed by professionals. Professionals employed by boards do not negotiate directly with dispensers of patronage. On the other hand, they are directly responsible for income provided by the ticket-buying public. A director is accountable to his board and to the public, but if the board interposes itself between director and public and a conflict results, "the Arts Council, in an understandable Establishment abhorrence of anarchical tendencies," will back any board against its director. Neville advocated periodic democratic election of boards by the play-going public of the region served by the theater. One criterion only should justify the firing of a director— whether or not he has succeeded in making the theater come alive to its public. And, most important, a director should be given sufficient money to permit his theater to expand. Direct election of board members, however, will not be favored by local authorities, for councils supplying major support would have little control over how the money is spent. Nor are Neville's proposals likely to win the plaudits of the Arts Council. Lack of precision in defining the "play-going public" leads to obvious difficulties; honest disagreement can arise as to how much money should be made available.

The editors of *The Stage*, after carefully considering the dispute, observed:

> The solution possibly lies in appointing an artistic director and a business manager to work hand in glove. Such a partnership is not easy to find, but it might lead to the smoother running of affairs, especially in Civic Theatres, where local councillors, many of them powerful figures in local politics, have their own responsibility to their local theatre. They would naturally not approve of what they might consider impetuous unpredictability on the part of the artistic director of their playhouse. But a business manager, wielding equal power, might be in a position to prevent clashes of the magnitude of the Nottingham affair.[42]

Development of New Talent A number of special schemes designed to train professional talent for the theater are today sponsored by the Arts Council. The New Drama Scheme, started in 1952, uses several devices to encourage the writing and the performance

41. *The Sunday Times*, 3 September 1967, p. 3.
42. *The Stage*, 14 August, 1967, p. 8.

of new plays. A limited number of bursaries, ranging up to £1,000, are awarded to writers to permit them to concentrate their energies for short periods on writing for the theater. Writers may not apply directly but are recommended to the drama director by members of the theatrical or literary professions. Sponsors are expected to keep in touch with grant recipients and submit a brief report at the end of the bursary period. Participants are not restricted in their work in any way, but council consent is required before they can dispose of the rights to plays written—a precaution designed to protect inexperienced writers. Four playwrights received awards in 1966–67. Among recipients who have later achieved renown are Arnold Wesker, Shelagh Delaney, Bernard Kops, James Saunders, David Campton, and Beverley Cross.

The second New Drama program, larger in size, involves limited guarantees against loss to theaters which present new plays. When started in 1952, £3,500 was earmarked for its implementation; in that year thirteen plays were evaluated, but only two were deemed to merit guarantees. By 1963–64 this scheme had greatly expanded; twenty-eight new plays were given their first (and sometimes their second) professional production in 18 different theaters. New play guarantees in 1965–66 totaled twenty-seven, and in 1967, thirty-eight; guarantees do not exceed £400 for any production. However, the author is guaranteed a minimum royalty of £150. Guarantees to stimulate the revival of neglected plays have since 1963 been made more available for a limited number of works, Vanbrugh's *The Provoked Wife*, Marlowe's *The Jew of Malta*, and others. The New Drama Scheme is viewed with enthusiasm by British theaters, both those which regularly receive Arts Council operating grants and small companies and theater clubs.

The New Designers Scheme, activated in 1961, subsidizes a limited number of young designers for on-the-job training in repertory theater. They are paid an agreed salary during the year of apprenticeship. Theaters are urged to permit each to design at least one complete production. A few designers who participated earlier in the basic program are appointed to a six-month "refresher" assignment where more advanced work is undertaken. Subsidies are also given provincial theaters with limited resources to enable them to engage leading designers for occasional guest productions. Eight persons took part in the New Designers Scheme in 1963–64 at a cost of £2,496; eight in 1964–65, at £2,984; and eleven in 1966–67, at £4,956. The Design Scheme has, on the whole, been highly satisfactory.

A program of training in theater administration was created in 1963–64 in collaboration with the Council of Repertory Theatres. During the first six months the trainee is associated with a single theater. He studies relationships between management and the board of directors, and between management and patrons, actors, producers, stage personnel, and others; financial responsibilities of management; and other aspects of theater operation. In the second six months the participant obtains more intensive training in specific phases of theater management at several other theaters. Training

8*

courses from three to six months are offered to persons already possessing some theatrical experience. In 1966–67, nine persons received training as administrators.

In 1966 the Council inaugurated a one-year program of training for young directors, each participant being required to have had some directing experience. In 1966–67, five participants were enrolled, with £4,050 expended on their bursaries. Under another program, awards are made to artists, playwrights, directors, designers, managers, and other theater professionals to permit them to study the theater at home or abroad, with stipends up to a maximum of £350. In 1966–67, eleven persons were helped in this way. And finally, since 1952 the Arts Council, with mixed success, has commissioned new plays, usually from established writers or directors, the stipend at present being £150.

Theater Subsidy to Undergo Further Expansion The Arts Council's efforts to provide support for the British theater are universally regarded as eminently successful. This is not to imply that mistakes were not made or that some programs of assistance did not leave much to be desired. The council, until recently, was severely handicapped by lack of funds. Most spectacular has been the sharp increase in 1966–67 of funds to the drama department. Growing appreciation of theater, particularly in the provinces, will undoubtedly influence the council to increase the proportion of its budget devoted to drama subsidy. Most of these additional moneys will probably be used to support more adequately companies presently aided, rather than to subsidize new theaters.

Over the next few years the council will increase aid to provincial theaters associated with it. Recognition of merit and achievement is not difficult, and subsidy requirements at present can be determined with relative ease. In London the picture is much more complex, for the London theater with its international reputation dominates the theaters of the country. With the Labour government in office, greater emphasis has been given to aiding theaters outside London, including Scotland and Wales, a policy which is likely to continue. Thus, the proportion of the council's drama budget expended in the provinces stood at 53 percent in 1964–65, this figure rising to 60 percent in 1965–66 and to 63 percent in 1966–67. The size of the allocations to the National Theatre and the Royal Shakespeare Company is sometimes questioned, but can be justified on the grounds that these are truly national institutions serving the entire British public. Financial provision for both will undoubtedly continue to increase.

10 / MUSIC AND MUSICIANS

The Government appreciate the need to sustain and strengthen all that is best in the arts, and the best must be made more widely available.
—*A Policy for the Arts*, 1965

World War II forced all musical arts to undertake a formidable task of reconstruction. The Arts Council, though handicapped by a modest Treasury subvention, heroically rose to the challenge.

During the war, CEMA provided "in bulk" concerts held in factories and hostels as well as in YMCA forces centers; while cities were being bombed, music was carried into the air-raid shelters and rest centers. These makeshift wartime canteen concerts were later transformed into full-length performances directly provided by the council after working hours. In addition, the Arts Council organized industrial clubs to foster an interest in music among workers. By 1948, twenty clubs, with memberships varying from 200 to 1,400, received assistance in the form of guarantees against loss, the council's policy being to leave full management in the hands of club committees. Opening their membership to include nonfactory workers, clubs ultimately became communitywide organizations. Through the National Federation of Music Societies, the council began to assist chamber music clubs, and later provided funds to aid music societies. By 1950 this scheme had greatly increased the number of its participants and included 104 clubs presenting 453 concerts, and 68 societies with 221 concert programs.

Initially, the most significant of the Arts Council's efforts was the assumption of major responsibility for symphony orchestras. In 1950 the council adopted a long-range policy, based on a report prepared by its music panel. Analyzing the artistic and financial factors requisite to maintaining orchestras of eighty to one hundred players, it formulated a plan by which increased support could be given to a limited number of permanent orchestras. Since wholehearted support by local authorities was essential, a proposal was advanced that subsidies be provided in equal amounts by the Arts Council and local governments. At that time council subventions went to the London Philharmonic Orchestra and to the City of Birmingham Orchestra, the Liverpool Philharmonic, and the Hallé in Manchester; aid was also forthcoming from the LCC and the cities of Birmingham, Liverpool, and Manchester. In the following decade the council hoped to increase the size of its grants but not the number of orchestras aided.

The direct provision of concerts by the council was a pioneer measure designed to encourage and stimulate the formation of independent music clubs, located generally in the smaller communities. By 1950–51 the demand had dropped to 302 as contrasted with 476 in 1948–49, 539 in 1947–48, 875 in 1946–47, and 1,163 in 1945–46. Once a concert series had developed strong roots, its management shifted to an independent body, with the council providing a guarantee against loss. New methods of introducing chamber music to wider audiences were tested, and some were particularly well received. But often the increasingly heavy per person cost of presenting concerts to small groups forced the council to transport audiences to concert halls centrally located.

Informal concerts were arranged by the council before officers of music societies to permit young artists to perform, thus facilitating their employment for professional engagements. Auditions were given throughout the country to musicians and to chamber music ensembles by specially appointed Audition Panels; in London alone during 1948–49, 322 were held, 88 qualifying for Arts Council work. This practice was temporarily discontinued in 1950 to avoid giving the impression that being passed by an Arts Council audition panel implied a promise of employment and a certificate of "State approval."[1] Later it was resumed and continued for more than a decade. By the mid-1960s, however, auditions ceased to be of much value to artists, since the council itself no longer employed musicians. The council established its own gramophone record library at its London headquarters, with thousands of records made available to music clubs, factories, hospitals, armed forces groups, and gramophone societies throughout Britain. Leased by the council since 1946, Wigmore Concert Hall in London is open to recitalists and music organizations, with rental fees set at levels consistently lower than the costs of maintenance and operation. In this way, musical events are accorded indirect subsidies.

Thanks to the Arts Council's continuing encouragement and financial support, Britain's musical life has been transformed in range and vitality. In 1950–51, £109,874 (19 percent of the Exchequer grant) was expended by the council on music. By 1955–56 the proportion of the council's Treasury grant for music fell to 16 percent or £129,825; and five years later, though the percentage remained essentially the same, the amount rose to £223,484. Grants and guarantees to symphony orchestras comprised the largest single category, amounting in 1960–61 to more than two-thirds of the music department's budget. Three permanent orchestras—City of Birmingham, the Hallé, and the Liverpool Philharmonic—were associated with the council during the entire decade, and two others—the Bournemouth Symphony and the Scottish National—subsequently joined the list. By 1960 small sums went to the London Philharmonic and the London Symphony for specific concert promotions, while the Royal Philharmonic Society, Brighton Philharmonic Society, Philomusica of London, and Northern Sinfonia Orchestra also received subventions, none larger than £2,000.

In the meantime, other significant developments were taking place. By 1954 the council's withdrawal from direct provision of concerts was virtually complete, that responsibility having been assumed by music clubs and societies. The council's record library was used extensively: in 1954 over 2,350 programs were made up and dispatched to some 300 organizations. At the end of that year, the library was transferred to the British Institute of Recorded Sound. The National Federation of Music Societies increased the number of groups it supported, and by 1961 only seventy-two indepen-

1. *The Arts Council of Great Britain: Fifth Annual Report, 1949–50*, p. 13.

dent music societies were directly aided by the Arts Council.[2] Several organizations promoting greater appreciation of new music were given limited subventions by the council. The two most important were the Society for the Promotion of New Music and the Music Section of the Institute of Contemporary Arts; the latter is still supported.[3] The society's programs varied from year to year: in 1958–59 ten chamber-music recitals were given in Wigmore Hall, and the international exchange of concerts was arranged with the Union of Polish Composers.[4] In the same year the Institute of Contemporary Arts sponsored four public concerts and two lecture recitals. The work of young British composers and rarely heard chamber compositions by Webern and Schoenberg were featured.

The title of the Arts Council's report for 1961–62, *A Brighter Prospect*, forecast the Music Panel's work during the 1960s. The council, beginning in 1966–67, raised its music budget to £832,027 (15 percent of its total Treasury allocation); expenditures in support of music registered a further increase in 1967–68. Moneys spent on music for 1965–66 amounted to £562,046, and in 1964–65, to £456,372. Securing adequate financing for Britain's symphony orchestras, including the four major ones in London, proved to be the most difficult problem.[5] Unlike members of the great provincial orchestras, London players were not employed full-time, but were engaged on a seasonal or concert basis, an unsatisfactory arrangement. The utopian solution was to engage players under full-time contracts and to raise subsidies to the level enjoyed by the great continental orchestras.[6] After consulting with the LCC on 21 December 1964, the Arts Council appointed a committee to examine the organization of four major London orchestras—the London Symphony, the London Philharmonic, the New Philharmonia, and the Royal Philharmonic—and, in particular, to explore the possibility of a rational and coordinated concert policy.[7] The committee's report, submitted in April 1965, was endorsed by Miss Jennie Lee at the Department of Education and Science, who expressed the hope that financial resources could be provided. Later the London Orchestral Concert Board, which distributed funds provided by the Arts Council and the GLC, gave guarantees for concerts performed by the four orchestras in the Greater London area, plus grants toward administrative costs.

2. *Partners in Patronage: The Sixteenth Annual Report of the Arts Council of Great Britain 1960–1961*, p. 37.

3. The Society for the Promotion of New Music, beginning in 1968, no longer required Arts Council assistance for it had received a large bequest from an amateur composer.

4. *The Struggle for Survival: The Fourteenth Annual Report of the Arts Council of Great Britain 1958–1959*, p. 43.

5. *Ends and Means: The Eighteenth Annual Report of the Arts Council of Great Britain 1962/63*, p. 23.

6. *State of Play: The Nineteenth Annual Report of the Arts Council of Great Britain 1963/64*, pp. 20–21.

7. A fifth major London orchestra, the BBC Symphony Orchestra, was of no direct concern to the committee.

Speaking in March 1966 at a conference organized by the Institute of Municipal Entertainment in London, Lord Goodman, chairman of the Arts Council, articulated one of the council's continuing concerns:

The major purpose for which we must use our money . . . is to cultivate new audiences for the arts . . . but it must not be done by means of a confidence trick. . . . You can't appreciate . . . good music without hearing it over a long period from relatively early childhood. . . . It is very necessary to make it clear to young people that there is something to be attained if they will work for it, because the situation with them is not satisfactory at the moment. . . . I believe the pop groups on the whole are winning the battle. At best we are holding our own; but it is very necessary, if we are to be a civilized and a cultivated nation, if the standards which mean something to you and something to me, are to be maintained, that we do win this battle, and we can only win this battle by teaching people what are the worthwhile things in life.[8]

Music in London Financial subsidization of orchestras in London was slow to develop and poor in relation to need. Immediately after World War II, parliamentary belt-tightening prevented legislators in the Commons and at County Hall from responding generously; but after 1955 moneys could have been made available if the arts had been accorded higher priority by those controlling the public purse strings. Until 1962 the arrangement of symphony orchestra programs was deplorably haphazard, with much duplication and waste.[9] Subsidization by the Arts Council tended to be on a "crisis" basis.

During its initial five years Arts Council subventions were accorded to four fully associated, permanent British symphonies, only one of which operated in London—the London Philharmonic. In late 1948 the London Symphony became associated with the council; it received help for twelve concerts in its 1949–50 season. Symphony concerts in London subsidized by the central government were provided principally by the London Philharmonic, which presented 193 concerts in 1955–56 and 169 in 1956–57; Arts Council subventions remained relatively modest—£14,500 in 1956–57 as contrasted with £10,000 five years earlier. The Philharmonic's 1956–57 programs were a mixture of the accepted and the adventurous.[10] The London Philharmonic became the first British orchestra to visit the Soviet Union, in October 1956. But shortly after returning to London, it was compelled by a financial crisis to reorganize and to reduce its operations. By 1958–59 the Arts Council supported fifty-seven specific concerts by the London Philharmonic, fifty outside London. Only ten concerts by the London Symphony were supported. Such minimal subsidy of London music prevailed for several years, with the bulk of Treasury assistance going to the

8. *Key Year: Twenty-first Annual Report 1965–66, The Arts Council of Great Britain*, p. 9.

9. Committee on the London Orchestras, *Report* (1965), p. 6.

10. *Art in the Red: The Twelfth Annual Report of the Arts Council of Great Britain 1956–1957*, pp. 45–46, 83.

provinces, a fact overlooked by those critics who customarily allege council discrimination against peoples residing outside the capital.

By late 1964 the inadequacies of Arts Council policy relating to London orchestras were clearly discernible. The Joint Orchestral Committee, set up in 1962–63, implemented a scheme under which moneys from the Arts Council and the LCC were placed in a pool, out of which three of the London orchestras received guarantees for concerts in the Royal Festival Hall. Results were positive. For 1963–64 each council contributed £36,000; in 1964–65 "pool" allocations were £39,000 each. The committee scrutinized each orchestra's policies, examined its accounts, and improved coordination and selection of programs. A financial crisis soon developed. It appeared likely that one or more of the four London orchestras might suspend operation. After consulting the LCC, the Arts Council named a thirteen-man committee to ascertain "whether the present and potential demand for the services of these orchestras makes it desirable for their number to be maintained, increased or reduced; whether, and if so, in what way, it is desirable for those four to be regrouped."[11] Coordination of concert policy was supported to ensure programs of the highest artistic metropolitan standard and continuous employment for orchestra members.

Five symphony orchestras gave concerts in London, but one of these, the BBC Symphony, was not considered. The others, in order of seniority, were the London Symphony, the London Philharmonic, the Philharmonia (now the New Philharmonia Orchestra), and the Royal Philharmonic. Founded in 1904 under the baton of Hans Richter, the London Symphony for a quarter of a century performed only a few months each year.[12] Managed by a limited company with members of the orchestra as shareholders, it performed in London and occasionally visited Europe; the 1912 season included a tour through Canada and the United States. Its operations were limited during World War II to a few concerts in the London area and some touring with ENSA. Reorganized as a nonprofit entity after 1945 to permit it to claim exemption from the entertainment tax and qualify for Arts Council support, it then presented an annual concert series at the Royal Festival Hall and occasional performances elsewhere in London and the provinces. In 1960–61 the LCC began to make grants in support of the London Symphony. Its International Series, which each year featured distinguished conductors and soloists, earned critical praise and wide public support. Postwar tours were made to three continents, and concerts were given at Edinburgh and at other festivals.

Established in 1946 by Walter Legge, the Philharmonia devoted most of its energies to producing recordings under contract with Electric and Musical Industries, Ltd. The introduction of long-playing and stereophonic records

11. *Report*, p. 3. Chaired by Lord Goodman, the committee consisted of three nominees of the Arts Council and three each of the GLC, the Musicians' Union, and the Orchestral Employers' Association.

12. Ibid.

in the 1950s had brought unprecedented prosperity to the recording industry. The Philharmonia gave only a few public concerts and received no aid from government sources. But in the early 1960s, when the quantity of recording work available seriously declined, a stepped-up public concert schedule failed to provide needed income.[13] In March 1964, Legge suspended operations, but the players quickly took control and founded a new organization, the New Philharmonia Orchestra. While the courage and spirit of its musicians were indeed admirable, a substantial subsidy was needed to ensure survival.

The London Philharmonic, formed in 1932 by Sir Thomas Beecham, was personally managed and partially financed by him during its initial seven years. In 1939 Sir Thomas suspended the orchestra and withdrew financial support, but the players assumed control and prevented its demise. The London Philharmonic (as indeed other orchestras) is acutely aware of its obligations to the living composer, and its record over the years for presenting new works is one of which it can be proud. In 1965 it gave a greater proportion of concerts in the provinces than did any other London orchestra.

Also founded in 1946 by Sir Thomas Beecham, the Royal Philharmonic was managed by the Anglo-American Music Association, Ltd. Remunerative recording work for Electric and Musical Industries, Ltd., provided a financial base until 1960. The orchestra performed annually at the Glyndebourne Festival of Opera from 1948 to 1963. When Anglo-American Music relinquished control in December 1963, a new company, Rophora, Ltd., was formed with the musicians as shareholders. The orchestra's financial position was precarious, with its principal activity the weekly concerts at the Odeon Cinema, Swiss Cottage.[14]

Thus, by 1964 all four orchestras were administered by the players themselves. But their financial condition was critical, requiring sizable public subventions to prevent collapse. Although impressed by the efficiency and enthusiasm of the player managements, the committee felt their burden was too heavy; also, they conjectured, the orchestral administration, particularly concert promotion, would benefit from disinterested outside assistance. Musicians complained that they had no assurance of permanent employment, paid holidays, sickness benefits, or pensions. Outside work was necessary. Artistic standards suffered from overlong hours and exhausting travel. Today, concerts for the most part must be promoted by the orchestras themselves, and this requires a subsidy—in the case of the Royal Festival Hall, an average of at least £1,200 per concert. "In our view these subsidies must be accepted as the price a great city must pay to provide a proper range of music for its citizens and visitors," asserted the committee. "This is a public service."[15] They also cautioned against using public funds merely to create employment for musicians. Rather, the government should assign concert

13. Ibid., p. 4.
14. Ibid., pp. 3–5.
15. Ibid., p. 6.

promotion involving heavy public subsidies to a body with musical knowledge and experience and a high sense of responsibility. Program coordination should be permanently established.

Assuring each orchestra access to a modern and well-equipped concert hall was a long-range and difficult problem. The Royal Festival Hall was available for concerts five nights a week, with dates distributed among London orchestras, regional orchestras, visiting continental orchestras, and music societies. Since the London orchestras were allocated only 2.2 concerts per week, the committee concluded that if all four were to survive, at least one would have to establish a permanent home elsewhere, possibly in the City of London's projected Barbican scheme.[16]

As to the crucial question of supply and demand, the committee believed "that the supply of orchestral music at present available in London compares favorably with anywhere else in the world. No one can complain that London does not provide its citizens and visitors with music on a scale befitting a great metropolis."[17] With too many concerts being played to half-empty halls, the committee hoped that larger audiences could be attracted with better program coordination, more effective promotion, and reduced prices to regular concert-goers. Believing that public interest in music generally would increase, the committee reported that available orchestral work justified "the existence of rather more than three but less than four orchestras." It could not recommend the permanent endowment of four orchestras, but was equally reluctant to allocate subsidies in a way which might cause one to disband. Hopefully, given breathing space, the case for four orchestras might be forcefully buttressed.[18] One proposed solution—to regroup the same number of musicians into three larger orchestras—had much merit, but the committee did not wish to cannibalize one of the existing four.[19]

The key recommendation advanced by the committee was the creation of an autonomous body, the London Orchestral Concert Board, to be established jointly by the Arts Council and the GLC and to consist of representatives nominated by the Musicians' Union and the Orchestral Employers' Association, plus representatives of the Arts Council and the GLC. Each orchestra would be represented but without the right to vote. The new concert board's responsibilities would be diverse: to consult with the GLC and the Royal Festival Hall concerning allocation of dates to orchestras; to confer with managements of other concert halls in the London area; to approve arrangements for concerts advanced by the orchestras; to sanction budgets

16. Concerts were given at the Royal Albert Hall, Fairfield Hall in Croydon, the town halls at Hornsey and Walthamstow, the Regal Cinema of Edmonton, and in the open air in London parks.

17. *Report*, p. 7.

18. The committee's decision not to recommend that one orchestra be permitted to die was, some observers thought, a political one, interested parties having convinced Prime Minister Wilson that such a course was highly undesirable.

19. *Report*, p. 9.

and general program plans; to allocate subsidies for approved concerts; and, finally, to try to induce local authorities and other bodies to provide additional subventions. The committee recommended that each orchestra initially should receive an annual grant of £40,000 as a major contribution to administrative costs, as well as a provision for holidays, sick pay, and pension schemes. To qualify for these annual grants, each orchestra must accept a financial adviser appointed by the board, periodically submit its accounts to the board, and adhere to a standard form of contract to be negotiated between the Orchestral Employers' Association and the Musicians' Union. Each participating orchestra could also qualify for specific subsidies for concerts approved by the board, to be paid either as guarantees or out-right grants. For this purpose, the board would require an initial annual sum of about £200,000 to enable it to subsidize some 200 concerts at £1,000 each. Though £1,200 per concert was currently being expended, the com-mittee hoped that board surveillance and guidance would effect economies in concert presentation. A basic guaranteed annual salary should be paid; £2,000 was suggested for an experienced rank-and-file player, with restric-tions on outside work permitted. Implementation of these recommendations, it was recognized, would adversely affect provincial orchestras, for already higher London compensation was attracting talented musicians to the nation's capital. Therefore, public assistance to provincial orchestras should be augmented to permit them to strengthen their organizations and raise performance standards.

The reception of the Goodman Committee Report was generally favorable, but with some opposition to the creation of the concert board. The *Guardian* praised the *Report*, endorsed its recommendations, and approved the com-mittee's desire to defer a decision on reducing the number of orchestras from four to three. If accepted, it wrote, the Report "will go a long way towards putting London Orchestras on a sensible footing"; apart from its other duties the board would be invaluable "in preventing crises which last year threatened arbitrary destruction to both the New Philharmonia and Royal Philharmonic."[20] *The Times* declared that the case for drastically increased subsidies "seemed inescapable" and reported that orchestral officials were enthusiastic about the report's general recommendations.[21] "Eyewash over Orchestras," a feature article in *The Observer*, asserted that no one questioned the need for setting up the board "to bring some order into a field which has in the past been occupied by a number of warring tribes." Nor did it deny that a permanent orchestra must either receive large subsidies or cease to exist. Admitting that the crumbs fed by the Arts Council and the LCC to the London orchestras had only sufficed to maintain them at starvation levels, *The Observer* cautioned that large subsidies alone would not solve the underlying problem of paucity of concert-goers in relation to the number of concerts provided. There were too many orchestras, but "instead of grasping

20. 14 June 1965, p. 8.
21. 18 October 1965, p. 13; 14 June 1965, p. 7.

the nettle, [the committee] proceed to dance round it with an astonishing series of evasions, *non sequiturs* and contradictions." The committee failed to recommend that four orchestras be merged into three (without throwing men out of work), because half of it, representatives of the Musicians' Union and the Orchestral Employers' Association, were undoubtedly committed from the outset to sustaining four orchestras. "In fact the whole report smells much too like one more cosy carve-up of public cash at the expense of the public consumer, who is interested, not in the *number* of London concerts, but in their *quality*."[22] Vigorous condemnation of a concert board came from the London Symphony Orchestra's general manager, Ernest Fleischmann, who declared at a press conference that the orchestra believed it completely unnecessary. Such a body would consist of "well meaning amateurs," unaware of the difficulties of promoting concerts. "If we had not been able to run our affairs competently for 61 years the LSO would not be here today."[23]

The committee's report was accepted in late 1965, and the new London Orchestral Concert Board proceeded to set about discharging its responsibilities.[24] Moneys placed at its disposal for 1966–67 totaled £350,000: £212,500 from the Arts Council and £137,500 from the GLC. The GLC also made an indirect contribution of £75,000 representing costs incurred in providing the Royal Festival Hall. Concert guarantees accounted for almost two-thirds of the board's budget, with grants of £30,000 to each orchestra toward administrative costs and providing players with two-week paid vacations and sickness benefits. For 1967–68 the board's basic income remained at £350,000 with an additional £20,000 to subsidize concerts in the new Queen Elizabeth Hall and Purcell Room, £12,000 derived from the Arts Council and £8,000 from the GLC.

The board's activities cannot be evaluated until the new scheme has been in operation for several years, though some insights can be obtained by examining briefly its effect upon the London Philharmonic. At the end of 1967–68, that orchestra, having completed its thirty-fifth anniversary, could view with satisfaction the first two years of its affiliation with the concert board. Its position has considerably improved financially in both 1966–67 and 1967–68 when the board allocated to it the basic grant of £30,000, plus £47,500 in concert guarantees. More generous support permitted the orchestra to raise salaries as well as to increase its permanent strength from seventy-two to eighty-eight players. Happily, the Philharmonic did not give fewer subsidized concerts: the board guaranteed thirty-nine concerts at the Royal

22. *The Observer*, 20 June 1965, p. 24.

23. Manchester *Guardian*, 22 July 1965, p. 4.

24. The Arts Council, after consulting with the Greater London Council, appointed the Concert Board in late 1965, its membership consisting of three nominees of each council, plus Sir David Webster as chairman. Sir David was also named chairman of its executive committee, whose membership was entirely separate from that of the board and made up of three independent members, three nominees of the GLC and three of the Arts Council, one from the Musicians' Union, one from the Orchestral Employers' Association, and one from each of the orchestras.

Festival Hall each year as contrasted with thirty in 1964–65. Its program in 1967–68 included an additional series of ten industry and commerce concerts in the Royal Albert Hall, fifteen concerts for the Inner London Education Authority, seventy performances with the Glyndebourne Festival Opera, concerts in regional centers, plus BBC television and sound appearances and a three-week tour of Scandinavia. Attendance at Festival Hall registered a modest improvement. The financial position of the other three London orchestras was strengthened by the major increase in subventions resulting in improvements in player compensation and fringe benefits, though increases in attendance have not been as large. The London Philharmonic played a key role in the Eastern Authorities Orchestral Association in 1965–66, its first full year of operation, providing concerts in an area composed of the Northern Home Counties, the East Midlands, Lincolnshire, and East Anglia. The program of thirty-three concerts was financed by £11,425 made available by the Arts Council and an equal sum contributed by 195 local authorities. In 1966–67 the Arts Council set aside £15,300 as its contribution to the association.

Chamber music in London has not been totally neglected by the Arts Council, although sums allocated to such small orchestras have been modest. The two most important have been Philomusica of London and the English Chamber Orchestra and Music Society, both of which have received subventions for a number of years; council guarantees in 1966–67 were £3,000 and £2,500, respectively. Philomusica's activities in 1964–65 included two visits to Western Germany, both outstandingly successful. The orchestra gave its usual series of concerts, both at the Royal Festival Hall and the Victoria and Albert Museum in London; visited a number of provincial cities; took part in the English Bach Festival at Oxford, the City of London Festival, and the Aldeburgh Festival; toured Wales under the sponsorship of the Arts Council; and participated in opera with the Handel Opera Society at Sadler's Wells.[25] Beginning in 1968, subsidies to chamber orchestras for concerts in the London area have been channeled through the London Orchestral Concert Board. The opening in 1967 of the GLC's Queen Elizabeth Hall, seating 1,100 should do much to encourage chamber orchestras, choirs, and ensembles, for it makes available a modern, attractive building, while the adjacent Purcell Room, seating 372, caters to smaller audiences.[26]

Music in the Provinces Since its establishment in 1946, the Arts Council has accorded major emphasis to the creation and development of symphony orchestras of quality in the larger provincial cities. In 1950–51 the council earmarked £28,000 for the support of the City of Birmingham Symphony, the Hallé, and the Liverpool Philharmonic; by 1955–56 orchestral aid had increased to £60,000, the Scottish National and the Bournemouth Symphony also receiving support. Five

25. *Policy Into Practice: Twentieth Annual Report 1964/65, Arts Council of Great Britain*, p. 67.
26. *Sunday Telegraph*, 5 March 1967, p. 11.

years later council subventions totaled £138,260, support going also to the Northern Sinfonia. By 1967–68 provincial orchestra allocations had risen to £401,785.

The council's largest provincial orchestral subventions in England for some years have gone to the Bournemouth Symphony, owned and operated by the Western Orchestral Society, Ltd., a nonprofit entity with a membership of some 2,395 individuals and organizations. Supported by 124 local authorities, it is a regional undertaking serving the west country. In 1967–68, £92,700 in grants and guarantees were made available to it by the Arts Council, but the orchestra drew on its account only to the extent of £80,000. In the previous year, grants and guarantees offered by the Arts Council totaled £83,350; actual payments amounted to £71,000. Treasury assistance was first accorded the orchestra in 1954–55 in the amount of £9,000 with Arts Council subventions increasing gradually to £30,000 in 1960–61 and £60,000 in 1965–66.

The orchestra, founded in 1893, was originally the Bournemouth Municipal Orchestra, controlled and financed entirely by the Bournemouth Corporation, a pioneer venture in local-authority cultural entrepreneurship. By 1954 the corporation sadly concluded that it could no longer bear the total subsidy cost alone and, in that year, with the assistance of grants from the Arts Council, a reorganization led to the establishment of the Western Orchestral Society, Ltd. The reconstituted Bournemouth Symphony's first five years were beset with financial difficulties, and the Western Authorities Orchestral Association was established "to preserve and foster an Orchestra of the West." Within a short time, 100 local authorities were contributing to the orchestra's support. Its permanent strength was enlarged to permit visits to communities widely scattered throughout the West and South of England.

By 1967, 124 different local authorities had joined in subsidizing the orchestra through the association: in addition to Bournemouth, these included seven other county boroughs, thirty-seven boroughs, and seventy-nine urban and rural districts. The association's executive committee, consisting of fifteen elected representatives, provides leadership on policy determination. The operation of the Western Orchestral Society itself is guided by a management committee of twenty, nominated by the association, the Bournemouth Corporation, and the Arts Council, the latter also having its own assessors in attendance. The orchestra grew from sixty-five players in 1954 to 115 in 1968. All players are not assembled at a given concert; rather, the orchestra has a pool of musicians available for a variety of purposes ranging from string quartets to complete symphonies. In 1967–68 the orchestra gave a total of 235 performances—51 in Bournemouth, 115 outside the town, and the remainder in studio broadcasts for the BBC and recording sessions. Twenty-one performances were given with the Welsh National Opera Company; and forty-four specially arranged for school children, with the orchestra engaged by education authorities. During the

orchestra's seventy-fifth anniversary year, 1968–69, concerts were given at the Winter Gardens in Bournemouth, with a seating capacity of 1,818; others were given in ten southeastern towns; four were in London. A summer series of forty-one concerts was also mounted. Two tours, paid for by local authorities, are made annually to the Midlands and North of England. At concerts promoted by the society itself, the orchestra in 1967–68 played to 70.2 percent of financial capacity (77.0 percent of seating capacity). In the autumn of 1965 the orchestra toured Europe for the first time, with great success.[27]

Despite continually rising costs, the society's financial condition improved in 1966–67, due in part to a £20,462 increase in earned income and more generous Arts Council subventions, which jumped to £71,000 from £60,000 in 1965–66 and £56,000 for 1964–65. Both Bournemouth Corporation and Western Authorities Orchestral Association subsidies have remained relatively constant—the former were £30,000 in 1967–68, £30,000 in 1966–67, £29,250 in 1965–66, and £28,500 in 1964–65; and the latter, £23,304 in 1967–68, £22,063 in 1966–67, £20,971 in 1965–66, and £18,265 in 1964–65. Winter Gardens, owned by the Bournemouth Corporation, is being remodeled with plans for a new concert hall for recitals and chamber music, seating about 400. Winter Gardens is rented for one weekly concert throughout the year, in 1967–68 at the cost of £8,000. A £3,577 surplus in 1966–67 brought the orchestra's finances out of the red—deficits having been £7,569 in 1965–66 and £5,002 in 1964–65. In 1967–68 the year's operations again ended in the black, with a surplus of £2,408. Financial disaster lurked in the background, however, for the orchestra in early 1967 was faced with a demand from the Musicians' Union that wages be raised to compare more favorably with those paid by London orchestras. Kenneth Matchett, general manager, pointed out that the towns of the Southwest have "a good record of support," but that the area's population is only about half that served by the Hallé and the Royal Liverpool Philharmonic.[28] Twenty-three Bournemouth players, unwilling to accept the disparity, had resigned during the previous year. The orchestra's proposal of a salary scale under which all players, after seven years' service, would receive minimum earnings close to those of London musicians, was rejected; virtual equality had to be achieved more quickly. Bournemouth asserted it could not raise further the level of its support, and the Arts Council indicated that at the moment it could grant only half the increases needed. Greater assistance clearly must come from the Arts Council, since the Southwest's resources are limited.

The Bournemouth Symphony's performances under Constantin Silvestri, principal conductor, are favorably received by both critics and audiences, although increases in attendance would be most desirable.[29] Projected expansion to create a pool of musicians and the introduction of new and

27. *Key Year*, p. 56.
28. "Bournemouth Orchestra Facing Financial Disaster," *The Times*, 25 March 1967, p. 7.
29. *The Times*, 27 February 1967, p. 16.

experimental activities should do much to heighten interest in music, especially for youth.

Unlike music in Bournemouth, symphonic music in Liverpool did not develop under local government auspices, for the city made no contribution to the Liverpool Royal Philharmonic until World War II. The Liverpool Philharmonic Society was founded in 1840 and has maintained its own orchestra, initially consisting of both amateur and professional players, giving twelve concerts each season. The Liverpool Philharmonic Orchestra over the years has presented programs of variety and distinction, its audiences being privileged to hear most of the great artists of the times. At the beginning of World War II it became apparent that only a permanent orchestra would satisfy the musical requirements of the city—the crucial question was where to obtain the necessary financing. By 1942 the society worked out an agreement with the Liverpool Corporation to transfer title to the Philharmonic Hall to the city, receiving in return free use of the building, provided a stipulated number of concerts were given and a permanent orchestra maintained.[30] The corporation then made available £4,000 annually, supplemented in 1947 by a £4,000 grant.

The range and quality of concerts given each year are impressive: during 1967–68 a Tuesday evening subscription series, a Saturday night series, a twenty-seven-concert series designed to appeal to Merseyside workers, and a summer series, besides special programs at Christmas. During the same year, the society presented 76 concerts in Liverpool, 10 in other towns, and was hired on 56 occasions for public concerts (mostly in communities outside Liverpool) and broadcasts; in addition, it gave 62 concerts for schools, sponsored by education authorities. In 1966–67, the orchestra had given 217 concerts, and in 1965–66, 238. The Liverpool Philharmonic Club offers its members monthly meetings featuring lectures and occasional concerts, a bulletin containing full details about the society's activities, priority bookings, and attendance at final rehearsals in Philharmonic Hall. The Liverpool Philharmonic Choir fosters interest in vocal music among adults, while the Merseyside Youth Orchestra caters to amateur players between the ages of fourteen and twenty-five. The Liverpool Philharmonic undertook its first tour abroad in October 1966, giving ten concerts in Switzerland and Germany, but tours within Britain are infrequent. Orchestral strength as of late 1967 stood at seventy-nine players and twenty administrative employees, including office staff responsible for the Philharmonic Hall and box office.

Representatives from the local authority form part of the society's committee of management: six committee members are nominated by the Liverpool Corporation, six are also elected from the society membership, and three are co-opted subject to the approval of the Arts Council. Financial

30. During World War II the orchestra was heavily engaged in providing concerts for war workers and troops under the ENSA scheme: it is estimated that between 1941 and 1945, 500 concerts were given, players traveling over 36,000 miles. In Liverpool, the number of concerts rose from ten in 1938–39 to 109 in 1943, audiences increasing from 10,359 to 127,369. *Programme.* 125th Anniversary Concert, 12 March 1965, pp. 29–30.

support accorded the Royal Liverpool Philharmonic by the Arts Council in 1966–67 totaled £68,000, £11,000 being a guarantee; while subventions in 1965–66 amounted to £52,000. Aid to the orchestra grew steadily, rising from £9,000 in 1950–51 to £12,000 in 1955–56 and £27,000 in 1960–61. In 1967–68, Arts Council allocations were further increased to a £65,000 grant and a £10,000 guarantee, the additional amount used primarily to meet increased wage costs. The Liverpool Philharmonic has been generously supported by the corporation; in fact, of all provincial orchestras, it has received the largest subsidy from a major local authority. Assistance to the orchestra in 1966–67 totaled £51,293, although a portion of this represented credits involving no cash payments. Most important, the city council provided £39,215 as a guarantee against loss, of which the orchestra claimed only £20,041, £4,000 being paid additionally as an annuity under the agreement originally entered into in 1942. For services performed in the operating of the hall, the city reimbursed the orchestra £500. Credit was claimed for £10,000, estimated as fair value for use of the hall by the orchestra. And £8,344 was paid for school concerts, which were considered a purchase of orchestral services rather than a subvention. The Lancashire and Cheshire Counties Fund, originally set up in 1954, currently receives contributions from ninety to a hundred nearby local authorities. The money is used to support equally the Hallé and Royal Liverpool Philharmonic Orchestras. Although nine-tenths of the contributions are £500 or less, several are substantial—in 1966–67 Liverpool gave £8,407 and Manchester, £7,488. The size of the contribution depends upon each authority's population and its proximity to Liverpool or Manchester. The Liverpool Philharmonic and the Hallé each received £17,043 from the fund in 1966–67. Liverpool Corporation's basic guarantee against possible deficit in 1965–66 was £28,282, with an actual payment of £18,577. In 1964–65 it was £26,702, £21,416 of which were turned over to the society.

Concerts given in the Philharmonic Hall have been highly successful as attested by public response, attendance in the 1,800-seat auditorium averaging over 90 percent of financial capacity in both 1965–66 and 1966–67. Critical reviews have been favorable, and provision of financial support by local authorities is highly satisfactory, due to the operation of the Lancashire and Cheshire Counties Fund and the liberal backing given by Liverpool City Council. Some society members have been concerned that the orchestra's close relationship to, and dependence upon, the city might limit freedom of action; but the Council's enlightened attitude renders this unlikely.

Local authority support of the City of Birmingham Symphony began under circumstances somewhat different from those which had prevailed in Bournemouth and Liverpool. Choral festivals, dating from 1768, were held intermittently, but it was not until 1849 that the Festival Choral Society established an orchestra to play for the festivals as well as for separate concerts. Only after World War I did Birmingham seriously set about creating a permanent orchestra, prompted by the sharp tongue of Sir Thomas Beecham

(musical and financial adviser to the local orchestra) and by the encouragement of the Lord Mayor, Neville Chamberlain. In 1919 the city council, on the recommendation of the parks committee, agreed to contribute one-half of the estimated annual deficiency of £2,500 for a period not exceeding five years; and in 1920 the City of Birmingham Orchestra was established. Directed by Adrian Boult, it was accorded renewal of the £2,500 guarantee in 1925 for an additional five-year period; in 1930 this was continued for another five years. Oddly enough, assistance stemmed from recommendations of the parks committee, which assumed that the concerts would be in the parks; from the beginning, however, the orchestra performed in the Town Hall. Not until 1935 was responsibility shifted to the general purposes committee, the £2,500 guarantee continuing to 1944. At this time a scheme was adopted establishing a full-time permanent orchestra of fifty-six players, with provision for an extensive series of education concerts and a full program open to the public. Council jurisdiction passed to the education committee, and a five-year grant not exceeding £7,000 a year was authorized, together with payment for services rendered to the schools, not to exceed £7,500 annually. In 1948 the orchestra's grant was increased to a maximum of £11,000 and its education concerts payment to not more than £10,000. Despite council assistance, the orchestra's financial condition deteriorated, with annual losses after 1946. Responsibility for general subsidies shifted back to the general purposes committee; and the city council, recognizing the desperate condition of the orchestra, raised the grant for 1953–54 to £21,000 and for 1954–55 to £25,000, where it remained until 1958, when it was set at £30,000. By 1963–64 the grant was increased to £35,000; in 1966–67 it totaled £44,443, and in 1967–68, £48,000. Subventions from other local authorities were modest; thus, in 1966–67 eight authorities provided £4,750 to underwrite twenty-two concerts. In addition, thirteen authorities engaged the orchestra for nineteen concerts for £7,717. However, obtaining greater local authority support is a continuing concern of the orchestra's management.

The Birmingham Symphony, aided by the Arts Council since 1946, benefited by steadily increasing Treasury subventions—£9,000 in 1950–51, £12,000 in 1955–56, and £22,000 in 1960–61. For 1966–67 it was accorded a basic grant of £54,000 plus a guarantee of £11,500, on which it drew only £7,443; in 1967–68 its grant stood at £65,000 with a £10,000 guarantee. The orchestra's operations produced small surpluses for many years, amounting to £7,961 in 1963–64 and £3,995 in 1964–65; but in 1965–66 it lost £3,726. A larger deficit was avoided in 1966–67, when supplementary grants were authorized from both the city and the council. Inadequate salaries for musicians still present a grave problem. Had the city not increased its grant by 30 percent in 1967–68, and had the Arts Council not raised its subvention to help meet increased wage costs, the orchestra would not have survived.

The Birmingham Symphony, a registered charity, is run by a committee of management numbering thirty-one persons—fifteen elected by members

of the society, six Birmingham city councillors, six nominated by the education committee, two players, and two co-opted by the committee. During 1966–67, 212 performances were given—66 in Birmingham, featuring a number of distinguished artists and conductors; 41 in the region around Birmingham; and 27—education concerts—in Birmingham, Nottingham, and Worcester. Other appearances included 19 with choral societies, 24 with the Welsh National Opera Company, 16 for the BBC, and 6 for film. The orchestra employed eight-nine musicians—all on full-time contracts—plus ten administrative personnel.

In a move to encourage children to attend the regular town hall concerts, the education committees have drastically reduced educational concerts. In 1953, when the orchestra lacked sufficient work, the schools program helped it to survive. By 1965 the orchestra had built up the largest concert program for young people in England. However, when the true cost became twice as large as the payments received, it no longer seemed wise to devote fifty-eight days to concerts for five educational authorities. The orchestra was frequently broken into six sections, each of which visited four schools per day with no admission charge. "Music You Love," an industrial concert series given in the Town Hall for several years, became progressively less popular, and so the number of concerts in 1966–67 was reduced from twelve to six. The Birmingham Symphony engages in limited tours outside the Midlands but undertook no trips abroad in the three-year period ending March 1967.

The orchestra is faced with a number of problems. The Town Hall, erected in 1834, suffers from serious deficiencies—unsatisfactory acoustics, uncomfortable seats, limited backstage facilities, inadequate refreshment amenities, and poor ventilation. The orchestra wishes to have a new hall constructed as a part of the central city development scheme, but approval has not been forthcoming and completion is many years away. Larger subsidies are needed to meet increased operating costs, to expand its program, and to improve performance. Diversification of local-authority support is needed, for the orchestra is unduly dependent upon the city of Birmingham. Concert attendance, relatively constant the previous two years, was the object of a concerted promotional drive in 1967–68, due in part to pressure from the corporation and the Arts Council. In 1966–67 an average of 65 percent of the slightly fewer than 1,900 seats in the hall were occupied for concerts featuring contemporary music. Performances of popular works averaged 95 percent.

Among provincial orchestras, the Scottish National benefits from the most generous public subsidy. Its support is more broadly based and derives from a greater number of local authorities. The orchestra traces its professional lineage back to 1874, when the Glasgow Choral Union first initiated a short season of concerts. By 1891 the Scottish Orchestra Society was formed and, in subsequent years, engaged for relatively short seasons such distinguished conductors as Richard Strauss, Edward Elgar, and Henry Wood. In 1933 John Barbirolli was appointed permanent conductor, suc-

ceeded by George Szell in 1936. Intermittent efforts to establish a permanent orchestra began in 1932, but it was not until 1950 that the Scottish National Orchestra was constituted and its players engaged on yearly contracts. Its principal role has been to provide the whole of Scotland with live symphony concerts wherever large enough halls exist to accommodate it, but increasingly it has performed throughout Britain, winning a national reputation.

In 1965–66 the Scottish National Orchestra gave 199 performances, traveling nearly 15,000 miles. Growth to ninety-six players permitted the orchestra for the first time to separate into two chamber sections, each making three-day tours to smaller towns. Performances during the year numbered 77 in Glasgow, 40 in Edinburgh, 15 in Aberdeen, and 10 in Dundee—these four cities providing the bulk of local-authority support. In 1966–67, 209 performances were given; 99 concerts were promoted directly by the society; 15 were given under hire to other organizations; 26 were played with Scottish Opera and 7 with the Glasgow Grand Opera Society; three were at the Edinburgh Festival; 42 were presented for educational authorities; 13 were on Arts Council tours to remote Scottish towns; and two were BBC studio broadcasts. The winter concert season, opening in Edinburgh and Glasgow on 7 and 8 October and continuing through March, consisted of 20 concerts in Edinburgh, 20 in Glasgow, 8 in Aberdeen, and 7 in Dundee, plus a few special performances. The 1967–68 winter season involved essentially the same distribution of concerts. For the first time in its existence, in October 1967 the Scottish National left Britain to give fourteen concerts in Vienna, Salzburg, Munich, Nuremberg, and other European cities.

A look at the orchestra's financial accounts reveals that it is truly a Scottish regional enterprise—not dependent upon a single local authority for the bulk of its subsidy, as is the Liverpool Philharmonic, but enjoying diversity of support. Thus, in 1966–67 it received £33,792 from Glasgow, £16,000 from Edinburgh, £5,136 from Aberdeen, £4,370 from Dundee, £1,000 from Lanark County Council, and £5,451 from 141 smaller local authorities. The total of £65,749 did not equal the Arts Council's subvention of £84,785, as the council would have liked, but in the previous year local aid exceeded the Treasury's contribution of £62,500. The Arts Council has assisted the orchestra since its establishment with £32,000 in 1960–61, £44,500 in 1962–63, and £55,500 in 1964–65. By 1967–68, though Arts Council subvention had risen to a £85,000 grant plus a guarantee of £20,000, local authorities were requested to increase their assistance substantially. Annual losses have not been infrequent, and by 1967 the society's accumulated deficit stood at £56,020.

Scottish National's operating costs have risen in recent years, reflecting higher salaries paid union musicians. Further increases in this category appear likely in the future. Since the orchestra earns only 35 to 40 percent of its total budget, it could find itself in serious trouble in a recession with lower ticket revenue and reduced Treasury and local authority grants, if

wage costs remain relatively constant. Fortunately, loss of players to London has not been as severe as that experienced by other orchestras. However, the destruction of Saint Andrews Hall, Glasgow, by fire in 1962 forced the orchestra to play in a converted cinema until 1968, when it moved to the recently renovated City Hall. Plans are under consideration to erect a concert hall in the new Glasgow arts center, but completion is not likely until the late 1970s. When away from its headquarters in Glasgow, the orchestra finds adequate halls in Edinburgh and Aberdeen, but conditions are usually far from satisfactory elsewhere.

The Hallé Orchestra of Manchester has a long and distinguished history. The Arts Council since 1946 has accorded its continuing grant and guarantee support, subventions in 1966–67 amounting to £72,100. The Hallé has also benefited from substantial local authority grants.

Northern Sinfonia is Britain's only permanent chamber orchestra. Its players are engaged full-time under year-round contracts. Other chamber orchestras are springing up in the provinces, such as the Bristol Sinfonia and the Midlands Sinfonia, but they are not yet permanently established. Northern Sinfonia presented its first public concert in City Hall, Newcastle-upon-Tyne, on 24 September 1958. It was formed to fill a gap in the North East left by the disbandment of the Yorkshire Symphony Orchestra. A Northern Sinfonia Concert Society to organize support for the orchestra and determine its policies was constituted, and within a short time Arts Council and local-authority assistance enabled it to extend its activities to neighboring towns. From the beginning Northern Sinfonia's repertoire has been comprehensive, including classical chamber works as well as contemporary music rarely heard outside London.

By 1961, eighteen full-time players were under contract, by 1967, 26. Total concerts by Sinfonia average each year about 150, with less than half performed in the Northern Arts Association region. About twenty-five are education concerts in local-authority schools. The 1966–67 program included a series of ten concerts at City Hall, Newcastle, six in Middlesbrough and Billingham, three in Darlington, and three in Carlisle. Newcastle attendance in 1966–67 averaged between 1,700 and 1,800 in the City Hall auditorium, which seats 2,200. Audience response, less satisfactory in other parts of the region, showed considerable improvement in 1966–67, due largely to more vigorous publicity and distinguished conductors and soloists.

In six of the first seven years of Sinfonia's existence, despite government subsidies, losses were incurred. The largest annual deficit was £8,200 in 1963–64. Arts Council aid, £1,100 in 1959–60, increased to £5,000 in 1962–63, to £16,500 the following year, and to £28,550 in 1966–67. Local-authority grants prior to the creation of the North East Arts Association exceeded Treasury subventions—£6,666 in 1961–62. The association at once provided major subsidies, giving £18,000 in 1962–63; by 1966–67 its contribution amounted to a general grant of £28,350, plus a £4,000 celebrity grant (to be used to engage noted artists and conductors). The orchestra's accumulated

debt, as of 31 March 1967, stood at £27,000; in 1964 the NAA gave Sinfonia an interest-free loan of £15,000, £4,500 of which was repaid. Early in 1967 a plan to liquidate the remaining debt was adopted: the Arts Council will contribute £13,500 over a three-year period and the NAA will make available an equal amount, offsetting the £10,500 owed it. Treasury sanction of Arts Council participation was contingent upon its payments being matched by local authorities and local industry. This elimination of the long-standing debt should do much to raise the morale of the orchestra and those supporting it.

Northern Sinfonia's success is remarkable. Its ultimate objective is to become a national, rather than a regional, orchestra. Strenuous efforts will be made in the future to avoid further deficits: for 1967–68 the Arts Council allocated £40,000 and the NAA earmarked £35,000. City Hall in Newcastle, not constructed specifically for orchestral concert use, is lacking in bar and restaurant amenities and has poor acoustics. For some time discussions have been under way concerning the erection of a music hall and a new theater as part of an arts center; the site has been selected, but plans for construction have yet to receive final sanction.

The National Federation of Music Societies Unique among the musical organizations which receive major Arts Council financial support is the National Federation of Music Societies, an association of approximately 1,000 leading amateur music clubs, choral, and orchestral societies in England, Scotland, and Wales. Allocated £125,800 for 1967–68 by the council, the federation provides to constituent societies with 100,000 members limited guarantees against concert loss. These are designed to raise artistic standards by underwriting a portion of the fees of the professional soloists, ensembles, and orchestral players.

The National Federation was formed in 1935 to help alleviate the economic deprivations suffered by professional musicians during the Depression. The number of engagements open to professional artists had drastically declined, and some amateur societies were struggling to survive. In promoting greater employment opportunities, the Incorporated Society of Musicians, a professional organization of musicians, focused attention upon the plight of these organizations. The Carnegie Trust financed the establishment of the federation and underwrote its assistance programs for fifteen years until, in 1951, the Arts Council assumed sole responsibility. Earlier, the Arts Council contributed funds to help support the federation.[31]

Federation membership is confined to amateur choral and orchestral societies. Chamber music clubs and operatic societies are ineligible. Each member society elects a representative to the National Federation, whose presidency has been held by Vaughan Williams, Sir Thomas Beecham, Sir Malcolm Sargent, Sir Adrian Boult, and other distinguished musicians.

31. *Arts Council of Great Britain, Second Annual Report 1946–47*, p. 46.

A council composed of up to forty-five members elected by the societies on a regional basis discharges overall governing responsibilities, but extensive powers are delegated to an eight-man executive committee. Member societies are grouped for administrative purposes in eighteen separate regions, each with an elected regional committee, which considers problems affecting societies in its area, screens applications for affiliation, and makes preliminary evaluations of requests for financial assistance.

Provision by the federation of information and advice to member societies is basic to their successful operation. A bulletin published six times a year conveys to local societies news of the federation's activities, as well as information relating to availability of financial aid, artists' fees, insurance, and other matters. From its London headquarters the federation counsels local societies on a wide range of questions—the most desirable form of society constitution, income tax liability, performing rights, rates of pay for orchestral players, society legal liability, and so forth. It operates a scheme for exchange between member societies of choral and orchestral music, circulating details of works which societies are prepared to lend or rent at modest rates. Publications issued by it include a catalog of choral works performed by affiliated societies since the federation's establishment, a companion catalog of orchestral works, a catalog of chamber music, and *Choral Latin—Some Notes for the Guidance of Choirs in the Pronunciation of Latin*. The federation monitors pending legislation affecting its local societies, mobilizing their influence when necessary. It may request the Department of Education and Science to urge local authorities to provide more generous assistance for societies. Or it may lend support for loan programs to assist local governments in constructing halls suitable for concerts. Societies are encouraged to investigate building construction plans to insure halls that will best meet their requirements. The federation negotiates group insurance under which all societies can obtain coverage for certain risks. Its Award for Young Concert Artists is granted to outstanding individuals, in the form of "engagements" with affiliated societies and clubs. And since 1964 an annual two-day course for conductors has been held.

The Arts Council subvention of £125,800 for 1967–68 includes a small sum earmarked to defray the costs of administration, the remainder going to underwrite assistance programs. Major emphasis is given to raising standards of concert performance by contributing the cost for professional soloists and orchestral players. This program is controlled for English societies by a joint allocation committee in London, made up of an independent chairman, the NFMS executive committee, and three representatives of the Arts Council music department. Separate allocation committees function for Scotland and Wales. Of the 975 societies belonging to the federation in 1967, 675 received guarantees. Criteria followed in considering the requests from different types of organizations vary slightly. The choral and orchestral societies whose total annual expenditure exceeds £500 were given guarantees varying from £50 to £1,000 in 1967–68. Those spending between

£100 and £500 received guarantees of £15 to £135, and those with less than £100, from £15 to £25. Music clubs that promote chamber concerts by professional artists profit from guarantees of £20 to £300. Sums paid under guarantees varied considerably, amounting to 100 percent for only the smaller choral and orchestral societies. The percentage of guarantee taken up by all societies has remained surprisingly constant. It was 91 percent for 1961–62, 90 percent in 1962–63, 89 percent for 1963–64, 90 percent for 1964–65, and 88 percent in 1965–66. Aid extended generally equals about one-fifth of anticipated professional expenses. The National Federation, whose secretary administers the guarantee program, works closely with the Arts Council. Cooperation between the two bodies in the field of amateur music is a cornerstone of its policy. A liaison officer periodically visits individual societies, attends concerts, and offers critical evaluation and professional advice.

The federation presses societies to apply to their local authorities for financial aid, usually forthcoming in modest amounts. Thus, in 1964–65, in all of Britain, local governments provided £15,909 and education authorities, £3,899. For some years, the joint allocation committee has awarded a limited number of prizes ranging from £150 to £250 to societies and clubs for originality and enterprise in their programs. And in 1955 the Arts Council set up for England a small fund, administered by the federation, from which chamber music societies can borrow, interest-free, to purchase pianos. As of 1 July 1967, fourteen societies had taken advantage of this scheme.

Support of the federation and its assistance programs for member societies constitutes one of the few instances of Arts Council patronage of a non-professional organization. Departure from the council's general rule, even here, is qualified by the requirement that funds allocated be expended to provide professional supplementation for what otherwise might be largely amateur performances. The improved quality of programs presented by federation societies and the increased size of aggregate audiences have induced the Arts Council to increase year by year the amount of money for concert guarantees.

Assistance to Artists The Arts Council, by awarding sums of money to individual artists in the music field, is involved directly as an art patron. In the two-year period, 1965–67, seven awards varying from £150 to £1,160 went to individuals seeking advanced training. Three recipients participated in management training—one with the Bournemouth Orchestra, another with the Hallé, and a third with the Royal Liverpool Philharmonic. Others benefited from clarino instruction, from apprentice conducting with the Vancouver Symphony, and from studying the structure of famous organs in European countries. Commissions, including presentation costs, went to composers for music to be performed by the Yorkshire and District Brass Band Associa-

9

tion, and for works to be played at the Tilford Bach Festival, the Three Choirs Festival, and a summer school of music. Composers' bursaries provided small sums to release artists from regular duties for short periods and to defray costs of presenting new works. Although council policy in this area is still very much in its formative stages, a strong case can be made for increasing the amount of money earmarked to encourage the work of individual creative artists and ensure an adequate supply of administrators.

Music Subsidy in the Future Although music does not require subsidies as large as those needed for opera and theater, the programs sponsored by the Arts Council and local authorities in the past twenty years have achieved impressive results. However, certain needs are yet to be met.

Cultivation of new audiences should be accorded high priority. Schools and universities should intensify their efforts to interest youth in good music; community arts centers and other organizations can play an increasingly important role in this work. Symphony orchestras prefer that youth acquire their taste for music by attending regular concerts in orchestral halls, rather than by listening to school performances played by truncated sections of the orchestra. Evidence seems to indicate, however, that special school programs by symphonies are still effective and should not be abandoned. New ways need to be devised to encourage adults from the business, industrial, and professional sectors to develop an interest in serious music. The operation of the London Orchestral Concert Board requires continued careful evaluation to ensure that it accomplishes its objectives. Grants made to it by the GLC and the Arts Council must be sufficiently large to permit it to support the London orchestras properly; contributions should be sought from local authorities in areas adjacent to the GLC, as many of their citizens listen to concerts at the Royal Festival Hall. If concert attendance fails to increase materially, support of four London orchestras cannot be justified. Undoubtedly, additional moneys will be needed by the provincial orchestras, and a large portion of assistance should be derived from local authorities. Governments in the regions served by each orchestra should make more generous provisions for support. The migration of musicians to London requires immediate remedial action. Ultimately all orchestra musicians should be employed under conditions conforming to a national minimum, with satisfactory annual compensation, pensions, and working conditions, for an increasingly large proportion of total orchestral operating funds comes from public sources. In a number of cities, new orchestra halls are needed, but the nation's fiscal difficulties are likely to preclude their construction for some years. The touring activities of the London orchestras and the scheduling of concerts by provincial orchestras require greater coordination to prevent duplication of programs and destructive competition for audiences.

Support and encouragement of music clubs and societies by the National

Federation of Music Societies and by local authorities are highly desirable, and allocations should be increased wherever there are opportunities for expanding local programs. Greater encouragement should be given to the presentation of recently composed works and the playing of infrequently heard classics. Provision of assistance to individual artists by the Arts Council will increase. It is hoped that the larger cities will wish to devote limited funds to augment these national programs.

11 / LITERATURE AND THE CREATIVE WRITER

When an immortal poet was secure only of a few copyists to
circulate his works, there were princes and nobles to patronize
literature and the arts. Here is only the public and the public must
learn how to cherish the nobler and rarer plants, and to plant the
aloe, able to wait a hundred years for its bloom, or its garden will
contain, presently, nothing but potatoes and pot-herbs.
—Margaret Fuller

Although at the time of its beginning in 1945 the Arts Council immediately set up programs to assist opera, ballet, music, drama, and the visual arts, it refused to treat literature as an art form. The plight of the other arts was painfully apparent, and the council's modest resources went to their resuscitation and development; literature received nothing. Further, there were those who did not even believe that the council's mandate as set forth in its charter authorized it to deal with literature at all. A few years later, means were discovered to assist poetry, but a full-fledged department of literature and a literature panel did not begin to function until January 1966.

Proceeding with its plans for a Festival of Britain in 1951, the government requested advice from the Arts Council concerning proposed programs. The council's recommendations included schemes for poets as well as composers and painters. Out of talks with a small group of poets and publishers emerged a plan for a worldwide competition among poets, to include entries from the Commonwealth as well as from Britain itself. Prize-winning entries were to be published by Penguin Books as *Poems of 1951*.[1] More important, the Arts Council was advised to become active in the field of poetry through a long-term policy of assistance. The council, therefore, constituted in 1950 a panel for poetry, initially composed of six members. During 1950–51 the council extended two small grants, one to the Apollo Society for the presentation of a series of poetry and music recitals, and another to the English Festival of Spoken Poetry. Since that time moneys allocated to poetry in England have increased, though at a relatively modest rate, rising from £648 in 1952–53 to £5,148 in 1964–65, the year prior to the formation of a department of literature. This department, now enjoying more generous support, was allocated £51,550 for its activities in England in 1966–67 and £63,103 for 1967–68.

Societies and Literary Magazines From the beginning, an important ingredient in the Arts Council's support of poetry has been the providing of grants to a limited number of poetry societies and related organizations. Thus, in 1950–51 modest assistance enabled the Apollo Society of London, founded in 1943 and specializing in the presentation of recitals combining poetry and music, to offer during the year a successful series of eight weekly recitals at the Arts Council's London headquarters as a part of the London Season of the Arts. Each program

1. The response to this worldwide competition for poetry written in English was surprisingly great, over 2,000 poets from many different parts of the world submitting entries. One entry "written in different colored inks came from the inmate of a mental hospital; another lavishly illustrated in color and impregnated with exotic scents was sent in by a postman in Ceylon; and a lonely competitor from an island in the middle of the Pacific Ocean, without access to a typewriter, pinned a £5 note to his long hand-written poem to defray the cost of getting it typed in London." Eric W. White, "Public Support for Poetry," *A Review of English Literature*, vol. 8, no. 1 (January, 1967), pp. 55–56.

was sponsored by a contemporary poet. Participating sponsors were John Betjeman, Walter de la Mare, Dylan Thomas, Stephen Spender, C. Day Lewis, Edmund Blunden, Edwin Muir, and Christopher Fry. In 1953–54 the society gave regular monthly performances during the autumn and winter months in the recital room of the Royal Festival Hall in London, attracting an audience of almost 2,000 persons to its May 1954 recital, *The Apollo Anthology*, containing a representative selection from the society's programs over the previous twelve years, was published during that year. Two Sunday recitals at the Aldwych Theatre featured Vanessa Redgrave, Tony Church, Ossian Ellis, Edith Evans, Christopher Hassall, and Nina Milkina. The society took part in a number of arts festivals held in different parts of Britain and presented programs in a number of country houses. Amounting to only £500 in 1966–67, the council grant helps to defray a portion of the society's administrative costs. Until its demise in 1967, the Contemporary Poetry and Music Circle, an organization which met monthly in Kensington, London, received a small annual grant from the Arts Council. Its purpose was to provide a congenial setting in which poets could read their work.

Beginning in 1964–65, the Arts Council assisted the Society of Barrow Poets, a semiamateur group based in London, diligent in making poetry attractive to new audiences drawn from varied economic and social backgrounds. Founded originally in 1951 by a group of London University students who attempted to sell, from a wheelbarrow, their work and that of other unknown poets, the society immediately encountered official non-cooperation. When the London County Council refused them a license, they retreated to the pubs. With a membership of six to eight men and women, the society presents a broad repertoire of poetry interspersed with music; in a typical year, appearances are scheduled in some thirty London pubs, and more than 150 programs are staged elsewhere in schools and colleges, at festivals such as the Aldeburgh, and at dinners and special occasions. Stressing the convivial side of poetry, the Barrow Poets recite from memory.

Poems presented are from every available source; some are profound; others are comic, simple, or sophisticated. Grouped together in short sections, centering on a particular theme or reflecting a certain mood, they are not restricted to any period or style. Violin and oboe provide the music supported sometimes by unique homemade instruments for certain effects. Traditional tunes, classical music, modern arrangements, as well as jazz, are used where appropriate.

In 1955 the Arts Council began making available small subsidies to a limited number of poetry magazines. Its policy was to restrict such aid to periods of three years or less. This flexibility has allowed the payment of more generous fees to contributors. First helped were *Delta*, *Listen*, and *Outposts*; the editor of the latter reported at the end of three years that the size of the magazine had grown and the subscription list had doubled. More recently, assistance has also gone to little magazines of general literary

interest, provided they devote adequate space to poetry. In 1962–63 a grant of £130 was awarded to the Universities' Poetry Committee for the fourth issue of their anthology *Universities' Poetry*. In the same year £150 enabled *Poetry and Audience* to purchase books of poetry to be added to the holdings of the new Poetry Room at the University of Leeds. The number of poetry publications assisted varies from year to year: in 1965–66 sixteen magazines in England, Scotland, and Wales were accorded grants, and in 1967–68 a comparable number. English magazines aided during the past several years with subventions almost invariably of £150 or less include *Agenda, Ambit, Cleft, Elam, Extra Verse, Harlequin Poets, Listen, Modern Poetry in Translation, Northern House, Outposts, Phoenix, Resuscitator, Stand,* and *Universities' Poetry*. In Scotland assistance went to *Poor Old Tired Horse,* an avant-garde literary periodical, and *Lines Review*; Welsh recipients have included *Taliesen* and *Anglo Welsh Review*. In his special introduction to the souvenir program of the 1963 Festival of Poetry at the Royal Court Theatre in London, T. S. Eliot pointed up the merits of the "little magazine" or the "little publisher" that make them worthy of support.

By the latter [i.e., the "little publisher"], I mean the small press which confines itself to the publication of new poets still unknown—the press which, owing perhaps to the devotion of one generous person, is on the lookout for new talent and is prepared to back it at a loss. Little magazines and little publishers come and go, but it would be a sad day when they vanished altogether. For the larger public capable of enjoying the work of young poets needs some assurance, not necessarily of notable success, but at least of the approval of critics in high places.[2]

During the early 1950s the poetry panel recommended the formation of a Poetry Book Society, a proposal favored by the Arts Council. In December 1953, the Poetry Book Society was incorporated as an independent non-profit company, limited by guarantee, with twenty-five registered members, to be governed by a board of directors, which today numbers nine. The society tries to reach persons of diverse backgrounds, particularly "the many who have limited leisure to sift out and discover the best English poetry being written today."[3] Each year an independent selection board of two to three persons, usually poets or critics, chooses four volumes of new poetry to distribute to subscribers. The individual subscription fee of £3 a year also pays for a copy of the society's bulletin, containing poetry news and contributions from the authors of books recommended. Schools and other organizations benefit from membership, for the society enables them conveniently to acquire a representative collection of modern verse. T. S. Eliot, one of the society's founders, emphasized the advantages school children could derive from the Poetry Book Society:

If every secondary school in the country joined the Poetry Book Society and had a shelf in its library exhibiting the books of new poetry, this year and last year and

2. White, "Public Support for Poetry," p. 63.
3. *Public Responsibility for the Arts: The Ninth Annual Report of the Arts Council of Great Britain, 1953–1954,* p. 45.

several years, and just left them there for the boys and girls in the upper forms to discover for themselves and find out what they liked, we would be doing a very great service, because it is in the years between 14 and 18, if ever, that people become readers of poetry and lovers of poetry, and also amongst those readers will be the poets of that generation.[4]

The society's biennial festivals of poetry have stimulated widespread interest in poetry both at home and abroad. The first of these, held at the Mermaid Theatre in 1961, featured the works of twelve poets. Successive festivals, held at the Royal Court Theatre, and the Queen Elizabeth Hall and Purcell Room, have each attracted as many as five thousand persons. Well- and lesser-known poets from Britain and, in 1967, from six foreign countries, read their works. Programs include lectures, films, verse drama, and other events as well as readings.

From its inception, the Poetry Book Society has received from the Arts Council the financial support essential to its existence and successful operation. Subventions in support of general operating expenses have remained small, amounting to £500 in 1961–62 and increasing to £1,550 in 1967–68. Additional sums have been made available partially to underwrite the costs incurred by the biennial festivals of poetry with a guarantee of £1,500 in 1965 and one of £1,680 in 1967. Society offices are located in the Arts Council headquarters in London, and Eric W. White, the council's literature director and assistant secretary, has served continuously as secretary of the society's board of directors. The actual subsidy is considerably less, for the Book Society remits to the council each year approximately £750 to offset in part office overhead and services of the director of literature and the secretaries. The society's membership has not reached the proportions hoped for by its organizers. In their campaign for increased membership in 1954, society officers had set a goal of 3,000 members; by 1965 the roster contained only 750 and in 1967 it held to essentially the same level.

Festivals and Readings Limited funds have supported literature and poetry festivals. For example, two festivals were aided in 1952–53: the English Festival of Spoken Poetry in July at the Royal Academy of Music, London, which sought to raise the standard of verse-speaking through contests of various kinds; and the Cheltenham Festival of Contemporary Literature in October, when C. Day Lewis and Jill Balcon presented a successful poetry recital. Launched originally in London in 1945, the English Festival of Spoken Poetry gave classes, lectures, and readings to encourage the appreciation of poetry. In 1956 there were two innovations—lectures by eminent poets (Dame Edith Sitwell spoke in that year on modern poetry) and seminar-discussions. Early in 1960 the Poetry Book Society, supported financially by the Arts Council and Associated Television, proposed a new type of festival, broader in scope and

4. *The First Ten Years: The Eleventh Annual Report of the Arts Council of Great Britain, 1955–1956*, p. 57.

with a somewhat different emphasis. Directors of the Festival of Spoken Poetry concluded that, rather than compete with the new enterprise, they should terminate their own activities.

Promoted by the Cheltenham Arts Festivals, Ltd., in association with the Arts Council and the Cheltenham Corporation, and presented in the Town Hall, the new Cheltenham Festival of Literature extended over a six-day period, 3–8 October 1966. Total expenditures, amounting to approximately £4,000, were met by a guarantee from the Arts Council of £1,000, £150 from the Cheltenham Corporation, £150 from the Gloucestershire County Council, £250 from Arthur Guinness, Son and Company, plus revenue from attendance. Participating in the programs were many of Britain's leading writers, critics, and literary editors. The program included a discussion on the state of British publishing, readings by Harold Pinter and Pat Magee, "The Feminine Sensibility" analyzed by five women writers, "Literature and History" by A. J. P. Taylor, and a discussion on contemporary drama by playwrights and journalists. Every evening, guest writers gave readings of their own works and answered questions.

The first Festival of Poetry at Stratford-upon-Avon was held in the summer of 1954. Aided by a modest Arts Council grant, the Trustees and Guardians of Shakespeare's Birthplace presented a series of readings on nine consecutive Sunday evenings at Hall's Croft Hall. Festival attendance has remained high. In recent years, in order to accommodate a large number of persons, the first of the nine programs takes place in the local town hall and the last at the Shakespeare Memorial Theatre. Once during the season a distinguished "Poet of the Year" is present to read his poetry. At the fourth Festival in 1957 a special exhibition entitled "Twenty-five Years of English Poetry: 1920–1945" displayed manuscripts, typed and corrected drafts of poems, and some first editions by Thomas Hardy, Dylan Thomas, and others. Christopher Hassall, in opening the exhibition, commented:

> I think it safe to claim that there's no other Festival in the country quite like this one. Because of the importance it has always attached to the work of living writers, it is itself gradually becoming of significance in the literary scene. And the longer it lasts, the more its continuance is taken for granted, the more will its value increase. Its effect must be cumulative. With the passage of time it will acquire authority, as already—with its visits from successive "Poets of the Year"—it has begun to establish a tradition all its own.[5]

Hassall's prediction was correct. The format of the Stratford Festival has remained essentially the same. Many of the participants are associated with the Royal Shakespeare Company, whose actors and actresses give a substantial portion of the readings. "Poets of the Year" have included John Betjeman, William Plomer, Laurie Lee, Christopher Fry, Louis MacNeice, R. S. Thomas, Stevie Smith, Ted Hughes, and W. H. Auden. Arts Council support is important largely for the recognition it accords, for the sums

5. *A New Pattern of Patronage: The Thirteenth Annual Report of the Arts Council of Great Britain, 1957–1958*, p. 60.

9*

given to the Trustees and Guardians are small: £475 in 1966–67 and £609 in 1967–68.

Beginning in 1958 the council has been making token grants to the Cley Women's Institute for the Little Festival of Poetry at Cley-next-the-Sea. Founded in 1952, the Cley Festival operates on a modest scale and appeals necessarily to a small local audience. Poetry is also a chief element in the programs of certain other festivals, such as Aldeburgh, Harrogate, and King's Lynn Festival of the Arts. In its desire to improve present standards of verse-speaking, the Arts Council has engaged in direct sponsorship of readings from time to time in addition to underwriting partially the English Festival of Spoken Poetry and recitals such as those organized by the Apollo Society. In 1954–55 the council arranged for three experimental poetry readings with participants—generally young and inexperienced in public speaking—chosen from lists put forward by the Apollo Society, the Barrow Poets' Committee, the BBC, the Central School of Speech and Drama, and other organizations. A second series of three readings was given in the spring of 1956, and the favorable response led the council to begin a regular series of "New Readings" the following year. These occurred annually, but after a time were discontinued as other opportunities for young readers to acquire experience opened up.

Public poetry readings by some of the nation's most talented men and women were sponsored by the council at its London headquarters. In 1956 two readings met with responsive audiences. First, Sir John Gielgud read excerpts from *The Ages of Man: Shakespeare's Image of Man and Nature*, as arranged by George Rylands. Music on the lute, played by Julian Bream, introduced each of the three segments of the program. Second, a memorial reading was held in October for Walter de la Mare, who had died earlier in the year, with Dame Peggy Ashcroft, Margaret Rutherford, and Christopher Hassall reading selections from his works. In October of the following year Dame Peggy Ashcroft gave another recital. Again, in 1963, the council sponsored special recitals honoring the 400th anniversary of the birth of Christopher Marlowe and the 100th anniversary of the death of John Clare.

Tours outside London were organized initially consisting of a team of two or three readers who gave an anthology of poetry representing different periods and authors. At first the council's regional offices and later the regional associations, whenever possible, arranged the scheduling and routing. In 1953 three poetry tours took place. In the Southwest, C. Day Lewis and Jill Balcon visited five cities, reading to capacity audiences and, to everyone's surprise, producing a small net profit from the tour. In the North, Christopher Hassall and Jill Balcon visited six cities, and a month later, Hassall and Nicolette Bernard visited three more. In many of these cities the reading of poetry was a novelty; for most, press reports indicate an enthusiastic reception. The council was encouraged to continue and expand this phase of its program. In recent years a somewhat different formula has been worked out. Each tour is mounted by two poets who present their own

poems using whatever method seems most appropriate. Eric White believes that the presentation of two poets' works imparts "an element of contrast in the programmes; and the poets' willingness to talk about their poems often helps the audience to find the right angle in their quest for understanding and appreciation, and to distance the individual poems from each other."[6]

Poetry Library and Manuscript Collection The Arts Council's support program for poetry includes the maintenance of a poetry library. Housed at the National Book League headquarters in London, the library opened on 12 May 1953. Books for the collection are chosen by the poetry panel. Only a relatively few are added each year, since available funds have been less than £500 annually up until 1965–66. Originally, the scope of the collection was restricted to verse published in Great Britain and the United States during the past quarter century; later, some contemporary verse drama was added. As a result of increased budgetary allocations in 1967, the library now seeks to acquire poetry published in English, also during the past quarter century, of some of the Commonwealth countries, particularly Canada, Australia, and New Zealand.

For a long time the poetry panel had worried about the fate of working papers and poetry manuscripts once they were no longer needed for printing and publishing, feeling that rejected words, scratched lines, discarded ideas—evidences of shaping and reshaping—in the worksheets, notebooks, and corrected scripts might reveal some insight into the creative process. Much of this material was thoughtlessly and totally destroyed; much of it went to America, where it was incorporated into specialized manuscript collections being built up in the main educational institutions. Since 1936 the University of Buffalo, for example, has amassed a collection of worksheets and notebooks of thousands of British and American poets with particularly rich materials relating to W. H. Auden, Robert Graves, and Dylan Thomas. Other American universities such as Indiana and Texas have become active in this field. British researchers were understandably reluctant to cross the Atlantic every time they wished to study in depth the working methods of certain British poets. Money for purchasing this kind of material was limited, and there existed no organization specifically responsible for their acquisition; nor did the Export Licensing regulations afford needed protection since they did not apply to manuscripts less than a hundred years old. More important, English scholars and librarians were curiously indifferent to the manuscripts of living writers and generally did little to preserve vital records. The council acted to remedy this situation. After setting up a National Manuscript Collection of Contemporary Poets, it found the British Museum prepared to collaborate in sponsoring such a collection. In

6. White, "Public Support for Poetry," p. 57.

the summer of 1963 the Pilgrim Trust offered a grant of £2,000 to launch the scheme.

Following the advice of the poetry panel, headed by C. Day Lewis, the Arts Council created a poetry manuscript committee (including representatives of the British Museum) to operate the program. Working in close cooperation with the British Museum's Department of Manuscripts, the committee acquires material from a poet or his executors, if possible as gifts to the nation's collection. Initially deposited in the British Museum on a loan basis, the materials are separately listed and indexed by the department of manuscripts. When manuscript items are purchased and finally transferred to the museum, the museum trustees reimburse the committee's fund for the purchase price so that the original fund is replenished for additional purchases. It is hoped that in time, poets will consider it an honor to be invited to deposit their working papers in the National Collection. Still, some poets do resist the efforts to preserve their manuscript materials. When, for example, John Masefield was asked to contribute to the collection, he candidly replied, "I have been thinking over the scheme you mention, and cannot help shrinking from letting untidy and unfinished papers pass into a national collection. A good many years ago, Mr. W. B. Yeats quoted some verses to me, partially on this subject.

> Accurst, who brings to light of day
> The writings I have cast away.
> But blest be he who shows them not
> And lets the kind worm take the lot.[7]

From 1766, when the British Museum acquired the autographed manuscripts of Pope's *Iliad* and Swift's *Journal to Stella*, to 1962, when the manuscript of Virginia Woolf's *Mrs. Dalloway* came into its possession, the museum has procured documents formerly belonging to most of the outstanding British writers of the nineteenth century as well as to some of the early twentieth century. However, its procedures for the acquisition of manuscripts have lacked continuity and organization and leaned too heavily upon the generosity of donors. The manuscript committee has attempted to bridge the gaps with materials of earlier twentieth-century poets, but often these materials are no longer available. Consequently, the living writer has been accorded a special emphasis, a rather risky policy when it is impossible to be certain which of the living poets, particularly the younger ones, will be remembered in fifty or a hundred years' time. The committee has been as thorough as its limited funds would allow. Nearly sixty poets have thus far been approached for representative specimens of their manuscript materials. In 1967, an exhibition of poetry manuscripts entitled "Poetry in the Making," staged by the Arts Council and the British Museum,

7. Reproduced in *State of Play: The Nineteenth Annual Report of the Arts Council of Great Britain, 1963–1964*, p. 46.

afforded the British public their first glimpse of some of the more interesting items in the collection. Philip Larkin said of the collection:

> Looking at it . . . one is struck first by its casualness, its fugitiveness, even. Clearly writing a poem today doesn't call for a golden pen or a tablet whiter than a star: the poet uses a nine-penny ballpoint and the first paper that comes to hand—a sheet of typing paper (blank, not bond), or else ruled pages from a cheap exercise book. Sometimes he cannot manage even this: Ted Hughes slits open a large brown envelope and writes on the blank inner side, Edmund Blunden uses the back of an illustration from Sotheby's catalogue. Others reach for paper showing where they are—Keith Douglas at the Middle East RAC Base Depot, or Edwin Muir at Battle Abbey College. Now and then we find the luxury of a notebook. Andrew Young has one. . . . Auden's is labelled "Simon Stationery, 890—3rd Avenue NYC." Is there a distinction here, between the notebook men and the loose-sheeters? Oppositions recur: the sprawlers and the crabbed, when it comes to handwriting; even the legible and the illegible. . . .
>
> Such physical details—William Plomer's different-coloured inks; John Betjeman's sheet which arrived crumpled as if rescued from the waste-paper basket that morning—fascinating today, will be still more so in a century or so's time, but the significance of poetry manuscripts in general is far from being confined to *minutiae*. For the scholar, concerned with finding out as much about an author and his work as possible, this is primary source material: this is what he wrote, how he wrote it, what he corrected, what he left. A manuscript will show how much trouble he took, how many drafts were necessary; a cancellation may clarify the meaning, for a writer will often put down the "prose" word while groping for the "poetic" one, or a cancelled expression may throw more light on what was in his mind.[8]

Assistance to Individual Writers Looking back on the policy it had evolved during the preceding twelve years, the Arts Council in 1960 commented that it had tried through both the spoken and the printed word "to encourage contact, communication and understanding between the poet and his audience." However, because of the small sums allocated to poetry—during the previous three years they had averaged about £2,000—the council was frustrated in achieving its goals. The crucial question was: How much did this expenditure actually benefit the poets themselves? The council knew there could be no precise answer, but it estimated that through direct and indirect payments the poets profited to the extent of slightly less than £500 per year, principally through royalties on Poetry Book Society selections, prizes, copyright fees accruing from oral readings, and payments for recitals. Arts Council policy had not yet embraced the provision of direct assistance.

The council's programs had concentrated on promoting an appreciation of poetry within the society and thus had indirectly aided its authors in a minor way. A few prizes were the only form of award that had directly augmented writers' incomes. In 1953 the council inaugurated a series of triennial prizes for published poetry, providing recognition for two cate-

8. Jenny Lewis, *Catalogue of an Exhibition of Poetry Manuscripts in the British Museum, April–June, 1967* (London: Turret Books for the Arts Council of Great Britain and the British Museum, 1967), pp. 14–15.

gories of works. First awards, designed to assist all poets, the firmly established as well as those in intermediate stages of their careers, are given for the best book of English poetry published during the three-year period. Amounting to £250 in 1965, recipients of this award have been:

1953	*The Year One*	Kathleen Raine
1956	*Song at the Year's Turning*	R. S. Thomas
1959	*Brutus's Orchard*	Roy Fuller
1962	*More Poems 1961*	Robert Graves
1965	*The Whitsun Weddings*	Philip Larkin

Designed to encourage and support writers who have only recently turned to poetry, the second type of prize goes for the best first or second book of original English verse published during each triennial period. Under this competition six books have been honored (two in 1956), the cash awards being somewhat smaller than those in the first category. For the 1962–65 period £175 was awarded to David Wevill for *Birth of a Shark*; in addition, *Flight to Africa* by Austin Clarke, and *Selected Poems* by A. D. Hope were singled out for special commendation and awards of £100 each. Annual literature prize awards have replaced the triennial prizes.

The poets' interest in the public performance of copyright poetry has been a point of concern to the Arts Council. Generally, poets were not being compensated when the fruits of their labor were read in public. This was in sharp contrast to musicians who were compensated for works played before public audiences; the Performing Right Society had assessed, collected, and distributed their fees for many years. Since this society had no counterpart to act for poets, publishers frequently assumed the role of poets' agents and collected the fees for the public performance of their poetry. Further complicating the deficiency was a negligence on the part of most publishers in making clear that no portion of the copyright poetry brought out under their imprint could be read in public without express permission and payment of a fee to the copyright holder, usually the poet. Promoters of poetry readings, particularly clubs and societies, often failed to realize that the provisions of the Copyright Act applied to their regular programs where attendance was restricted usually to members and an occasional guest or two. But legally these provisions did hold.

Responding to a recommendation by its poetry panel, the Arts Council convened in 1964 a special conference to insure adequate compensation for poets. Only a few pages long, the report of the conference summarized the rights accruing to poets under existing legislation and made recommendations to the council. Section 2 of the Copyright Act, 1956, pertains to copyright in literary, dramatic, and musical works. The provisions relating to poetry maintain that copyright exists in every original poem which is unpublished and in original poems which are published, provided first publication took place in the United Kingdom or in other countries adhering to the law, such copyright remaining in effect for fifty years after the author's death. Although Parliament has not defined "performing the work in

public" so far as poetry is concerned, the conference concluded that in addition to readings and recitals in theaters and halls, advertised as open to the public, "all meetings of literary and poetry clubs to hear poetry read aloud normally come under the category of 'public performances,' even if the audience on these occasions is confined to club members."[9] Thus, it is necessary in each instance for the group to obtain permission from the poet or his agent prior to any performance, and the copyright holder possesses the power to withhold consent, if he so desires. The 1956 act also provides that where copyright poetry is read in a school classroom by a teacher or pupil and where the audience is limited to students, teachers, and others directly connected with the school's activities, the performance is not to be considered "public."

Varying with the size of the hall and the length of the poem and subject to review every three years, a schedule of fees for poets was recommended by the report.[10] To facilitate the collection of fees, it was urged that, whenever possible, copyright owners should grant a blanket license to approved organizations which are actively engaged in presenting professionally spoken poetry in public places. The more important bodies of this type are the Apollo Society, the Arts Council, Barrow Poets, the Company of Nine, the Poetry Book Society, and the Stratford-upon-Avon Poetry Festival. These license holders could then perform copyright poems without obtaining prior permission, provided the poems were read complete and uncut, due acknowledgment made, fees paid, and a report rendered the owner at six-month intervals, listing the poems used and accompanied by proper payment. And, finally, the conference suggested that the Publishers' Association inform their members of the advantages of printing in each book of copyright poetry a statement about the existing copyright restrictions and the persons to whom those wishing to arrange a public performance should apply for information. The Arts Council approved the report, which also received favorable consideration by the Publishers' Association and the Society of Authors. Its recommendations have been put into effect.

Aware that income from book royalties, performing fees, or prize money was not sufficient to meet the needs of Britain's poets or to make them feel that society valued their productions, the Arts Council in 1964 initiated a small program of £750 (or lower) poetry bursaries designed to enable poets for short periods to devote all of their time to creative writing. In the fall of 1964, when representatives of the Publishers' Association met with the

9. Report of the Copyright Conference, reproduced in *State of Play*, p. 101.

10. At public performances to which the audience pays admission, held in halls with a seating capacity of 250 or less, the fees would range from 10s. for a poem of 30 lines or less to 15s. for one of 50 to 100 lines, with 7s. 6d. added for every extra 50 lines. Fees for performances in halls seating over 250 persons would be slightly higher. When recitals are given by a club or society in rooms seating 50 or less, to which no admission is charged but the members' attendance is covered to some degree by regular subscriptions, 5s. would be paid for poems 50 lines or less and 7s. 6d. for longer works. Charges for performances in rooms holding more than 50 would be 7s. 6d. and 10s. respectively.

poetry panel to discuss matters of common concern, the suggestion was made that the Arts Council extend its activities to the field of literature as well as poetry; some months later, early in 1965, the association specifically proposed bursaries for writers, awards to assist in the publication of approved works of research, and prizes for books. In February 1965, the Labour government's white paper *A Policy for the Arts*, promising greater support for the arts, declared that one of the major elements in its program relating to the arts was the encouragement of the living artist. Money for this purpose would be increased. As for literature, proposals had been made to the government to assist "young authors of special promise before they have been able to establish themselves, of authors in mid-career who are prevented by lack of funds from undertaking prolonged research required for some work of particular academic value, and of older authors who are suffering hardship."[11] The question of sources of funds needed to finance new programs was considered, and three possibilities were mentioned. Gifts on a modest scale from private individuals, corporations, and foundations had been helpful in the past. Practices in Europe, particularly in Sweden, where the necessary moneys are made available by the government, and in France, where they are derived from a number of sources including a small levy on the turnover of publishing firms, might prove worthy of examination. Lastly, through amendment, the government could extend the period during which royalties are payable after the author's death beyond the present fifty years, the additional money to be placed in a special fund administered by a statutory body for the benefit of living authors.

In January 1966, the Arts Council abolished its poetry panel, replacing it with a new literature panel. Shortly thereafter a literature department was set up to administer all programs in this field, its small staff being headed by Eric White, assistant secretary and director, helped by an assistant director. Writing in the May 1966 issue of *Socialist Commentary*, C. Day Lewis, chairman of the literature panel, discussed the work of the panel and the difficulties confronting its attempts to provide support in the literature field. Its main task is to make available to other kinds of creative writing—the novel, the short story, biography and autobiography, and translation—the kind of help poetry has received from the council for some years.[12] It is far easier to provide support for the other arts than for writing—a one-man undertaking. Other panels generally deal with organizations and groups—theaters, opera and ballet companies, orchestras, music societies, art galleries, etc.—who take the initiative by submitting applications for grants. The literature panel must first map strategy for the best utilization of its resources for literature by the council and, having done this, it must go out and find the writers most deserving of financial assistance.

Poets cannot make a living from their writing, nor can most prose writers. Reporting that a novelist is fortunate if he receives more than £150 to £300

11. Cmnd. 2601, *A Policy for The Arts* (1965), p. 18.
12. C. Day Lewis, "First Aid for Writers," *Socialist Commentary*, May 1966, pp. 23–24.

from each of his first few books, each of which took a year or more to write, and that there are accomplished and experienced writers who after twenty years have incomes which do not exceed £1,000 a year, C. Day Lewis urged the nation to mend this situation. Why should almost all serious writers be forced to take regular full-time jobs to avoid living on the lowest level of subsistence or diverting their energies to literary pot-boiling? He believed there should be a hard core of full-time professional writers who could devote their full energies and skills to practicing their art at the highest level of which they were capable. British society, trade-union oriented and semi-socialist, does not encourage half-time doctors, engineers, managers, foremen, or workmen at the bench or on the assembly line. C. Day Lewis's answer to critics who oppose subsidizing literature on the grounds that, if writers cannot make a living from their profession, they should take up some other kind of work, was simple but impressive.

It is through its literature more than any other feature of its life that an age is remembered and judged: and, more urgent still, writers have the duty to preserve our language, to affirm civilized values, and to enlarge the imagination of their contemporaries— "where there is no vision, the people perishes." It is essential work, and we should give our good writers decent conditions in which to perform it.[13]

At present the council recognizes that British opinion does not favor the subsidization of such an elite, that the government is not willing to make available money sufficient to put such a system into effect. The best that can be done is to assist writers through the bursary system. Between 1964 and 1966 thirteen poetry bursaries were given. The literature panel has now extended the bursary scheme to prose writers, the conditions pertaining to the awards being similar to those stipulated earlier for poets. In December 1966, the council announced that it had awarded the first fifteen bursaries for prose writers (novelists, and short-story writers, some of whom also have written plays and poetry), three in the amount of £1,200 and the remainder of £800 each. The annual bursaries may be supplemented from time to time by emergency grants to writers of merit who need funds to continue projects upon which they are working or to support them until they start a new one.

Panel chairman C. Day Lewis reports that one of the difficult problems in assisting writers is that of timing. For a young writer, the experience of struggle, adversity, and discouragement may be a good test of his integrity and stamina. After he has experienced this testing, council assistance may be most timely.

A middle-aged writer, who has continued to do good work for twenty or thirty years, with inadequate rewards in money or prestige maybe, wakes up one morning and thinks he might as well pack it in: he knows he has good work in him still, but the incentive to get on with it has thinned away. Ideally, it is this writer I should like

13. Ibid., p. 24.

to catch at the critical moment, to show him he is not forgotten, and restore his confidence.[14]

Bursaries are an obvious means of accomplishing this end. The award of a prize to a person in such a situation can have a most beneficial effect on his morale. The literature panel still searches for the proper method of choosing the prize winners; it has been apprehensive that selection by a board of judges may result in a compromise decision not reflective of the highest merit. It appears likely that different kinds of schemes will be tried each year over a period of five years before a settled policy is agreed upon. For 1966–67 four prizes of £1,000 each were awarded, one in each of the categories of poetry, novels, short stories, and biography. By having a distinguished member of the panel in each field designate the book written by any living author which made the greatest impression on him—a work he considers to have permanent value—the disadvantages of compromise are avoided and a way opened up to encourage older writers. The prize competition in 1967–68 gave recognition to the best first or second books written by an author during the past two or three years. Prizes are also awarded by the Scottish and Welsh Arts Councils.

The council is exploring the possibility of a program under which publishers can be assisted in the publication of books, including translations, which are of substantial merit but not feasible commercially. In 1966 it inaugurated a limited scheme, agreed to by the Publishers' Association, to make available maintenance grants for writers recommended by publishers; the award is related to the publication of a particular book or books for which the publisher has contracted to pay the author a fixed advance on royalties. The first award was in the amount of £800. Another subsidy plan under consideration would provide a basic annual income for a period of one to three years to an author while he is writing a book. Funds to underwrite this program could derive from two sources: from the Arts Council as a grant and from the publisher as an advance on royalties.

As suggested in the white paper, the literature panel has looked into authors' rights and has worked out in detail a new Public Lending Rights Scheme. A subcommittee was constituted to consider the difficult problem of the adequacy of payments to writers for the use of their books in public libraries, and in April 1966 a conference was held attended by representatives of the various interests involved. Writers and publishers deem it extremely unfair that, when a single copy of a book is taken from a library a hundred or more times, the author is paid royalty on a single copy only. Free public libraries command such loyalty among the British people that neither political party would dare to propose levying a charge on borrowers. Contained in a report approved by the Arts Council, the subcommittee's findings recommended a plan somewhat similar to that which functions in Sweden and Denmark, which insures that writers get a more equitable return for the

14. Ibid.

pleasure they give their readers. Financed by an allocation from the Exchequer amounting to between £1,000,000 and £1,250,000 per year, a special organization would be set up to make payments to authors. The basis of payments would be determined by the size of book stock through a survey indicating the number of books on library shelves available for use by the public. This seemed a more equitable arrangement than to compensate authors on the basis of the circulation of their books, even though it would favor authors of more serious works likely to be borrowed from libraries over authors of very popular books purchased in large numbers rather than borrowed from libraries. Payments to authors would probably average £200 to £300 per year for serious works and perhaps £750 to £1,000 for widely read books. The author's financial condition was not the dominant consideration in the advocacy of this proposal. The literature panel also plans to take into account the author's income tax position, for their occupation is rewarded in a haphazard and fluctuating fashion, in contrast to occupations producing a regular income. Nor is the British writer's substantial dollar earnings in the United States accorded any export rebate. It is clearly evident that the literature panel conceives of its role not merely as an advisory body in the dispensing of subsidy funds, but also as a watchdog for the welfare of writers and for the enhancement of literature generally.

A word concerning the limited assistance made available from private sources is appropriate here. Funds have been provided from time to time for prizes and commissions by the Guinness Company, and the Whitbread Company has assisted the Society of Barrow Poets in their pub programs. The Pilgrim Trust, as noted earlier, helped to establish the National Manuscript Collection of Contemporary Poets, and private benefactors have supported the "little magazine" or the "little publisher." The late E. C. Gregory gave funds to the University of Leeds to establish a number of fellowships, one of which is always held by a resident poet.

An example of official patronage not previously mentioned is the Gold Medal for Poetry created by George V in 1933, its initial recipients being Laurence Whistler (1934), W. H. Auden (1936), and Michael Thwaites (1940). Suspended for the remainder of the war, the medal has since been awarded to Andrew Young, Arthur Waley, Ralph Hodgson, Ruth Pitter, Edmund Blunden, Siegfried Sassoon, Frances Cornford, John Betjeman, Christopher Fry, William Plomer, R. S. Thomas, Philip Larkin, and Charles Causley. Consideration is restricted to books of verse by British subjects in the English language and to translations exceptionally well done.

Expansion and Future Development The Arts Council's activities in the field of poetry and in the other areas of literature during its first twenty years failed to meet the needs throughout England, Scotland, and Wales. The council's decision to devote the overwhelming proportion of its resources to opera, ballet, theater, and music to the neglect of literature except for the minute allocation to poetry drew severe criticism.

Justification rested on the premise that the nation's opera and ballet companies, theaters, and orchestras were fighting for their very survival. Without doubt the needs of literature were considered less pressing.

Fortunately, with the advent of the Labour government in 1964 and the issuance of the white paper in 1965, aid to literature, as to the other arts, was substantially increased. Literature's share in 1966–67 for England, Scotland, and Wales totaled £55,866, and in 1967–68, £81,216, as contrasted with £5,358 for 1963–64 and £12,048 for 1965–66. However, the relationship of these larger allocations to the council's total resources remained modest. The proportion earmarked for literature in 1966–67 was 1.5 percent and in 1967–68, 1.2 percent: for 1965–66 it was 0.3 percent and 1963–64, 0.2 percent. The newly constituted literature panel under the leadership of C. Day Lewis, and the Arts Council's positive response, skillfully and vigorously articulated and implemented by Lord Goodman, have sparked a much-needed critical evaluation of the current status of literature and the identification of areas where support is needed. Most important, new ways of providing support are being devised. Particularly striking is the assistance given to writers; significant is the desire of the council to explore ways of improving the economic status of writers other than direct subvention. A comparison of Arts Council expenditures for literature in 1967–68 with those of 1963–64, set forth in Table 8, illustrates the change of emphasis which has taken place.

TABLE 8 Arts Council Expenditures for Literature in Great Britain: 1963–64 and 1967–68

	1963–64		1967–68	
Assistance to writers:				
Bursaries	£500 ⎫		£28,250 ⎫	
Translators, publishers, and maintenance grants	... ⎬ 9.3%		12,625 ⎬ 55.9%	
Prizes	...		4,000	
Travel and research grants	... ⎭		500 ⎭	
Grants and guarantees to organizations				
including literature festivals	3,542	66.2%	21,025	25.9%
Subventions to literary magazines	725	13.6%	12,749	15.7%
Direct promotion by the Arts Council:				
Poetry readings and recitals	471 ⎫ 10.9%		355 ⎫ 2.5%	
Poetry Library and miscellaneous expenses	120 ⎭		1,712 ⎭	
Totals	£5,358	100%	£81,216	100%

In the immediate future, the Arts Council does not expect to increase substantially its subsidies to literature. Writers, in the future, will benefit from payments received under the Public Lending Rights Scheme, but this does not mean that the council will be able to lessen its concern for the welfare of the substantial proportion who will continue to need assistance and encouragement. Responsibility for assistance to poetry societies, literary organizations, and other groups, and the mounting of poetry tours, are likely to be shifted, at least in part, from the Arts Council to the regional arts associations as existing ones are strengthened and new associations organized.

12 / THE VISUAL ARTS

'Tis the privilege of art
Thus to play its cheerful part,
Man on Earth to acclimate
and bend the exile to his fate.
—Ralph Waldo Emerson

"O dear Mother outline! of wisdom most sage,
What's the first part of painting?" She said,
 "Patronage,"
"And what is the second, to please engage?"
She frowned like a fury, and said: "Patronage."
"And what is the third?" She put off old age
and smiled like a siren, and said:
 "Patronage."
—William Blake, *On Arts and Artists*

In its report dealing with the subsidy needs of the arts published in 1959, the Gulbenkian Foundation panel headed by Lord Bridges concluded that the "support and enthusiasm which the visual arts command in Britain is less than in other countries, and public taste is much less developed in this than in other spheres."[1] In recent years the national government and, to a lesser degree, the local authorities have intensified their efforts to remedy this deficiency; unfortunately, the larger monetary allocations made in support of the visual arts have been considerably eroded by inflation. Visual arts are aided principally in two ways: first, professional art is displayed in publicly maintained galleries and museums, both national and provincial, and in traveling exhibitions; and, second, assistance is given to living artists, who frequently desperately need monetary support and official recognition and encouragement. The Arts Council activities which relate to the visual arts, developed experimentally by its art department staff in response to specific needs and exhibiting in some instances a remarkable creativity, are examined in this chapter. British art galleries and museums possess great diversity, both in the size and scope of their collections and in the range of activities which they sponsor. Of particular interest are the National Gallery, the Tate, and other art institutions maintained by the central government. Problems facing provincial galleries are examined, and detailed case studies of two galleries are presented—the Walker Art Gallery in Liverpool and the City Art Gallery, Birmingham.

Arts Council Support of the Visual Arts In 1951 the Arts Council observed that of its four departments, Art was most heavily engaged in direct management "for the plain reason that no other body exists, or has ever existed, in this country to disseminate the visual arts on a national scale"—making up each year scores of exhibitions which were sent out on tour to towns and villages throughout Great Britain.[2] This remains true today, although the council has discontinued all other direct provision except to Opera for All. Thus, in 1966–67, of the £143,413 which it expended on art in England, £90,973 were used to underwrite the cost of art exhibitions.

After World War II, works of historic and artistic importance which had been hidden away in places of safety for the duration of the conflict were once again available for public enjoyment. In 1946–47, fifty-four exhibitions of paintings, drawings, sculpture, and graphic art were held throughout Britain. Of particular interest were *Spanish Paintings* and *French Lithographs from 1875 to the Present Day*; modern art was represented by an exhibition of the works of Paul Klee and a collection, *British Painters, 1939–45*. Significant was the opening of the council's own small gallery at 4 Saint James's Square, London, which for a time briefly displayed exhibits prior

1. *Help for the Arts: A Report to the Calouste Gulbenkian Foundation*, p. 45.
2. *The Arts Council of Great Britain, Sixth Annual Report 1950–51*, p. 30.

to their being sent out on tour. And spectacular was the four-month *Open Air Sculpture Exhibition* in Battersea Park in 1948, organized by the LCC with assistance from the Arts Council and viewed by more than 150,000 people.

The council directly managed most of the important special London exhibitions held during the Festival of Britain in 1951: one of Henry Moore and another of Hogarth, shown at the Tate Gallery, two anthologies, *British Painting 1925–50*, temperas by William Blake, and a *60 Paintings for '51* exhibition were particularly well received. For two decades no gallery of adequate size was available to house large visiting exhibitions, with the result that the council was forced to avail itself of the hospitality of the Tate, the National Gallery, or the Victoria and Albert Museum, a solution not completely satisfactory, for the host institutions frequently had to temporarily dismantle portions of their permanent exhibitions. The council in the mid-1950s enlarged exhibition space at its headquarters, but the space problem was not to be finally resolved until the opening of the Hayward Gallery on the South Bank in July 1968.

Data published by the council relating to exhibitions sponsored by it during the period 1946–56 revealed the magnitude of this phase of its total program. Exhibitions put on throughout Britain numbered 512: 87 were held in Scotland, 12 in Wales, and 413 in England. Of those in England, 272 featured original paintings, drawings, and sculpture; 103, prints and applied arts; and 38, reproductions. These exhibitions were shown to the public on 4,425 different occasions. In the year 1955–56 alone, attendance throughout Britain exceeded 750,000.[3]

The council's exhibition program took on an international flavor in 1958 and 1959.[4] Noteworthy was the Council of Europe's great exhibition, *The Romantic Movement*, containing nearly a thousand works contributed by fifteen countries, which opened in July 1959 at the Tate and at the Arts Council Gallery. Arranging it was the largest single operation ever carried out by the art department up until that time.[5] Other exhibitions included *Art Treasures from Japan*, *The New American Painting*, organized jointly by the Arts Council and the Museum of Modern Art in New York City, and collections of the works of *Lovis Corinth* and of *Francis Gruber*, both displayed at the Tate and at centers outside London.

During the early 1960s the council's showings, both in London and in the provinces, continued to be characterized by diversity and artistic excellence. An outstanding exhibition arranged by the art department in 1966–67 was a selection of Rodin bronzes, first displayed in Newcastle and then dispatched

3. *The First Ten Years: The Eleventh Annual Report of the Arts Council of Great Britain 1955–56*, p. 35.

4. *The Struggle for Survival: The Fourteenth Annual Report of the Arts Council of Great Britain 1958–1959*, pp. 23–24.

5. *The Romantic Movement* included outstanding works by Delacroix, David, Gros, Prud'hon, Géricault, Canova, Chassériau, Caspar David Friedrich, Turner, Constable, Goya, and Daumier, and numerous other artists.

to seven regional centers for periods of six weeks each. *The Thames in Art* generated public interest at two festivals, Henley-on-Thames and Cheltenham. Several touring exhibitions consisted of works by young British artists. Of particular interest was *Picasso Sculpture*, displayed at the Tate in the summer of 1967. Over the twelve-month period, 135 exhibitions were staged by the council throughout Britain, separate showings totaling 524 given in 243 different centers.

The casual visitor to a council exhibition, if he gives thought at all to how it was organized, is likely to underestimate seriously the amount of work which goes into its preparation. The initial steps may be taken three or four years before the exhibition opens. Suggestions as to scope and emphasis may come from a diversity of sources and must be analyzed in relation to the council's past and future programs and budget. If an exhibition is accepted provisionally, it will probably be scheduled to open two or three years later. A major exhibition whose works are much in demand by other exhibitions cannot be mounted unless preliminary inquiries reveal that key items will be available when desired. A qualified person is selected to choose the works and write the introduction for the exhibition catalogue. A tentative budget is agreed upon, and a staff organizer is charged with the responsibility for seeing to it, if possible, that expenditures remain within the limits set.[6] The problems of assembling, displaying, and supervising valuable collections involve both patience and promotional flair.

The government in its 1965 white paper declared that one of its major objectives was to encourage the living artist who, all too frequently, experienced great difficulty in the early years of his career and was forced to abandon painting as a profession. A new scheme to implement this recommendation was undertaken by the Arts Council, but monetary allocations have been limited. In 1966–67, only £12,860 were expended for all of Britain.

From the beginning, however, the Arts Council had extended limited assistance to painters and sculptors. By 1951 it had paid some £10,000 in fees to artists who lent works from their own studios for council exhibitions. It also provided direct help by purchasing pictures for its own loan collection, £1,700 being spent on acquisitions in 1950.[7] It then evolved a program for making loans to young sculptors, if they lacked operating capital. For example, £500 might be required to enable a sculptor to pay the cost of casting a life-size figure in bronze; under this scheme, loans could be repaid when the work was sold.[8]

The council is not certain what its role in this area should be in the future. In 1967 it observed that "whether this limited form of patronage should be

6. Principal items contained in the budget are the cost of insurance, transport, installation, organizing, catalogue printing, and advertising, against which must be set estimated income from admission charges, catalogue sales, and booking fees to be paid by galleries outside London.

7. *The Arts Council of Great Britain, Sixth Annual Report 1950–51*, p. 24.

8. *Art in the Red: The Twelfth Annual Report of the Arts Council of Great Britain 1956–1957*, p. 22.

aimed directly at enhancing the status of the professions by signally honoring and rewarding outstanding successful work, or rather at improving the chances of good and promising artists who have not yet achieved outstanding success, is not a question that can be finally decided in categorical terms; it must remain a matter of degree."[9] The council has been criticized for selections it has made, but it is not discouraged by occasional mistakes. It has shied away from boldly helping as many young artists as possible for it believes this would constitute wholesale encouragement of mediocrity.

For the three-year period, 1965–66 through 1967–68, funds were provided for three types of awards in the visual arts—grants for a sabbatical period, purchase awards, and commissions. Painters, sculptors, and print-makers were eligible. Encouragement of artists who have not received the recognition they deserve is the basic objective. Recipients are chosen by a special seven-man selection committee; their names are submitted to the Arts Council for final approval. No artist can make direct application for an award. Candidates are nominated by the committee, by Art Panel members, or by others of acknowledged judgment, and examples of their work are submitted in evidence. Sabbatical grants totaling £4,700 were awarded to seven artists in 1966–67—four painters, two sculptors, and one constructivist. These stipends were designed to free artists employed in teaching or other occupations from financial pressure for periods up to six months so that they could devote their full energies to creative work. Purchase awards were given to artists who had been away from art school for some years and had achieved moderate success, to encourage them to develop their talents further: £4,600 were expended for this purpose in 1966–67; eight of the twelve recipients were painters whose works were acquired at commercial rates. The council responds to requests from public bodies for financial help in commissioning works of art, usually to be placed in universities, public buildings, or on public sites. Funds go to the governmental authority which commissions each work; the artist is paid by it when the work is completed.[10] In addition, Scottish artists were accorded six bursaries, varying from £50 to £700. Truly imaginative is the Welsh Poster Arts Scheme, designed to encourage the display of art despite a lack of adequate art museums. It converts advertising billboards into outdoor public art galleries, commissions being offered for printed designs which are shown on some 300 sites in towns and villages. Display changes are effected regularly.[11]

9. *A New Charter: The Arts Council of Great Britain Twenty-second Annual Report and Accounts Year Ended 31 March 1967*, p. 13.

10. In 1966–67 commissions in England totaled £1,700—the Leicestershire Education Committee received a contribution toward the purchase of sculpture for a grammar school, and the Arts Council itself arranged for three sculptors to produce schemes for the facade of Leeds City Art Gallery. The Scottish Council awarded four commissions of £30 each, and the Welsh Council gave three small United Nations Competition Commissions. During 1967–68 the Arts Council contributed toward the cost of a large sculpture commissioned for the new town center at Thornaby-on-Tees, Durham.

11. Designs are of two sizes, approximately 20 feet by 10 feet and 6 feet by 10 feet.

In October 1967, the council revised its awards scheme. It felt that a useful purpose had been served, but that the needs of individual artists for assistance had changed. Sabbatical awards were discontinued, since almost all of the artists it deemed qualified had been assisted. Purchase awards also were terminated, for it wished to avoid the possible danger of lowering artistic standards. Greater reliance will, in the future, be placed on helping an artist by purchasing his work for the Arts Council's own collection. However, £7,000 were retained in the awards fund for 1968–69 and are to be used in contributing to the commissioning of works for public sites; £2,000 were kept in reserve to meet special cases as they arose.

Shortly after its incorporation in 1946, the Arts Council began to assemble its own collection of contemporary British art, its modest sums spent annually constituting a form of patronage for living artists. By breaking its holdings down into a number of circulating exhibitions, which are shown throughout the country, the council discharges, in part, its responsibility for "increasing the accessibility of the fine arts to the public." In 1967 exhibitions from its collection included: *British Painting Before 1940, British Painting 1940–1949, British Painting 1950–1957, Henry Moore, New Painting 58–61, New Painting 61–64, Pictures for the Proms, New Sculpture 1960–66, Sculpture from the Welsh Collection, 20th Century Drawings,* and *Works from the Scottish Arts Council.*[12]

During 1950–51 the touring of films on art was undertaken experimentally with immediate success and, since then, has occupied an important place in the Art Department's program. A film projection unit travels from October through March with a repertory of some twenty 16mm. films. Art societies sponsor film showings, make the necessary local arrangements, and pay the council modest fees to cover expenses.[13] A number of these films were produced specifically for the Arts Council and financed by it.

Grants and guarantees are made to a substantial number of arts organizations: £35,246 were spent for this purpose in England in 1966–67. The most generous allocation, £14,500, was accorded the Institute of Contemporary Arts in London. Contributions toward the operating expenses of a limited number of art galleries were made, the largest going to the Whitechapel Art Gallery. Other institutions aided included the Arnolfini Gallery of Bristol, Red House Museum and Art Gallery at Christchurch, Lake District Art Gallery in Kendal, Bear Lane Gallery and Museum of Modern Art in Oxford, and Plymouth City Museum and Art Gallery. Perhaps twenty art societies and clubs which mount temporary exhibitions and engage in other

12. Book value (cost of acquisition) as of 1 April 1967, totaled £133,507—this included £14,765 for the Scottish collection and £12,273 for the Welsh collection. Reproductions owned by the council at its three centers were valued at £8,565. Works of art expenditure for 1966–67 totaled £15,386 for the Arts Council, £1,975 for the Scottish Council, and £2,762 for the Welsh Council. Reproduction purchases costs totaled £593.

13. Among films circulated in recent years are *Turner, Epstein, Francis Bacon, Henry Moore, Five British Sculptors Work and Talk, La Promenade Enchantée, Humanism: Victory of the Mind, Drawing with the Figure, Ned Kelly, Three Scottish Painters,* and *L'Homme à la Pipe.*

activities were assisted with small allocations; among these were the Bourne-mouth Arts Club, the Newlyn Society of Artists, the Norfolk Contemporary Art Society, the Penwith Society of Arts, and the Truro and District Art Society. Token amounts went to a small number of arts centers, festival organizations, and bodies representing professional artists.

Direct operation of galleries is contrary to council policy; it does, however, maintain a small art gallery in Cambridge which features changing exhibi-tions throught the year, some of which are organized by its local staff. When the Hayward Gallery on the South Bank in London opened, the Arts Council assumed responsibility for its management, and the council uses its facilities for its own exhibitions. Special exhibitions now sponsored by the council at the Tate Gallery will, in the main, be shifted to the new Hayward Gallery.

The council's "Housing the Arts" program, during its first three years of operation, has channeled a smaller proportion of its funds to the art department than to music and drama. Contributions are made to defray capital costs of exhibition facilities and lecture rooms erected by arts centers, and toward the construction of new facilities in existing art galleries to house temporary exhibitions or provide lecture rooms.[14] In each case, the council insists that some support be forthcoming from local authorities.

The art department has used the additional funds placed at its disposal in 1967–68 primarily to expand programs already under way rather than to develop new ones. This policy is likely to be adhered to in the future. Pro-viding assistance to living artists undoubtedly will continue to be one of its most difficult tasks. Amounts given to individual artists under the commis-sion scheme need to be increased. Purchasing art works, or commissioning them, is preferable to awarding bursaries, for the first two methods command respect within the profession and do not connote a "student status" as do bursaries. Commissions enjoy two advantages: they stimulate local authority participation, both increasing public interest and adding to the "pool" of funds available for this purpose; and, by placing the art produced in public locations, they enable a large number of persons to enjoy it. The sabbatical scheme has been quite effective and could be changed to permit a second award in this category to an individual, thus providing additional incentives. The council maintains a small fund, £3,000 in 1968–69, which is used to help local authorities and other bodies provide studio working space for artists. The art department has been consulted by the Post Office concerning a plan to borrow pictures by living artists and display them in its post offices throughout the country. This scheme is highly desirable and could also be adopted by the Ministry of Public Building and Works for the buildings it

14. Galleries aided in 1965–66, 1966–67, and 1967–68 include: Art Gallery, Malvern; Dorset County Museum Gallery, Dorchester; Towner Art Gallery, Eastbourne; Carlton House Terrace, London; City Art Gallery, Bradford; Art Gallery, Hove; Rye Art Gallery; Art Galleries, Tewkesbury; Shipley Art Gallery, Gateshead; Public Art Gallery, Royal Leamington Spa; and Whitworth Art Gallery, Manchester.

maintains at home and overseas.[15] Magazines concentrating on the visual arts are frequently faced with insolvency, for they are expensive to produce and their circulation is small. Council aid could help to insure their survival, but thus far a systematic program has not been evolved.[16] Although a small grant is made to the Artists Placement Group in London, which fosters placement of artists in industry, greater attention could be given by the council to assisting artists in securing remunerative employment. The department would like to do more to aid regional galleries in mounting their own temporary exhibitions; funds available locally for this purpose are limited, and provincial galleries have difficulty in persuading owners of good pictures to consent to loans, particularly from abroad. The need for additional funds to expand the "Housing the Arts" program is particularly pressing, since exhibition facilities in many provincial cities and towns are strikingly inadequate.

The National Gallery Visitors to the National Gallery would be amazed to learn of the difficulties that were encountered in establishing the gallery and of the haphazard methods that characterized its development.

The National Gallery's formation was curiously casual. Sir George Beaumont, in 1823, offered his valuable picture collection to the nation if the government would provide suitable accommodation. The Reverend W. Holwell Carr also announced that he would give his collection to the government. Earlier, suggestions had been made by Sir Joshua Reynolds and others that Britain establish a gallery, but opposition had been outspoken and Parliament did nothing. Constable bitterly opposed the idea.

Should there be a National Gallery . . . there will be an end of the art in poor old England, and she will become, in all that relates to painting, as much a nonentity as every other country that has one. The reason is plain: the manufacturers of pictures are then made the criterion of perfection, instead of nature.[17]

In 1823, the famous Angerstein collection was about to be lost, having been offered to the Prince of Orange for £70,000. In spite of financial difficulties stemming from a long and exhausting war, the House of Commons voted £60,000 for the purchase and exhibition of the Angerstein collection. On 10 May 1824, the infant National Gallery opened in a house on Pall Mall, maintenance costs immediately becoming a responsibility of the Treasury.

The government in 1826 wisely purchased for £9,000 three notable

15. The ministry has for some years expended considerable moneys to purchase works of art to be displayed in the buildings for which it is responsible.

16. In 1966–67, £100 to *Form Magazine* was the only grant authorized in this category. Since then the Arts Council awarded grants to two additional art magazines, *Studio International* and *Control*.

17. Reproduced in Anthony Blunt and Margaret Whinney, eds., *The Nation's Pictures* (London: Chatto and Windus, 1950), p. 29. Information contained in this chapter relating to the history of the galleries maintained by the national government is based in part on data presented in this volume.

paintings, one of which was Titian's *Bacchus and Ariadne*. The Beaumont collection was transferred to the gallery, and numerous gifts from private donors gradually enriched the collection. Beginning in 1828, the trustees complained that gallery premises were inadequate; the government failed to respond, and until the turn of the century the trustees were involved in a continuous battle to induce Parliament to provide facilities for the growing collection. The Treasury, in 1834, purchased two important works by Correggio for what was then considered an enormous sum, £11,500, but turned a deaf ear to pleas for money to acquire the Lawrence collection of drawings. In this period in the gallery's development, exhibition space became almost totally deficient; public controversy raged over the cleaning of pictures; and gallery policy concerning picture acquisitions was haphazard— a number of opportunities to make the collection truly representative were lost. On the positive side, the gallery's administrative arrangements were improved, and numerous private bequests were received, including one from the painter J. M. W. Turner, consisting of 283 oil paintings and some 19,049 drawings and sketches. Exchequer funds financed a number of significant purchases, including the Kruger collection of early German pictures.

The appointment of Sir Charles Eastlake as director in 1855 ushered in one of the great periods in the history of the gallery. Under his leadership, energetic efforts were made to expand the collection. By gift and by purchase the nation acquired important works by Titian, Botticelli, Veronese, Bellini, Filippino Lippi, and many others. In 1857–58, the Lombardi-Bali collection of 221 early Italian paintings was purchased for £7,035. Beginning in 1860, Eastlake bought numerous examples of early Flemish work.

The National Gallery Loan Act of 1883 was significant, for it permitted the Trustees to lend works acquired by gift or bequest, thus releasing large numbers of less important pictures to provincial galleries. In 1885 two pictures were purchased—Raphael's *Ansidei Madonna* and Van Dyck's *Charles I* —for £87,500, a sum so large that the government abolished the annual grant-in-aid of £10,000 for the next two years. By 1895 the great era had ended when masterpieces could be acquired with relative frequency. Germany emerged as a strong competitor on the Continent, and American buyers were beginning to bid for pictures. The export of masterpieces overseas was not subject to control, and the loss of important pictures generated public anxiety over the probable fate of many famous works then in private collections. In 1905 the nation was shocked to learn that the "Rokeby" *Venus* by Velazquez was up for sale and likely to leave the country. Fortunately, aid was forthcoming from the National Art-Collections Fund, which had been established in 1903 to raise money to save important works of art for the nation, and the picture was purchased for the National Gallery. Holbein's *Christina Duchess of Milan* was saved at the eleventh hour by private donations and special government grants, but the Bowood *Mill* by Rembrandt, £95,000, went to the United States.

The gallery, thus far, had not often been forced to cope with physical violence, but in March 1914, the "Rokeby" *Venus* was attacked by suffragettes, and two months later these intrepid ladies inflicted serious damage on five Bellinis, with the result that the gallery was closed temporarily. During the 1920s and 1930s, outstanding works were acquired, some by means of special Treasury grants-in-aid and contributions from the National Art-Collections Fund, and others as a result of bequests and gifts. With the advent of World War II, the gallery evacuated its entire collection to Wales for safe storage in a slate quarry. By the end of 1945 the collection was returned to London; in the years that followed the considerable war damage to the building was repaired: most important, steps were taken to install air conditioning to protect the gallery's priceless treasures from soot and grime and fog.

In 1955 the Trustees published a special report covering the gallery's operations from 1938 to 1954, highlighting certain of its activities and forcefully presenting a concise statement of its needs—especially the inadequacy of purchase funds. From 1947 through 1953 the Treasury grant for acquisitions was £7,000 per year; in 1954–55 it stood at £10,500. Income from trust funds was of the same order of magnitude. Urgently required were Exchequer moneys to permit the purchase of pictures which would otherwise be exported. Artistic wealth in private hands was being forced on the market by the pressure of taxation; if public bodies could not buy at least the more outstanding works, this part of the nation's capital would become seriously impoverished. During the war the government controlled the export of works of art. By 1944 it adopted the policy of not granting an export license for any picture or portrait if the National Gallery or the National Portrait Gallery opposed it, and in 1949 a reviewing committee was formed to hear appeals. In 1952 a standing Reviewing Committee on the Export of Works of Art was constituted to advise the Chancellor, an arrangement which exists today. The owner who wishes to export is well protected, for the issuance of his license can only be delayed a few months while any museum wishing to acquire the work of art attempts to raise the money. The committee can recommend a purchase grant to the Chancellor, but the number of pictures thus acquired by all galleries has been limited.[18] The trustees, while recognizing that the new arrangement was more equitable to the owner, asserted that unless galleries possessed funds to permit them to make offers, the result would be an increase in the export of treasures.[19] The fact

18. *The National Gallery, 1938–1954* (London: The Trustees), 1955, pp. 9–11.

19. During the twelve-month period ending 30 June 1966, the Board of Trade received 3,082 applications for individual export licenses, of which 251 were for manuscripts, documents, and archives. Only eleven cases were referred to the reviewing committee because the appropriate expert adviser recommended that a license to export the object concerned should be refused. The committee recommended that a license be withheld in five of these cases; three objects were acquired by museums, the other two being retained in Britain by their owners. Cmnd. 3130, *Export of Works of Art 1965–66: Thirteenth Report of the Reviewing Committee Appointed by the Chancellor of the Exchequer in December, 1952*, HMSO, 1966, pp. 5–13.

that no work is subject to control if it has been in Britain less than fifty years and is less than a hundred years old precludes export restraint for much significant art. Thus, certain French Impressionist pictures are not subject to export regulations.

The acquisition of masterpieces which would otherwise be exported was not the crucial problem, for important gaps in the collection could only be filled from abroad or from British collections not subject to export license. This was true of many schools and many painters, particularly productions of more recent times. Thus, it was no longer easy to acquire good examples of French paintings of the nineteenth century, and yet Britain's national galleries possessed inadequate holdings. The £20,000 income available to the National Gallery for purchases in 1955 placed it in an impossible situation: private collections in the country contained perhaps ten pictures whose average price was not much below £250,000 and another hundred whose average price would be in the neighborhood of £50,000. Special Treasury allocations made in a crisis left much to be desired. Obviously, what was needed was an appropriation sufficiently large to permit the gallery to pursue an orderly program of acquisition, but the trustees, taking into account the existing political climate, urged that a £80,000 per annum grant be sanctioned by the government; this sum, while not adequate, would enable them to compete more effectively for more highly priced masterpieces.[20]

The government turned a deaf ear to the gallery's plea for a substantial increase in its purchase grant, raising it to only £12,500 for 1955–56. A genuinely encouraging breakthrough occurred in 1959, when the grant was increased to £100,000. The regular purchase allocation rose to £125,000 in 1960–61 and was fixed at £200,000 annually for each of five years beginning 1964–65, thus permitting a degree of long-range planning. An important change in the law relating to the settlement of estates was introduced in the Finance Act of 1956, which made it possible for art works to be accepted by the Inland Revenue authorities in discharge of death duties: the objects were removed from the owners' homes and transferred to national galleries and museums. Since that time various important pictures have been added to the gallery's collection by this means. Continued efforts to secure land to permit the National Gallery to enlarge its building resulted in the purchase in 1958 of the Hampton site adjacent to its western boundary. Special Exchequer grants, though few in number, have permitted the acquisition of important paintings: in 1960, £75,000, in conjunction with gifts from the Pilgrim Trust, the National Art-Collections Fund, and other sources, saved from export the *Portrait of Mr. and Mrs. Andrews* by Gainsborough; £163,500, made available the following year, underwrote the purchase from France of two life-size *Danseuses* by Renoir; and £40,000, together with funds from the Wolfson Foundation, financed the acquisition of Goya's *Duke of Wellington*. Shortly after being placed on exhibition, the Goya

20. *The National Gallery, 1938–1954*, pp. 10–13.

painting was "kidnapped" and £140,000 was demanded for its return. Though the painting was later discovered and the author of the ransom notes convicted for theft of the frame, the incident raised serious doubts about gallery security.

The National Gallery, whose collection numbers slightly more than 2,000 pictures, is administered under the general aegis of a board of trustees, eleven in number, who are named by the Prime Minister.[21] The trustees' powers are not narrowly defined by statute: they approve purchases, gifts, and bequests of pictures to be added to the collection; sanction cleaning of pictures, with minor exceptions; authorize the loan of pictures; approve plans for substantial alterations of the building and its facilities, together with major operating arrangements; and examine and approve new building plans. Designation of the gallery's director is by the Prime Minister. Appointments and promotions of senior staff are made sometimes by the board, sometimes by the director; at other times they are made on the recommendation of a selection board set up by the Civil Service Commission. The gallery staff, numbering 176, while not technically civil servants, are employed under procedures similar to those used by the civil service and enjoy comparable working conditions.[22] The chief executive officer, with a large staff complement, is responsible for routine administration and common services; other units include the scientific department, and the conservation department, and the publications department.

Major exhibitions are held only infrequently at the National Gallery, for wall space is limited and they necessitate temporary storage of significant portions of the permanent collection. The gallery, however, since 1963, has utilized its board room for a series of small exhibitions.

Pictures not on display in the exhibition galleries can be seen in the Reserve Collection Rooms (crowded more closely together), excepting those on loan. In 1967 approximately 140 pictures were on loan to provincial galleries under an Arts Council scheme, the length of time away from Trafalgar Square varying from two to five years and subject to extension. Considerable numbers of paintings are also loaned to other national museums and galleries and to the Ministry of Public Building and Works for display in public buildings.

Acquisitions depend largely upon the availability of adequate funds. Inflation in art prices has offset, in part, the effectiveness of the larger public subventions recently provided, and future acquisitions from the steadily

21. Trustee terms are seven years, occupants not being eligible for immediate reappointment.
22. The collection is organized into four separate departments: Earlier Italian and Netherlandish; Flemish, Dutch, and Spanish; Italian 1500–1600 and French Nineteenth Century; and Italian from 1600, French to 1800, German, and British. In addition to the director and the keeper, gallery personnel includes at present one deputy keeper, three assistant keepers, ten restorers, five persons in the scientific class, four in the executive class, four in clerical, five craftsmen, and more than a hundred warder-attendants. Persons working in the publications department are excluded from the total of 176, for they are technically employed in a self-financed department.

10

dwindling stock of masterpieces in private hands will require increasingly larger sums. When Britain's financial position eases, it is hoped that governments will effect still further increases in the annual purchase grant as well as sanction more readily special grants for special acquisitions. Much larger sums of money could be forthcoming from the private sector if changes were made in the tax laws, particularly as they relate to estate duty and income tax and surtax.

Estate duty changes could be made easily through the extension of a principle already in use. Under present law, if a testator bequeaths a painting or a sculpture to a national museum, the value of this object is not aggregated with the rest of the estate for taxation purposes. But if he leaves money to a gallery, the amount is aggregated and duty is paid, placing a heavy burden on the heirs. Exclusion of cash bequests appears indefensible and could be remedied without difficulty by enumerating in a statute the names of museums and institutions for which it would be waived. The lack of incentive for British citizens to make gifts to galleries and other institutions during their lifetime is even more striking. In the United States one can give cash or property to galleries and other nonprofit institutions to a maximum of 20 percent of total income, this amount being deductible before computation of income tax due. Thus far, Parliament has not assisted museums in this way. A patron may covenant to give a sum of money each year for seven years, but he is accorded no surtax relief in respect of these payments; if he desires to make a lump-sum payment of money or give a work of art, he receives no reduction of any kind in his tax obligations. In 1955 the Royal Commission on Taxation of Profits opposed the granting of such exemptions; the Standing Commission on Museums and Galleries has recommended their adoption. Thus far, no government has effected the desired changes. The chief argument against granting such exemptions is that they constitute an indirect subsidy to museums which could be more consistently and effectively provided by parliamentary vote rather than by relying upon the caprice of private benefactors. But even well-disposed governments find it politically difficult in an era of high taxation to provide sufficiently large direct subventions to take the place of what has been destroyed—private benefaction on a significant scale. The National Gallery trustees view refusal to take the necessary steps to increase private support as doctrinaire folly. It is difficult to dissent from their assertion that if decisive action is not taken soon it will be too late—"The stock of pictures worthy and desirable for inclusion in the National Gallery is constantly diminishing while the appetite of both public and private collectors in America and on the Continent steadily grows, whetted by the successes they have already achieved at our expense."[23]

Tightening laws governing export of works of art would greatly benefit both the National Gallery and other museums, national and provincial.

23. *The National Gallery, January 1965–December 1966* (The Trustees, 1967), p. 10.

Today, works valued at less than £2,000 are excluded from export control, yet many of them (except for painting) would enrich the collections of the smaller galleries. Methods of evaluation should be rationalized and value should be established by a panel of experts at the time an export license is requested. Proof that present methods are grossly inadequate is illustrated by the sale in 1966 of one of the most famous pictures in the United Kingdom —Rubens' *Daniel in the Lions' Den*—to the National Gallery, Washington, D.C., for $480,000 after it was exported at a valuation of £500 with no license required. The Board of Trade ruled that no more than £500 had been paid for the picture and that this was the valuation which excluded it from export control.[24] The establishment of a moderately large nationwide purchase fund, as repeatedly requested by the reviewing committee, would enable some of their recommendations against export to become effective.[25] Thus far, no government has responded. The present three-month delay in granting a license is not long enough to permit the raising of the necessary purchase funds and should be substantially lengthened.

The National Gallery's plans for an addition to the building have been delayed, and the current economic crisis may result in further postponement. The Hampton site, purchased in 1958 to permit westward extension of the gallery, was subsequently exchanged with the Portrait Gallery so that the extension of the National Gallery building could be northward and then eastward, covering the area now occupied in large part by the National Portrait Gallery. A new National Portrait Gallery building would be erected on the Hampton site after demolition of its present structure. Thus far, a full-scale model of one of the new rooms in the proposed extension has been constructed to permit a thorough testing of improved lighting techniques and other changes. A good many improvements have been effected in the present building, but Exchequer funds have not yet been provided to air-condition the east wing.

The Tate Gallery The Tate Gallery contains the national collection of British painting, of modern foreign painting, and of modern sculpture. The need for creating a permanent collection of modern art, to constitute a record and to provide encouragement for living artists, was not widely recognized in the Victorian era. Sir Francis Chantrey, a well-known sculptor who died in 1841, by leaving the nation a large sum of money for the purchase of British painting and sculpture (no part of the bequest could be spent on housing the collection) in effect challenged the

24. Ibid., p. 32.

25. The automatic replenishment of such a fund as suggested would, of course, involve a continuous expense over which Parliament has no control; but would this differ appreciably from the present practice of promising the National Gallery a purchase grant of £200,000 for a quinquennium? To meet this objection, a maximum figure could be specified, although to do so would reduce flexibility and perhaps at times limit the number of purchases thus financed.

government of the day to erect a gallery worthy of the British school. Several valuable collections of British art were subsequently given to the nation. Governments, while proclaiming that art was an important aspect of cultural life, were reluctant to spend money on it. James Orrock, a landscape painter, in 1890 was bitingly critical of the National Gallery for its policy toward British art, asserting that its British paintings were mostly second-rate and that the great Turner collection of drawings and watercolors was stored away in the cellars.[26]

Henry Tate at this time offered the nation his collection of sixty-five paintings to be hung in the National Gallery, but, pressed for space and not enthusiastic, the gallery declined the gift. Later, Tate, in a letter to the Chancellor of the Exchequer, published in *The Times*, renewed his offer, insisting that a gallery devoted exclusively to British art be established, independent of the National Gallery and supported by annual grants from the Treasury. The Chancellor's response, cautious and evasive, induced Tate to withdraw his offer. Vigorous public debate raged for months; the proffered pictures were severely criticized, even by the artists Sickert and George Moore. A new Chancellor took office and in 1892 an agreement was reached providing that a separate galley would be erected on the site of Jeremy Bentham's "model" penitentiary at Millbank. The Tate Gallery opened in 1897; subsequently the building and the collections experienced continuing expansion, largely as a result of private munificence and generous support accorded by the Contemporary Art Society and the National Art-Collections fund.

The Tate Gallery initially was placed under the control of the National Gallery, whose trustees and director were responsible for its administration. The scope of the Tate rapidly expanded: it began in 1915 to house the National Collection of British Painting (of all periods) and two years later was designated the National Gallery of Modern Foreign Art. In 1917 a separate board of trustees and a separate director were appointed, although the pictures remained vested in the National Gallery trustees. Except for sculpture, the collections of the two galleries to some extent overlapped and, as time passed, the desirability of the Tate having an independent status became increasingly evident. A government committee, constituted to assess the relationship between the two galleries, in 1946 urged that the Tate be given a completely independent status; as for collection overlap, it recommended that every twenty-five years the National Gallery should exercise an absolute right of removal from the Tate and that outstanding pictures originally acquired by the Tate as modern should be "promoted" at those intervals. An act passed by Parliament in 1954 accorded separate status to the Tate; trustees of either gallery possess the power to lend or transfer works of art to the other, the two boards being directed to consult together about such loans and transfers, bearing in mind the desirability of "securing that

26. Blunt and Whinney, *The Nation's Pictures*, pp. 67–75.

each picture is in that collection where it will be available and on view in the best context."[27]

The Tate's collection is divided into two parts: British paintings up to 1900, together with British sculpture of the later nineteenth century; and modern paintings and sculpture from all schools (circa 1900 to date). The National Gallery, however, possesses a selection of modern British paintings, but if these cease to be hung on its walls, they must be transferred to the Tate. By the year 2000 the crucial question of whether or not non-British pictures painted after 1900 are to be transferred to the National Gallery will arise; the Tate prefers to maintain the existing dividing line, its modern collection beginning with the post-Impressionists.

The ten trustees of the Tate, appointed by the Prime Minister, are responsible for basic policy and administration. Liaison with the National Gallery is assured in part by the practice of naming two persons to membership on both governing bodies. The gallery, with a staff of 160, as authorized April 1968, possesses a relatively simple administrative organization headed by a director, under whom serve two keepers, one responsible for the British collection and the other for the modern collection. A deputy keeper, primarily concerned with administration, supervises the mounting of exhibitions and the making of loans, as well as the overseeing of the work of the senior executive officer, who is charged with accounting and establishment responsibilities, transport, insurance, and security. The keeper of the conservation department and the manager of the publications department also report to the director. Expenditures by the Tate for 1967–68, including salaries and purchase grants, totaled approximately £286,000; additional service costs (maintenance, furniture, fuel, light, taxes, stationery, and printing) amounted to some £107,500.

The gallery's collection in March 1968 consisted of 5,277 numbered items. Of these, approximately 1,200 paintings, watercolors, and drawings and 160 pieces of sculpture were on exhibition; 480 items were on loan; and the remainder were held in the reserve collection. Exhibitions are becoming increasingly popular at home and overseas. Of the 146 items loaned to temporary exhibitions in 1965–66, several were of particular interest: a group of twenty-nine Turners displayed in the Museum of Modern Art, New York; five Bonnards lent to the Royal Academy's exhibition in London; and four works shown at the Venice Biennale. Tate loans to public galleries and buildings, which numbered 545 for the same period, are generally for five years; works are then brought back to the gallery for inspection, and if they are in good condition, they are returned to the borrower for an additional period.[28]

27. National Gallery and Tate Gallery Act, 1954, 2 and 3 Elizabeth, Chapter 65, section 2. In case of disputes, the two boards submit proposals to a committee of arbitration consisting of the two directors and two trustees from each board, with a chairman named by the Treasury. This machinery has not been utilized.

28. Loans to public galleries in Britain included: British Museum, Imperial War Museum, London Museum, National Gallery, National Maritime Museum, National Portrait Gallery,

Special exhibitions at the Tate, perhaps a half dozen annually, have been mounted in recent years. The majority have been organized by outside bodies and have extended over periods from four to eight weeks each. In 1965–66 the gallery's single direct undertaking focused upon the work of Victor Pasmore; the Contemporary Art Society featured an exhibition, *British Sculpture in the '60's*; and the Arts Council sponsored displays of work by Arshile Gorky, Alberto Giacometti, Max Beckmann, and others. In 1967–68 the gallery played a more active role in this area, directly sponsoring four exhibitions. The Arts Council mounted two exhibitions at the Tate—*Picasso Sculpture* and *Cubist Art from Czechoslovakia*. Tate exhibitions attract large crowds; total attendance to the gallery for 1967–68 was 1,010,773. With the opening of the Arts Council's new Hayward Gallery, most Arts Council exhibitions will be displayed there. The Tate will embark on its own program involving about five exhibitions a year, of which one will be of major international significance.

Despite the splendor of its possessions the Tate suffers from numerous deficiencies. Its holdings reflect gaps caused by its rather haphazard growth. The trustees did not possess a purchase income over which they could exercise unrestricted control until 1946, when the government provided a grant of £2,000. Beginning in 1950, the Treasury grant for acquisitions was gradually increased, but by 1959–60 it amounted to only £40,000, inadequate to the gallery's needs. In 1964–65 an annual allocation of £110,000 was approved for each of the five succeeding years, divided into two parts— £60,000 to acquire works either British or foreign, and £50,000 to purchase foreign pictures painted between 1900 and 1950, the latter authorized in an effort to make up for past deficiencies. Special Treasury grants for specific works are small in size and sanctioned infrequently.

The Tate Gallery looks to the future with confidence but is confronted with deficiencies similar in many respects to those facing the National Gallery. Most pressing is the need for substantially larger purchase allocations. Ideally, to permit the gallery to compete effectively in the art markets, the Exchequer needs to make available a basic grant of £200,000 each year, plus a lump sum of perhaps £600,000 covering a five-year period and to be drawn upon whenever high-priced works that are desired become available. The inadequacies of the present gallery building have been painfully evident for more than twenty years, particularly the lack of exhibition space. To meet this need, the present structure will be enlarged, both for the permanent collections and temporary exhibitions, a small lecture theater, new restaurant, additional offices, and work and storage rooms; the total cost is estimated at £1,500,000. Approximately £1,000,000 of this is to be allocated by the Treasury, and the remaining £500,000 must be raised from private sources. It is hoped that the new facilities will be ready for use in 1973 or 1974.

and Victoria and Albert Museum, all in London; National Museum of Wales, National Gallery of Scotland, and Scottish National Gallery of Modern Art. Loans were also made through the Arts Council to twenty-eight public galleries outside London.

Other National Galleries In addition to the National Gallery and the Tate, a number of other art galleries are maintained by the central government. These include the National Portrait Gallery, the Victoria and Albert Museum, the British Museum, the Wallace Collection—all in London—and the National Museum of Wales, the National Gallery of Scotland, Scottish National Portrait Gallery, and the Scottish National Gallery of Modern Art. Sums allocated by the government to implement this form of arts subsidy in 1967–68 are set forth in Table 9.

TABLE 9 Civil Estimate Allocations in Support of Selected National Galleries and Museums, 1967–68

Gallery or Museum	Net Salary and Other Operating Expenses	Purchases Grant-in-Aid	Building Maintenance and Service Costs	Total Expenditures
National Portrait Gallery	£74,000	£8,000	£47,200	£129,200
Victoria and Albert Museum	796,062	178,938[a]	486,000	1,461,000
British Museum	1,965,000	297,000	1,797,000	4,059,000
Wallace Collection	71,000	—	31,300	102,300
National Galleries of Scotland	98,000	45,000	38,000	181,000
Total	£3,004,062	£528,938	£2,399,500	£5,932,500

[a]. Of this sum, £100,000 is placed in a fund administered by the Victoria and Albert Museum, from which grants are made toward the cost of approved acquisitions by local museums and art galleries.

The National Portrait Gallery, founded in 1856, is unique in one important respect—the portraits in oil, supplemented by drawings, busts, medallions, and miniatures, have been placed in the collection because of the fame of the sitter only. Rules governing admission, adopted at the initial meeting of the trustees, have undergone little change: in each instance, the celebrity of the person is to be determined "without any bias to any political or religious party." Nor are serious faults, although recognized by all, deemed sufficient ground for not including portraits that may be valuable in illustrating the nation's history. Portraits of living persons are excluded. The collection possessed no permanent home until 1896, when the present gallery on Trafalgar Square was opened.[29] Items in the collection numbered 4,575 as of mid-1967; the earliest painting from life was one of Henry VII dated 1505. Perhaps a third of the collection can be placed on display, while other holdings are immediately available upon request.

The National Portrait Gallery, like other national art museums, suffers from a deficiency of purchase funds. As late as 1960–61 it received a grant for acquisition amounting to only £4,090. This amount was increased to £8,000 in each of five years beginning 1964–65, a sum not adequate to meet present needs. Additions to the collection in 1964–65 totaled 80, 31 by gift

29. The Portrait Gallery has not placed a heavy burden on the Exchequer, for the building construction costs were met almost entirely from funds received from private benefactors and a major portion of the collection was acquired by gift or bequest.

and bequest, and 49 by purchase; in 1965–66 gifts numbered 17, and purchases, 22.

The Victoria and Albert Museum is one of the world's noted collections of fine and applied arts of all countries, periods, and styles, including oriental art. It was an offshoot of the Museum of Ornamental Art, opened in London in 1852, which five years later was merged with a new museum of science and art assembled at South Kensington. The art and scientific collections expanded rapidly, their scope being successively enlarged until, in 1909, the title *Victoria and Albert* was reserved for the art collections only; the scientific collections became the responsibility of a separate Science Museum. Victoria and Albert collections include: bronzes, costumes, engravings, furniture, jewelry, paintings, sculpture, and many other items, arranged in two distinct, but equally important, groups. The primary collections, numbering more than a dozen, exhibit masterpieces of all the arts, brought together by style, period, and nationality and specially arranged to form unified displays and to follow the development of the visual arts in Europe from Early Christian times onward. Special rooms display Islamic and Oriental art. The eleven departmental collections are arranged on the basis of material or type of objects.

The Victoria and Albert, employing a staff of some 600 persons in 1968, is headed by a director and organized into twelve separate departments, its administrators reporting directly to senior officials in the Department of Education and Science, of which it is a constituent element. Unlike the other national galleries, it possesses no independent board of trustees. Museum personnel are central government employees, although their titles differ from those of civil servants. The department of paintings, created in 1857 as a result of a gift to the nation of 233 oil paintings by British artists, initially was called the National Gallery of British Art, but with the formation of the Tate Gallery, it ceased to collect actively new works in oil. Today its holdings include some 2,000 oil paintings, more than 4,000 watercolors and some 1,500 portrait miniatures, of British and Foreign schools. Only a portion of these works can be placed on exhibition; thus, the complete collection of oil paintings by John Constable, a selection of his drawings, and a broad selection of other British paintings are displayed; a smaller proportion of the watercolors is put on show, these being changed annually in the interest of conservation; some 300 portrait miniatures are available for public scrutiny. The department of prints and drawings, founded in 1909, holds approximately half a million prints and drawings, a collection of great diversity that reflects an emphasis on the applied arts.

Funds allocated by Parliament for the purchase of objects for the collection and books for the library need to be greatly increased: the grant for these purposes was set at £70,000 annually for five years beginning in 1964–65. Fortunately, the Victoria and Albert does not compete in the fantastically expensive market for oil paintings as do the Tate and the National Galleries.

Additions to its collections of visual art consist of sculpture, watercolors, drawings, prints, and miniatures of all periods.

An important responsibility of the Victoria and Albert is the administration of a special fund from which grants are made toward the cost of approved acquisitions by local museums, art galleries, and libraries. Treasury allocation for this purpose was £100,000 in 1967–68 and in the two previous years; this type of support has increased substantially: £15,000 in 1959–60, £25,000 in the four succeeding years, and £50,000 in 1964–65. Numerous local museums and galleries have received much-needed assistance in expanding their collections, acquiring works of art which they could not afford to buy because of pitifully small purchase funds placed at their disposal. Grants are sanctioned only if the object under consideration costs £50 or more, provided they do not exceed 50 percent of the agreed price and the Keeper of Circulation has verified that the object in question is authentic, fairly priced, and a suitable acquisition.

Traveling exhibitions of the National Museum Loan Service, about a hundred in 1967–68, are organized by the Victoria and Albert's circulation department and dispatched to the provinces for showing to the public in museums, art galleries, and libraries. These include both fine and applied art materials (silver, ceramics, costume, etc.). Rembrandt etchings, Benin bronzes, medieval alabasters, and Pop Graphics are illustrative of collections recently sent on tour. Many smaller collections are sent to art schools, colleges of education, and university departments.

The British Museum is triad in function: it houses the National Library of Books, the National Museum of Archaeology, and a collection of works of art in all media (except paintings), dating from primitive times to the present. Particularly outstanding is its collection of prints and drawings. The museum was established by an act of Parliament in 1753; a body of trustees was appointed to assume responsibility for the library, the natural history collection, antiquities, and works of art bequeathed to the nation by Sir Hans Sloane. Other major collections were entrusted to the museum's care, and in order to acquire funds for acquisition, housing, and maintenance, £95,000 was raised by public lottery. The initial grant for general maintenance was not voted by Parliament until 1762 and amounted to £2,000. Throughout its history, the museum has grown by means of a combination of private benevolence and Treasury support, the treasures in its custody, in the main, having come to it by successive gifts of great collectors.[30] Accessions of great importance have derived, too, from Royal gift and special parliamentary grant. Although economic conditions have changed drastically since World War II, private gifts continue to be significant.

Funds allocated by Parliament to underwrite the purchase of objects for the entire collection totaled £297,000 in 1967–68, a sum almost universally regarded as inadequate.[31] Alarmed by the rising market prices demanded

30. *The British Museum, Report of the Trustees, 1966* (London, 1966), p. 10.

31. Data indicating the division of purchase funds between the library, archaeology museum,

10*

for valued objects and the increased competition from the many new galleries and museums, the trustees called upon the government to be prepared to treat supplementary grants for special circumstances as "a matter of regular policy rather than of unanticipated benevolence." Staff complement in 1967 totaled some 1,350 persons; employees were not civil servants, although they worked under similar conditions and enjoyed comparable rights. The museum's organization, headed by a director, consists of central services (publications, photography, guide, lectures, information, and exhibitions), research laboratory, and eleven professional departments.

The Exchequer also underwrites the cost of maintaining the Wallace Collection, housed in Hertford House, London. This aggregation of paintings bequeathed to the nation in 1897 by Lady Wallace, widow of Sir Richard Wallace, is, by reason of its range and quality, one of the important picture galleries of the world. There is, in addition, furniture, sculpture, and porcelain of impressive quality. The collection contains numerous masterpieces of French painting of the eighteenth century, some important paintings of the French seventeenth-century school, a large number of works by French nineteenth-century painters, and works by Rubens, Van Dyck, Murillo, Velasquez, Rembrandt, Frans Hals, Hobbema, and Pieter de Hooch.[32] The donor's will specified that the collection was to remain closed, no additional works to be added to it.

Finally, there are the National Gallery of Scotland, the Scottish National Portrait Gallery, and the Scottish National Gallery of Modern Art—all administered by a single board of trustees. The first two were constituted in their present form by an act of Parliament in 1906. The National Gallery of Scotland contains the national collection of paintings, drawings, and engravings other than those of primarily Scottish historical interest. Its building was opened to the public in 1859, having cost £50,431 to erect, of which £30,000 came from the Treasury. Control of the gallery was entrusted to the board of manufacturers.[33] Works of art contained in the collection derived from three principal sources—the Royal Institution, the Royal Scottish Academy, and the College of Edinburgh. Since its inception, the collection has been enlarged by many valuable gifts. After 1906, the cost of maintenance was placed on the parliamentary estimates, and limited funds were made available for acquisitions. The gallery's holdings, if compared to those of the National Gallery in London or the Tate, are modest, but the collection does contain many outstanding works. Most pressing is the need for an

and art collection are not available. The total grant-in-aid for purchases stood at £20,000 in 1946–47. Between 1938 and 1967 only five special Treasury grants were made to the museum, totaling £305,000.

32. Blunt and Whinney, *The Nation's Pictures*, pp. 104–16.

33. The board of manufacturers had been formed in 1727 to administer the annuity granted to Scotland by the Treaty of Union and the Revenue of Scotland Act of 1718 as an equivalent of extra taxation. Operating costs were paid from the annuity initially, and no funds were provided for acquisitions. The authorized staff complement for the three Scottish galleries stood at eighty-one for 1967–68.

adequate building; under the present arrangement, dating from 1946, the collections of drawings and prints, their keeper, and the library are all housed nearly a mile distant from the rest of the gallery. Acquisitions constitute the second major difficulty, Treasury allocations for purchases having been pegged at £25,000 annually for five years beginning 1964–65. This sum has been designated to cover the needs of both the National Gallery of Scotland and the Scottish National Portrait Gallery.

The Scottish National Portrait Gallery, like its counterpart in London, houses a varied collection of authentic portraits. Its origins can be traced to 1882, when J. R. Findlay anonymously offered to the board of manufacturers £10,000 to establish a gallery of portraiture, provided the government would make available an equal sum. Parliament quickly responded, and Findlay in 1884 offered to provide funds to erect a building to accommodate the gallery and the National Museum of Antiquities if a site were made available. A plot of land in Queen Street, Edinburgh, was purchased, funds coming from the board of manufacturers and the Treasury; the present building was erected and opened to the public in 1889. Over the years the gallery's collection has steadily increased, although public funds allocated to it for acquisitions have until recently been disappointingly small. It, too, has a serious space problem.

The announcement in Parliament on 23 January 1959 that Inverleith House, Edinburgh, would be made available as a temporary home for a new gallery of modern art in Scotland was enthusiastically welcomed by many people who had long been aware of the need for creating such an institution. The new gallery, since it opened in 1960, seeks to bring to Scotland the whole repertory of modern western art as well as the best of contemporary Scottish painting.[34] To cover such a wide field has thus far been virtually impossible—purchase grants totaled only £7,500 in 1963–64 and £20,000 from 1964–65 to date. Theoretically, special Treasury grants for more expensive pictures could be obtained. The impossibility of securing such assistance without an adequate annual purchase grant was demonstrated by the gallery's experience in June 1963, when the trustees attempted to buy a noncontroversial cubist Picasso for £20,000. Only £1,900 of their annual £7,500 was left, and the trustees asked the Treasury for £18,100 to permit them to bid. The response from Whitehall was negative on the grounds that the sum requested represented too large a proportion of the price. If the entire annual grant had been available, it would have barely equaled the 33 percent, which was regarded by the Treasury as the minimum for a special grant. The purchase grants for the current quinquennium are not yet sufficiently large. For years to come reliance must be upon the generosity of lenders and on temporary exhibitions. Inverleith House, though pleasantly situated and possessing considerable charm, needs to be replaced by a larger, permanent building.

34. *Scottish National Gallery of Modern Art* (Edinburgh: Board of Trustees, 1963).

Provincial Art Galleries The 1965 white paper declared that "compared with many other civilized countries we have been in the habit of financing some fields of the arts on no more than a poor law relief basis."[35] This judgment is particularly true of provincial museums and galleries supported or administered mainly by local authorities. Speaking in the Commons on 26 February 1960, the Financial Secretary observed that the Conservative government looked with favor on a survey of local museums and galleries by the Standing Commission on Museums and Galleries, for it was concerned that "interest in the arts should be fostered not only in the three capital cities but in the main centers of provincial life." The Members, he hoped, would welcome such an investigation as "a step towards the solution of the troubles of what may fairly be called the 'Cinderella group' in the family of arts."[36]

Published by the Standing Commission in 1963, the survey contained detailed information pertaining to each of 876 museums, analyzed the scope and range of their activities, and set forth a series of recommendations. Provincial collections in the fine arts numbered 110: other collections included applied art, archaeology, natural history, science and industry, ethnography, folklore, and military material. Actually, only about thirty galleries possessed significant collections of paintings, drawings, or sculpture. Those in Cambridge, Glasgow, Liverpool, and Oxford, containing masterpieces of all schools, had achieved a high national standard as a result of magnificent gifts and wise buying.[37] Smaller collections of first quality, embracing foreign as well as British schools, were found at the Bowes Museum at Barnard Castle, the Barber Institute affiliated with Birmingham University, the Birmingham City Art Gallery, Bristol City Art Gallery, Leeds City Art Gallery, and in galleries located in Leicester, Manchester, Plymouth, Sheffield, Southampton, Truro, and York.[38] There were also important collections of British art in a number of smaller museums and galleries which possessed few or no foreign paintings. "Less inspiring is most of the large quantity of work which has been collected, by benefactors or by the museums . . . in the course of the last hundred years. Some of this has topographical interest; most has none."[39]

Although the commission did not view contemporary art with contempt, it strongly urged galleries to develop a more acute sense of discrimination. In fact, it felt that twentieth-century art should be emphasized by provincial galleries, since it often can be bought at prices they could afford. Locations of provincial collections were found to be haphazard and irrational with

35. Cmnd. 2601, *A Policy for the Arts: The First Steps* (HMSO, 1965), p. 19.

36. Standing Commission on Museums and Galleries, *Survey of Provincial Museums and Galleries* (HMSO, 1963), p. 79.

37. The Fitzwilliam Museum, Cambridge, the Ashmolean Museum, Oxford, and the Barber Institute, Birmingham University, are wholly financed by university funds.

38. *Survey of Provincial Museums and Galleries*, pp. 7–8.

39. Ibid.

large areas poorly served. Funds for acquisition, even in the larger museums, were inadequate, and those possessed by the lesser galleries, pitifully small. The policy of featuring temporary exhibitions was enthusiastically endorsed; all galleries were urged to do more in this area, not only making use of the traveling exhibitions of the Arts Council and the Victoria and Albert, but even more important, organizing their own exhibitions and borrowing from private and especially local sources. Security arrangements, conservation of paintings, and housing conditions were found to be unsatisfactory in many of the galleries.[40]

A potentially significant development has been the formation of eight area museum councils covering the British Isles, the first of which was established on an experimental basis in the Southwest of England in 1959.[41] Designed to facilitate the reorganization and improvement of museums within each area, councils are financed by local authority contributions and by allocations from the Treasury, the latter amounting to £21,700 in 1966–67 and £37,750 in 1967–68. The Terms of Reference adopted by the North Western Museum and Art Gallery Service are illustrative of the roles which area councils hope to perform:

The objects of the Service are to stimulate interest in museums and art galleries and their development so as to provide the most efficient service, and to advise as to the co-ordination of their resources and work.

(a) by providing technical services for the conservation, preservation and restoration of archaeological and natural history specimens, works of art and other material, and practical assistance in the improvement of display, publicity and presentation;

(b) by providing for the exchange of information and the giving of expert advice upon such matters as the identification of objects, acquisition of materials, display and organization;

(c) by circulating loan collections and by providing travelling exhibitions consisting of material from the art galleries and museums in the area of the scheme, and also from outside sources; and

(d) by arranging for the loan and exchange of works of art and other items between art galleries and museums within the area of the scheme.[42]

Initial progress has not been as great as was anticipated, but there is no question that the scheme, when fully implemented, can greatly strengthen provincial museums and galleries.

On balance, prospects for the future are encouraging. Throughout the nation more money is being made available to support provincial galleries, derived largely from local authorities but to some extent from private sources, particularly in the larger cities. Improvement in the professional qualifications of staff is discernible, and modest efforts are being made to provide

40. Ibid., pp. 9–13.

41. The area councils and their headquarters are as follows: South West (Bristol), Midlands (Birmingham), North West (Manchester and Liverpool), North of England (Durham), Yorkshire (Leeds), South Eastern (London), Scotland (Edinburgh), and Wales (Cardiff).

42. Standing Commission on Museums and Galleries, *Report on the Area Museum Services, 1963–1966* (HMSO, 1967), p. 25.

training under the auspices of the Museums Association, financed by the Carnegie Trust, the government having declined to provide the needed resources.[43] The number of traveling exhibitions dispatched from London by the Victoria and Albert Museum in recent years has appreciably increased, and galleries continue to profit from the exhibition services of the Arts Council. More attention is now given to the cleaning and restoration of pictures; this important work is performed by area councils and also by larger galleries for smaller institutions in their regions. Ties with local education authorities are being strengthened and schemes implemented to develop greater interest in art among the youth.

The Standing Commission's survey, released in 1963, called upon the government to spend an additional £450,000 annually to implement its recommendations.[44] Treasury response has been positive, but sums made available have not risen to the levels requested. Area councils were constituted as suggested, but their 1967–68 allocation was one-fourth of the £150,000 originally specified. No funds were released to finance the recommended personnel training schemes. And the proposed increase from £25,000 to £200,000 in the Victoria and Albert grant-in-aid of purchases fund and the proportionate increase in the aid fund administered by the Royal Scottish Museum were only partially realized; a total of £108,000 was authorized in 1967–68. Difficulties encountered by provincial museums in acquiring works of art, particularly paintings by major artists, are so great that drastic action needs to be taken. Establishment of a fund totaling £1,000,000 annually could easily be justified.

The government's position as outlined by the Financial Secretary in 1960 was that the Treasury should not assume financial responsibility for the capital or running costs of provincial galleries and museums, for these are the proper responsibility of the local authorities. The commission, however, recommended that the central government assist local museums by making available, through the area councils, capital grants for building in those cases where museum authorities could not obtain the needed funds from other sources. The Treasury did not respond to this suggestion.[45] The Housing the Arts Fund, administered by the Arts Council, is for "capital assistance towards the cost of theaters, concert-halls, arts centers, etc., and of extensions and improvements to existing buildings," and grants are not made to museums and galleries for housing their permanent collections. The commission considered broadening the purposes of the Housing the Arts Fund to include museums and galleries, but decided against it, for many museums have little or no connection with the arts.[46]

43. Ibid., pp. 12–13. Opportunities for training are also provided by the Department of Museum Studies at Leicester University and by fine art departments in other British universities.

44. *Survey of Provincial Museums and Galleries*, p. 75.

45. Standing Commission on Museums and Galleries, *Seventh Report 1961–1964* (HMSO, 1965), p. 20.

46. *Report on the Area Museum Services 1963–1966*, pp. 10–11.

A brief examination and analysis of the operations of the Walker Art Gallery, Liverpool, and the City Art Gallery, Birmingham, will highlight some of the problems encountered by British provincial galleries today. The Walker Art Gallery was the first provincial gallery to be given a special grant from the Exchequer to assist in the purchase of a major painting. When *The Holy Family* by Rubens was acquired by the gallery in 1960 for £50,000, the Exchequer made available £25,000 to augment funds raised locally from the city council, private individuals, and trusts.[47] The gallery was opened to the public in 1877, but its ancestry can be traced to 1810, the founding date of the Liverpool Academy of Arts, a body which operated an arts school and held annual exhibitions. Public subsidy of the exhibitions, admittedly modest, began in 1830, when the corporation donated annually £200; this subvention continued until 1867, when disputes among local artists brought about its demise. The corporation, in 1871, staged the first Liverpool Autumn Exhibition, and since housing for this popular event was not adequate, Andrew Walker, upon becoming mayor in 1873, offered to erect a suitable building at his own expense. The new gallery, opened in 1877, initially housed the exhibition, then known as the "Academy of the North," for six months each year. No permanent collection existed, but as time went on, pictures were occasionally given by local citizens and works were purchased from exhibition profits. Unfortunately, the organizing committee pursued an unenlightened acquisitions policy, and until the end of World War I, the gallery's collection contained for the most part anecdotal and photographic paintings of the late nineteenth century. Significant acquisitions were made upon occasion, including a collection given by William Roscoe emphasizing Italian and Flemish painting of the fourteenth, fifteenth, and sixteenth centuries, and a sizable bequest which contained paintings by George Frederick Watts, sculpture by Auguste Rodin, and etchings by Palmer, Whistler, and Seymour Haden.

In 1929 the Liverpool Corporation made its first annual grant from local taxes for the purchase of works of art, a practice which has continued to the present day. Additional bequests of money permitted the filling of some historical gaps in the collection of British pictures, but were not large enough to underwrite the acquisition of costly works of the continental schools. A most important bequest was received in 1945, the Holt collection, containing pictures by Gainsborough, Reynolds, Turner, Raeburn, and Romney, all of whom previously were represented inadequately or not at all. By 1960 the most important pictures owned by the gallery were exhibited in a dozen rooms. The total collection, including prints, pottery, and other works,

47. In November 1959 *The Holy Family* which had previously been sold for export, came before the Reviewing Committee on the Export of Works of Art. The committee, not wishing it to leave Britain, recommended that no export license be granted for three months, to permit purchase by a public institution for £50,000. It also supported an application by the Victoria and Albert Museum for a special Treasury grant of up to £25,000, to enable a provincial gallery to acquire the picture. H.M. Treasury, *Government and the Arts 1958–64* (1964), pp. 11–12.

numbers more than 6,500 items; of the 2,000 pictures, only 300 can be placed on exhibition at any one time.

Liverpool Corporation appropriations in support of the Walker Gallery gradually increased over the years, totaling £117,252 in 1966–67 and £115,571 in 1967–68; offsetting income received for the two years were £8,579 and £8,635, respectively. Fifty-seven full-time staff are employed. Since the war, attendance has fluctuated considerably—120,885 in 1951, 187,436 in 1955, and 127,596 in 1964. Recently, Liverpool citizen interest in the gallery increased substantially, attendance rising to 213,191 in 1965 and to 234,000 in 1967–68; most important, people appear to be visiting the gallery regularly to view its permanent art treasures, rather than merely its temporary exhibitions. Purchase of outstanding works of art is facilitated by support from Merseyside commerce and industry which in recent years has given between £60,000 and £70,000, most of it under the seven-year covenant arrangement. When it expends private funds, the gallery obtains limited additional sums on a matching basis from the National Art-Collections Fund and the Victoria and Albert Museum. Support from the Victoria and Albert amounted to approximately £10,000 in 1966–67, but this allocation was reduced to £5,000 in 1967–68. Liverpool Corporation contributions to the purchase fund also suffered from the economy axe, having been reduced from £11,500 in 1966–67 to £5,000 in 1967–68.

Ten to twelve special exhibitions are held in the gallery each year. Of particular interest are the John Moores Exhibitions, begun in 1957 and held every two years, which encourage leading British artists to exhibit their work in Liverpool, and provide encouragement, and a place to offer their work for sale, to those who are less advanced in their careers. At the sixth exhibition, 23 November 1967–21 January 1968, three purchase prizes—£1,500, £1,000, and £750—were awarded, the works becoming the property of the gallery; five prizes of £100 and five of £50 each were also given.

The gallery makes energetic efforts to interest school children in the visual arts. In 1967–68, 673 groups (15,498 students) ranging from small children to students training as teachers, visited the gallery. Illustrated talks are given by the gallery's Schools Officer, and general programs are designed to encourage school leavers to continue visiting the gallery after graduation. The Schools Loans Service operates a program designed to stimulate interest in original works by providing oil paintings and artists' lithographs to hang in schools. New works are being acquired continuously; £500 per year were made available for this purpose by the Liverpool Education Committee, and an equal sum by the gallery.[48]

Plans have been developed for an addition to the gallery consisting of three large exhibition rooms, and added facilities to be used by the Schools

48. Oil paintings, chiefly by British artists, are from the nineteenth and twentieth centuries, including some genre and topographical pieces and some by contemporary Liverpool artists adhering to the more advanced trends in painting. The colored lithographs and prints are by contemporary French and British artists.

Service. However, construction is not likely to be undertaken for some years in view of Britain's tight economic situation. Serious gaps in the collection exist, and if the desired pictures are to be purchased, not only must a more generous allocation of funds be made for this purpose by the city but efforts to obtain greater sums from industry and other local and regional sources need to be intensified as well. An even larger proportion of the people of Liverpool and those resident in the surrounding region should be encouraged to visit the gallery. Financial support by neighboring authorities would permit expansion of the gallery's permanent collection and an increase in services rendered to the public.

The Birmingham City Art Gallery differs from most other provincial galleries in that from the very beginning it was a municipal enterprise, operating costs being met from local taxes. Established in 1867 and housed in the Free Library, it was shifted to the Council House in 1885, where it occupied a series of rooms constructed for its use. New galleries erected in 1912 with moneys bequeathed by John Feeney permitted it to expand its facilities, and in 1919, six additional rooms were added. The Birmingham Museum and Art Gallery embraces four disparate units under a single administration: the department of art, the department of archaeology, the department of natural history, and the department of science and industry, the latter housed in a separate building.[49] Oversight of its affairs by the city council is exercised by a libraries and museums committee consisting of twelve members, aldermen and councillors, to whom the director and the four department heads report. The committee is responsible to the full council but specific sanction for actions taken by it is required only under exceptional circumstances. The entire museum and gallery staff totals some 190 persons; of the professional staff, six are employed in the department of art. Museum and gallery expenditures in 1966–67 (excluding the department of science and industry) amounted to £220,614, income received being £20,729; in 1967–68 total costs increased to £238,296, income, to £21,465.[50]

The gallery's permanent collection is known particularly for its paintings and drawings of the Pre-Raphaelites and its collection of watercolor landscapes. English painting of the seventeenth, eighteenth, and early nineteenth centuries is fairly well represented, and efforts to acquire works of the Continental schools from the thirteenth century on, including pictures by Italian, French, and Dutch masters of the seventeenth century and landscapes of the nineteenth-century French school, have strengthened the collection. Its sculpture holdings contain a limited number of works by Epstein, Rodin, Renoir, Henry Moore, Barbara Hepworth, and a small but interesting collection of Continental sculpture from the sixteenth to the nineteenth

49. Three departments have branch museums, and the art department is responsible for Aston Hall, a seventeenth-century house containing fine furniture and paintings.

50. Accounts for the three departments housed in the main building—art, archaeology, and natural history—are not broken down, with the result that the precise expenditures for the art gallery alone are not obtainable.

centuries.[51] Paintings customarily are displayed in sixteen separate galleries, some of which are cleared upon occasion to accommodate temporary exhibitions.

For more than three-quarters of a century, no funds derived from local taxes were voted by the corporation for the purchase of works of art; councillors adhered to the prevailing philosophy of laissez-faire. The generosity of Birmingham citizens who contributed funds and works of art was admirable, but it did not permit the building of a large and well-rounded collection. An Association of the Friends of the Art Gallery was founded in 1933 to permit individuals of modest means to contribute to art acquisition; today 1,400 members make available about £1,500 each year. Some modern works bought by the friends are inevitably controversial and, to lessen criticism of the gallery, they are initially made available on loan, title passing to the city only if, after some years, they are accepted by the public. The corporation recognized the need for public funds in 1946 by voting £1,000 to be used for acquiring pictures and other museum objects; in 1947 the grant was increased to £5,000. By 1957 the purchase grant had risen to £12,000, at which level it remained through 1965–66. In 1966–67, due to economic stringencies, the amount was cut to £11,000, and in 1967–68, to £5,000. Although it is designated for all four departments, the art gallery spends the major portion of it. Parliament, in 1958, sanctioned legislation permitting the corporation to set up a special Museum and Art Gallery Fund to finance purchases, funds not to exceed in any year one-quarter of the product of a penny in the pound rate. When fund accumulations reach £100,000, annual payments cease until acquisition expenditures reduce it below this level. In 1960 *The Roman Beggar Woman* by Degas was acquired with the aid of this fund, at a cost of £35,000, and in 1964, Delacroix's *Portrait of Madam Simon* was purchased, virtually exhausting the fund. Corporate replenishment will undoubtedly be delayed until Britain's general economic conditions improve.[52] During the past two decades the gallery has temporarily acquired many important pictures by means of short- or long-term loans, since it did not command the resources to purchase the more expensive oils. Thus, in 1967 a Rembrandt, a Bellini, a Tintoretto, a Degas, a Hobbema, a Van Dyke, and works by several other famous painters were displayed to the public.

A large number of special exhibits are featured each year by the gallery. These pictures come from the permanent collection or are borrowed from provincial galleries, the Arts Council, or private individuals.[53] The gallery occasionally dispatches exhibits to countries overseas. Expenses are paid by

51. The gallery's permanent collection frequently is enriched by loans of valuable works owned by private collectors.

52. Financial assistance is regularly derived from the Victoria and Albert Grant-in-Aid Fund, and contributions are occasionally received from the National Art-Collections Fund.

53. Beginning in 1968, small grants were obtained from the Arts Council to help underwrite exhibition expenses.

the British Council, the Board of Trade, or the foreign borrower.[54] Noontime and other lecture programs are presented weekly in addition to concerts arranged by the Birmingham Chamber Society. A Schools Liaison Officer organizes limited programs for young people and advises teachers who bring groups of children to the museum and gallery.

As for the future, no plans are projected to increase gallery space or expand the physical facilities available to the art department. The most pressing need is for significantly larger sums to permit purchase of new pictures, drawings, and other works of art in order to strengthen the gallery collection. Birmingham, highly industrialized and second only to London in size, is sufficiently wealthy to provide the kind of local authority support needed. Local interest and sustained dedication are vital to achieving a more adequate financial allocation. Birmingham industry, which has not contributed appreciable funds for art purchases, can possibly be persuaded to provide some of the funds required. As in Liverpool, a larger proportion of the people residing in the regional area could profit from more frequent visits to the gallery; their attendance would be encouraged by the development of additional imaginative programs and sustained publicity.

54. In 1965 English watercolors, drawn largely from its own collection, were displayed in Amsterdam and in Vienna; in the following year, during a British Trade Week in Lyon, France, an exhibit of British Painting and Watercolors, 1700–1900, was featured; in October 1967, the gallery lent a number of nineteenth-century British works for exhibition in Tokyo.

13 / FESTIVALS OF THE ARTS

The morning trumpets festival proclaimed.
—Milton

ost festivals are of comparatively recent origin, a manifestation in part, at least, of postwar prosperity and increased leisure. In 1967 the Arts Council compiled a list of ninety-two festivals known to be held in England that consisted of, or included, professional events. Of these, thirty-nine were accorded council assistance. The proliferation of festivals is the product of the growth of a healthy interest in the arts and reflects to some degree cultural competition between cities and towns and festival entrepreneurs. Commercial incentives are not absent, for local business can profit from the influx of tourists from other parts of Britain and abroad. Thus, Edinburgh receives an estimated infusion of between two and three million pounds annually as a result of the Edinburgh Festival. Of the festivals reported in 1967, nine were biennial, two were held every three years, and the remainder annually; the shortest covered one day, while more than one-third operated from six to fourteen days.

The Three Choirs Festival, established more than two centuries ago, made music in Gloucester, Worcester, and Hereford cathedrals acceptable when it devoted a part of the festival profits to local charities.[1] The attempt to commemorate Shakespeare in his birthplace, Stratford, was begun by David Garrick in 1769, though regular seasons of Shakespeare's plays did not take place until a century later. Several large provincial towns, after their phenomenal growth as a result of nineteenth-century industrialization, began to grope for cultural respectability by promoting big musical festivals, often on a three-year basis; two, Leeds, and Norfolk and Norwich, survive to the present day. People living in the smaller towns and the countryside also enjoyed access to festivals organized in their communities. After the turn of the century, Glastonbury was selected by Rutland Boughton as the center for his musical activities because of its association with the Arthurian legends, which he used as a basis for an operatic cycle. Friends and supporters helped him launch a festival in this out-of-the-way part of the country, which revived a number of early English operas and performed his own musical dramas. The Glastonbury Festival failed to survive, but its effects were beneficial and far-reaching.

In the early 1930s a wealthy couple, John and Grace Christie, conceived the idea of founding an opera festival in Glyndebourne, Sussex, which met with immediate success and operates today without regular support by the Arts Council from mid-May through July. The widely acclaimed achievements of Glyndebourne were due to a number of factors: high professional standards were consistently adhered to; leading artists were persuaded to accept contracts to perform there; adequate financial support was available from private sources; and, most important, until 1945 very little opera was produced in Britain. With the advent of war the Glyndebourne opera seasons and all other festival activities ceased. The only significant development to

1. Eric White, "Festival Thoughts," *New Society*, 19 August 1965, pp. 24–25.

occur during the war was the idea for the founding of the Edinburgh Festival. For a short period Glyndebourne Opera toured with a production of *The Beggar's Opera*, and while they were in Edinburgh, "the Christies and Rudolf Bing were struck by the romantic beauty of the blacked-out city in the light of the full moon and its fortuitous resemblance to Salzburg. Surely, they felt, this would be a worthy setting for an international festival of the arts."[2] After the war, influential people in Edinburgh took up the idea, and with the encouragement of the Arts Council and a grant of £10,000 the Edinburgh International Festival of Music and Drama opened on 24 August 1947, running for a period of three weeks. In the summer of 1946 Glyndebourne reopened with Benjamin Britten's *The Rape of Lucretia*, produced by the English Opera Group, which it then dispatched on tour under Arts Council guarantee. Not satisfied with the minor role planned for it in the festival's 1947 season, the English Opera Group took their new production of Britten's *Albert Herring* to Europe that summer, participating in several festival programs in Switzerland. Upon their return, Britten and his friends decided to constitute their own festival organization; the Aldeburgh Festival was inaugurated in the summer of 1948. Arts Council support of festivals remained limited, its principal contribution going to Edinburgh. However, the council did enter into contracts with festivals, granting them the status of "association" in relation to itself and agreeing to give to each such advice and assistance as was deemed desirable and practical, though not necessarily providing financial assistance. On 31 March 1949, the list of festivals in association with the council included the Aldeburgh Festival, the Bath Assembly, the Canterbury Festival, Cheltenham Festival of British Contemporary Music, Edinburgh International, Swansea Music Festival, and Three Valleys Festival.

The Festival of Britain, held in 1951, removed any latent doubts concerning official approval of the festival movement. In December 1947 the Labour government announced in Parliament its decision to celebrate the centenary of the Great Exhibition of 1851 with a nationwide Festival of Britain, 1951, dealing with industrial design, science and technology, and the arts. Some months later a Festival of Britain office was set up, and the Arts Council was entrusted by the Chancellor of the Exchequer with full responsibility for ensuring appropriate representation of the arts in the festival. The council's policy decisions relating to scope and procedure, approved in July 1948, involved a threefold approach: to promote a London season of the arts in May and June 1951; to foster arts festivals in twenty-two centers scattered throughout Britain; and to stimulate wherever possible the local effort and the special occasion in artistic endeavor. Through a grant of £400,000, allocated by the Treasury, it was able to finance the arts phase of the festival. The London season of music turned out to be a phenomenal success. In the London County Council's newly constructed Festival Hall and concert halls elsewhere in London, nearly 300 concerts were presented,

2. Ibid.

representing the entire British musical tradition from symphony to brass bands, from concerts for children to organ recitals, and from chamber music to massed choirs. The decision to invite only British orchestras proved to be a wise one; average attendances at concerts in the Festival Hall during the Arts Council's tenure averaged approximately 85 percent of physical capacity. Opera seasons at Covent Garden, Sadler's Wells, and Glyndebourne were equally successful. To mount a similar comprehensive eight-week drama program was not deemed practical, although major theater companies submitted plans and money was earmarked for grants and guarantees to schemes that included the classics and important contemporary plays. A great effort was made to ensure that Britain's leading actors participated and were not on Broadway or occupied elsewhere in film-making. The results were mixed, some plays ending in failure. Among numerous exhibitions of contemporary art, one of the most important displayed the work of Henry Moore.

The twenty-two principal arts festivals staged throughout the country which were associated with the council, and the hundreds of special events, minor festivals, concerts, plays, operas, and exhibitions held from one end of the country to the other which received assistance from the council were received with enthusiasm. The quality and vigor of most of the established festivals—Edinburgh, the National and International Eisteddfod in Wales, Stratford, Cheltenham, and Aldeburgh, to mention but a few—remained high. The new festivals especially created for 1951, while not always as successful, were significant in their own right. The twenty-two centers invited by the Arts Council to prepare festivals merited the confidence placed in them (except in one or two instances), and generated a spirit of joyousness. About one-quarter of the council's extra Treasury festival grant was spent in financing the provincial arts festivals, the whole operation demonstrating the wisdom of the council's preference for working with established, independent organizations whenever possible. A number of the new festivals survive on a permanent basis today. The enduring legacies of the 1951 celebration include two of particular importance. One was the revival of the great cycle of medieval mystery plays, not performed since the sixteenth century, which have now become the main feature of a regular triennial festival in York. The other was the development of the South Bank in London as one of the finest sites in the world for arts festivals, as demonstrated by its use for the first Commonwealth Arts Festival in 1965.

During the summer of 1952, eight festivals were receiving help from the council. Of these, King's Lynn, created in 1951, overcame initial organizational difficulties and with subsequent annual subventions won for itself a significant place in the cultural life of the Norfolk region. Most striking was the development at Cheltenham, where the Festival of British Contemporary Music, begun just after the war, attempted to become the central component in a triptych of festivals devoted to contemporary painting and sculpture,

music, and literature.[3] During the late 1950s and early 1960s, a number of festivals supported by the Arts Council grew slowly; in early 1967, 65 festivals throughout Britain received subventions—39 in England, 6 in Scotland, and 20 in Wales, with individual grants ranging from £25 for the Ryedale Festival of Music and Drama to £35,000 for the Edinburgh Festival. Council resources allocated for festivals in 1965–66 totaled £56,720, and in 1966–67, £82,776.

The policies pursued by the Arts Council and local authorities in fostering festivals of the arts and the problems encountered in providing financial support can best be comprehended by examining in some detail the history of a few of the more successful festivals—the Edinburgh Festival, the Festival at Bath, Aldeburgh Festival of Music and the Arts, Cheltenham Festival, and the Festival of the City of London.

The Edinburgh Festival The Edinburgh Festival was an ambitious enterprise from the first, and the financial risks, though large, were offset by generous contributions, public and private. Sir John J. Falconer, Lord Provost of Edinburgh, set the tone at the first festival in 1947, when he observed:

> The idea is a new one for Edinburgh, but I feel confident we will succeed in establishing our fair city as one of the pre-eminent European Festival Centres. To succeed, we require the help and co-operation of lovers of art the world over. . . . We wish to provide the world with a Centre where, year after year, all that is best in music, drama, and the visual arts can be seen and heard amidst ideal surroundings. Edinburgh will be wholly given up to Festival affairs—she will surrender herself to the visitors and hopes that they will find in all the performances a sense of peace and inspiration.[4]

The standards of performance were to be the highest the world could provide. A principal originator of the festival design was Rudolf Bing, then director and general manager of the Glyndebourne Opera, who before the war ended had visualized the opportunity for an international arts festival in Great Britain, particularly since the European festivals, such as those of Salzburg and Munich, could not suddenly be resumed with the advent of peace. Edinburgh was chosen as the most desirable site, for unlike other cities it had not suffered major bombing. Its theaters, halls, and galleries were adequate for such a major undertaking. Without difficulty visitors could be accommodated in existing hotels, homes, and hostels. Most important of all, its officials and town council were interested in creating a festival, and willing to contribute freely of their own time and to sanction a generous subsidy.

Early in 1945, before the war in Europe was over, Bing approached the city authorities. A Festival Society was set up without delay and the year 1946 was spent in active preparation. From the beginning the society

3. The visual arts failed to become a permanent feature of the Cheltenham Festival Series.

4. Edinburgh Festival Society, Ltd., *Edinburgh Festival: A Review of the First Ten Years, 1947–1956* (1956), inside cover.

profited from the insight and experience of Edinburgh city council members. Today, of the twenty-one society council members, the city is represented by the Lord Provost, who is chairman; the Treasurer, who serves as deputy chairman; two baillies; and eight councillors.[5] Two immediate problems had to be dealt with before the opening of the festival on 24 August. The first was financial. Ninety-eight separate performances during the festival resulted in a gross expenditure of £85,023. The Edinburgh City Council responded liberally with a grant of £22,000; individual firms and private citizens contributed £19,791; and the Arts Council, at first somewhat aloof but soon impressed with the determination to achieve artistic excellence, made available £20,000, a generous sum considering the small size of its Exchequer allocation. Added to these gifts was income from the sale of tickets and other sources, amounting to £64,246 and producing a gross income of £126,037. To everyone's satisfaction the society made a profit of £41,014 the first year. This was placed in a Festival Fund for the financing of future festivals. The assembling of a program of high quality was far from easy. Naturally, artists wanted to know what company they would be appearing in before agreeing to a definite booking, and yet early acceptance by distinguished artists was essential. Bruno Walter and the Vienna Philharmonic resolved this dilemma when they agreed to take part in March 1946. Other participating orchestras were the Orchestre de Colonne de Paris, conducted by Paul Paray; the Hallé, by Sir John Barbirolli; the Liverpool Philharmonic, by Sir Malcolm Sargent; the Scottish National, by Walter Susskind; and the BBC Scottish Orchestra. At first, opera was thought to be too expensive for the new venture, but soon it was realized that without opera the festival would be deficient. Thus, Glyndebourne accepted an invitation, presenting at the King's Theatre Verdi's *Macbeth* and Mozart's *Le Nozze di Figaro*. To the Lyceum for the first fortnight came the Old Vic company with *The Taming of the Shrew* and *Richard II*; this was followed by M. Jouvet's company with Molière's *L'Ecole des Femmes* and Giraudoux's *Ondine*. Sadler's Wells Ballet, with Margot Fonteyn and Frederick Ashton as leading dancers, and Constant Lambert as musical director, also performed.

The fickle Edinburgh weather has been a handicap in all the festivals. From one year to another the quality of programs has fluctuated. Few observers, however, have contended that the long-term trend is other than upward. Thus, during the initial ten-year period, 1947 to 1956, the number of performances rose from 98 to 164, gross expenditures increasing more than twofold and reaching £208,705 in 1956. Attendance had registered a substantial increase. First records, from 1949, showed a total of 49,795 visitors; in 1950 this number increased to 57,032, and figures for successive years were 52,185 in 1952, 80,469 in 1954, and 89,570 in 1956. The increase

5. The Society's articles of association as amended in 1964 provide that the council, made up of not less than ten and not more than fifty members, shall be chaired by the Lord Provost or the City Treasurer and shall have at least one-third of its membership drawn from the town council.

of overseas visitors was equally striking, rising from 11,226 in 1950 to 37,357 in 1956. During the festival's first ten years, much that was distinctly Scottish was included in the programs. Initially, two Scottish orchestras participated along with the Glasgow Orpheus Choir. When the Scottish Military Command brought forth the famous Tattoo on the castle esplanade in 1950, it became necessary to provide seats and stands for 7,000, sometimes twice nightly. An allied operation, not sponsored by the Festival Society, the Tattoo contributed handsomely in support funds, making £15,000 available in 1953 and £8,000 in 1956. In the drama field, Tyrone Guthrie was commissioned to stage the vast sixteenth-century Scottish "morality" by Sir David Lindsay, *Ane Satyre of the Thrie Estaites*, in the impressive assembly hall of the Church of Scotland. The production won such favor that it had to be repeated in 1949 and 1951. In later years performances by Edinburgh's own repertory theater, the Gateway, were included in the festival list, and thus visitors were introduced to modern Scottish plays, especially those of James Bridie. The assembly hall was regularly used for open stage productions of Shakespeare and Ben Jonson as well as Scottish pagentries and music-making.

Pictorial art was not a part of the original festival blueprint, but the Royal Academy organized an exhibition of the works of Vuillard in the first year and presented special exhibitions in subsequent years. In 1950, when works of Rembrandt were shown, these exhibitions became officially a part of the festival. A succession of displays of the works of ancient and modern masters was assembled in both the Academy and the Scottish National Gallery. Also featured each year was an International Festival of Documentary Films, organized by the Edinburgh Film Guild to display the best work from many countries. What has become known as the "Fringe" should be mentioned. Initially, this term was applied to exhibitions put on by societies seeking to encourage Scottish arts and crafts, for example the Saltire Society's "Gladstone's Land." An increasing number of producing groups, both amateur and professional, have contributed to the festival, living on the festival's borders and not officially included in its program since their standard of work inevitably varies and their coming may be planned long after the festival's plans have been formalized.

The amount of public subsidy for the Edinburgh Festival, Britain's largest, evolved in a rather interesting way. In 1947 the corporation made available £22,000, which together with the Arts Council's £20,000 plus private donations, gave the festival outside support totaling £61,791, or 73 percent of gross expenditures. The ensuing profit of £41,014 torpedoed any thoughts of retaining government support at that level. Edinburgh immediately reduced its grant to £15,000 and kept it at that level until 1958, when an increase to £26,250 was sanctioned; in 1961 its regular subsidy was raised to £51,250 and then pegged at £50,000 for four years. City support for 1966 and 1967 was £75,000; the grant for 1968 was set tentatively at £50,000, a reduction which was immediately characterized by the festival

director as "a vote of censure on the festival."[6] Later it was raised to £75,000. In addition, the corporation provides special allocations for publicity and other purposes from time to time and makes available the services of the City Chamberlain's Department to handle most of the financial work connected with the festival, a form of hidden subsidy not shown in the accounts. The Arts Council grant was cut to £5,000 for 1948 and then to £3,000 each for 1949, 1950, and 1951. Modest increases were subsequently made to £7,500 in 1955, £10,000 in 1958, £15,000 in 1960, £20,000 in 1961, £35,000 in 1966, and £50,000 in 1967. During the first twenty years, gross expenditures exceeded gross income on ten different occasions, but only in 1962 and 1963 did the festival fund fall to dangerously low levels. The fund balance, in the latter year £3,855, rose in 1964 to £64,492, due to the receipt of a £25,000 special grant from Edinburgh, plus an operating profit of £35,637. The festival's management has convinced the Arts Council and the corporation that their subventions should be sufficiently large to permit a healthy balance in the fund account, on the grounds that it has no operating income for some eight months between the end of one festival and the commencement of bookings for the next. None of the other festivals to be discussed in this chapter has been accorded such generous treatment. In 1966 subventions public and private constituted 48 percent of the festival's gross expenditures.

The scope of artistic events sponsored by the festival in recent years have further strengthened its position as one of the leading international festivals. The 1967 festival, for example, included performances by the New York City Ballet, the Edinburgh Festival Opera, the Cleveland (Ohio) Orchestra, the Berlin Philharmonic Orchestra, the Harvard Glee Club and Radcliffe Choral Society, the Hampstead Theatre Club, the Stockholm Marionette Theater, and the Traverse Theatre Club of Edinburgh. Also offered were exhibitions at the National Gallery of Scotland and other galleries, and the annual Military Tattoo and International Film Festival.

Festival at Bath The proposal to establish a festival at Bath sprang from the imagination of Ian Hunter in 1947. Hunter—then associated with Glyndebourne and later the Bath Festival's managing director—persuaded the Bath city authorities to sponsor a children's festival; its success prompted the local council to turn it into a more general festival presented by the Bath Assembly from 1949 until 1953. By the latter date enthusiasm had waned, and the festival was discontinued until 1955, even though modest financial support had been forthcoming from the Arts Council. In 1955 the city reassessed its position and asked Hunter, in collaboration with Sir Thomas Beecham and other distinguished artists, to reconstitute a festival in a somewhat different form. The resultant Bath May Festival included opera, ballet, orchestral concerts, chamber music, and a magnificent outdoor reconstruction of the battle of Trafalgar. Beecham's last operatic production in England was presented in the eighteenth-century

6. *Sunday Telegraph*, 27 August 1967, p. 10.

Theatre Royal—the little-known Gretry opera, *Zémire et Azor*. Unfortunately, the festival was a financial disaster; some of the worst weather ever recorded in Britain held down attendance, and certain difficulties in controlling costs added to the deficit.

The festival remained inoperative for three years. A feature of the 1955 festival was the appearance in Bath for the first time of Yehudi Menuhin, who again accepted an invitation when the festival was revived in 1958. In 1959 he was made artistic director, a post he held until 1968.[7] The success of the 1958 festival resulted in a decision to project it on an annual basis. To the 1959 festival Menuhin brought his newly formed chamber orchestra, which performed the complete cycle of the Brandenburg concertos, the kind of program that regular audiences in Bath have now come to expect. Menuhin's contribution was to attract to the festival a dazzling succession of artists—Nadia Boulanger, Schwarzkopf, Los Angeles, Seefried and Schneiderhan, Michael Tippett, Pierre Boulez, Monteux, Kertesz, Colin Davis, and, of course, members of his own family—his sister Hephzibah, his brother-in-law Louis Kentner, and his son-in-law Fou Ts'ong. Chamber music evenings included the first appearance at Bath of Jacqueline Du Pré, then hardly known but now one of the important young British artists.

Opera and ballet have not figured as prominently as music in the festivals. Landmarks were Menuhin playing to Fonteyn in *Swan Lake* and, two years later, Menuhin playing unaccompanied Bartok on the stage of the theater with Fonteyn and Nureyev dancing a newly choreographed ballet by Kenneth Macmillan. In 1966 the festival featured Ballet for All in "How Ballet Began" and "La Fille Mal Gardée and the English Ballet," and in June 1967, the Ballet Rambert performed with Yehudi Menuhin playing. More recently, the festival has turned to opera; in 1966 Menuhin conducted for the Phoenix Opera three performances of Mozart's *Cosi Fan Tutte*, and in 1967 Menuhin conducted a new production of *The Abduction from the Harem*.

Drama has been conspicuously absent from the festival offerings. However, the 1966 program did include Larry Adler in *One Man's Show* at the Theatre Royal, and *The Building of the Abbey*, a dramatic production presented against the background of the Abbey Church. The 1966 festival offered such items as a lecture by Hugh Trevor-Roper on "The Eighteenth-century Enlightenment," a forum of musicians and architects discussing "Music and Environment," an art exhibition, and a festival cricket match. In 1967 a Foyles literary luncheon was the first occasion in a series planned to include literary events in the festival.

Like the other British festivals, the Bath Festival is mounted by a company limited by guarantee and operated by an association, the Bath Festival Society, Ltd. Its powers to promote education and knowledge of the arts, extremely broad by definition, are exercised by a council of management

7. For an account of Menuhin's farewell program at the Bath Festival, see *The Times*, 1 July 1968, p. 7.

composed of at least twelve members, five of whom must be local residents. One is named by the Bath City Corporation and one by the local Independent Television contractor. Beginning in 1968, artistic direction has been exercised by a triumvirate consisting of Colin Davis, Jack Phipps, and Sir Michael Tippett; Phipps serves as festival manager. A glance at the festival's financial statement for the year ending 31 December 1966, indicates that total expenditures in support of the twelve-day festival amounted to £30,470, of which £13,543 came from grants and contributions and the remainder almost entirely from box-office receipts. The deficit of £287 was substantially smaller than that of the previous four years; in 1965 the festival lost £3,493. For some years the city placed £2,500 at the disposal of the society; since the festival was reconstituted in 1958, the Arts Council has made available annual subventions, with a grant of £3,500 for 1965–66 and again for 1966–67. Grants and contributions from all sources amounted to 45 percent of the festival's total expenditures.

The Aldeburgh Festival of Music and the Arts In August 1947, the newly formed English Opera Group toured across northern Europe to Switzerland to participate in a festival in Lucerne. The group's twelve continental performances were highly successful artistically, although it appeared that a deficit of at least £3,000 would be incurred. As they traveled from one city to another, it struck some of the leading members of the company that "there was something absurd about travelling so far to win success with British operas that Manchester, Edinburgh and London would not support."[8] Peter Pears came forward with the proposal that they make their own festival, a "modest Festival with a few concerts given by friends." Aldeburgh, the home of Benjamin Britten and Peter Pears, was designated the location.

Back in England, the directors of the English Opera Group were approached, but due to their own precarious financial condition they found it impossible to accept responsibility for the new venture. Benjamin Britten, Peter Pears, and Eric Crozier discussed their plans with a number of Aldeburgh residents. The response was favorable; a committee was set up, and within a short time £1,400 in the form of guarantees (total expenses were estimated at £2,500) were raised, most of it from local residents. In its early years the festival sought to emphasize the art of the area and the town. Commenting upon the first festival held 5–13 June 1948, the Earl of Harewood, one of its chief backers, observed:

> The various items on the programme "belong" to Aldeburgh and Suffolk in the sense that Mozart did to Salzburg. They are at the same time, many of them, of world-wide fame. Through them, local patriotism, with its enhanced sense of physical relationship with its surroundings and its intimate local associations, finds its point of contact with the national and the international.[9]

8. Eric Crozier, "The Origin of the Aldeburgh Festival," *Programme Book* (Aldeburgh Festival of Music and the Arts, 1948), p. 6.
9. The Earl of Harewood, "The Aldeburgh Festival," p. 5.

Musical offerings were particularly rich and included Peter Pears with the Aldeburgh Festival Choir and Chamber Orchestra, religious music in the Parish Church by Pears and Benjamin Britten, the Zorian String Quartet, a chamber concert conducted by Britten and Arthur Oldham, and performances of the Aldeburgh Serenade Concert. Three performances of Britten's comic opera *Albert Herring* were given by the English Opera Group. As for poetry, recitals of verse, music, and song were featured, concentrating on the poetry of the Bible and of the sea. Literary interest was stimulated by "Suffolk Writers—Past and Present," an exhibition of early editions and original manuscripts. Lectures were given by E. M. Forster, William Plomer, Tyrone Guthrie, Steuart Wilson, and Sir Kenneth Clark. There were exhibitions of paintings by Constable and of contemporary paintings by East Anglian artists.

Central and local government support has figured much less prominently in the financing of the Aldeburgh Festival than in the Edinburgh and Bath festivals. Aldeburgh, with a population of approximately 3,000, is located in a predominantly rural area. The local authority has provided only token support, and assistance from industry has been minimal. Arts Council support, in the form of guarantees, has always been helpful, rising by slow progression from £500 in the early 1950s to £2,500 in 1961–62, and then leveling off for several years. In 1966–67 the Arts Council guarantee was £3,000, and in 1967–68, £4,500. Nor has the festival enjoyed the patronage of a modern-day Maecenas. Apart from the Arts Council, the festival has relied mainly on the support of some 400 comparatively small subscribers whose gifts are greatly enhanced by the tax concession on covenanted subscriptions. For the financial year ending 31 August 1966, subscriptions to the value of £3,860 were received, a portion of which had been given for specific festival events. These moneys were placed in a festival fund from which annual working deficits have been paid. Net deficits were £2,295 for 1965, £3,152 for 1966, and an estimated £1,229 for 1967. Aldeburgh is self-supporting to a greater degree than most festivals, earned receipts amounting to 77 percent of the £26,869 total expenditures for 1966, and 88 percent of the total of £46,285 for 1967. Not to be overlooked are the contributions of Benjamin Britten, for not only does he give Aldeburgh the first performance of many of his new compositions but he has attracted to the festival some of the world's greatest artists.

Administrative arrangements have altered considerably since the festival was set up in 1948. Under the original constitution, artistic direction and administration were viewed as separate functions. The festival was governed by an elected council, assisted by a general manager. The council each year engaged the English Opera Group, or more specifically the group's artistic directors, to present program proposals for the coming festival. This setup was deemed unrealistic, and full authority relating to all questions was placed in the hands of the three artistic directors and the general manager, the council becoming an advisory body. In the 1950s the ties with the

English Opera Group were loosened, and the artistic directors functioned on their own, though some of them retained connections with the opera group. The festival's subscribers elect the officers (chairman, artistic directors, treasurer, and manager) and appoint the council. The directors—Benjamin Britten, Peter Pears, Imogen Holst, and Philip Ledger—and the manager meet many times throughout the year and deal with every aspect of the festival, practical details as well as the composition of each program. The general manager is the only full-time paid employee, and he is responsible for all matters pertaining to administration.

During the early 1960s the festival authorities became increasingly aware of the inadequacies of the physical facilities available for housing the expanded and varied programs which were being projected. The Jubilee Hall was only suitable for chamber music and small operas; the churches, only for sacred music. The number of people unable to buy tickets was sufficiently large to be embarrassing, and in the minds of some, the festival appeared to be precious, and reserved to an overprivileged clique. A major drive to elicit the attendance of young people in large numbers was not successful. A malt house, four miles from Aldeburgh, became available for purchase, and in 1966 a concerted drive was launched to raise money to acquire it. In May a fifty-year rental lease was signed, and in less than a year's time the necessary reconstruction and adaptations were completed at a cost of £165,000. Without access to public funds except through the Arts Council, which contributed £25,000, the bulk of the money for the new "Maltings" had to be raised from private subscription, not without considerable difficulty. Designed for concerts and opera, the new hall had an auditorium seating 800 persons, an open stage, excellent acoustics, and the needed auxiliary facilities such as dressing rooms and restaurant. In 1967 the festival's repertory was expanded and the length of the festival extended from fourteen to twenty-four days. Press reports and audience reception were enthusiastic. Ticket sales rose from the previous year's £14,637 to £34,700, and the festival played to virtually full houses throughout the month, netting substantially increased earnings sufficient to meet the cost of maintaining the new hall. The festival suffered a serious setback in 1969 when the concert hall was virtually destroyed by fire. Plans for rebuilding the house have been approved, and the work of reconstruction undertaken. Today's festival programs are more varied than those of the early years, and the orientation toward the local scene is much less pronounced. Thus far, no efforts have been made to include theater as an integral part of the festival offerings.

The Cheltenham Festival In June 1945, five weeks after the end of the war in Europe, the first of the Cheltenham festivals took place. The product of extraordinary foresight in the previous year and a determination to hold a music festival, war or no war, Cheltenham was thus the pioneer of the new movement, now widespread,

to offer to local inhabitants and visitors a combination of the holiday spirit and an opportunity for the serious appreciation of the arts. Local government initiative was dominant from the beginning, for G. A. M. Wilkinson, Cheltenham's entertainments manager, presented the tentative plans to the entertainments committee of the Cheltenham Corporation for the new festival and urged that it be of greater cultural value than the series of popular concerts featured at the festivals at Brighton and Folkestone. The suggested theme was new English music, with a completely new work offered at each program. The Cheltenham Festival was designed "to provide a focus for that surging interest [in music] but it was chiefly devised to give a hearing—and encouragement—to the many young British composers who were then making their individual marks but were finding concert-promoters a little shy of their kind of music."[10] The first festival's three concerts by the London Philharmonic Orchestra were presented by three composers who conducted their own works—Britten (then in his thirties), Walton (in his forties), and Bliss (in his fifties). Many succeeding festivals presented the same pattern of concerts: they challenged the audience's resilience of taste with examples of the new music by British composers and in the same program offered recognized modern works. Audience response and critics' evaluations were enthusiastic. Future prospects appeared promising.

In 1946 the festival featured four orchestral concerts by the London Philharmonic, this time conducted by Malcolm Sargent. Five composers appeared on the platform to conduct their own works—Britten, Bliss, Moeran, Rubbra, and Tippett. Music by Delius, Elgar, Ireland, and Rawsthorne was also played. In a critics' forum, each of the four participating critics gave a lecture. This emerging pattern was adhered to, with additions, in the next three festivals, although lectures were discontinued after 1947 and the critics' forum after 1950. Under the direction of John Barbirolli, the Hallé Orchestra in 1947 began a fifteen-year association with the festival. In 1948 the festival was extended to two weeks; important in that year, too, was the festival's inclusion of opera, put on by the English Opera Group. Since then opera has not been featured regularly; however, in 1955, 1956, and 1959 the Intimate Opera contributed fifteen small operas from their engaging repertory of miniatures. The theatrical possibilities of the festival have been limited by insufficient financial resources, even though the management committee has ambitions in this area. In 1963 the Western Theatre Ballet presented two programs in the festival, and Dylan Thomas's *Under Milk Wood* was featured at the Everyman Theatre. In 1949 the first Cheltenham Festival of Contemporary Literature was well received; literature festivals are separately organized and in recent years have been held in October (see chapter 11).

The policy of playing at least one new work annually and letting it find its level among established masterpieces was most desirable. But in 1961 the committee, because of the difficulty of finding new works of sufficient merit,

10. Frank Howes, *The Cheltenham Festival* (London: Oxford University Press, 1965), p. 6.

thought it advisable to redefine the festival's format to include important British works written in the past fifty years, masterpieces of the twentieth century (not necessarily British), and one program (not necessarily by a full symphony orchestra) made up of more progressive works.[11] More recently, a number of other orchestras have participated, as well as the Hallé, including the BBC orchestras, the London Symphony, and the Royal Philharmonic.

The Cheltenham pattern of patronage is an interesting one. The first two festivals were managed directly by the entertainments committee of the Cheltenham Corporation, and the corporation still exercises a major responsibility, for under the constitution of the Festival Company a majority of its board of directors must be members of the borough council. The first Arts Council grant of £100 was extended in 1947, but in view of the council's policy at that time of not making grants directly to local authorities it became necessary to set up a local nonprofit-making company to administer the festival. In 1967, Cheltenham Arts Festivals, Ltd., was governed by a seventeen-man board of directors, including the mayor, two aldermen, and five councillors; assisting the board were two committees, one for the music festival and one for the literature festival. Arts Council subventions have continued down to the present; until 1963–64 they did not exceed £2,000. Through 1960–61 Cheltenham received the second largest of all Arts Council annual festival grants. Expenditures for the 1967 Cheltenham Music Festival totaled £12,000, this sum being covered by receipts from admissions, and subventions amounting to approximately 55 percent—a guarantee from the Arts Council of £4,500; grants from the Cheltenham Corporation, £1,500; Gloucestershire County Council, £300; Arthur Guinness Son and Co., Ltd., £250; and the Worshipful Company of Musicians, £150.

In evaluating the festival, one must point to the significant number of substantial works that have had their initial performances at Cheltenham. The initial festivals drew good attendances, but as the programs became more adventurous in accordance with basic policy, the size of audiences varied. Cheltenham has not been able to acquire an image as a holiday festival comparable to that of Edinburgh, as the founders had hoped. Nor has it been as successful in bringing visitors from all over the country as have those festivals which focus on classical music. But efforts to attract larger audiences and to improve the festival's financial position continue. Program innovations also continue—jazz has been admitted to the scheme, and recently an international flavor was added by inviting orchestras from Czechoslovakia and Poland to participate. The commitment to modern music remains in force.

Festival of the City of London Of comparatively recent origin (1962) is the Festival of the City of London. Earlier in its history the corporation had commissioned numerous musical works, but in modern times the link between the city and the performing

11. Ibid., p. 17.

arts had become indistinct and tenuous. By 1960 plans for development of the Barbican were well advanced. A festival, though held for only two weeks every second year, would, it was hoped, foster a favorable atmosphere for launching the new and exciting Barbican Arts Centre.

In November 1961, the necessary sanction for the initial establishment of the festival was given by the Court of Common Council, which agreed to make available to the nonprofit City Arts Trust, Ltd., the sum of £7,500. Once plans were well formulated, something over £25,000 were donated by individuals and industrial and commercial concerns within the City. Two works were commissioned: *A Song for the Lord Mayor's Table*, by Sir William Walton, for the Worshipful Company of Goldsmiths; and a trio, by Alan Rawsthorne, for the Worshipful Company of Musicians. An anonymous donation made possible the commissioning by the trust of four other works, by Edmund Rubbra, Arnold Cooke, Richard Bennett, and Phyllis Tate. Particularly successful were the presentation of Gilbert and Sullivan's *The Yeomen of the Guard*, in the precincts of the Tower, and the Lime Street Fair, which included dancing in the streets that attracted 30,000 people. Public interest in the initial festival was encouraging, and press comments consistently laudatory; final receipts indicated that 92 percent of available tickets were sold.

Plans for the 1964 festival had not progressed beyond the tentative discussion stage before the City indicated its satisfaction with the success achieved in 1962 by increasing its appropriation to £25,000, to be made available over a two-year period. The Arts Council provided a subvention of £2,000, and additional funds were raised from sources within the City. Beginning 6 July and extending through 18 July the range of events, nearly all scheduled in the evening, was most varied. Organ recitals were held in a number of City churches. Performances were given by the London Symphony Orchestra, the Bath Festival Orchestra conducted by Yehudi Menuhin, Philomusica of London, the Philharmonia Orchestra, conducted by Klemperer, the Amadeus Quartet, and the English Chamber Orchestra. The Art of European Song, given on successive nights, focused on Germany, Britain, Scandinavia, France, Italy, and Russia. There were lecture recitals, jazz concerts, light opera, drama, exhibitions, and even ox-roasting and fireworks.

The 1966 festival received increased governmental assistance: the City made available £35,000, and the Arts Council, £7,000. Greater emphasis than in former years was given to opera in Southwark Cathedral, with the English Opera Group appearing each day in works that included Benjamin Britten's *The Burning Fiery Furnace* and *Curlew River*. A recital by Peter Pears and Benjamin Britten and concerts by the English Chamber Orchestra, the New Philharmonic Orchestra, and the London Symphony Orchestra and Choir were given at the Guildhall. Recitals and symphonic and choral concerts were given at Saint Paul's Cathedral, at the churches of Saint Sepulchre and Saint Andrew, Holborn, at Goldsmiths' Hall, and at other

halls. A program of drama about Samuel Pepys, sponsored by the Apollo Society, was presented at the Draper's Hall.

Brought into being as a result of official action and sustained by corporate and Arts Council subvention, the City of London Festival is now well established. It is likely to be enhanced, better housed, and unified by the completion of the Barbican Arts Centre.

Canons of Festival Subsidy The British experience points up a number of rules which may be considered essential to a system of festival patronage. (1) Of paramount importance is the quality of artistic direction. Edinburgh has been fortunate in its long succession of extremely competent professional directors—Rudolf Bing, Ian Hunter, Robert Ponsonby, Lord Harewood, and, at present, Peter Diamond. Aldeburgh owes an immense debt to Benjamin Britten, Peter Pears, Imogen Holst, and, more recently, Philip Ledger; Bath, to Yehudi Menuhin; and King's Lynn, to Ruth, Lady Fermoy. (2) Physical accommodations available determine to a great extent the nature of the programs to be presented. For some years the Edinburgh Festival directors were unable to induce the city to erect an opera house to supplant the present inadequate accommodations. Aldeburgh would have had quite a different content had it not been able to use several magnificent Anglican churches. Prior to the recent fire, Aldeburgh Festival possessed one of the nation's best concert halls at the Maltings, Snape. If suitable buildings are not available to house a festival, the local authorities, with Arts Council aid, should seek to make adequate provision. (3) Festivals do not realize their full potential unless they encourage new work. Cheltenham, as shown, concentrates on new British music. Important new works have been commissioned by other festivals; for example, Britten's *War Requiem* for the Coventry Cathedral Festival in 1962, and Michael Tippett's *Concerto for Orchestra*, for the Edinburgh Festival in 1963. To be effective, a commissioning policy must be planned some years in advance, for failures are not infrequent and superlative results are not achieved according to fixed time schedules. (4) The Arts Council is firmly committed to the policy of not assuming the initiative; rather, it waits for local groups to generate the necessary local interest and come forward with concrete plans. In fact, since the 1951 Festival of Britain, council aid has been accorded in most instances only to festivals which have been in actual operation for a number of years. Of the more recently established arts festivals, two are of particular importance—Harrogate, founded in 1966, and Brighton, in 1967. (5) It is important that festivals do not occur in close proximity or at the same time, if they compete for the same audiences. Of the ninety-two festivals operating in 1967, only eight were held between 1 October and 31 March. The new regional associations can do much to ensure proper coordination. (6) Festivals should not be considered the equivalent of week-by-week entertainment for the local population. Energetic efforts should be made to attract new clientele, particularly young people. (7) Most festivals

wisely choose multiple coverage, rather than concentration upon a single art form, for not only are the arts interrelated, but larger audiences respond well to this type of festival. (8) Local authorities should be willing to contribute generously, for their inhabitants benefit greatly. The Arts Council would like to see local industry and commerce come forward with substantial sums, considering subscription a privilege. It wants to see charitable foundations make grants to underwrite special projects, such as commissioning schemes. The council itself makes grants to festivals, provided the artistic standards are sufficiently high, and the size of its subventions varies in each instance since no precise formula is adhered to. The proportion of costs covered by receipts ought to be substantial, the council holding to the view that it is unlikely (and perhaps undesirable) that subsidies from all sources should exceed 50 percent of the gross expenditure.

In the future, grants made directly to festivals by the Arts Council are likely to be larger now that the overall Treasury allocation to the council is more adequate. As regional associations come to be constituted throughout Britain, they will undoubtedly become the mechanism for channeling funds to support many of the festivals and, equally important, they will devote special attention to encouraging the formation of new festivals where there is a need and sufficient local interest.

14 / REQUISITES OF A VIABLE PATRONAGE SYSTEM

We need the arts, and all the great lift of the spirit they can give us, urgently here and now.

The state itself should be a generous patron of artists of many kinds.
—J. B. Priestley, 1947

O utlining the responsibilities which he felt a socialist government should exercise in safeguarding the welfare of the arts in Britain, J. B. Priestley insisted that the State must create favorable conditions for the artists, both "creators and executants." Orchestral players and opera singers require an adequate number of new concert halls and opera houses, the formation of new orchestras and opera companies, and steady employment at adequate wages. Dramatists, actors, and ballet dancers cannot function properly without well-equipped playhouses and theatrical organizations on both a national and municipal scale. Admitting that these needs were elementary, Priestley sadly observed that they were not being met and that he knew of "no plans even aiming at their fulfillment."[1] He worried about original genius, especially the young and unrecognized writers, painters, and composers, who were suffering from gross neglect. To bring about drastic change he advocated large expenditures by the Treasury and by local authorities, although he feared the dead hand of "committee art" and the dangers of political intervention.

Priestley's assessment, fortunately, proved to be unduly pessimistic. The cumulative effects of wartime fatigue undoubtedly colored his judgment. Austerity permitted only limited government funds to support the arts. The inadequacy of the Treasury grant-in-aid to the Arts Council appears to have been widely recognized. The council in its 1948 annual report declared that in many fields its programs were restricted by lack of money, and that requests for assistance far exceeded its ability to respond on the scale it desired.[2] In 1949 the British Actors' Equity Association, when it presented evidence to the select committee of the House of Commons inquiring into the operations of the Arts Council, stated that "we wish to say emphatically that we are in agreement with the peculiarly English method which has been found in the Arts Council of stimulating cultural life without strangling it. . . . Our main criticism of the way it has been established is that the Government grant is too small."[3] The select committee reported that council policy of holding a balance between the various schools of artistic expression had been justified and that it had "given no cause for alarm that they were or might become an instrument of State censorship."[4] The committee did not, however, support Priestley's plea that encouragement be given to individual artists.

During the 1950s, total sums spent by the central government and the local authorities to subsidize the arts registered modest increases year by

1. "If the English were as excited about poetic tragedies and string quartets as they are about Test Matches, then very soon I am prepared to prophesy, we should bring forth the most enchanting poetic tragedies and string quartets." J. B. Priestley, *The Arts Under Socialism* (London: Turnstile Press, 1947), pp. 9–24.

2. *The Arts Council of Great Britain: Third Annual Report 1947–1948*, p. 6.

3. *Nineteenth Report from the Select Committee on Estimates, Session 1948–49, The Arts Council of Great Britain*, no. 315 (HMSO, 1949), pp. 158–59.

4. Ibid., p. xv.

year. Yet at no time did the arts have at their disposal resources sufficient to permit them to achieve much more than minimal objectives. In some instances only holding operations were possible. Budgetary augmentation was subject to the eroding effects of inflation. And in the early 1960s the relative position of the arts registered only minor improvement. The initial spectacular jump in Exchequer allocations occurred in 1966–67, when total estimates covering museums, galleries, and the arts were set at £11,966,700, £1,814,700 higher than the previous year; included in this total was an increase for the Arts Council of £1,790,000. Again, in 1967–68, the national arts budget was appreciably larger, amounting to £14,140,000, an increase of £2,173,000. Arts Council moneys amounted to £7,200,000—£1,500,000 more than in 1966–67. Arts allocations from the Treasury for 1968–69 totaled £15,395,000, and for 1969–70, £17,100,000. Included in these appropriations were Arts Council grants of £8,404,000 for 1968–69 and £9,286,000 for 1969–70. The straitened economic conditions which accompanied the devaluation of the pound in 1968 led the Treasury to slow arts subsidy expansion, at least temporarily. Although local authority support remains at levels below those hoped for by the sponsors of the 1948 Local Government Act, it has risen substantially in recent years.

For more than twenty-five years, Britain has provided government encouragement and support to the arts, and its programs of subsidy have achieved remarkable success. The nation has acquired through experimentation an understanding of the arts and insights into their problems which have permitted it to utilize its subsidy moneys to good advantage. Some mistakes have occurred, as depicted in the preceding chapters. But steady progress has been made toward high standards and the availability of the best in the arts to the whole nation. The crucial question is, can the performing arts even survive in Britain without government subsidies? That the performing arts under present economic conditions and without substantial public subventions would find it impossible to operate at a high professional level is beyond dispute. Nor would their dissemination outside London be economically feasible. In opera and ballet, if assistance were not forthcoming from the Treasury and local authorities, the prewar pattern of short seasons with top talent imported from abroad on a temporary basis would undoubtedly prevail, combined with limited performance by amateur organizations. Professional symphony orchestras could operate on a restricted basis without aid from the public purse, but evidence submitted to the Goodman committee underscored the economic difficulties which beset them. Symphonies able to pay their way unaided would unquestionably be smaller and fewer in number than those operating at present. Theater life would be greatly impaired were subsidies discontinued. The National Theatre would not have been founded. Nor could the Royal Shakespeare at its London base perform its role of experimentation and innovation. Other professional theaters in London and the provinces, if they survived, would in varying degrees be forced to adopt the formula used by commercial companies—

emphasis on popular plays, presentation of experimental or avant-garde works only sparingly, and operation on a continuing-play rather than a repertory basis. As for the visual arts, it scarcely needs mentioning that only a few significant collections of paintings and drawings would be available for enjoyment by the British public should the maintenance of art galleries be repudiated as an accepted function of government.

The successful operation of the British system of arts patronage, as explored in the preceding chapters, permits the formulation of a tentative theory of arts subsidy. Public patronage could not be introduced until certain conditions existed within British society. Its effective functioning is dependent upon the maintenance of suitable organizational arrangements and the development of adequate administrative procedures. To assert that these features are of universal applicability would be hazardous. However, they do offer guidance to other countries which face similar problems in their efforts to create systems of government patronage or to improve existing systems.

When Britain's Arts Council was accorded permanent status in 1945, the people already possessed a substantial appreciation of both the creative and the performing arts. Popular education played an important role, insuring that the youth were exposed to the arts in their formative years. Crucial also was the influence of the BBC; since the late 1920s it had energetically sought to create a mass audience interested in good music, opera, theater, and literature, and, with the coming of television, ballet and the visual arts. In other countries such as the United States, where radio and television facilities are privately owned and commercial advertising is the dominant consideration, public interest in the arts is much more limited.

Government leaders, by taking the initiative and providing positive leadership, can exercise a very constructive type of cultural statesmanship. Much of the major legislation in other fields enacted by Parliament since the turn of the century has enjoyed the active support of vigorous and powerful pressure groups, in some cases without wide popular support. But the number of persons earning their livelihood from the arts or deriving profits from enterprises associated with them has always been small and has lacked political influence. If patronage legislation is enacted, it must come as a result of genuine concern on the part of party leaders.

Legal authorization of subsidy programs should be couched in broad terms. When the Labour Government in 1945 decided to continue the work of CEMA and constitute a permanent organization to administer various types of artistic assistance, it did not do so by means of legislation. Rather, it promulgated a royal charter which gave to the Arts Council maximum independence, a position traditionally above the rough and tumble of partisan politics, and much prestige. A brief document, the charter consisted of provisions broadly phrased. Extensive discretion was given to the council in matters of internal organization, precise programs of assistance, and

11*

administrative procedures. The new royal charter granted in 1967 retained the desired flexibility.

There are differences of opinion as to the best location in the national governmental structure for the agency which administers arts patronage. The Arts Council under the general supervision of the Treasury possessed the advantage of direct and unimpeded access to the Exchequer, though critics claimed that the Chancellor and his associates dealt parsimoniously with the arts. However, it is by no means certain whether the national museums and the Arts Council would have received appreciably more under a different ministry, for the government during much of this period had to cope with the rehabilitation of the economy. With the shift in parliamentary responsibility for the Arts Council to the Department of Education and Science by the Labour Government in 1965, the arts acquired a spokesman in the Cabinet and the Commons, independent of the Treasury. Certainly arts subsidy and education are related functions, and their association can be justified on logical grounds. Thus far the arts have received generous estimates allocations under education. However, available evidence suggests that Jennie Lee is playing a substantially greater role than her predecessors, who presided at the Treasury. The clearest danger under the present arrangement lies in the possibility that the arts might become subordinate to education, the department's chief interest, with the result that the emphasis on the professional arts could be lessened and standards of performance lowered. The naming of a Minister of Culture with a separate department embracing all arts support functions is a third organizational possibility, one likely to be adopted at some future time.

Crucial is the avoidance of all political interference in the patronage of the arts. The British record appears to be a good one, Parliament having restrained any impulses that might have led it to tell the Arts Council to whom assistance should be extended and in what amounts. An exception was the government's practice until 1966 of setting the allocations for the Royal Opera House and the National Theatre independently of the Arts Council's budget.

Precisely at what level should monetary allocations for patronage programs be set? A formula could be devised calling for the expenditure of a specified sum per capita, with proportions earmarked for support in the provinces. But adequacy is a relative matter. Thus far Arts Council grants from the Treasury have not been great enough to permit the council to meet justifiable needs. The most glaring deficiency, perhaps, has been in housing for the arts, moneys allocated for this purpose being only a fraction of what is required. Undoubtedly, larger sums should be expended in support of literature, but here new subsidy techniques need to be devised to obtain maximum benefits. Art gallery purchase grants are still woefully inadequate, both for nationally and locally administered galleries. Local authority outlays for arts support, if substantially increased, could provide the means for insuring much wider diffusion especially in the less thickly

populated parts of the country. "Even if the Treasury had the money to pay for the whole arts bill, this would not be a good idea," said Jennie Lee in 1966. "Local authorities should play their part—and industry, and trade unions, and the great trusts."[5]

Decision-making in patronage allocation under Arts Council arrangements is a collective one. Who should receive financial aid and in what amounts is determined by the council and not by the secretary-general or other members of the staff. The council is less likely to be subjected to casual or unjustified criticism than is a single administrator, and unquestionably is less amenable to pressure and political influence. This does not mean that the council lacks advice, for the specialist advisory panels and the council's own professional staff usually consider each question in advance and submit recommendations.

The Arts Council and the local authorities have exhibited remarkable ingenuity in devising different methods of providing aid, each designed to meet a particular need. Usually an organization receives support in a number of different ways. Thus, a theater may be accorded revenue grants and/or guarantees, touring grants or guarantees, funds for capital items other than buildings, new drama and neglected play subventions, transport subsidies, funds to operate training programs, and grants under the Housing the Arts scheme. Skill is requisite both to the proper assessment of subsidy requirements and to the selection of ways by which the council can put its resources to best use.

Provision of financial help to individual artists, particularly in the early years before they become well established, is a phase of arts subsidy which until recently was not undertaken to any appreciable extent by the Arts Council. A proposal that more must be done in this area was put forward by Labour in its white paper in 1965, when it observed that the artists' "ability to develop and sustain a high level of artistic achievement lies at the center of any national policy for the arts."

The scope of a patronage program—the determination of which arts are to be supported—is of much importance. The Arts Council has confined its support activities to a relatively few areas—professional opera, ballet, drama, art, music and poetry and, more recently, literature. It decided early that amateur participation in the arts could be fostered most appropriately by the schools and universities and by volunteer bodies functioning in local communities. If amateur arts are ever to be subsidized by the national government, it would be far better that their support be administered by a separate governmental organization. The council, by not becoming involved with the amateur arts, can more easily raise standards in the professional arts. The council has avoided the pitfalls of underwriting projects focused primarily upon the education of the youth. The cultivation of an understanding and appreciation of the arts by young people should be accorded a high priority but can best be left to the educational system and to other

5. Manchester *Guardian*, 25 February 1966, p. 3.

organizations. It has, however, looked with favor upon efforts by Covent Garden and Sadler's Wells, by symphony orchestras and repertory theaters, to encourage British youth attendance at regular professional performances.

The British believe that the national government should, whenever possible, refrain from itself becoming an arts entrepreneur. The obvious exception to this policy is its operation of the national art galleries. The Arts Council keeps direct provision to a minimum, relying primarily upon independent nonprofit organizations which it helps to support. Exceptions to this practice are the operation of the Wigmore Concert Hall in London, management of the new Hayward Gallery on the South Bank, the mounting of traveling art exhibitions from its own collection, art film tours, a poetry library, and Opera for All.

During the past hundred years the central government relied heavily upon the grant-in-aid system in education, health, welfare, police, fire services, highway construction and other local government functional areas, but in arts patronage it has studiously refrained from employing this device. Rather it relies upon the permissive provisions of the 1948 and 1963 acts and upon encouragement which it gives in negotiating with individual orchestras, theaters, and other organizations about their annual subventions. Arts Council assistance is frequently dependent in part upon the willingness of local authorities to make funds available to arts organizations whose activities benefit local people. "Cooperative patronage" stimulates local interest by encouraging participation in artistic enterprises.

The British experience with arts patronage demonstrates the continuing need for planning and for better coordination of resources. Duplication or conflict in support efforts by the national government and the local authorities, though infrequently encountered, must be eliminated. Regional arts associations offer an effective means of pooling the resources of many local governments in a large geographical area and of underwriting artistic activities which are beyond the financial capabilities of a single local authority. Thus far the obvious impediments to long-range planning of subsidy operations arising from annual appropriation of moneys by Parliament and by local councils have not been overcome.

And, finally, efforts have continuously been made to avoid rigidity. Flexibility and willingness to experiment have characterized the actions of those involved in artistic subsidy—the Arts Council and its staff, the administrators of artistic enterprises, Members of Parliament, and local councils.

INDEX